W9-AHA-090

MICHELANGELO
The Vatican Frescoes

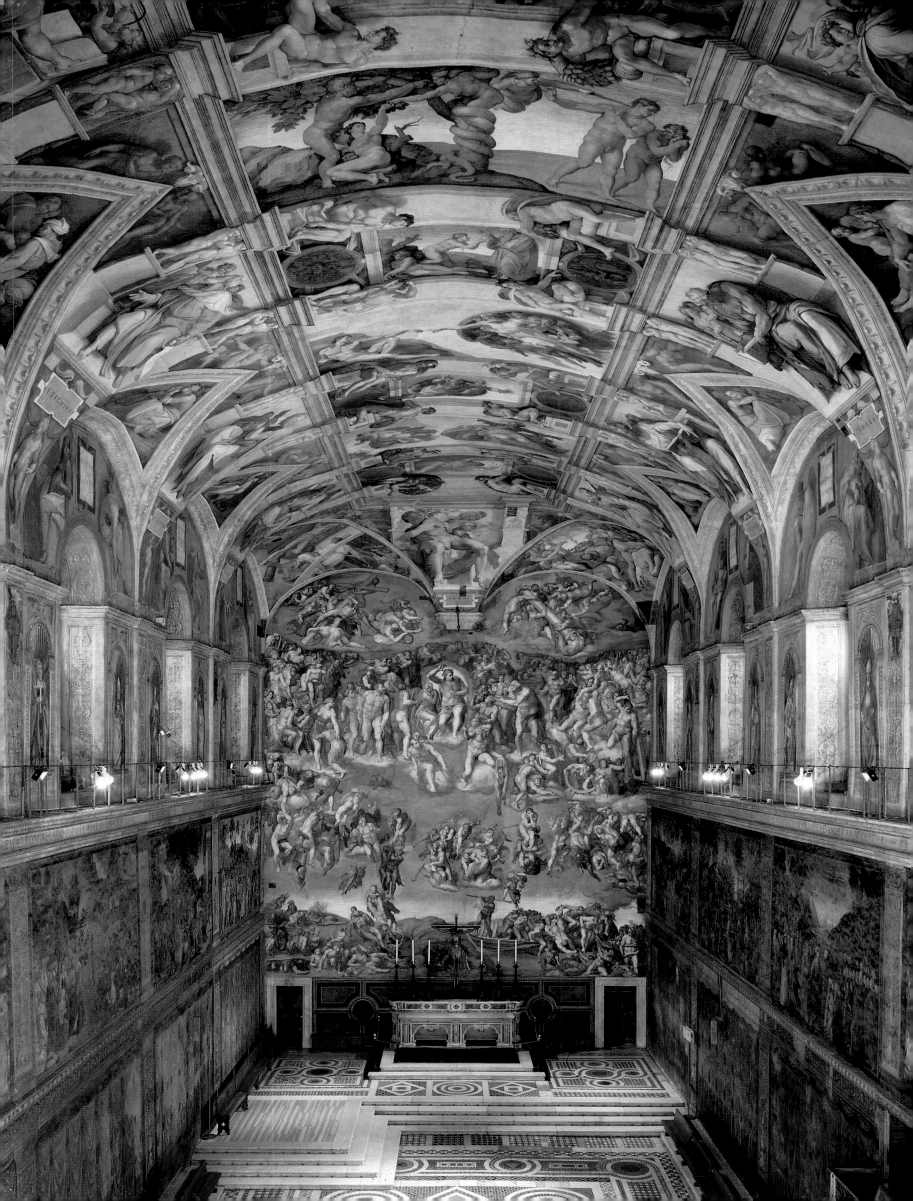

PIERLUIGI DE VECCHI

Professor of Art History at the University of Macerata

MICHELANGELO
The Vatican Frescoes

with an essay on the restoration by

GIANLUIGI COLALUCCI

Chief Restorer, Vatican Laboratory for the Restoration of Paintings, Papal Monuments, Museums, and Galleries

Abbeville Press Publishers

New York London Paris

Portrait of Michelangelo.

Right: Michelangelo transcribed a fair copy of a "tailed" sonnet, addressed to Giovanni di Benedetto da Pistoia, in the right margin of a quick sketch. The sketch shows a standing figure with arm outstretched and head tilted back, busy painting an odd figure resembling a child's dummy on the ceiling above him.

Concept and design:
Franz Gisler, Lucerne

For the English-language edition:
Translators: David Stanton and Andrew Ellis
Editor: Mary Christian
Production Editor: Leslie J. Bockol
Jacket Designer: Celia Fuller
Typesetting: CS Publishing, Freiburg i. Br.
Photolithos: La Cromolito Srl, Milano
Printing: Buri Druck AG, Wabern–Berne
Binding: Buchbinderei Schumacher, Schmitten/Berne

A production of
EMB-Service for Publishers, Lucerne

Copyright © 1996 EMB-Service for Publishers, Lucerne, and NTV, Tokyo
English translation copyright © 1996 EMB-Service for Publishers, Lucerne

Printed and bound in Switzerland

First edition

10 9 8 7 6 5 4 3 2 1

ISBN 0-7892-0232-8

Library of Congress Cataloging-in-Publication Data available upon request.

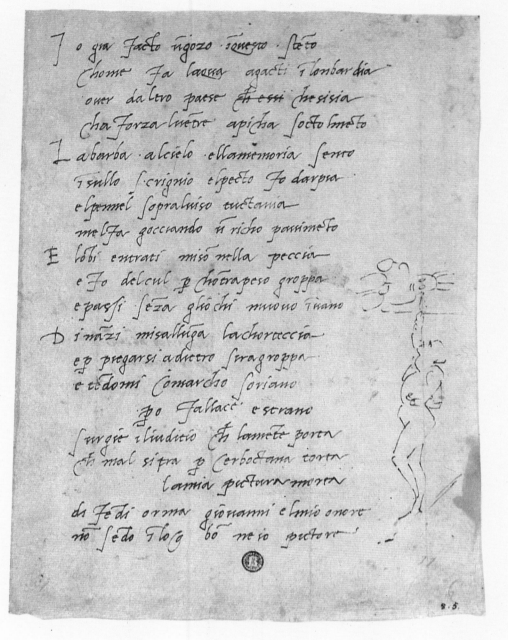

I' io già fatto un gozzo in questo stento

This comes from dangling from the ceiling–
I'm goitered like a Lombard cat
(or wherever else their throats grow fat)–
it's my belly that's beyond concealing,
it hands beneath my chin like peeling.
My beard points skyward, I seem a bat
upon its back, I've breasts and splat!
On my face the paint's congealing.

Loins concertina'd in my gut,
I drop an arse as counterweight
and move without the help of eyes.

Like a skinned martyr I abut
on air, and, wrinkled, show my fat.
Bow-like, I strain toward the skies.

No wonder then I size
things crookedly; I'm on all fours.
Bent blowpipes send their darts off-course.

Defend my labor's cause,
good Giovanni, from all strictures:
I live in hell and paint its pictures.

CONTENTS

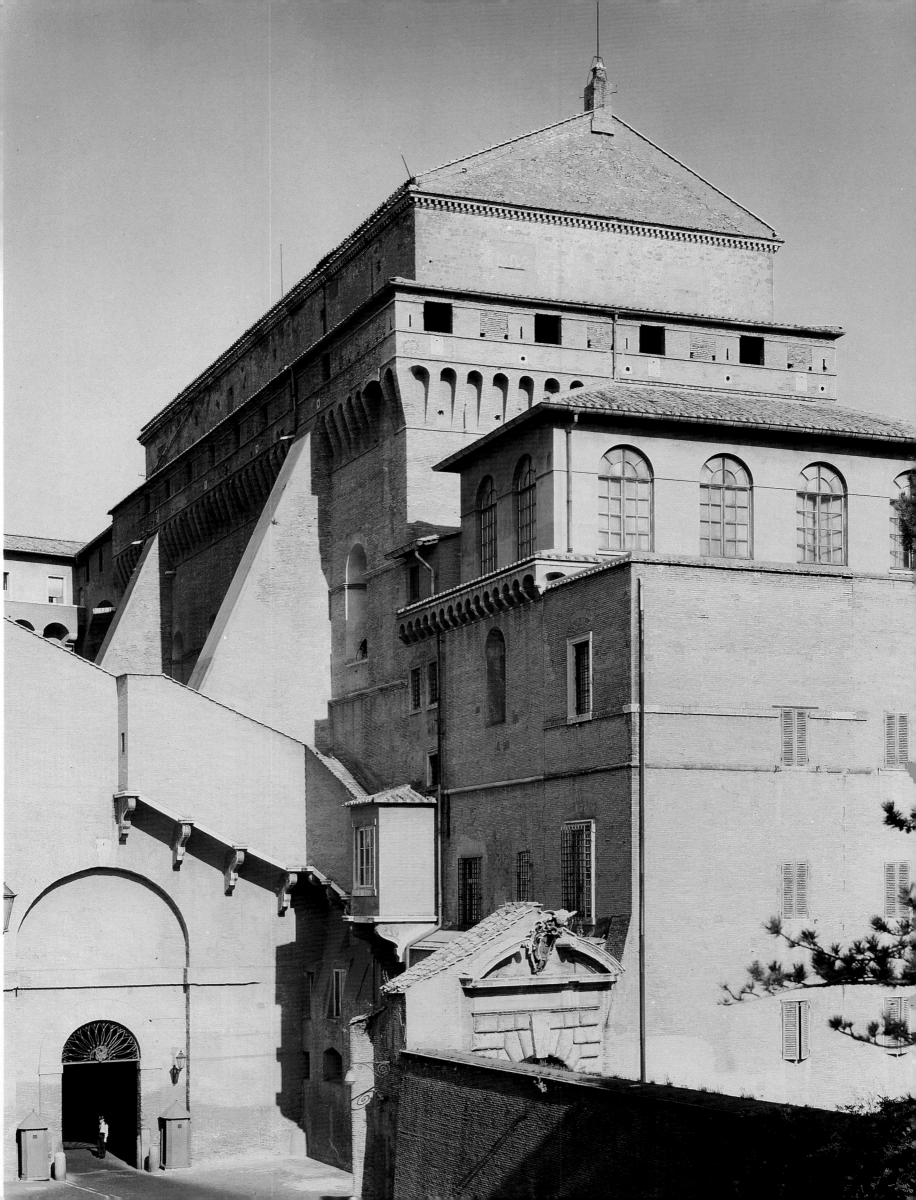

INTRODUCTION

In a note dated February 2, 1477, Cardinal Giuliano della Rovere (who would later become Pope Julius II) observed that, after celebrating the Mass in the Capella Magna, Sixtus IV appointed him Archbishop of Avignon. This is the last known mention of a liturgical service in the ancient palatine chapel before work began on the construction of what was to become known as the Sistine Chapel. Mentioned for the first time in a document dating from 1368, and adorned with the work of Giottino and Giovanni da Milano the following year, the preexisting building was not demolished entirely. The irregularity of the floor plan—the side walls converge slightly toward the far end, which, in turn, is not quite parallel with the entrance wall—is difficult to account for in a building erected in the late quattrocento, and recent investigations have revealed that the medieval walls were preserved at least as high as the first cornice of the present chapel. While the bulk of the perimeter walling was retained, the building itself—deemed unsafe—was provided with an inner wall of brick and bolstered with a scarp base; vaults were added both above and below the chapel, where the private rooms for the officiators were completely refurbished.

The vast chamber of the chapel, measuring about 131 by 46 feet (40 by 14 meters) is surmounted by a shallow barrel vault with six tall windows cut into the long sides, forming a series of pendentives between them. Two further apertures, set into the wall behind the altar, were closed up when Michelangelo Buonarroti began work on the *Last Judgment*. A marble mosaic floor of exquisite workmanship, inspired by medieval examples, describes the processional itinerary up to and beyond the *cancellata* or marble screen, to the innermost space, where it offers a surround for the papal throne and the *quadratura* of the cardinals' seats. The walls are divided into three orders by horizontal cornices; according to the decorative program, the lower of the three orders was to be painted with fictive "tapestries," the central one with two facing cycles—one relating the Life of Moses (left wall) and the other the Life of Christ (right), starting from the end wall, where the altar fresco depicted the Virgin of the Assumption, to whom the chapel was dedicated. The cornice dividing the lower and middle orders projects considerably less than the one above, where the wall is set back to accommodate a narrow passageway. The upper order is endowed with pilasters that support the pendentives of the vault. Between each window below the lunettes, in fictive niches, run images of the first popes—from Peter to Marcellus—who practiced their ministry in times of great persecution and were martyred.

The ceiling was frescoed by Piero Matteo d'Amelia with a star-spangled sky, whereas the wall frescoes, when Perugino had already completed the altar with the Virgin of the Assumption and the first two episodes of the Life of Moses and the Life of Christ on the end wall, he was flanked by other master fresco artists from Florence—Ghirlandaio, Botticelli, and Cosimo Rosselli—who were summoned after the pontiff withdrew the interdiction against their native city, and military action was halted. A contract dated October 27, 1481, between Giovanni de' Dolci (the supervisor of the Vatican palaces and probably the architect of the Chapel itself) and the four artists stipulated that the frescoing of the remaining ten vertical sections with their stories, fictive tapestries, and portraits of pontiffs, should be completed by

Opposite: The exterior of the Sistine Chapel, seen from the northwest, i.e., the side opposite that of the main entrance to both the Sala Regia and the chapel.

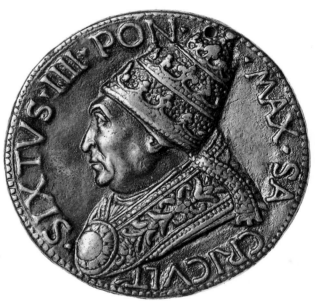

The medal by Antonio Guazzalotti da Prato bears a portrait of Pope Sixtus IV, the founding patron of the imposing chapel in the Vatican palaces from whom the chapel takes its name. A Franciscan by vocation and doctor of theology before being elected pope in 1471, Francesco della Rovere's career included teaching posts at the universities of Bologna, Pavia, Siena, Florence, and Perugia, the appointment to prior-general of the order (1464), and subsequently to cardinal (1467). Shortly after his election the cardinal performed a gesture of great symbolic value, by which he reinstalled on the Capitol several antique reliefs and bronzes—including the *Lupa*, or figure of the suckling she-wolf. The gesture was seen as the restitution to the Roman people of indelible legacies of the city's imperial past. In addition to numerous urban improvement schemes and commissions for monuments, della Rovere was responsible for endowing the Biblioteca Apostolica, opening its doors to scholars, and appointing the humanist Bartolomeo Sacchi (called Platina) prefect of the library, as featured in the fresco by Melozzo da Forlì.

March 15, 1482. The deadline was not honored, and Signorelli was replaced by Perugino for the fresco depicting the Testament of Moses, which then included the Death of Moses on the entrance wall. Other artists, such as Piero di Cosimo, Bartolomeo della Gatta, and Fra Diamante, worked alongside Michelangelo on minor commissions.

The layout of the pictorial program is very closely linked with the architecture of the chapel. The ratio of approximately three to one between the side and end walls, together with the presence of windows, dictated the system of partitions, with six vertical sections on the main walls, and two on the others. In the facing episodes from the Old and New Testaments—whose "typological" correspondents were made explicitly to be means of *tituli*, or inscriptions, on the frieze above—numerous contemporaries of the pope and artists were portrayed as witnesses to the events represented, thereby underlining the scenes' symbolic significance and their reference to the present. Moses, in his role as the guide and law-giver of the chosen people, and the priest Aaron prefigure Christ, who is portrayed as guide, law-giver, and priest. The written law of Moses is made concrete in the evangelic law, and the supernal powers, united in Christ, are transmitted to Peter and thus to his successors, the popes. Seen as a whole, the cycle is therefore an earnest doctrinal and political assertion of the sacred nature and fullness of the powers conferred on the Roman papacy.

Irrespective of the complexity of the iconographic program, and of the problems the artists had to overcome to meet the expectations of the papal commission, the frescoes completed under the pontificate of Sixtus IV demonstrate astonishing stylistic consistency, as noted by John Shearman; the feat was possible because the various artists accepted the discipline imposed by a common scale of the figures, lines, and horizons, chromatic range, conventions of landscape representation, and in particular the visual rhythm, parameters which were probably laid down by Perugino during the first phase of work. The impression of uniformity is strengthened by the extensive use of gilded detailing, which adorns not only the drapery and decorative features, but also the painted architecture and landscape features, making certain details more luminous and prominent. The quantity of gilded areas must also be seen in relation to the specific functions performed in this chapel, and to the beautiful radiance created by the reflections of the candles and torches during the numerous evening functions.

The particular nature of the terrain on which the chapel was built may have been the main cause of the structural faults that soon began to threaten the building. In 1504 a large, ominous crack appeared in the ceiling after subsidence in the foundations caused the south wall to tilt; for several months the chapel was declared off-limits. Modifications ordered by Julius II primarily concerned the insertion of tie-bars above the main vault and in the lower vaults; in August that year the chapel was described with the wording "under construction," but services were resumed by mid-October. The recent restoration of the ceiling frescoes brought to light a long flaw running from the northeast corner, plugged with brick before Michelangelo started work, perhaps in the summer of 1504, when other repairs were effected on the central part of the vault. There is every reason to believe, therefore, that the

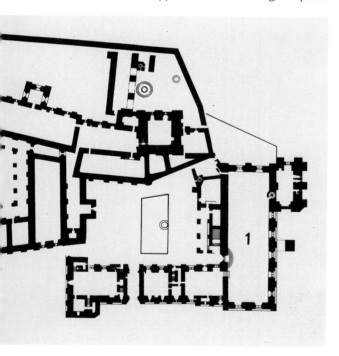

Plan of the papal palace of Avignon. During the papacy's residency in the French city (1305–1377), the popes resided in a building that outdid the one they had abandoned in the Vatican. Pope Clement VI had the upper floor of the Avignon palace graced with a vast chapel (right, marked 1) measuring about 171 by 49 feet (52 by 15 meters), whose crenelated exterior was similar in design to that of the Sistine Chapel in its original configuration.

original frescoes by Pier Matteo d'Amelia were seriously compromised, which is why Julius II commissioned Michelangelo to repaint the ceiling.

The commission most likely dates from April 1506, before the artist stormed off to Florence, outraged at the pope's decision to forsake the project for his tomb, on the eve of the laying the foundation stone for the New St. Peter's Basilica.

In a letter sent to Michelangelo on May 10 that year, the chief joiner and *capomaestro* Piero Rosselli notes that the previous evening, the pope ordered Giuliano da Sangallo to proceed to Florence and bring Buonarroti back to Rome, whereupon Bramante, the latter's rival, remarked to the pontiff: "Holy Father, nothing will come of it: I know Michelangelo well, and he has told me over and over again that he does not wish to be involved with the chapel, nor to receive your commission for it. ... Holy Father, I think he is not suited for the job, as he has not enough experience with painting, and here the figures are all high up and foreshortened, which is quite different from painting figures at ground level". From this one can infer that the pope had already offered Buonarroti the job of frescoing the Sistine Chapel—perhaps as an attempt to appease the artist for having canceled the tomb project. To his dismay he had met with a staunch refusal. The mention also reveals that Bramante envisioned a fictive architectural scheme for the ceiling, with a host of foreshortened figures seen from below, and felt that Michelangelo lacked the necessary experience to undertake a task of this magnitude—an estimation that cannot be attributed to spite or hostility, as not even Buonarroti considered himself a *pittore* as such, but rather a *scultore*; furthermore, the reputation he had acquired up until this point in his career rested principally on his sculptural works.

A somewhat forced reconciliation with Julius II took place in Bologna, regarding which the artist later wrote: "I was obliged to present myself, a yoke about my neck, and beseech his pardon". After spending a year and three months modeling and casting the bronze colossus of the pope for the facade of the church of San Petronio, Bologna, Michelangelo returned to Florence hoping that his obligations to Julius were over, but soon received a *breve* ordering him to reach Rome to begin work on the ceiling of the Sistine Chapel, a commission he effectively embarked upon on May 10, 1508.

Profound modifications were made to the original scheme, which had consisted of figures of the Apostles in the pendentives and geometrical compartments across the central part of the vault. Instead, Michelangelo began producing drawings and cartoons, while designing and overseeing the construction of the scaffolding that would enable him to execute the work. A document dated July 27, 1508, refers to the completion of the scaffolding and the first preparations of the surfaces to be frescoed. After a spate of initial setbacks, Michelangelo proceeded to paint the first half of the ceiling, through August 1510; work was resumed when the finished half had been revealed and the scaffolding dismantled and moved, ready to complete the rest, a phase that lasted from autumn 1511 to October 1512. An idea of the reaction of Michelangelo's contemporaries can be gleaned from his biographer, Giorgio Vasari: "This work has been and truly is a beacon of our art, and it has brought such benefit and enlightenment to the art of painting that it was

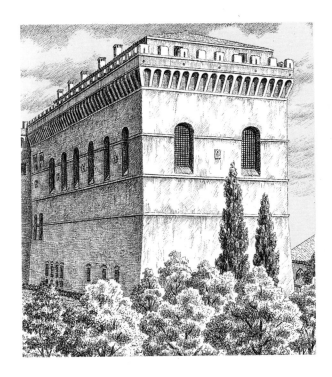

Reconstruction of the original design of the Sistine Chapel seen from the northwest corner, with the crenelations and *chemin-de-ronde*, before the addition of the buttresses on the long walls, and before the altar wall windows were closed and other buildings raised alongside.

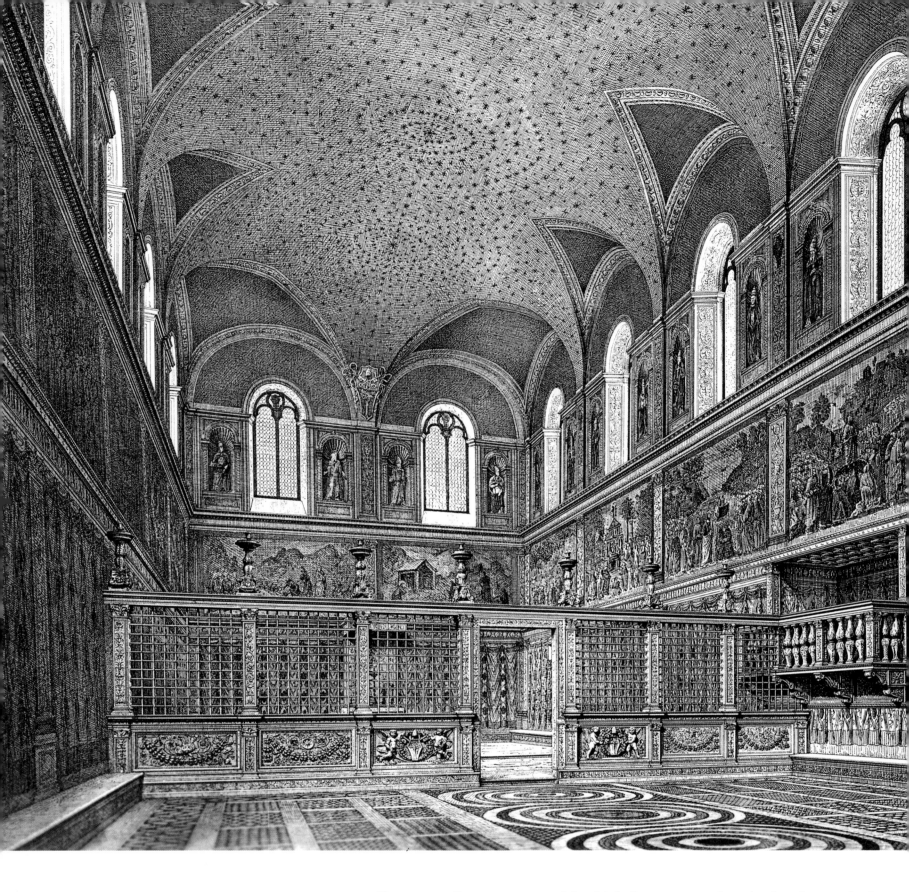

sufficient to illuminate a world which for so many hundreds of years had remained in the state of darkness. And, to tell the truth, anyone who is a painter no longer needs to concern himself about seeing innovations and inventions, new ways of painting poses, clothing on figures, and various awe-inspiring details, for Michelangelo gave to this work all the perfection that can be given to such details."

Michelangelo's frescoes on the ceiling and lunettes brought a new splendor to the Sistine Chapel. It remained, then, for Julius's successor Leo X (formerly Cardinal Giovanni de' Medici)—most eager to link his family name to this complex of such universal prestige, whose construction and decoration had

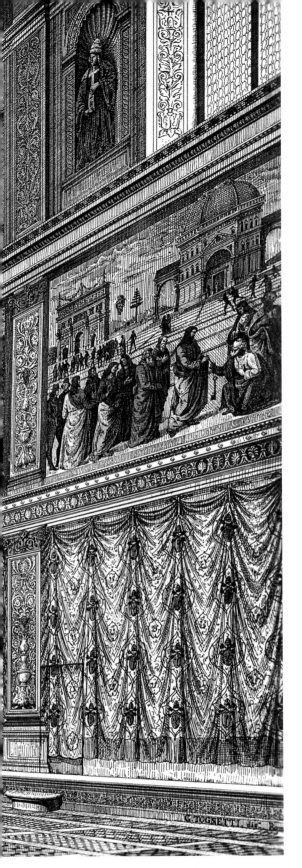

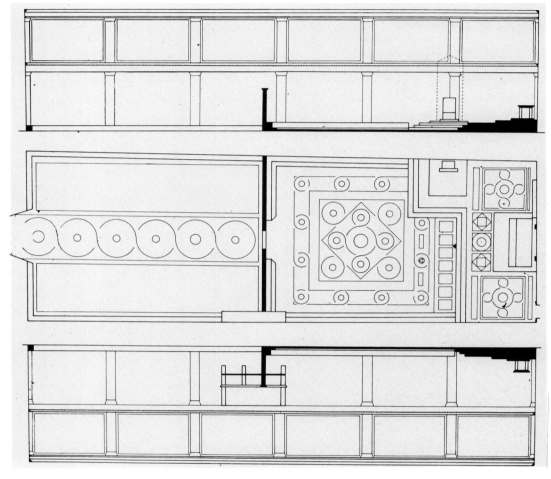

Left: Reconstruction of the interior of the Sistine Chapel in the days of Sixtus IV, before Michelangelo's alterations to the ceiling, showing its former decoration of star-spangled frescoes by Pier Matteo d'Amelia. The chamber is better lit and affords a more coherently enclosed volume, the walls having a concerted rhythm of division via cornices and pilasters. The *cancellata* can be seen in its earlier place, before being moved closer to the entrance to leave more room for the "papal chapel."

Below: Drawing of the inlay design of the marble floor, showing the definition of the processional itinerary preceding the *cancellata,* decorated with a continuous twin spiral that encloses six circles. The widest of these, near the entrance, is in por-

phyry (the so-called *rota porphyretica*) and marks the point at which the pope, celebrant, or humble pilgrim halts to genuflect when entering the chapel. Beyond the *cancellata,* the geometrical pattern marks the position of the pontiff's throne, the seats of the cardinals, and the area for the members of the papal "family." The pattern within the main enclosure indicates the position of the quadruple censing: one for each of the three rows of cardinals' seats, and one toward the altar. The floor pattern before the altar marks the positions of the officiant.

thus far been the glory of the della Rovere dynasty—to adorn the chapel with a set of magnificent tapestries. To this end, probably in the last months of 1514, Leo engaged Raphael to execute the cartoons. The tapestries, which were woven in Brussels in the workshop of Pieter van Aelst, feature the lives of Saints Peter and Paul, with episodes drawn from the Acts of the Apostles. These were designed to be hung on special occasions in such a way as to cover the simulated tapestries commissioned by Sixtus IV gracing the lower register of the walls, near the altar, beyond the *cancellata* in the enclosure that was reserved for the pontiff, the cardinals, the prior-generals of the various monastic orders, the officiants of the Mass, and the upper echelons of the

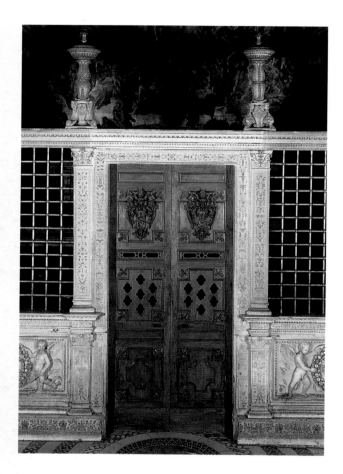

Gateway at the center of the Sistine Chapel's *cancellata*, dividing the part reserved for the pontiff and the liturgical celebrations from the area admitted to the faithful (constituting a very select crowd). The upper pillars enclose gratings—originally in gilt iron but now of wood—and a row of candelabrum above the lintel. The two inner marble tablets of the lower order are sculpted with putti bearing the emblem of Sixtus IV; the others are adorned with vegetal motifs.

papal court. The only painted section left exposed was *Saint Paul Preaching at Athens*, the last scene of the cycle, on the left wall in the compartment preceding the *cancellata*, in which the saint appears to be addressing the public gathered in the chapel. On the end wall, on either side of the altar, *The Miraculous Draft of the Fishes* marked the start of the scenes of the Life of Saint Peter, with scenes unfolding on three other tapestries on the right wall, under the Sistine frescoes depicting the Life of Christ; whereas the *Martyrdom of Saint Steven* initiated the scenes on the Life of Saint Paul. These comprised a further five works beneath the frescoes illustrating the Life of Moses on the opposite wall. Linked iconographically with the cycle painted for Sixtus IV, the new tapestries celebrated the figure of the reigning pontiff as the heir to Peter and Paul, the architects of the Church, representing respectively the Jews and the Gentiles. Aware of their direct correlation with Michelangelo's ceiling frescoes, Raphael favored a tragic style for the cartoons, starting with the scene of the Fire in the Borgo, simplifying the compositional schemes and endowing the gestures and movements of the characters with a more marked eloquence of expression of sentiment and passion, with the purpose of rendering them more universal and exemplary. On December 26, 1519, the first seven tapestries woven in Flanders were installed in the Sistine Chapel, and, as observed by the master of ceremonies, Paris de Grassis, "The entire chapel is marvelous in every aspect".

In the years that immediately followed the death of Raphael and Leo X, further subsidence of the foundations of the Sistine Chapel made its stability once more a primary issue. On Christmas Day, 1522, the lintel over the entrance broke off, taking the life of a Swiss guardsman walking alongside Adrian VI as they were entering the chapel. Other deep cracks formed during the conclave held in 1523, causing alarm among the cardinals; Antonio da Sangallo was directly called in to assess the safety of the building. Engineering work was carried out to stabilize the foundations of the east end of the chapel, causing damage to the two frescoes terminating the cycles on the Life of Christ and Life of Moses, which had to be redone by Hendrick van den Broeck and Matteo da Lecce.

The first act of destruction not imputable to the precariousness of the building's structure, but prompted knowingly by the chapel's patrons, was the consequence of a decision of Clement VII, the pope who commissioned the *Last Judgment* fresco to adorn the end wall. The first hints of the pontiff's intentions are found in a letter to Michelangelo from Sebastiano del Piombo, dated July 17, 1533: "His Holiness has instructed me to write to you on his behalf ... that he has ordained that, before you return to Rome [you may] willingly work as much for yourself as you have already done and will continue to do for his Holiness, and [that he will] commission from you such things as you have never dreamed." Clement met with the artist about two months later at San Miniato al Tedesco, and on this occasion he probably communicated his intentions, though the reaction they elicited was most likely far from the enthusiasm he expected. Be that as it may, in time the stubbornness of the artist, who stayed in Rome from October 1533 to May 1534, was gradually eroded, thanks also to his suspicions regarding the newly instated Duke of Florence, Alessandro de' Medici, and to his growing disaf-

fection for the tasks on hand in Florence, which were dragging on with effort and an increasing need for the help of assistants.

It happened, however, that Clement VII died on September 25, 1534, a mere two days after Buonarroti's transfer to Rome, and the latter therefore found himself released of his commitments, albeit, as Vasari notes:

After the election of the new pope, Paul III, not much time passed before he, too, summoned Michelangelo, and after offering him special signs of affection and proposals, he tried to convince Michelangelo that he ought to serve him and that he wanted him nearby. Michelangelo refused this request, declaring that he was unable to do so, since we was contractually obligated to the Duke of Urbino until the tomb of Julius was completed. At this, the pope became angry and said:

'I have had this desire for thirty years, and now that I am Pope am I not to satisfy it? I will tear up this contract, and, in any case, I intend to have you serve me!'

When Michelangelo saw his determination, he was tempted to leave Rome and find some means of completing the tomb. Nevertheless, being a prudent man who feared the pope's power, he decided to keep him waiting and to satisfy him with words, given that he was a very old man, until something came up.

But words were not enough, and Michelangelo resumed his studies of the composition and cartoons, after considerable preparatory work on the wall. At the beginning of the summer of 1536 the artist finally mounted the scaffolding ready to start. The fresco took five years to complete, and was finally exposed to view on the eve of All Saints' Day, 1541.

Clement VII's commission and the rapid development of Michelangelo's ideas for a representation of the Last Judgment to cover the entire end wall of the Sistine Chapel led to the obliteration of the frescoes painted at the time of Sixtus IV: the first figures of the popes, the first two scenes of the life of Christ and life of Moses, the image of the Virgin of the Assumption (to whom the chapel was dedicated), together with the first two lunettes, representing the Ancestors of Christ, frescoed earlier by Michelangelo himself. Furthermore, the artist decided to radically alter the spatial configuration of the chapel, which had until then presented a harmonious and contained chamber. His new scheme started with the lighting conditions: the two large windows set into the altar wall were closed up.

In this way, the entire formal and iconographical system that had gradually been pieced together in the space of over four decades, with uncanny overall coherence and consistency was completely modified to suit the aspirations of the pope and Michelangelo, who were personally living through the exaltation of those very ideals and myths and would see their subsequent collapse. Both men were firsthand witnesses to the spirit of *renovatio* that swept through the Eternal City under the guide of Peter's successors; both testified to the tragic events that led to the exacerbation of the religious wars and the radical self-questioning, and, not least, the appalling Sack of Rome itself, the seat of the Vicar of Christ, the city which for a vast portion of Christians had come to be identified with a new Babylon.

Looking onto the chapel is the celebrated *cantoria*, or little choristers' gallery, comprising a niche set into the right wall measuring some 16 by 7 feet (5 by 2 meters), and fitted with a coffered ceiling and elaborate decorated balustrade in marble. Here sat the *cantori* (choristers), usually twelve in number, who accompanied the liturgical ceremonies.

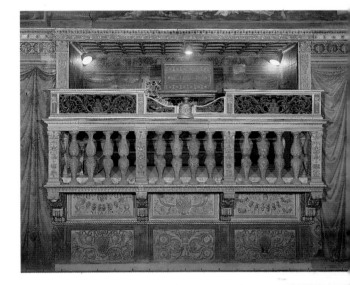

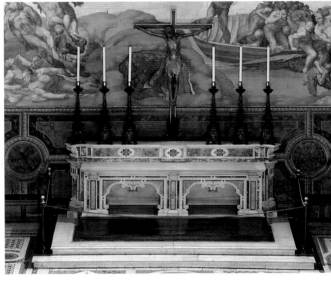

The present altar of the Sistine Chapel, free-standing and of marble, is 18th-century; the original was of stone and grouted into the wall. The crucifix is standard altar furniture. The original altar also had an altarpiece, by Perugino, representing the *Assumption of the Virgin*, but this, and the entire original decoration of the altar wall, was removed with the insertion of Michelangelo's *Last Judgement*.

The Lunettes

The lunettes form the highest part of the walls of the chapel; they are situated above the upper cornice, below which are the figures of popes frescoed at the time of Sixtus IV. Their vast semicircular surfaces (about 21 feet 4 inches wide by 11 feet high, or 6.5 by 3.4 meters) are interrupted at the center bottom by the crowns of the window arches and are delimited at the sides by the curves of the pendentives linking the walls to the vault, of which the triangular spandrels form part.

It is not known whether they had been decorated before Michelangelo painted the chapel—and, if so, how—since no information in this respect may be gleaned from the watercolor drawing by Pier Matteo d'Amelia

showing the original decoration of the vault with a starry sky.

In the iconographic scheme of the frescoes painted by Michelangelo, the lunettes, together with the eight smaller triangular spandrels, contain the figures of the Ancestors of Christ according to the sequence of forty generations listed at the beginning of the Gospel of Saint Matthew. This also inspired the text of the motet *Liber Generationis Iesu Christi* by Josquin des Préz contained in an anthem book of the Sistine Chapel at the time of Julius II, when the artist was working in the chapel. The names of the ancestors are written in Latin capitals on a tablet placed in the center of each lunette, at the top of the window arch, on a rectangular fictive slab, painted in

dark tones with light green borders. The tablet is enclosed by its own painted bronze frame, resting on a base and consisting of half-balusters at the sides; it is surmounted by a small classical female head.

Following the chronological order, the first ancestors of Christ were represented in the two lunettes at the top of the wall behind the altar. Beginning with the lunette on the left, the sequence continued with the one on the right, moved to the adjacent side wall, then to the opposite one; from there it alternated between the two side walls until it reached the entrance wall, opposite the starting point. In this way, Michelangelo adopted the same distributive pattern of the sequence of the

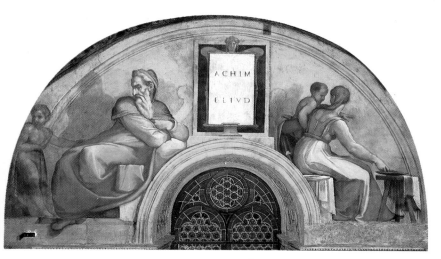

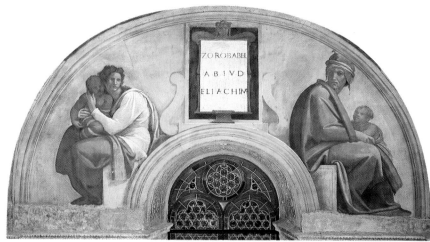

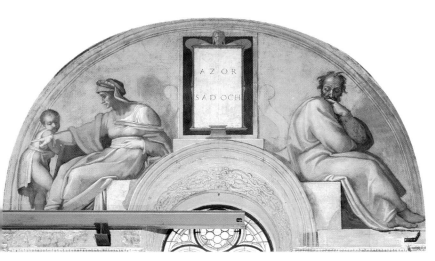

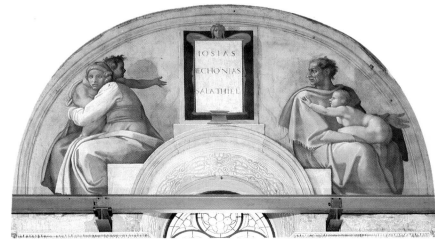

popes frescoed at the time of Sixtus IV. An exception, however, is the lunette with the tablet bearing the names of Josiah-Jechoniah-Shealtiel. Although, in chronological order, this is immediately after that of Hezekiah-Manasseh-Amon, the artist placed it on the same wall, not on the opposite one. As well as allowing the first and last lunettes to be opposite each other, the change in the pattern was probably intended to give emphasis to the time when the Israelites were deported to Babylon.

The generations of Christ's ancestors are represented in the eight spandrels by family groups and, in the lunettes, by groups or single figures on either side of the tablets. Due to the lack of typological elements or precise attributions

and, in most cases, of iconographic precedents, it is difficult, if not impossible, to identify the figures represented. In many cases, the suggestions made are not well-founded and are lacking in credibility. In any case, the possibility that Michelangelo was attempting to provide representations of a historical character may be excluded: the theme of the lunettes and the eight smaller spandrels is the uninterrupted sequence of the generations in the long wait for the coming of the Messiah. The message is not conveyed by the individual scenes, but rather by their totality; in this sequence of human types, the artist sought above all to differentiate the expressions, the poses, and the groupings, with a preponderance of

variations on certain themes, such as maternity or, for the male figures, often anguished meditation, solitude, and despondency. An echo of the way in which Michelangelo's contemporaries viewed the figures in the lunettes may be found in Giorgio Vasari's *Lives of the Artists*. This is what he had to say on the matter:

It would take too long to explain the many beautiful and different poses and gestures Michelangelo imagined to represent the genealogy of the Fathers, beginning with the children of Noah, and to display the ancestry of Jesus Christ. It is impossible to recount the diversity of details in these figures, such as their garments, their facial expressions, and

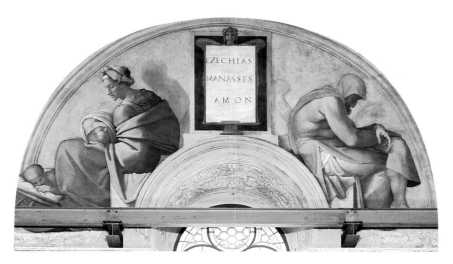

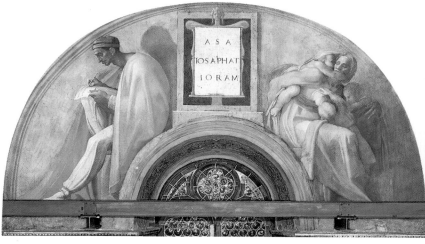

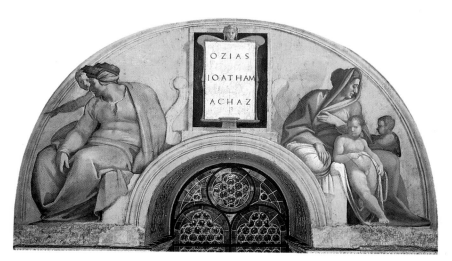

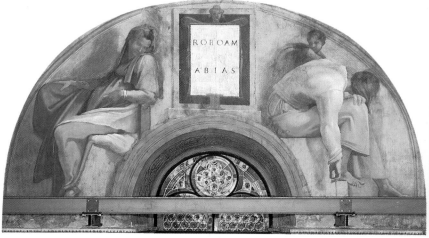

countless extraordinary and original inventions, all most beautifully conceived. In them there is no single detail that was not brought into being by Michelangelo's genius, and all the figures are most beautifully and skilfully foreshortened, while everything that is to be admired is worthy of the highest praise and splendid.

When he frescoed the vault of the chapel, Michelangelo started from the area near the entrance wall and proceeded towards the altar, thus the order in which the lunettes were painted is the reverse of that of the chronological sequence of the ancestors of Christ.

As far as the time taken to execute the Sistine decoration is concerned, in the past the hypothesis was advanced that during the first stage of the work, which concluded in August 1510, Michelangelo painted the whole of the vault, and that during the second stage—from the autumn of 1511 to October 1512, with a different type of scaffolding—he frescoed the lunettes, and possibly the spandrels as well. This hypothesis, which was refuted by Johannes Wilde in 1978, conflicts with the concordant testimony of Vasari and Ascanio Condivi. It has also been rebutted by Fabrizio Mancinelli's reconstruction of the scaffolding Michelangelo devised. This consisted of a suspended structure with steps on the sides that, in order to avoid interfering with the religious services in the chapel, did not rest on the ground, but rather on six pairs of trusses, themselves supported by the *sorgozzoni* (beams projecting diagonally upward from holes in the wall) to which Vasari refers: "And so Michelangelo ordered scaffolding built on poles [*sorgozzoni*] which did not touch the wall, the method for fitting out vaults that he later taught to Bramante and others, and with which many fine works were executed." Despite Vasari's praise, from a technical point of view, Michelangelo did not invent anything new, but skilfully adapted a system that was already in use for constructing vaults.

On this scaffolding, which was initially erected in the first half of the chapel, and was later dismantled and re-erected in the second half, the artist

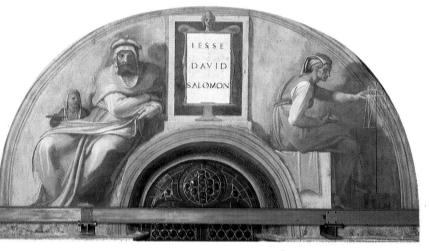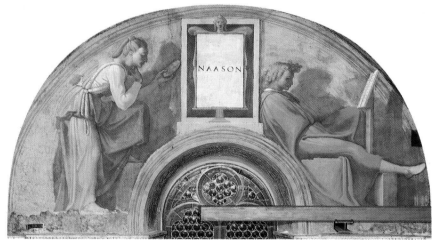

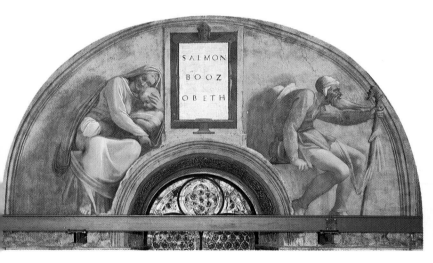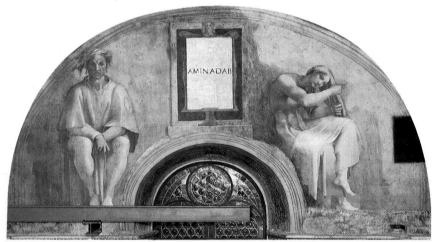

was able to paint not only the scenes in the central part of the vault, but also the figures of the *ignudi*, prophets, and sibyls, as well as the spandrels and lunettes. Thus, the first eight lunettes were painted during the first stage of the work, together with half of the vault, while the second eight—including the two on the altar wall that were later destroyed—were executed in the second stage. This is also confirmed by the fact that, in the eight sheets of the so-called Oxford sketchbook, there are exclusively studies of figures present in the last lunettes, together with preparatory sketches for figures in the area of the vault closest to the altar wall.

Only a few decades after their completion, the lunettes were particularly affected by the progressive darkening from which all of Michelangelo's frescoes in the Sistine Chapel suffered. This was particularly due to their position: in addition to the deposits of dust and soot from candles, lamps, and braziers, vast whitish stains of salification caused by the seepage of rainwater (especially after fire damaged the roof in December 1544) soon appeared on the frescoed surfaces. In a letter to Vasari of May 7, 1547, Paolo Giovio wrote that "Michelangelo's chapel . . . is being consumed by saltpeter and cracks." It is likely that the first applications of animal glues, later repeated on various occasions, date from this period; their purpose was to conceal the presence of the salts, revive the colors, and restore legibility to the scenes. Significantly, travelers at the end of the eighteenth century, from De la Lande to Goethe, reported that the frescoes appeared to be totally lacking in color. In particular, the lunettes, generally considered to be gloomy, nocturnal scenes, were given very little attention by visitors to the Sistine Chapel.

Although the results of the restoration that was concluded in 1986 were spectacular, the striking difference between the colors of the frescoes, which could now be seen in their original splendor, and their previous appearance was, for a time, the cause of wholly unjustified polemic. Subsequently, the cleaning of the whole vault, which restored the relationships of form and

THE ANCESTORS OF CHRIST IN THE LUNETTES
OF THE SISTINE CHAPEL

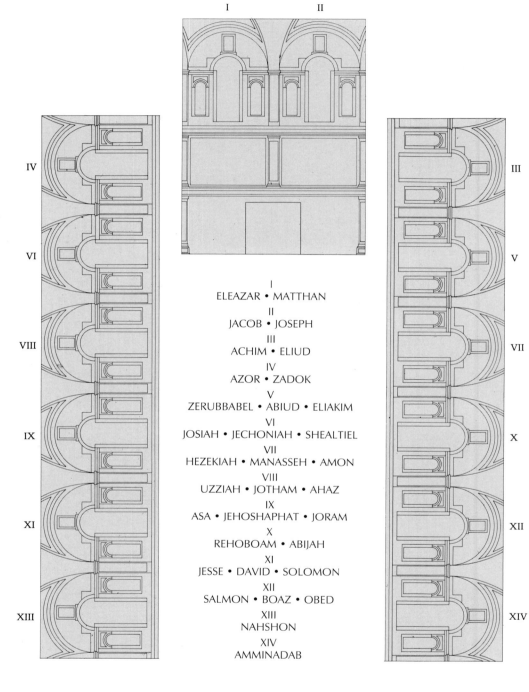

I
ELEAZAR • MATTHAN
II
JACOB • JOSEPH
III
ACHIM • ELIUD
IV
AZOR • ZADOK
V
ZERUBBABEL • ABIUD • ELIAKIM
VI
JOSIAH • JECHONIAH • SHEALTIEL
VII
HEZEKIAH • MANASSEH • AMON
VIII
UZZIAH • JOTHAM • AHAZ
IX
ASA • JEHOSHAPHAT • JORAM
X
REHOBOAM • ABIJAH
XI
JESSE • DAVID • SOLOMON
XII
SALMON • BOAZ • OBED
XIII
NAHSHON
XIV
AMMINADAB

color between the various parts of the entire fresco cycle, has, to some extent, attenuated the first disturbing impact. However, the results of the later stages of the restoration have confirmed the impression that, thanks to their technical and stylistic inventiveness, the lunettes are one of the most innovative sections of the whole cycle.

After the first difficult months spent on the scaffolding, during which he had acquired complete mastery of the techniques required, Michelangelo proceeded from the vault to the lunettes. Here he had to deal with flat, vertical surfaces that allowed him to work in a less tiring position and to move back and forth, giving him a better view of his work. This explains, in particular, why the execution was more rapid: with only one exception, the lunettes were painted in not more than three *giornate* each, without the use of cartoons. Only in the central tablets—the axial feature of the composition in which it was essential that architectural elements should be perfectly horizontal and vertical—have traces of indirect incision and the use of instruments such as the ruler and plumb line been found. The outlines of the large figures were rapidly sketched out onto the *arriccio*, using preparatory studies. However, only minute sketches relating to these studies have survived, such as those in the Oxford sketchbook (these are of the type that Vasari described as having been made "to find the manner of the poses and the first composition of the work"), while nothing remains of the intermediate drawings, although it cannot be excluded that they existed. In this way, as Fabrizio Mancinelli has pointed out, "the drawing and the pictorial stages fuse together at the moment of execution on the wall."

Thus, the color acquires a fundamental structural function: it becomes a primary instrument for constructing volumes, creating the plasticity of the figures, and defining their spatial relationships. It is pure, intense color, usually applied thinly in a very liquid state, often with successive layers of glazes, in order to obtain halftones. Also the very frequent use of iridescence, instead of

having a purely decorative function, as in numerous previous works (some of the figures of popes painted in the chapel at the time of Sixtus IV, for instance) is nearly always intended to define the volumes more precisely by means of planes of light. In other words, it is a substitute for traditional chiaroscuro, and not merely the representation of watered silk or other fab-

The last lunettes, painted when the fresco cycle was nearing completion and the artist was being continually urged by Julius II to finish the work, were executed even more rapidly, not only by simplifying the shape of the tablets, but with increasingly succinct formal effects.

Michelangelo displayed as much audacity and freedom in his conception

epic one of the sequence of the generations before the incarnation of Christ. Thus was created a remarkable assortment of figures presenting great typological and psychological diversity. This ranges from the attitudes that are mainly self-absorbed, sullen, melancholic, or burdened by the sense of indescribable anguish of almost all the male figures, to the delicacy and grace

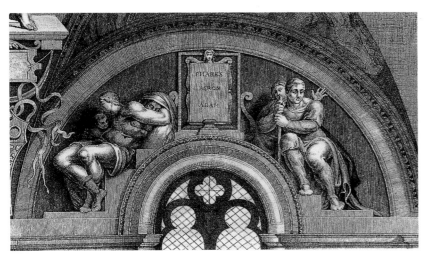 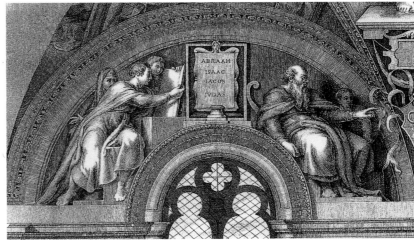

rics then in use. Furthermore, the play of changing colors greatly increases the legibility of the figures, not only from a distance, but also in conditions of semi-darkness, or when they are seen against the light, as in the case of the lunettes, which are situated above the windows of the chapel.

On the *intonaco*, which had been spread with great care, Michelangelo used brushes of varying widths and degrees of firmness. Making use of the body of the pigments, he literally modeled the figures as if they were sculptures, alternating more flowing brushstrokes with other denser ones that, on occasion, were interwoven and brought into sharp focus a number of details in the foreground, especially in the faces. Other parts, and the figures in the background, however, appear to have been only roughed out and are not in focus—so that they seem to be "unfinished"—using a procedure that is reminiscent of the effects of the *gradina* (three-toothed chisel) in two of Michelangelo's marble reliefs, the *Pitti Tondo* and the *Taddei Tondo*.

of the poses of the biblical figures as he did when he painted them; this may also have been due to the absence, in most cases, of a specific iconographic tradition. The distinctive shape of the lunettes, with the tablet in the center above the window arch, meant that compositions of a "pedimental" type had to be devised, with figures in the foreground sitting, or notably reclined, in a restricted space closed by a plastered wall of a rose hue that, as Gianluigi Colalucci has observed, recalls the color of the old Roman walls made of lime and red *pozzolana*, faded by time and the elements. The relationship with the architectural space was, as always, of fundamental importance for the way it stimulated the imagination of the artist, who, at first, seemed to produce variations—with unusual twisting of the limbs—on more traditional poses, sometimes of classical derivation. Later, however, as the studies in the Oxford sketchbook demonstrate, he made much greater use of drawing from life, although he always transferred his figures from the everyday domain to the

or the mature solemnity of some of the female ones, and the expression of mysterious, profound tenderness that governs the relationships between mothers and children. Even in the very rich panorama of Renaissance painting, these are extraordinary scenes that, taken as a whole, contrast sharply with the stereotyped view of Michelangelo's art that has gained wide currency.

Above: In the lunettes situated at the top of the altar wall, Michelangelo painted the first two groups of the ancestors of Christ according to the sequence of the Gospel of Saint Matthew: Abraham-Isaac-Jacob-Judah and Perez-Hezron-Ram. The two frescoes were destroyed when the artist decided to extend the painting of the Last Judgment to the whole wall. However, they are shown in two drawings reproducing the whole vault (now in the collections of Windsor Castle and the Ashmolean Museum, Oxford), and in two engravings by Adamo Ghisi.

ELEAZAR • MATTHAN
Eliud begat Eleazar. Eleazar begat Matthan. Matthan begat Joseph.
Matthew 1:15

Eleazar, father of Matthan, is generally believed to be the young man on the right. His head is seen in profile, and he appears to be immersed in his thoughts; his torso is seen frontally; his legs are crossed; his left arm is outstretched, his wrist lying across his raised right ankle, while his right arm, resting on a yellow cushion, is folded, his hand touching his shoulder. He is wearing a white shirt open at the side, its neckline bordered with green, tight apple-green hose with purple shadows, and a red cloak, slipping off his left shoulder and fastened with a cord to a clasp above his neck. Behind him are visible the heads of a woman, wearing a deep purple head-cloth, and a child.

nette. The poses of the two figures in the foreground, represented with strong plasticity, appear to have been devised in order to create a contrast: the woman on the left is seen in full profile, while the young man on the right is depicted in a more dynamic pose, with his head and legs turned from the plane of the torso seen frontally. Particularly evident is the similar range of colors used for both figures: red, yellow, white, green, and purple.

This lunette, probably the first to be frescoed by Michelangelo, was also the first to be cleaned during the recent restoration campaign. The background is painted in a very intense hue of lilac, which was toned down by the artist in

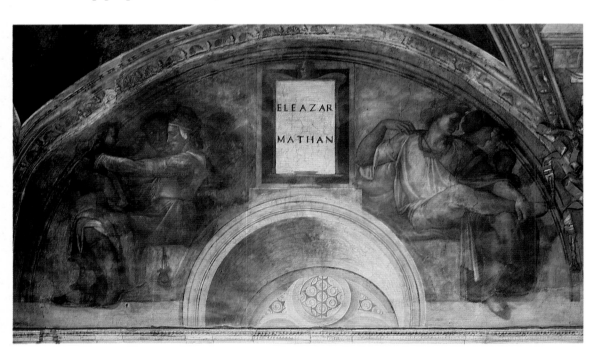

Before the restoration.

In the left part of the lunette, Matthan, in the background, seems to be turning with an expression of astonishment or apprehension toward his wife who, seated and seen in profile, plays with the child Jacob, who frisks on her knees.

The two groups, each of three figures, occupy most of the surface of the lu-

the following lunettes. Two *pentimenti*, regarding the profile of the face and the height of the left shoulder, have been found in the figure of Eleazar, which is more completely finished and more precisely executed than the figures in the lunettes, which were frescoed subsequently.

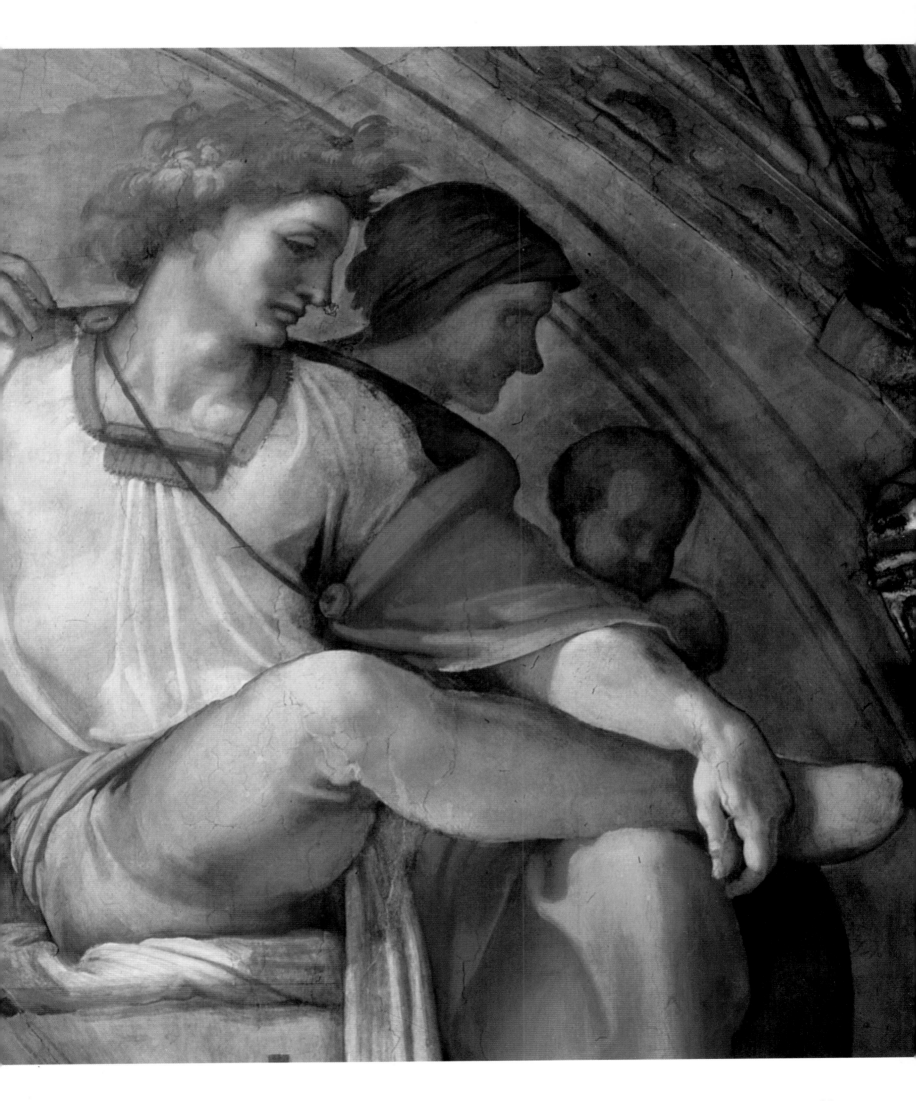

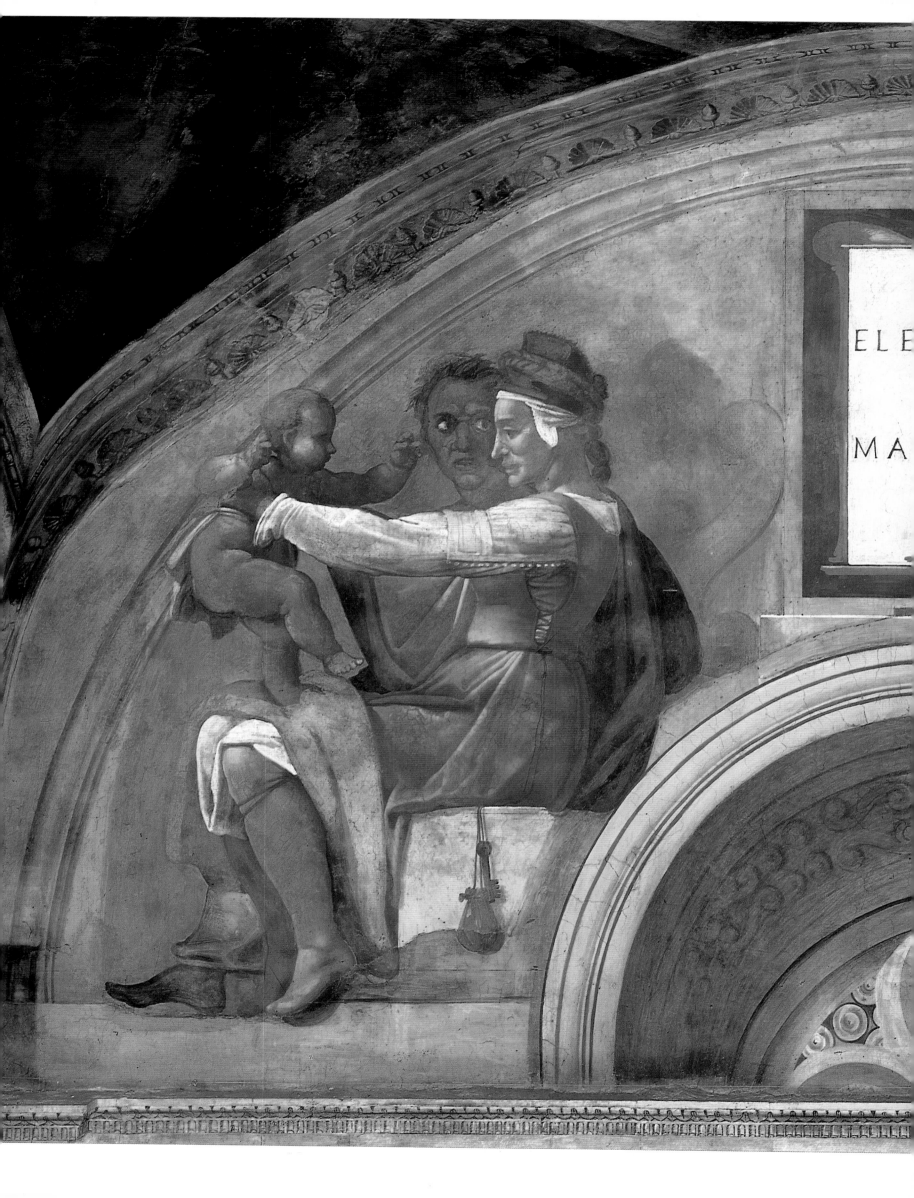

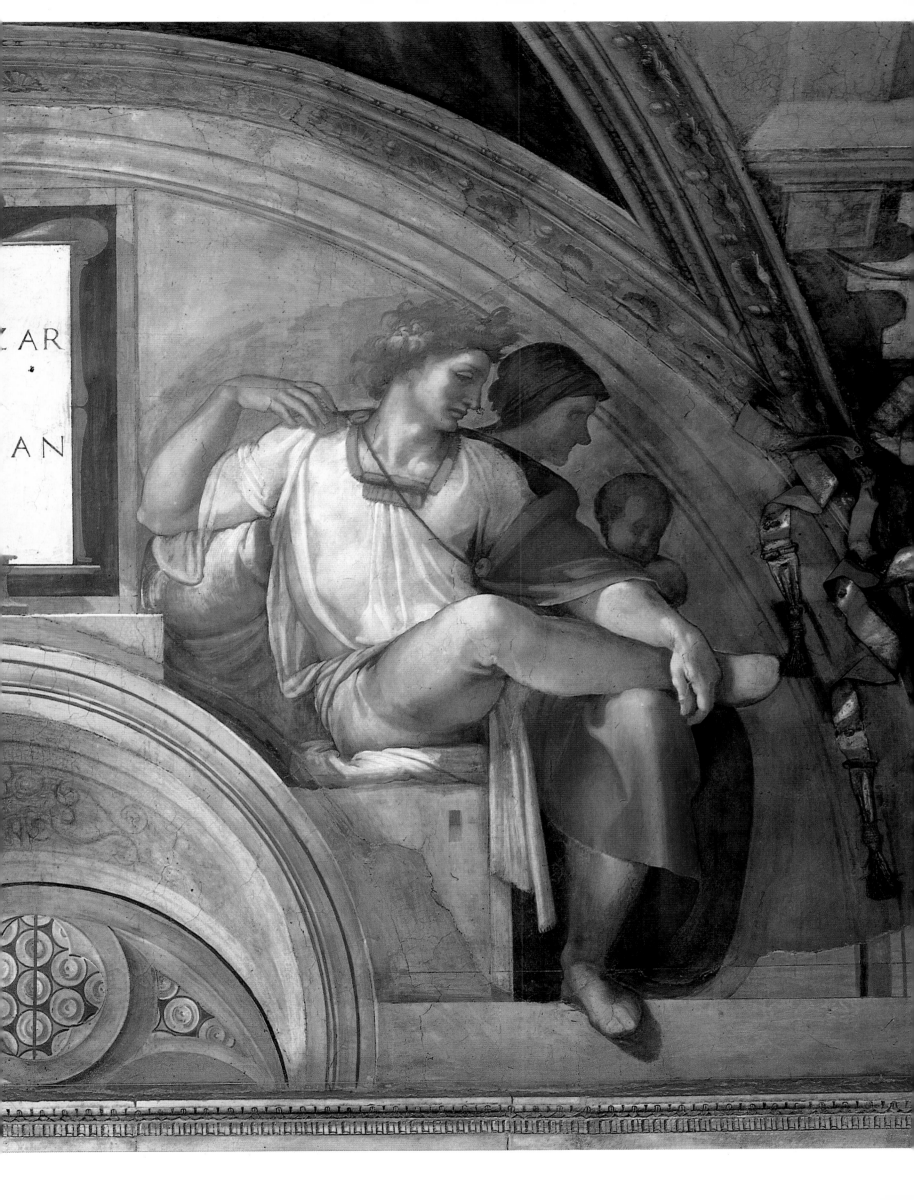

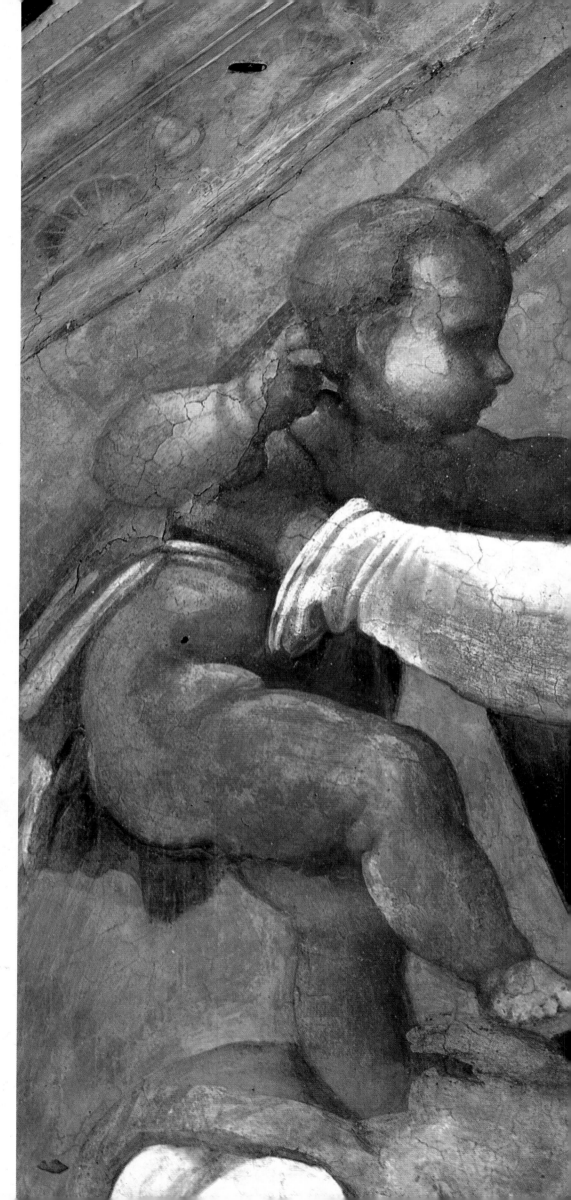

On the left side, salification from the seepage of rainwater has caused corrosion of the *intonaco* in a number of places, with the consequent flaking and modification of the colors. On Matthan's face a vertical black line is visible; forming part of the underdrawing, this indicates that the head was originally placed farther right.

The clothes and headdress of the woman in the foreground are also represented in detail: the laces of the bodice under her arm; the short yellow oversleeve; the fur-lined skirt drawn above her knees; and the hat—in reality, this was a men's style that was in fashion toward the end of the fifteenth century, especially in Venice, among Armenian Jews.

In front of the stone seat, a key and a bag of coins hang from a cord. As was the end of Eleazar's foot that rests on the ground, the lower part of the bag was repainted during the pontificates of Pius IV and Gregory XIII. The difference in tone indicates that the frescoes had already darkened, only fifty years after they had been completed.

Before the restoration.

24

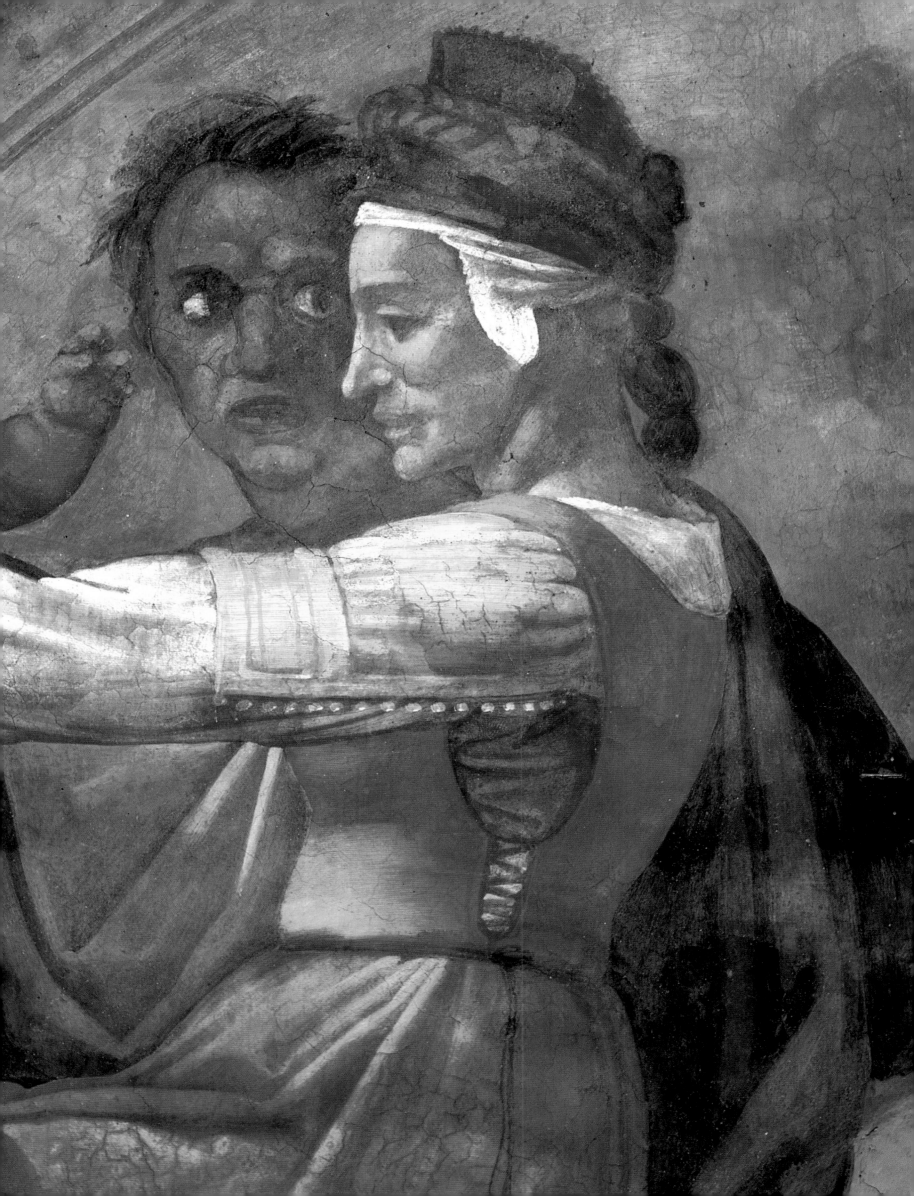

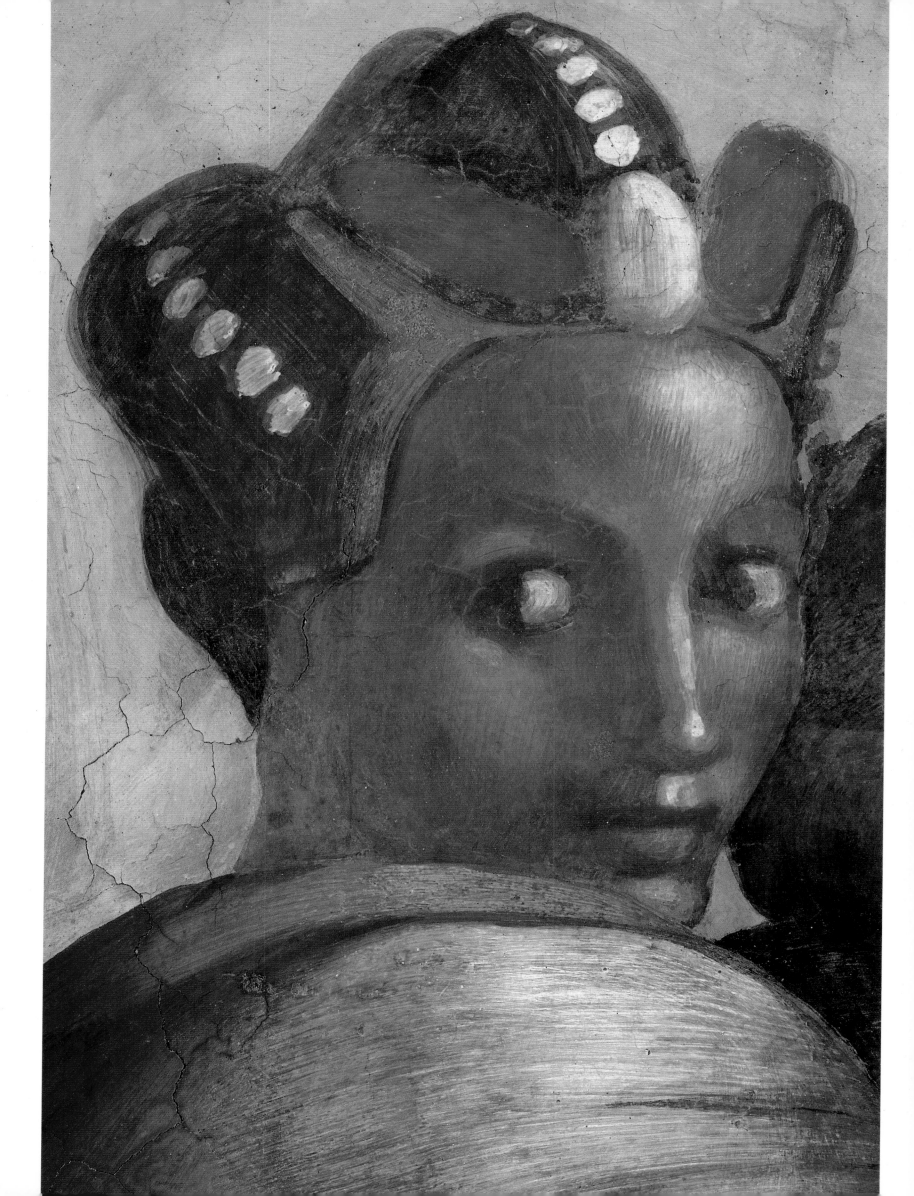

JACOB • JOSEPH

Matthan begat Jacob. Jacob begat Joseph, the husband of Mary, of whom was born Jesus, who is called Christ.

Matthew 1:15–16

Before the restoration.

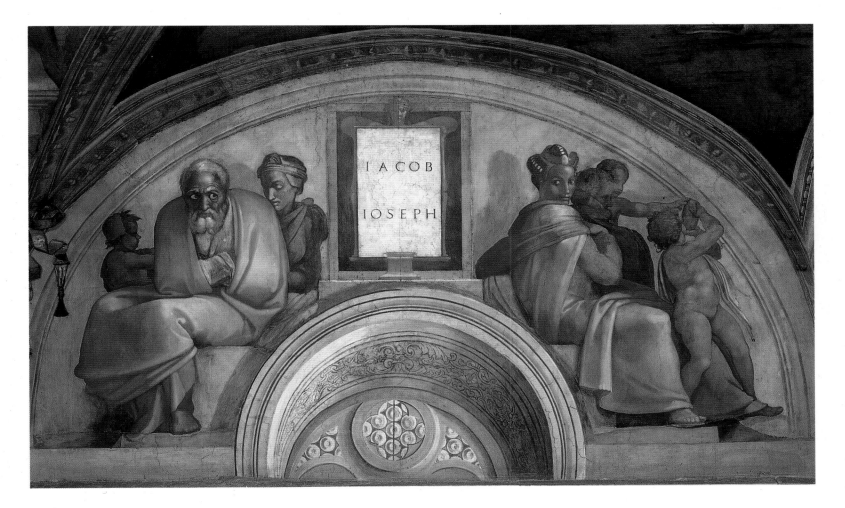

At the top of the entrance wall of the chapel, to the right of the viewer, next to the Eleazar-Matthan lunette, there is the one (the only lunette in the first half of the vault having a tablet without the lateral brackets) concluding the genealogical sequence of the ancestors of Christ in the Gospel of Saint Matthew: "Jacob begat Joseph, the husband of Mary, of whom was born Jesus, who is called Christ." The compositional schemes of the two lunettes correspond: in both there is a female figure in the foreground seen in full, or half, profile and facing the outer wall of the chapel, and a male figure, on the internal side, with his torso seen frontally.

Sullen and perplexed, wrapped in a huge yellow ocher cloak and seemingly withdrawn, the old man—generally believed to be Jacob—dominates the family group on the left due to his expressive power and the quality of the color. Similarly, on the right, the female figure, usually thought to be Mary, is more prominent than the other members of the Holy Family and the child holding a mirror. In Jacob's face, the thick network of minute, often intersecting brushstrokes, brings every detail clearly into focus, while the other parts of the figure are depicted more succinctly, and the brushwork is more fluent. Mary's face seems to fade slightly in depth in comparison with the emphasis given to the color of the iridescent veil covering her shoulder, which at that point changes to deep blue.

27

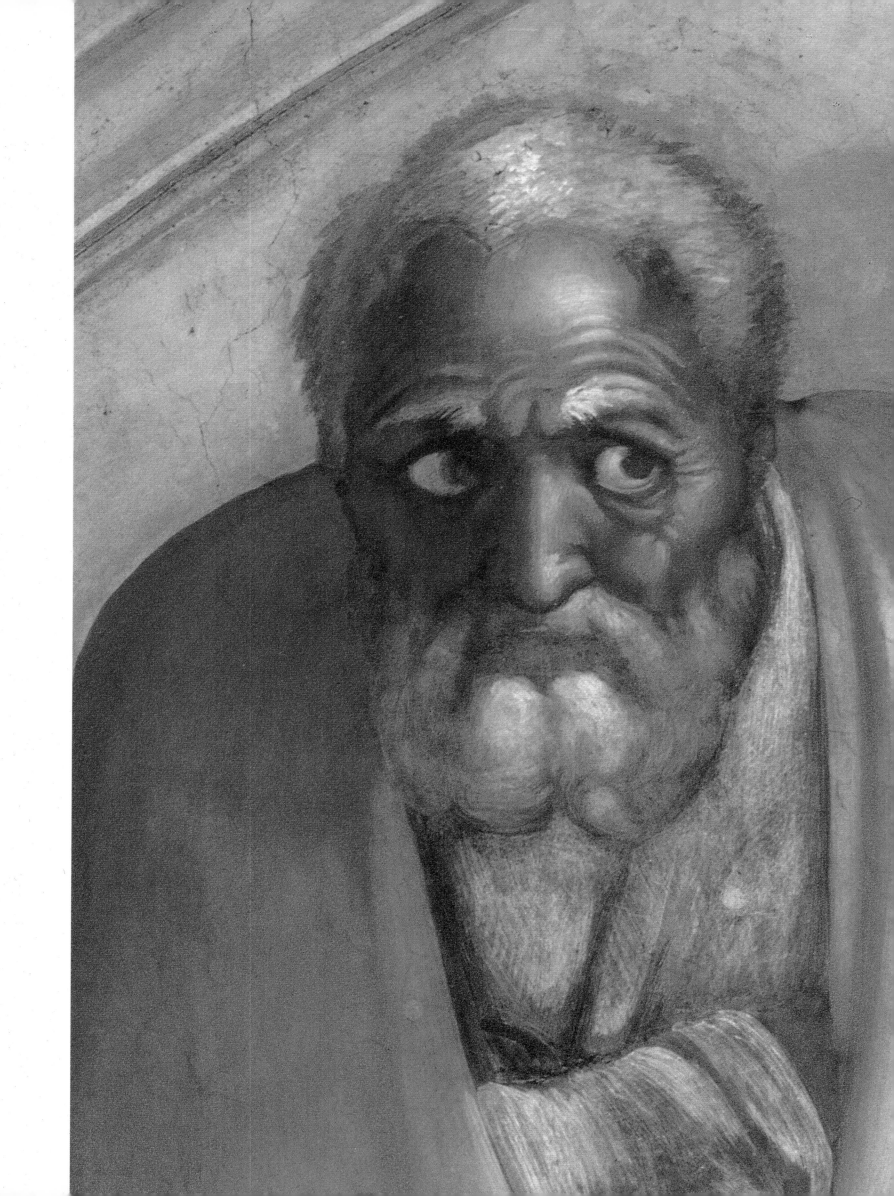

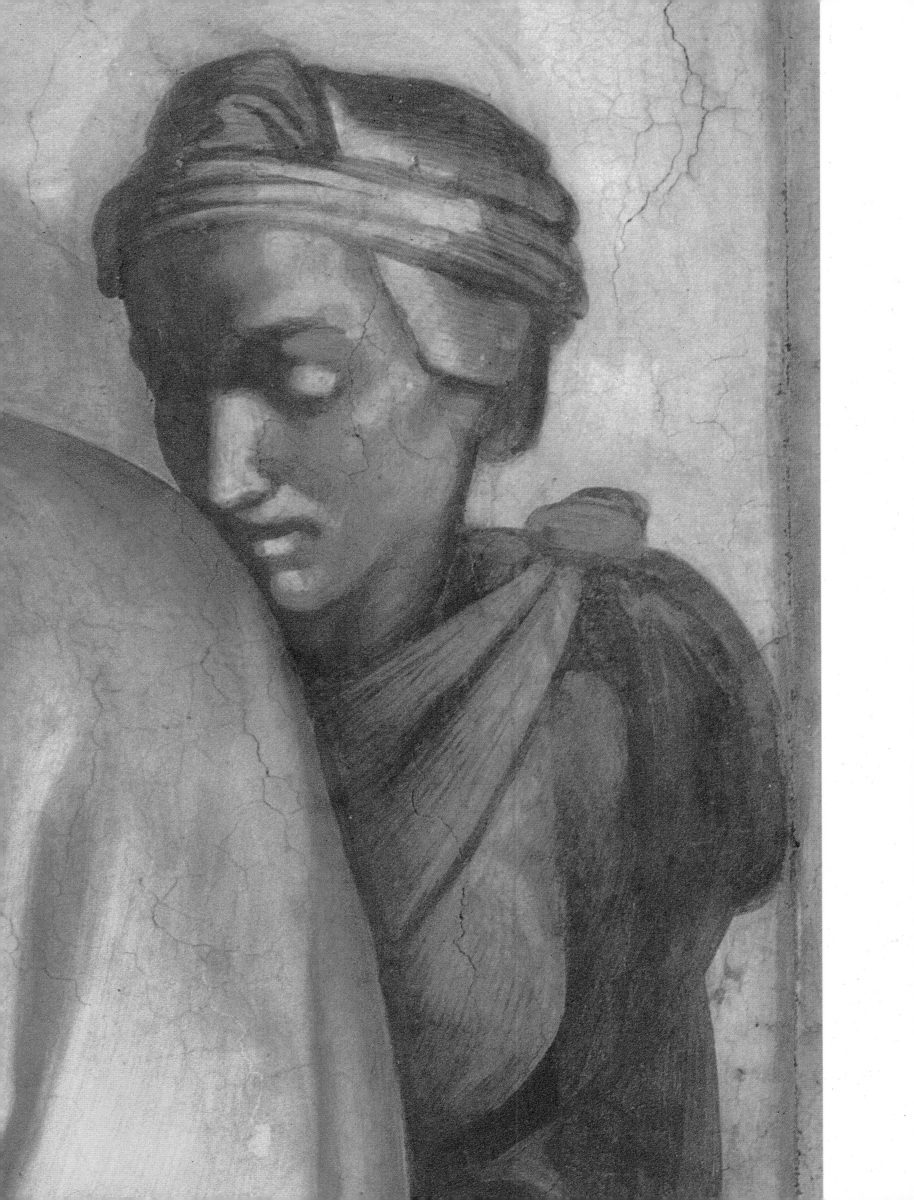

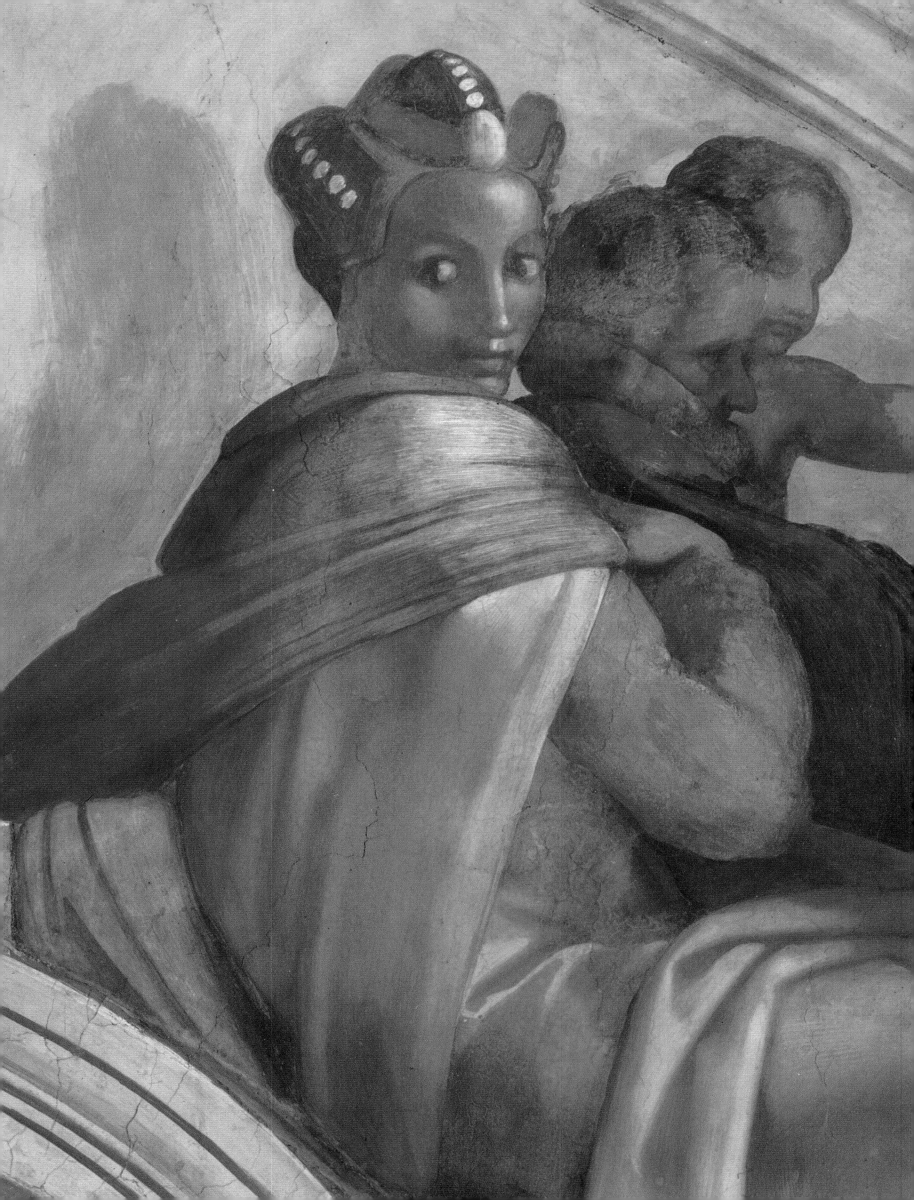

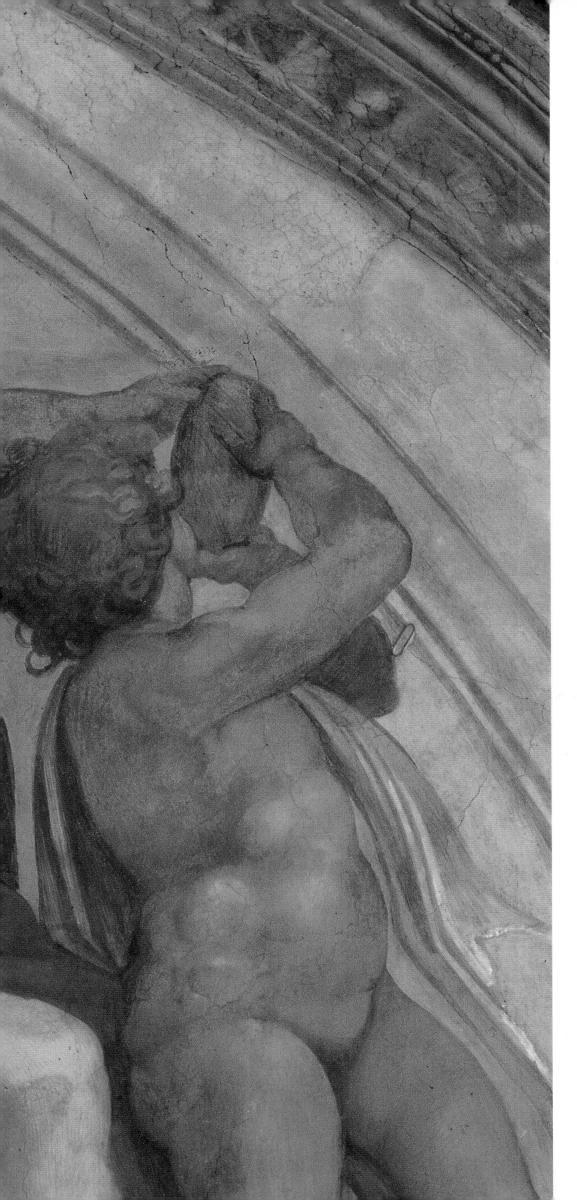

The identity of the figures represented in the lunette is uncertain; Frederick Hartt (1989) suggested that the old man enveloped in the yellow cloak was Joseph, while the young woman in the foreground on the right was Jacob's wife. The prominence of the figure, however, seems to favor the traditional identification of the latter as Mary. Wrapped in a rose mantle which covers part of her yellow dress and its greenish shadows, barefoot, and wearing an exotic headdress, she turns toward the spectator. Her very beautiful face affects an expression of surprise. Behind her in the shadow, Joseph holds the Christ child, who stretches out an arm toward the round mirror held up at the height of his face by a naked female child, possibly an allegory of the Church.

In this area, damage caused by the seepage of rainwater has been noted. Aside from part of the small female figure, this has not, however, attenuated the modeling and the strength of the colors in the scene.

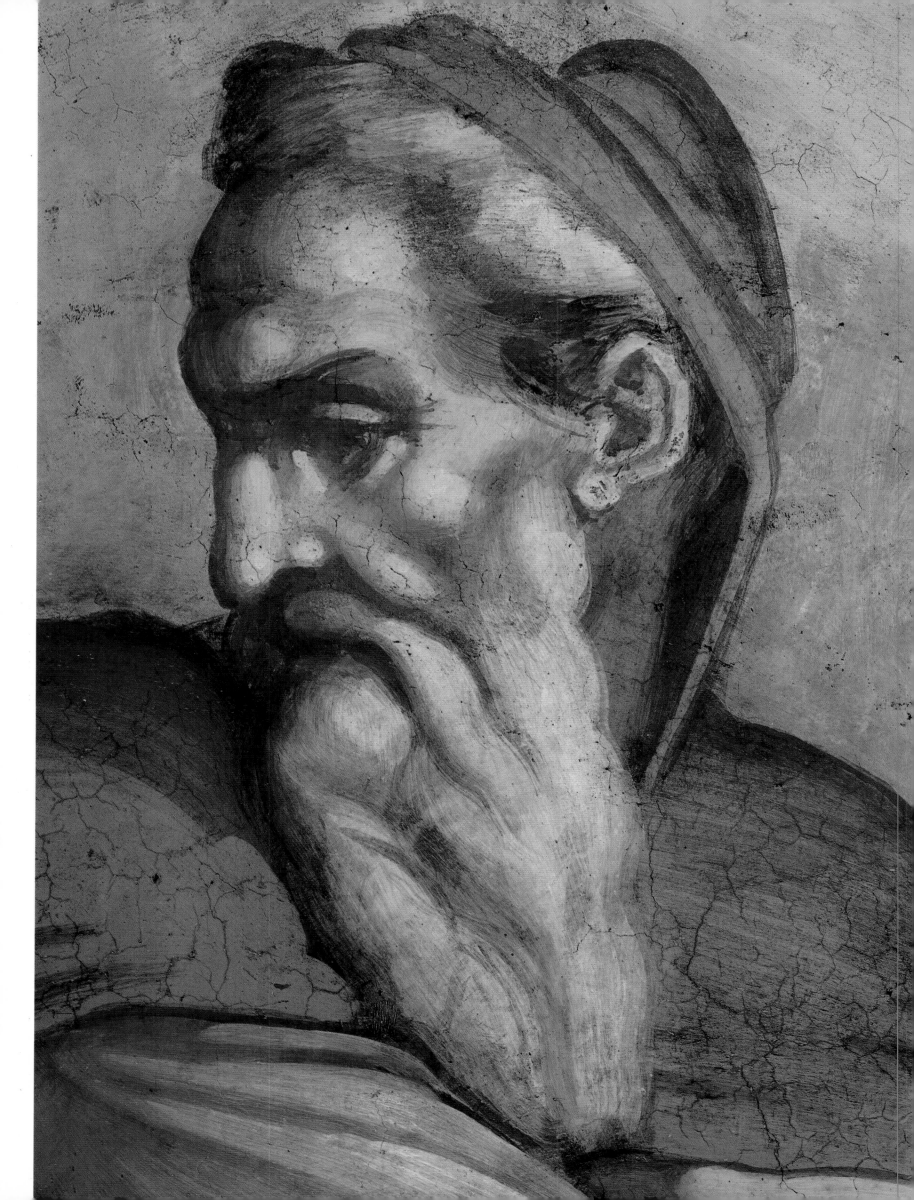

ACHIM • ELIUD

Zadok begat Achim. Achim begat Eliud. Eliud begat Eleazar.

Matthew 1:14–15

Before the restoration.

The identity of the figures is far from certain, and it is not possible to establish which of the two, Achim or Eliud, is the old man with a child next to him on the left, and which the child held by his mother on the right.

This lunette, the first of those frescoed on the south wall, was executed in four *giornate:* one for the tablet and the upper part of the cornice, one for the group on the right, and two for the group on the left. Of the last two *giornate,* the first comprises a limited

figure is largely due to the prominence, in *contrapposto*, of the knees and the crossed arms, with the right elbow projecting notably and the hands folded in toward the body. This effect is heightened by the magnificent arrangement of the drapery, especially on the left knee and over the edge of the stone seat. The meditative attitude of the old man—apparently renunciatory, but in reality extremely dynamic—is counterbalanced on the other side of the lunette by the fascinating spontaneity of the woman's

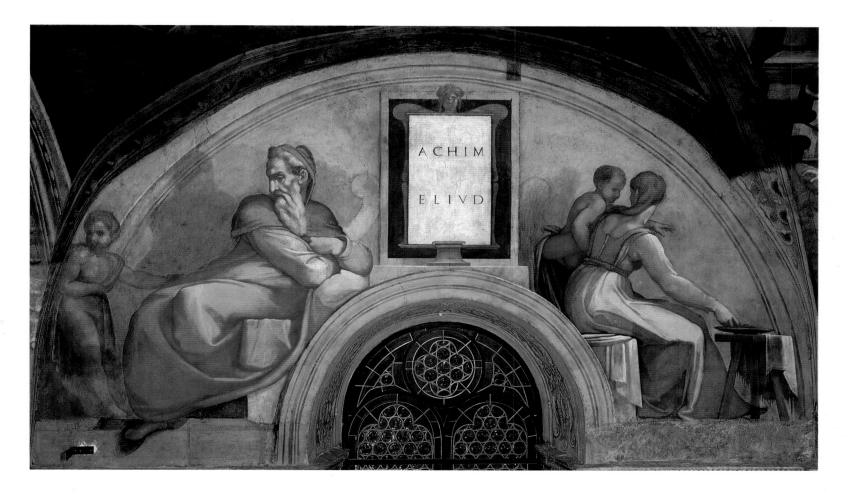

area at the top, triangular in form, with the base at the level of the old man's brow in the foreground. Since this is an extremely unusual shape, it is likely that, because he was dissatisfied with the results, Michelangelo destroyed and repainted most of the figure: its elaborate pose is, in fact, very carefully constructed, with vigorous twisting of the limbs. The sculptural effect of the

gestures. Turning toward her child, she stretches out her arm to take some food from a plate placed on a stool in the foreground. Thus, from the pose Michelangelo proceeds to real action, and in the juxtaposition of the two figures, contrasts an active life with a meditative one. The artist subsequently addressed himself to this theme on a number of occasions.

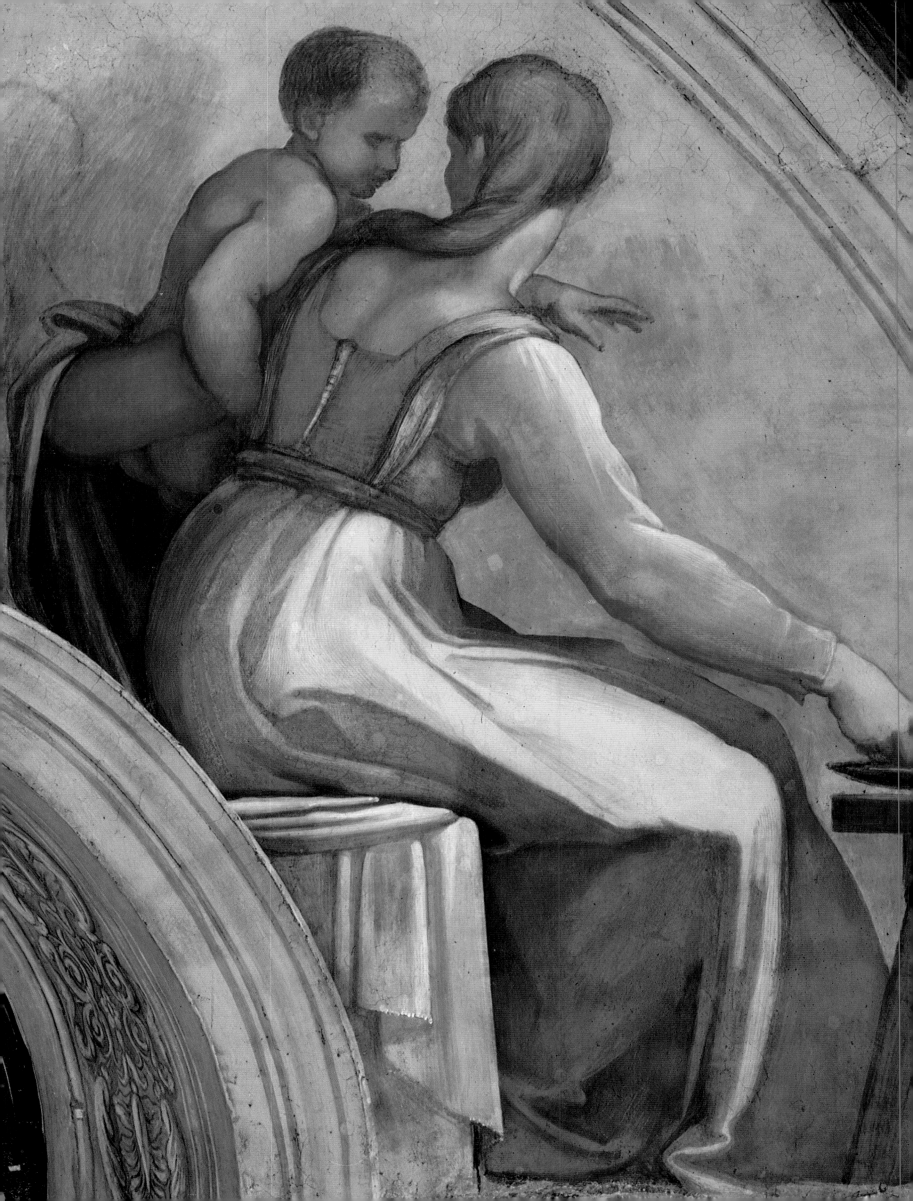

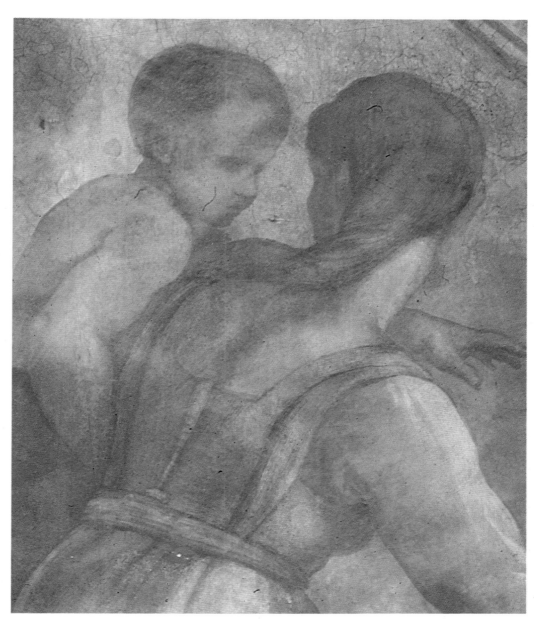

Before the restoration.

In the group of the woman and her child, Michelangelo has created the spatial division of the scene with subtle passages of color and light, rather than with powerful effects of plastic modeling and the pattern of the folds of the drapery. He alternated liquid, broad brushstrokes for the background with other denser, more closely woven ones for the parts nearest to the viewer.

In the figure of the woman, who is absorbed in a tender exchange of gestures and glances with the child, the restoration has revealed astounding accords and juxtapositions of colors. These include the yellow highlights and the iridescent violet shadows on the pale green of the dress, and the reddish shadows and the white highlights on the violet halftones of the long sleeve of her shirt.

AZOR • ZADOK

Eliakim begat Azor. Azor begat Zadok. Zadok begat Achim.

Matthew 1:13–14

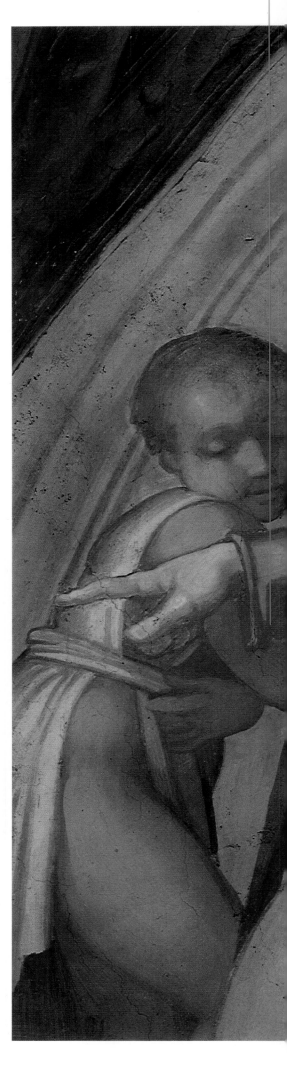

This is the first lunette on the north wall. The absence of information regarding the figures represented has thwarted any attempt to identify them. On the left a seated woman is shown indicating something outside the lunette to a boy (or a girl) who seems to be engrossed in writing or drawing and turns somewhat hesitantly. The woman's pose, with its great naturalness and self-possession, is a variation on the twisted head, shoulders, and legs of the other figures. She is wearing a rose dress with lilac shadows, which is slipping off her shoulders; it is tied round the waist by a green sash bordered with yellow. The mantle folded back on her arm is deep yellow, while

man, his face furrowed by deep lines. Tightly wrapped in his yellow ocher mantle, from which only his head and an arm emerge—the green sleeve, painted *a secco*, is the only element in contrast with the dominant color—he appears to be prey to distressing thoughts.

The body, modeled concisely with great plastic power by the interplay of light and shade, and the pattern of the folds of the mantle, stands out clearly against the background. The face, set back from the brightly lit shoulder, is rendered with rapid strokes done with a brush lightly loaded with paint, using the gray of the *intonaco* as the ground, burnt umber for the darker parts, and,

Before the restoration.

various colors are combined in her strange headdress: ultramarine, vermilion, and yellow mottled with green and orange. Michelangelo defined the profile of the face with a red outline, painted with the tip of the brush.

On the other side of the lunette, seen sideways on, but with his head turned toward the viewer, sits a solitary mature

for the lighter ones, ocher, touches of white, and red glazes.

The number of figures present in this lunette is half that of the first lunettes painted by Michelangelo. This sense of isolation intensifies the expressive power of the figure of the pensive man, which some have interpreted as being an imaginary self-portrait of the artist.

36

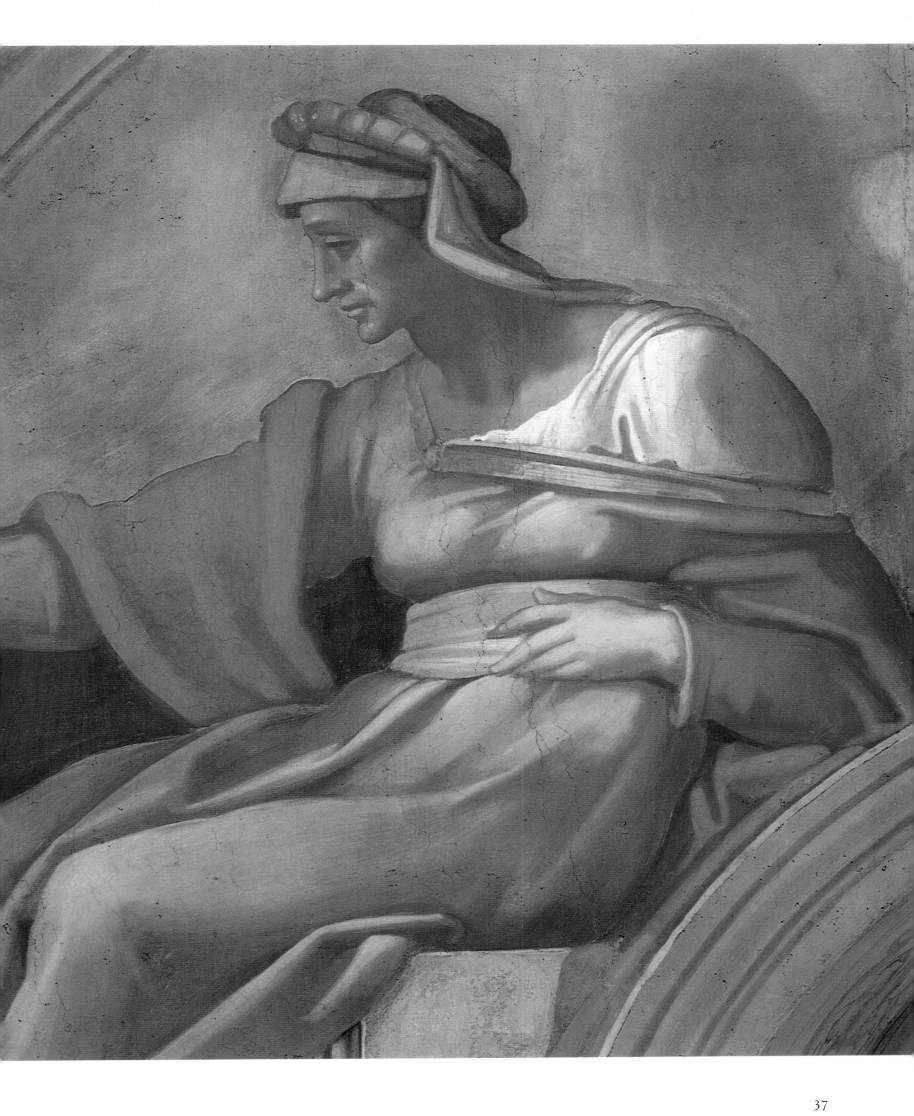

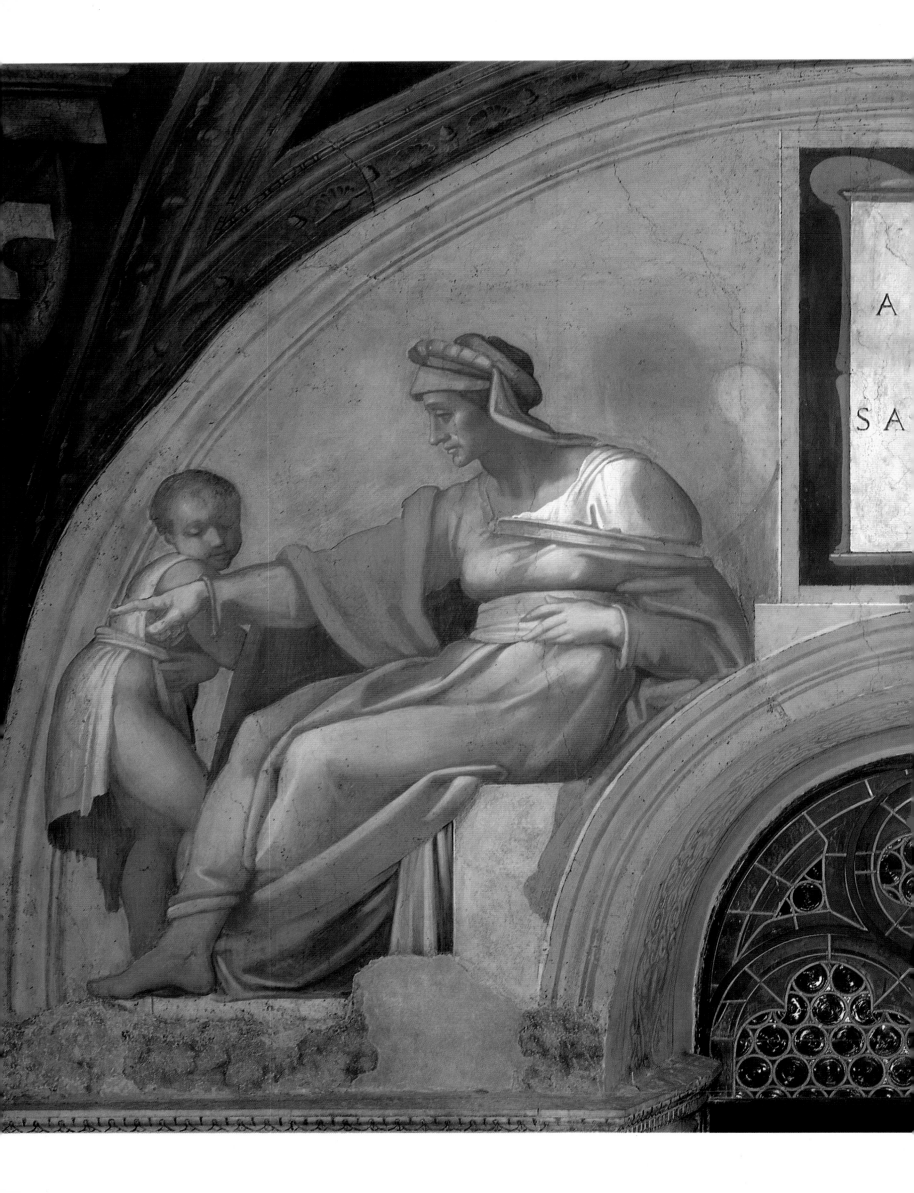

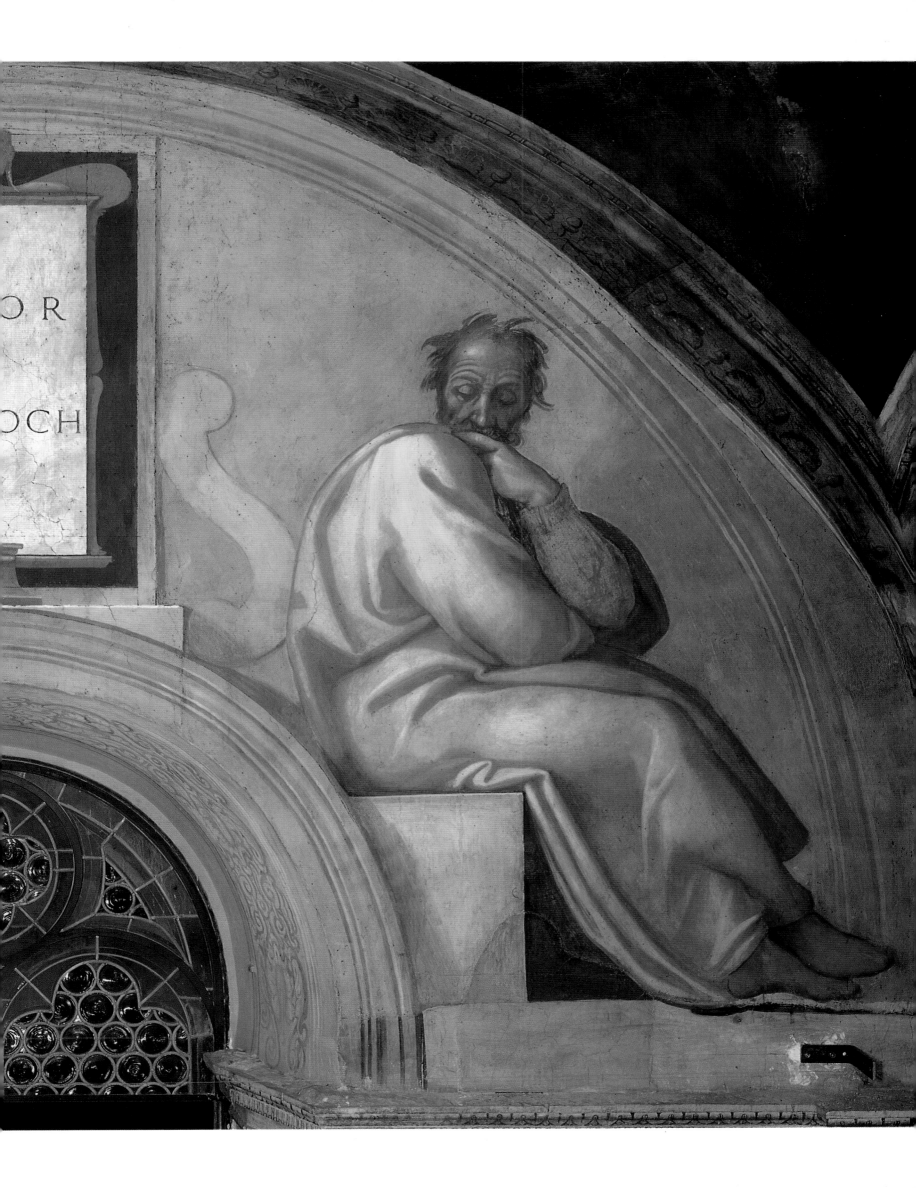

ZERUBBABEL • ABIUD • ELIAKIM

Shealtiel begat Zerubbabel. Zerubbabel begat Abiud. Abiud begat Eliakim.

Matthew 1:12–13

The tablets in a number of lunettes bear three names: in these cases one of the three refers to the group depicted in the spandrel above. In effect, the spandrels link the walls of the chapel, to which the lunettes belong, to the area of the prophets and sibyls, and the vault itself. Except for the four corner spandrels, however, they form part of the sequence of the ancestors of Christ.

their gazes fixed on the same point. Bareheaded, wearing a white dress, her legs covered by a yellow mantle, the woman hugs a child wrapped in a red shawl with white stripes. The intensity of the colors in the group on the left is counterbalanced on the right by darker tones that are equally refined. Enveloped in a violet cloak and wearing a wide green hat (painted *a secco*) adorned

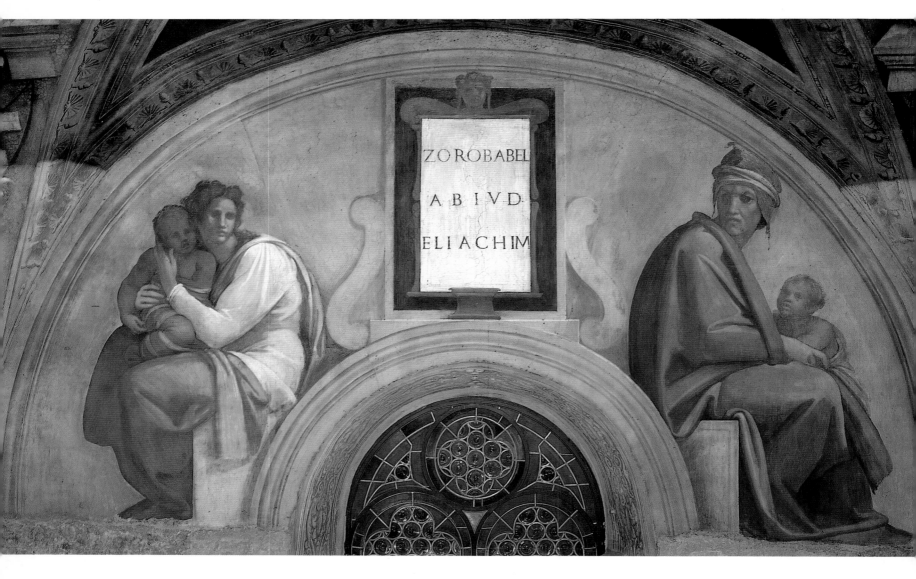

In this case too, in the absence of any precise information, the identities suggested for the figures are quite hypothetical. The arrangement of the figures seems to be inspired by the quest for symmetrical correspondence. A man and a woman, both accompanied by a child, are seen sideways on; they are seated with their backs to each other, but turn their heads toward the viewer,

with a yellow ribbon, the man turns, his face less sullen than those of some of the other figures in the lunettes. The child is clinging to the man as if he wishes to attract his attention, with an expression of slight anxiety on his face: sketched out with rapid brushstrokes, this appears to be blurred because it is further away.

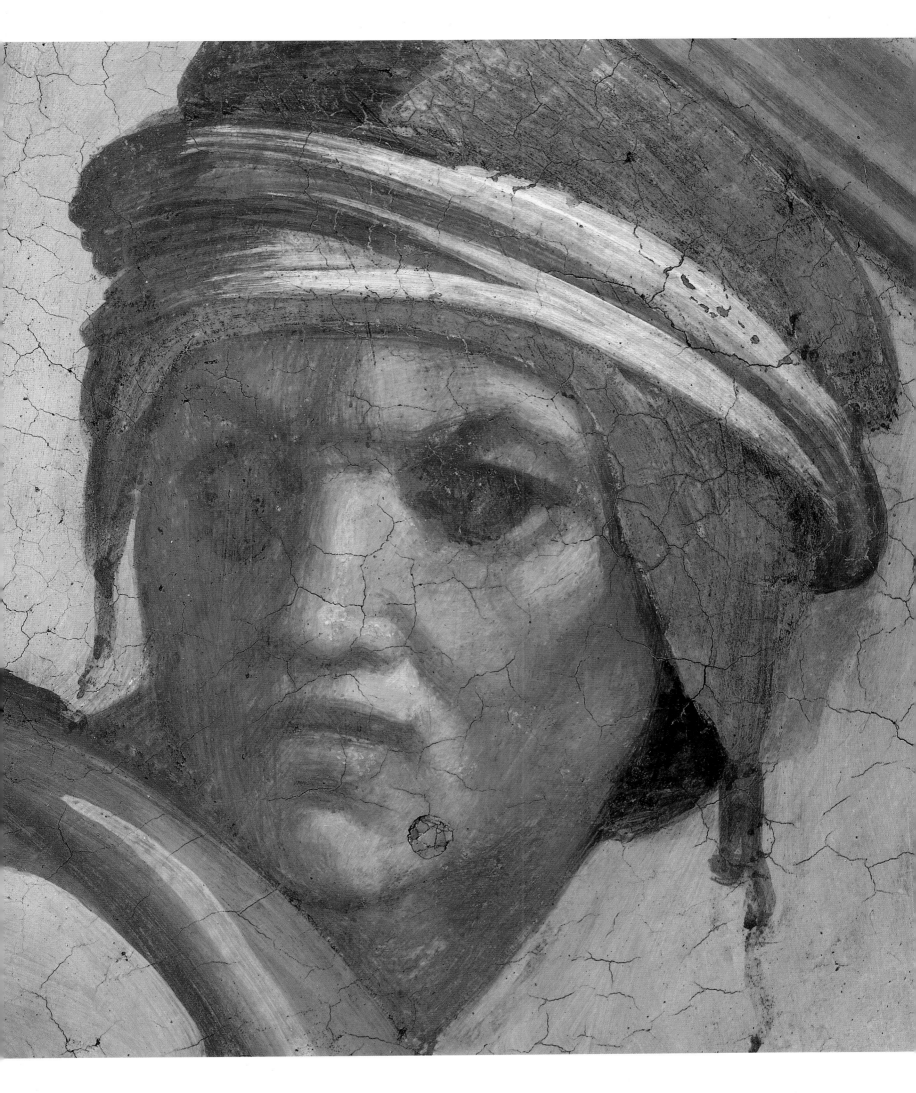

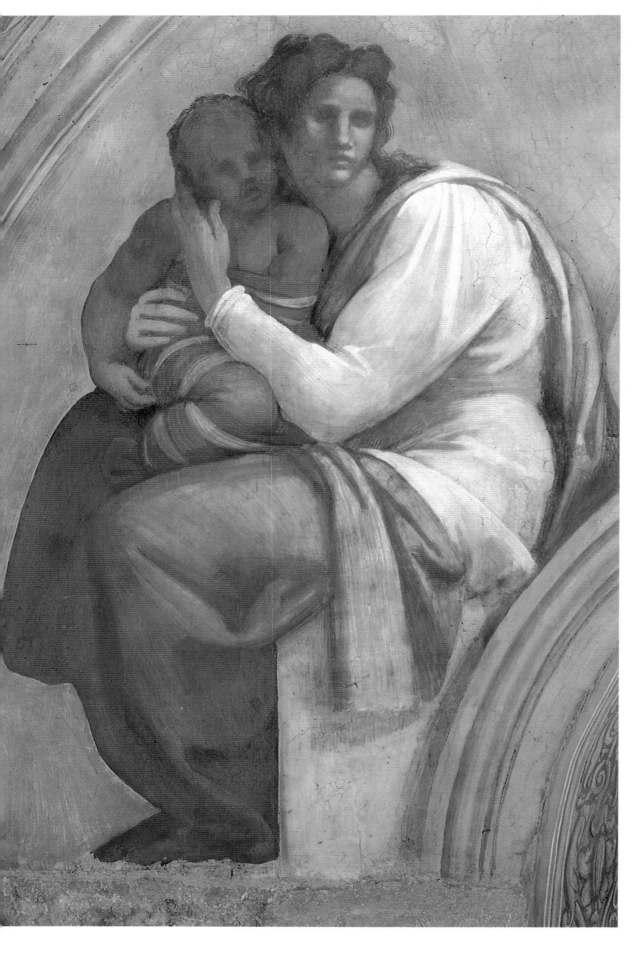

Before the restoration.

Seen close up, the faces of the woman and child prove to have been executed with great rapidity and succinctness, rather like forceful sketches. However, thanks to certain refinements in their execution—the alternate use of brushes of various widths and degrees of firmness, and the juxtaposition and layering of brushstrokes of color that vary from fluid to dense—from a distance, the figures acquire remarkable plastic relief, together with a clear sense of perspective. The seam of the *giornata* runs exactly along the woman's back. This proves that, although he did not use cartoons for the figures in the lunette, Michelangelo made a quick drawing of the whole composition on the *arriccio* before he frescoed the central tablet.

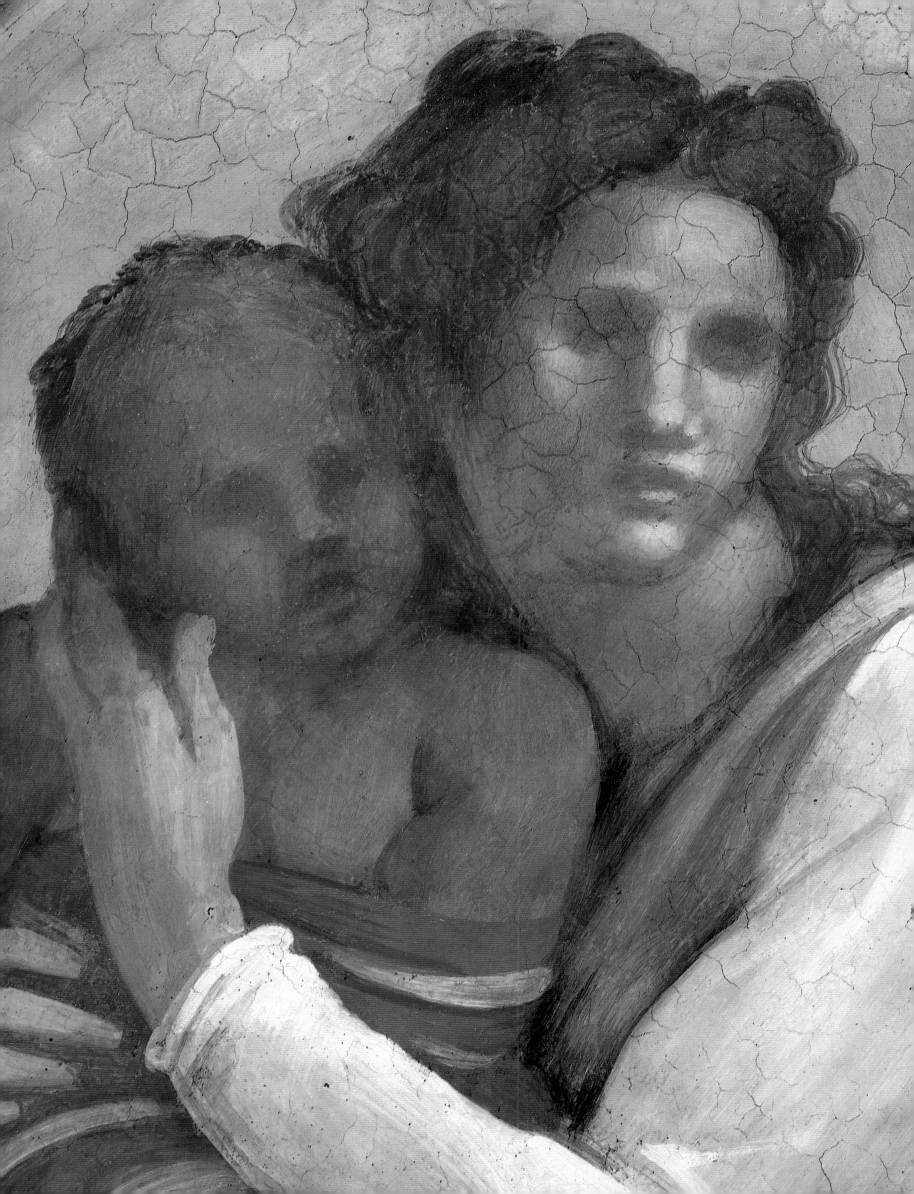

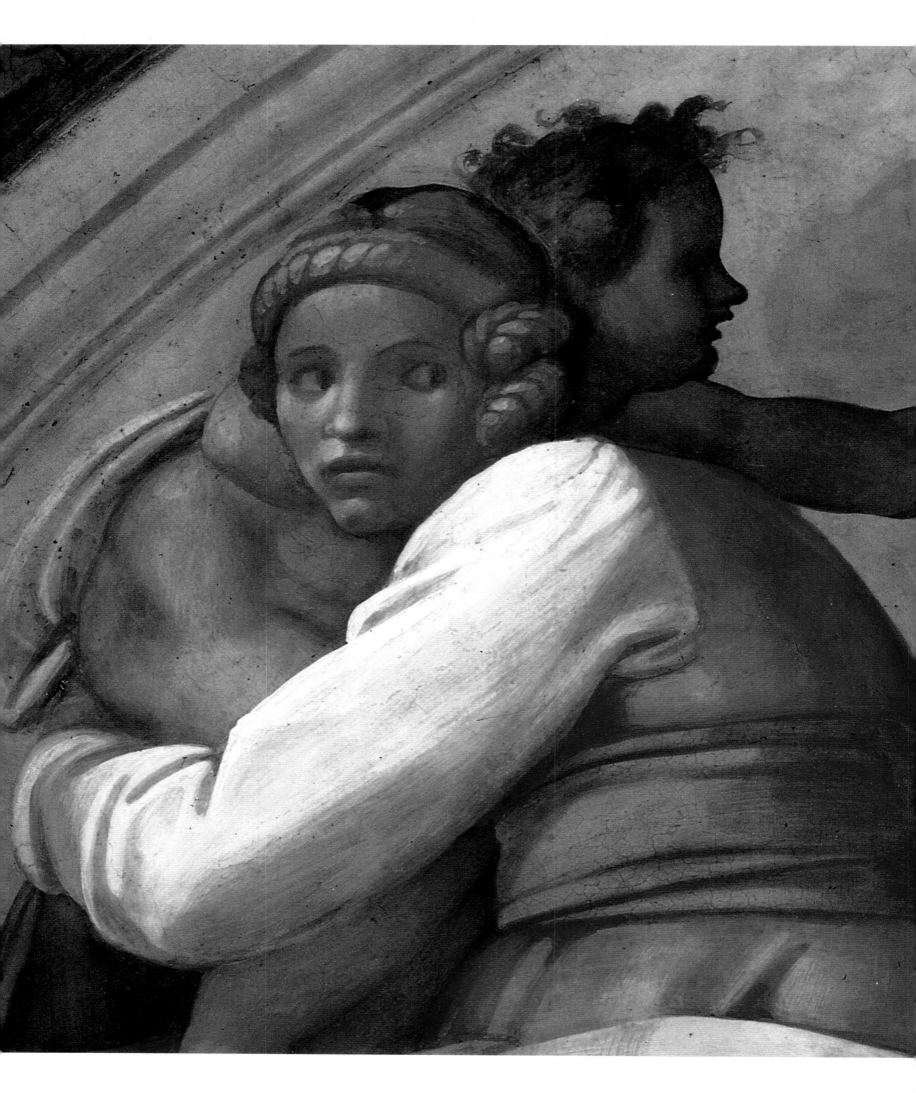

JOSIAH • JECHONIAH • SHEALTIEL

Amon begat Josiah. Josiah begat Jechoniah and his brothers around the time they were carried away to Babylon. And after they were brought to Babylon, Jechoniah begat Shealtiel and Shealtiel begat Zerubbabel.

Matthew 1:10–12

Josiah, the son of Amon, is usually considered to be the man depicted on the right, and Jechoniah the child that he holds on his knees, while, on the opposite side, the child's mother is believed to be holding in her arms another of the sons begotten by Josiah during the Babylonian Captivity. In this case, the family of Jechoniah with Shealtiel as a child is thought to be represented in the spandrel above.

The lunette with the tablet bearing the names of Hezekiah-Manasseh-Amon, who, in the chronological order of the ancestors of Christ, come imme-

For the first time, the artist established a clearly dramatic rapport between the figures in the two groups in the same lunette. In particular, this was assigned to the postures of the two children leaning eagerly toward each other with outstretched arms: the one on his father's lap holds a small object that is no longer recognizable, while the other seems to be trying to grasp it. The man suddenly turns his head with a vigorous mien that is difficult to interpret—possibly he is surprised, as his open left hand would seem to indicate—while the woman suddenly draws back, clasp-

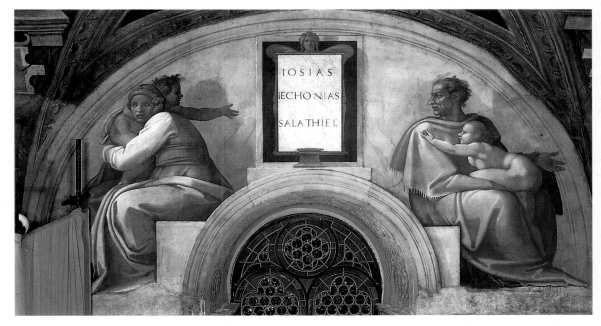

diately before Josiah, is next to this one on the same wall, instead of on the opposite wall, as it should have been according to the distributive pattern adopted by Michelangelo for the whole cycle. The interruption of this pattern, which was subsequently followed regularly, was probably intended to draw attention to the period of exile in-Babylon.

ing her son more tightly as if to protect him better, with an expression of great alarm on her face. And, once again, the brighter colors of the woman's figure—a deep rose dress with a green scarf round her waist, a white shirt and a yellow ocher mantle—are in marked contrast with the dominant darker tones of the green cloak with violet shadows that envelops the man.

45

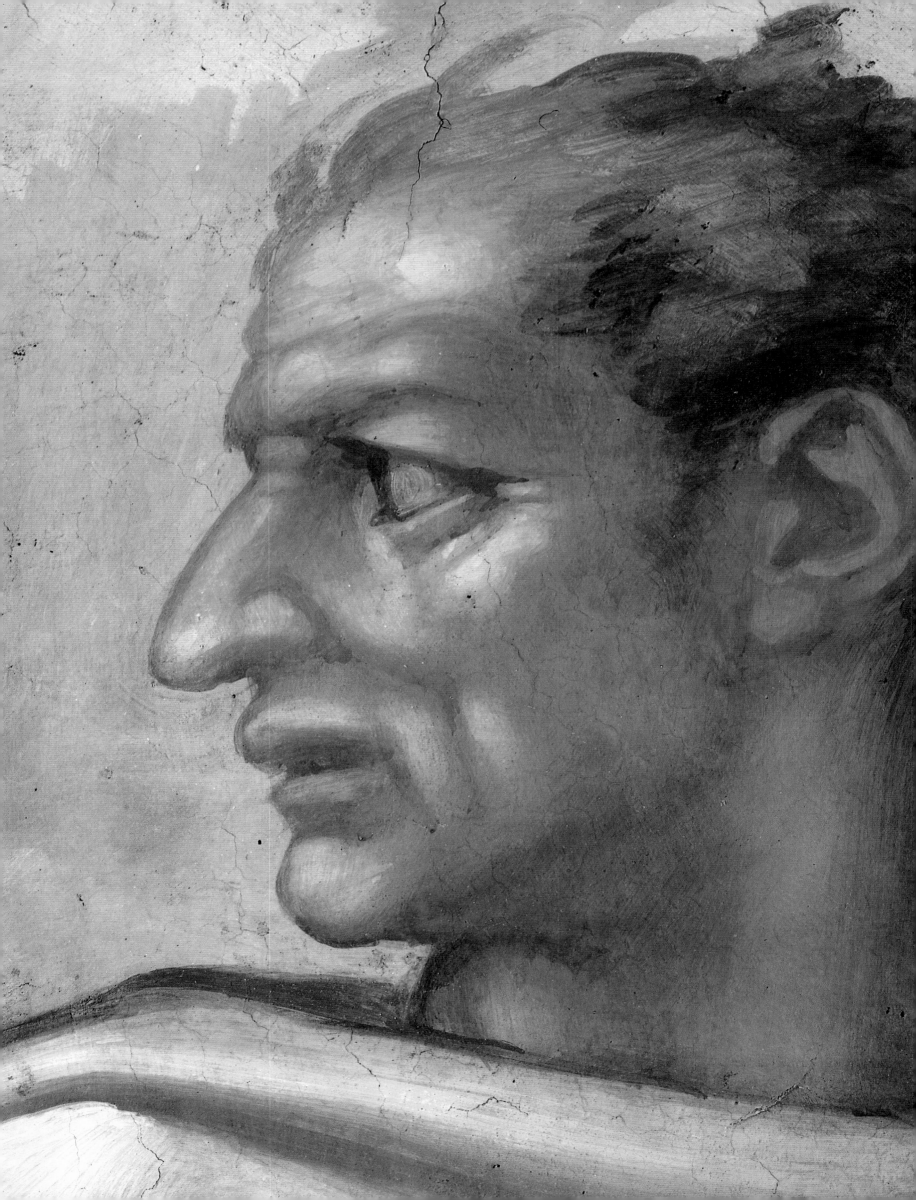

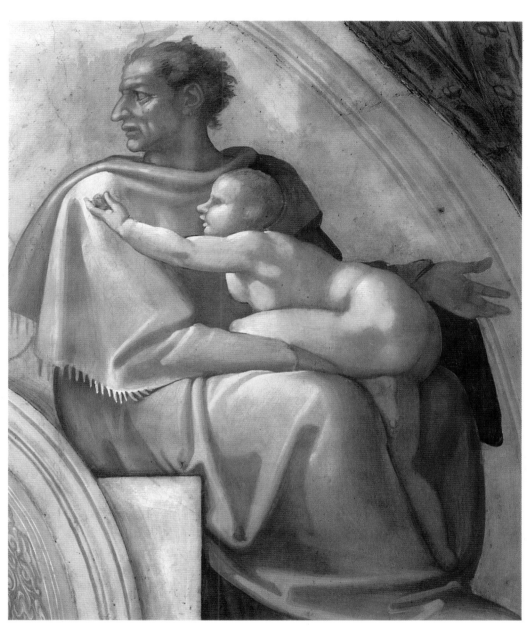

The man's face is strongly characterized both by its physiognomy and the tensely alert expression; this is defined by a very clean-cut profile and modeled with remarkable vigor by means of broad reddish glazes on the underlying flesh tone. His hair, too, is mainly painted with glazes of color applied with firm, rapid brushstrokes. The vigorous manner in which the man turns his head, the relationship between his neck and the cloak covering his shoulders, and the deep, sculptural rendering of the folds bring to mind the splendor of classical reliefs or the models of Roman portraiture.

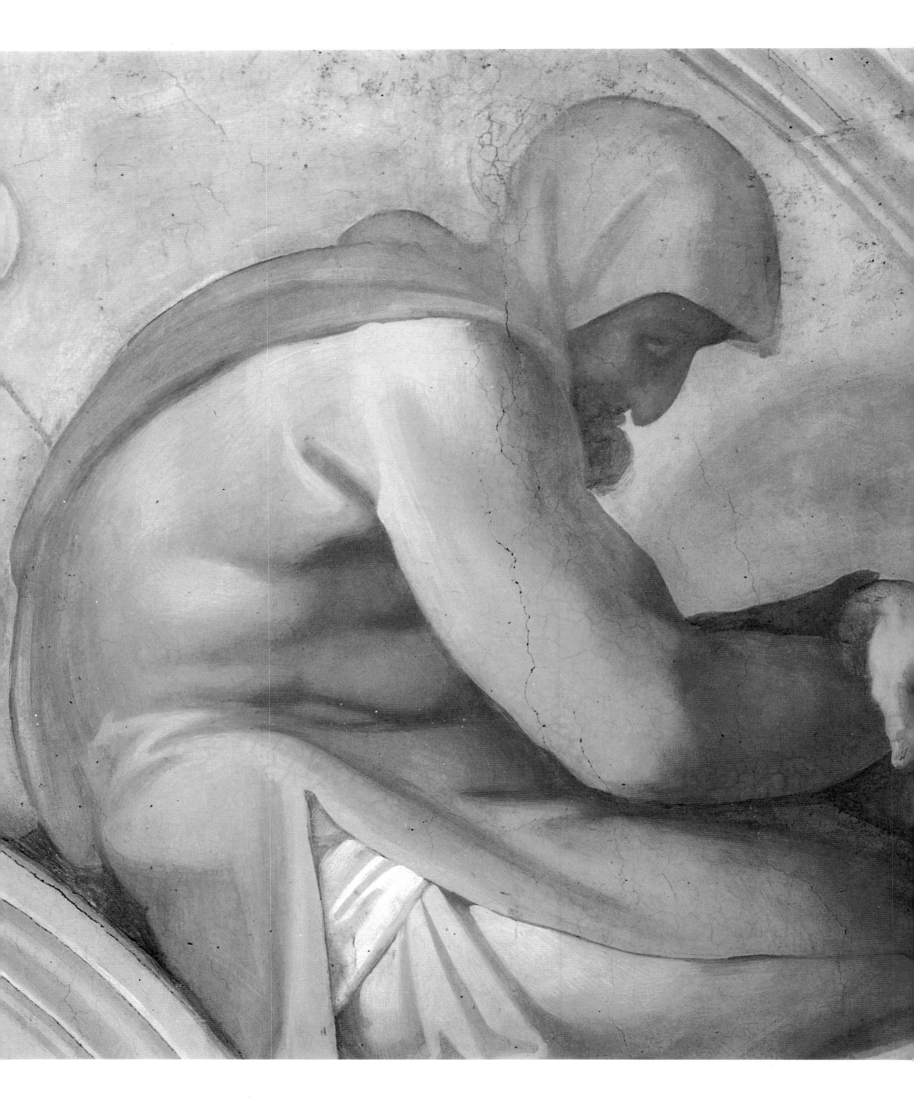

HEZEKIAH • MANASSEH • AMON
Ahaz begat Hezekiah. Hezekiah begat Manasseh. Manasseh begat Amon.
Matthew 1:9–10

The two main figures, seated and seen in profile, have their backs to each other. The solitary man seated on the right, slumped forward with his face in the shadow—apparently sleeping, but, in reality, probably immersed in anguished meditation—is usually considered to be Manasseh, filled with terrible remorse for having favored idolatrous cults and persecuted the faithful followers of Yahweh. The young woman on the left is thought to be Meshullemeth, the mother of Amon: her lips half-closed, an expression of infinite tenderness on her face, she is totally absorbed in the baby she is holding in her arms,

of desolate self-abandon of Manasseh is countered by the grace, vitality, and tenderness of the woman.

The delicate range of colors in the clothes of the two figures tone with different scales, but there are precise links: the reddish-rose mantle that envelops the woman below her shoulders, modeled with very light brushstrokes in the parts in the light, is matched, with a slightly paler tonality, by the man's tunic, which is open at the sides.

There is, moreover, greater contrast in the pattern of light and shade in the yellow of the skirt covering the woman's legs and the green of her shirt

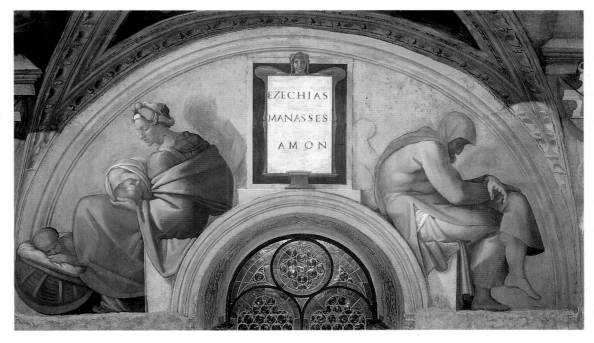

while her feet rock the wooden and wickerwork cradle where another child sleeps. Hezekiah as a child is believed to be depicted in the spandrel above, together with his mother and his father, Ahaz.

Although the two figures appear to be remote from each other, there is a complementary relationship due to the emotional contrast. Thus, the attitude

compared to the colors—which are, however, deeper—of the man's clothes and stockings. On the other hand, the penitential violet-gray cloth that covers the bowed head of Manasseh, falling over the curve of his back, appears to be more delicate in tone than the blue-gray ribbon that is intertwined with a white one in Meshullemeth's elaborate hairstyle.

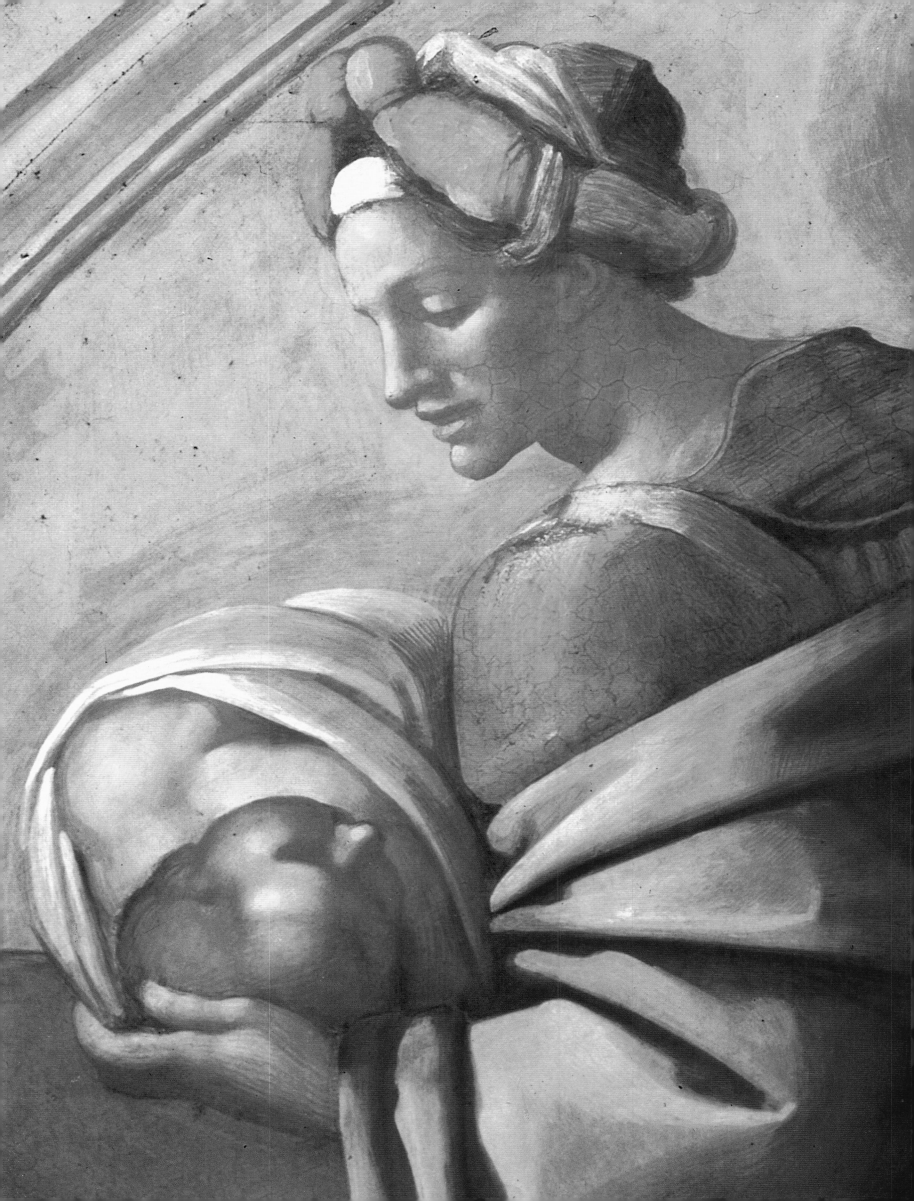

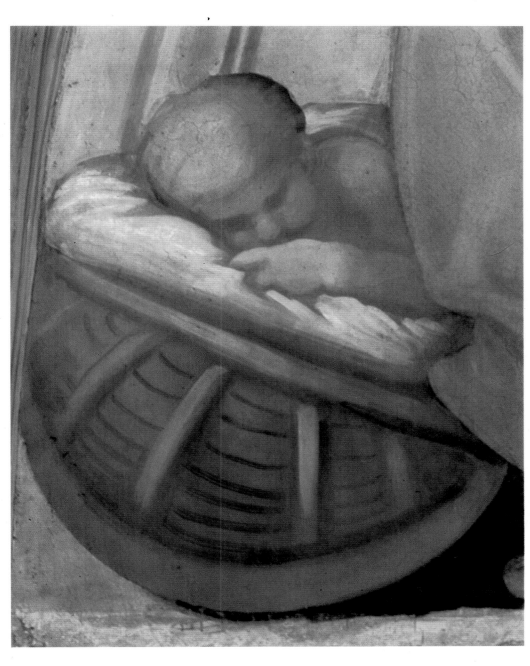

Studies, with slight variations in the position and the rotation of the torso, were made for the figure of the mother in two sketches in black chalk on a sheet now in the Biblioteca Reale in Turin. On the verso of this, there is a study for the Libyan Sibyl. The variant selected, with the shoulder in foreground lowered and brought forward, is more natural and accentuates both the contact between the woman's body and the foreshortened one of the child, and their exchange of glances.

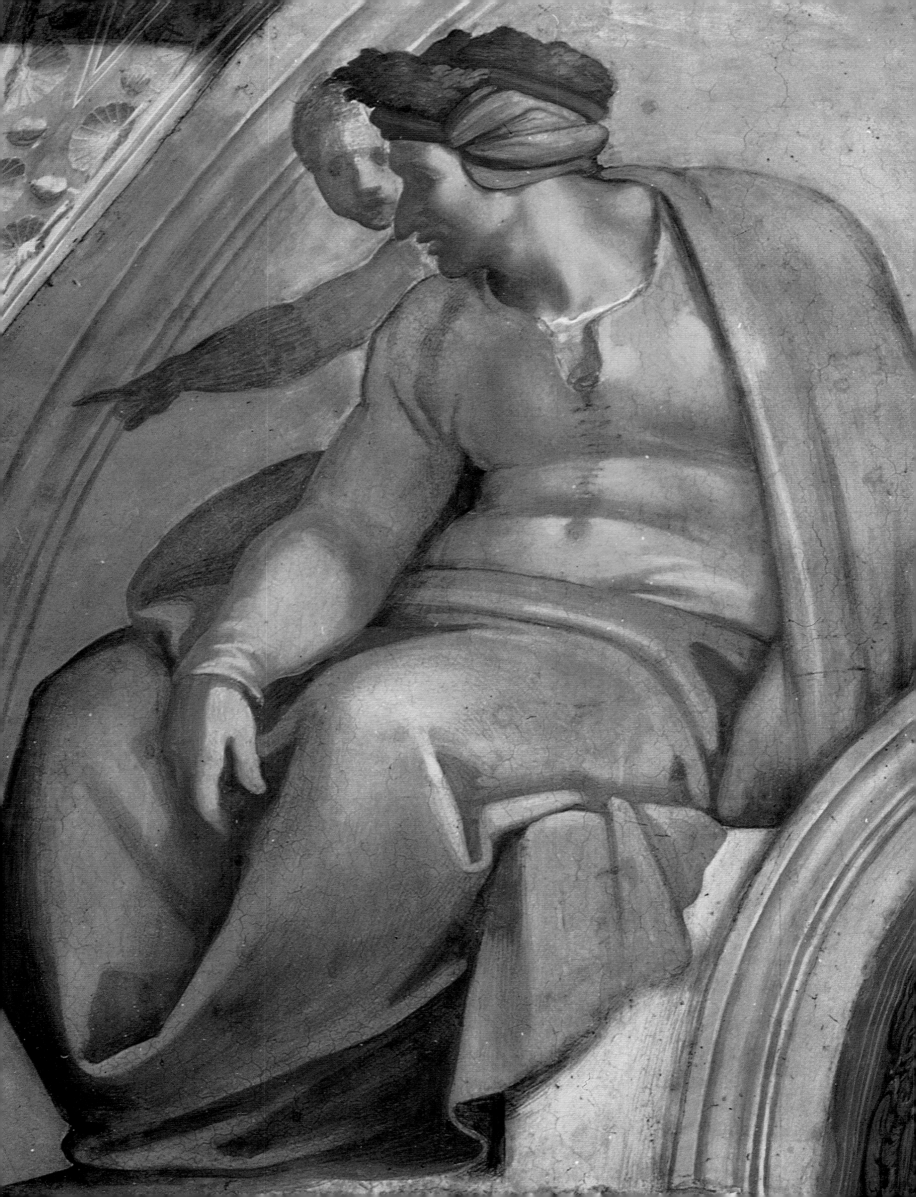

UZZIAH • JOTHAM • AHAZ
Joram begat Uzziah. Uzziah begat Jotham. Jotham begat Ahaz.
Matthew 1:8–9

Before the restoration.

The symmetry of the poses of the principal figures appears to be studied: the torsos of both are seen frontally, but they face outward in opposite directions. The boy in the foreground, in front of the woman, reinforces the plastic equilibrium of the scene; and there is decidedly sculptural and monumental emphasis in the two groups that seem to be compressed into the limited space of the lunette.

hind him is indicating. The right part of the lunette is dominated by the tonality of the heavy reddish-orange mantle with deep yellow shadows that the woman presses to her breast. Although her gaze is not directed at them, she seems to be protective toward the two children by her.

All the figures were painted very rapidly, without *pentimenti*—aside from the one that may be discerned behind

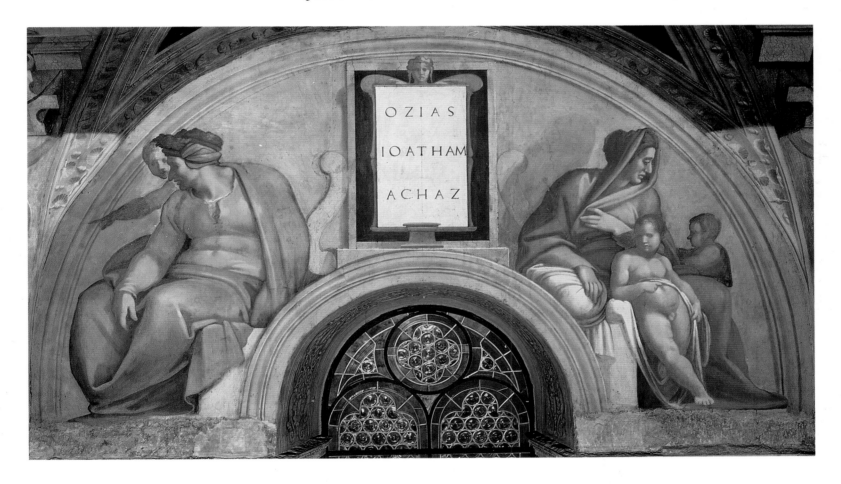

Under a loose green mantle, the man on the left—traditionally considered to be Jotham accompanied by his son Ahaz—is wearing a yellow tunic with lilac shadows on the shoulder and arm; these echo the color of his cap, which is tied to his head with purple ribbons. In a relaxed attitude, leaning forward with his arm resting in his lap, he gazes with parted lips at a point that the boy be-

the woman's neck—with layers of liquid, transparent color.

This mode of execution is all the more remarkable if the complexity of the poses and groups, and the size of the figures, are borne in mind. Furthermore, no trace of the transfer of cartoons, either by pouncing or incision, has been found on the surfaces of the frescoes in the lunettes.

53

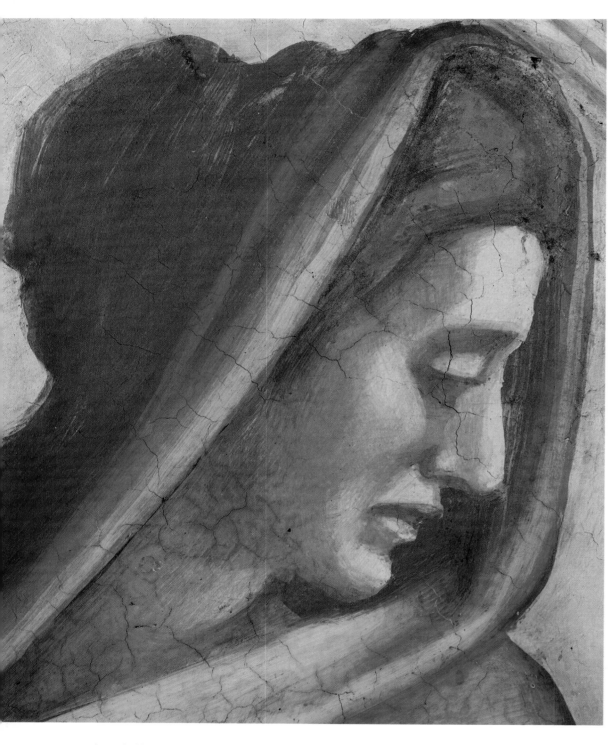

The veiled head and the gravity of the attitude and expression of the female figure, together with the pattern of the drapery, reveal that she was probably based on a classical model. The same applies to the boy in the foreground. His pose resembles that of ancient funerary statues of torch-bearing genii, and appears to be derived (with variations) from one of the figures of nude youths in the background of the *Doni Tondo*. With regard to the other boy seen in profile in the background, it has been rightly observed that he appears to have been drawn by the artist with the brush rather than painted.

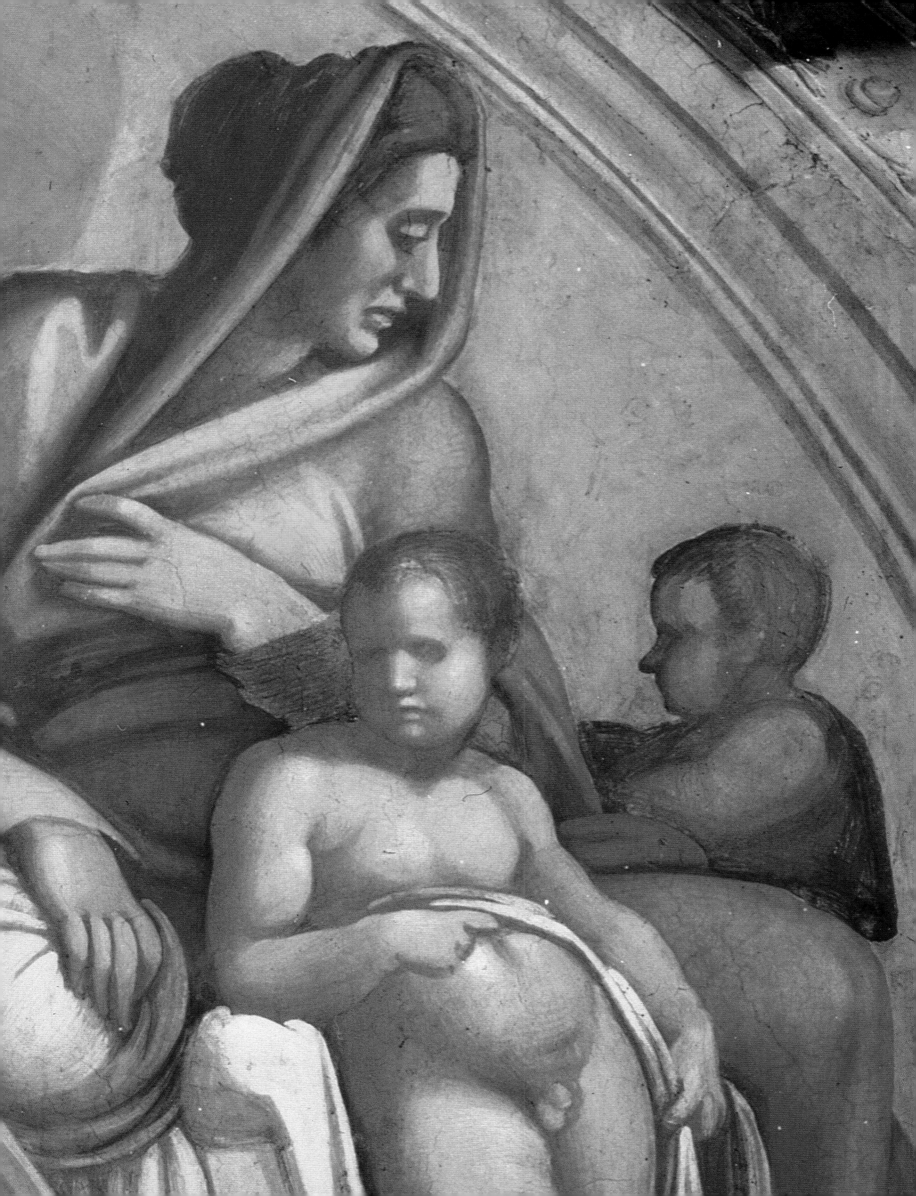

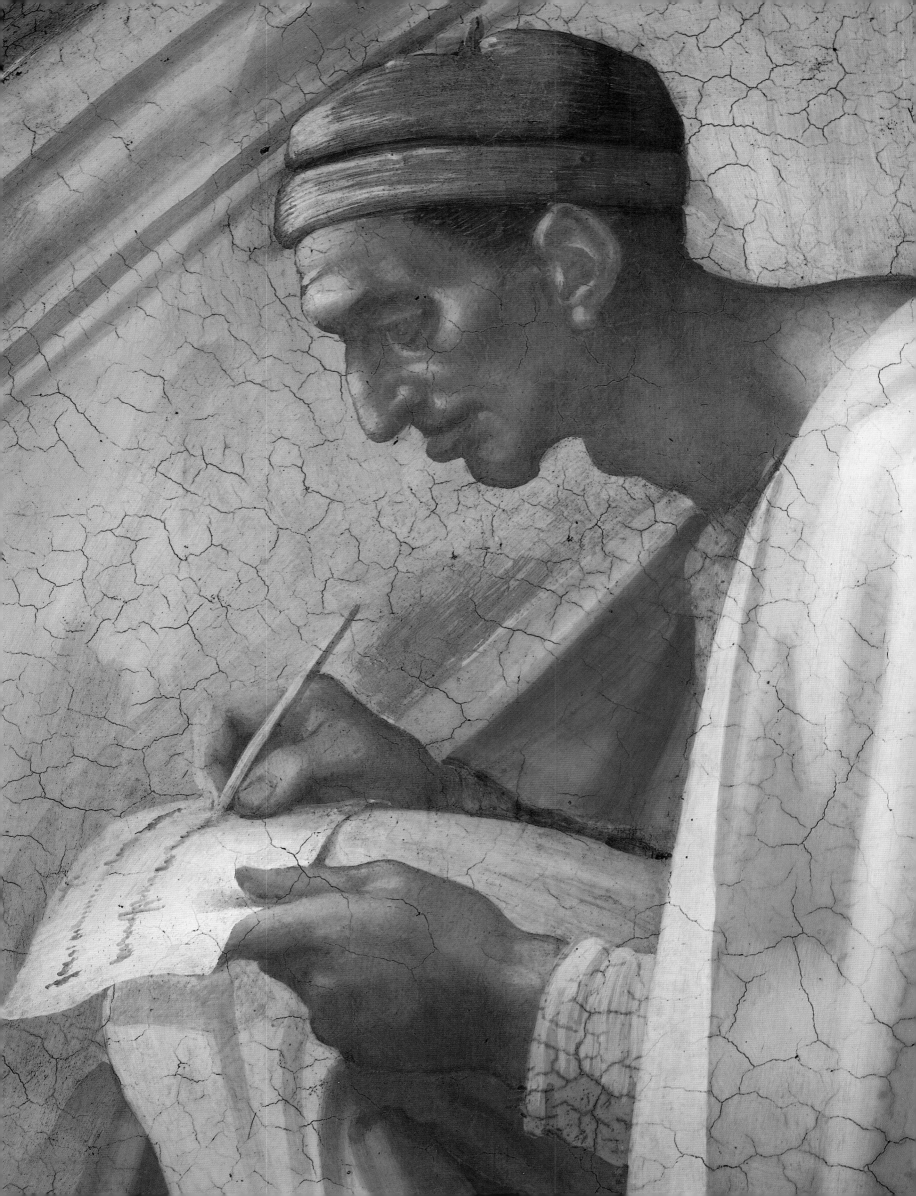

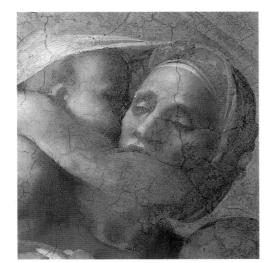

ASA • JEHOSHAPHAT • JORAM

Abijah begat Asa. Asa begat Jehoshaphat. Jehoshaphat begat Joram. Joram begat Uzziah.

Matthew 1:7–8

This lunette forms part of the second group that was painted after the suspension and resumption of the vault frescoing, probably when the work was nearing conclusion. The shape of the tablets is different (they are without the lateral brackets), the color of the background appears to be even lighter, the size of the figures has increased, and the execution is even more rapid and fluent.

As in other cases, the two main figures at the opposite extremities of the lunette appear to be wholly separate in

his raised knee. He is wearing a loose yellow mantle with bright red shadows that are greenish in the halftones, white trousers tied round the ankles (a style often associated with Orientals in painting) and rose shoes. A gray cap covers his bony head; with its hooked nose and large ears, it is thrust forward on a long neck, from which a prominent Adam's apple protrudes.

On the opposite side, similar skill, with descriptive and expressive naturalness, are displayed in the compact

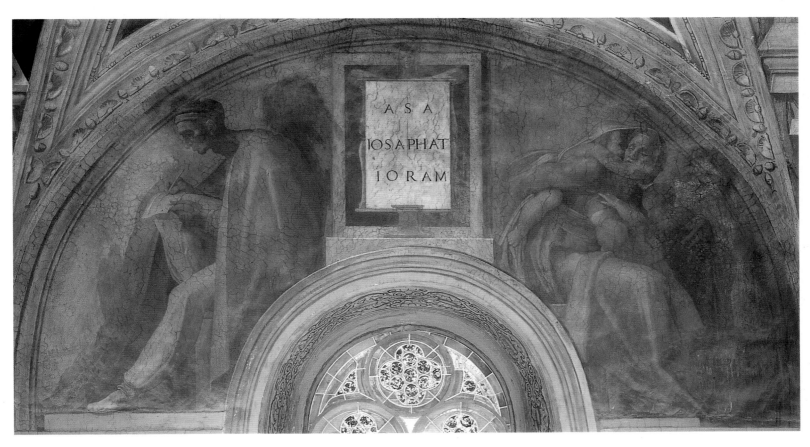

Before the restoration.

their expressions and poses, but relate to each other through the correspondence of form and color. On the left, an emaciated old man, traditionally considered to be Jehoshaphat, is seen in full profile. He is sitting in an unusual pose—one leg is extended and the other bent, with the foot resting on the seat—and is engrossed in writing with a reed pen on a parchment placed on

group, very similar to an allegory of Charity, of a mother with her three children. Clasping one of them, she turns toward another who, having climbed onto her back, puts his arm round her neck and kisses her on her cheek; the third puts his lips to her bare breast. The yellow gown with iridescent orange shadows echoes the dominant color of the man's cloak.

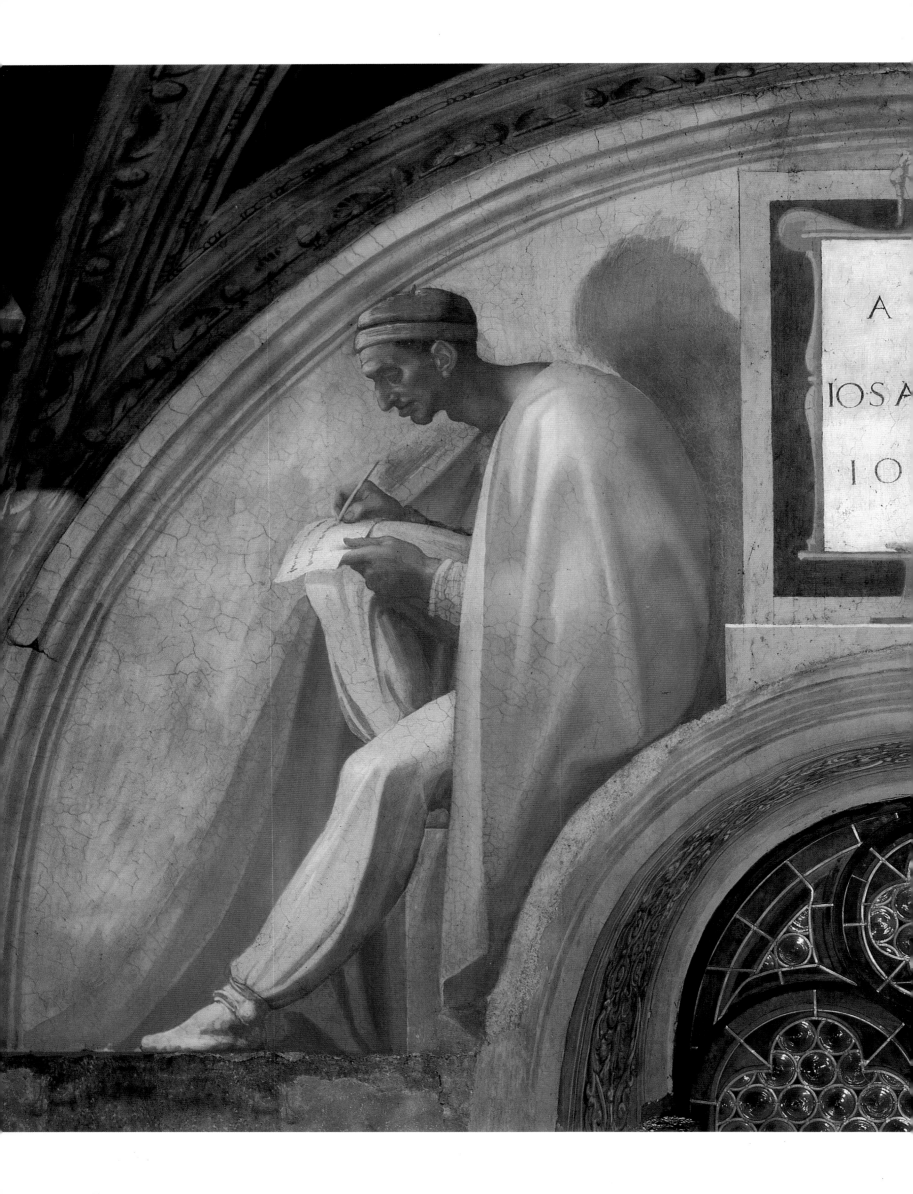

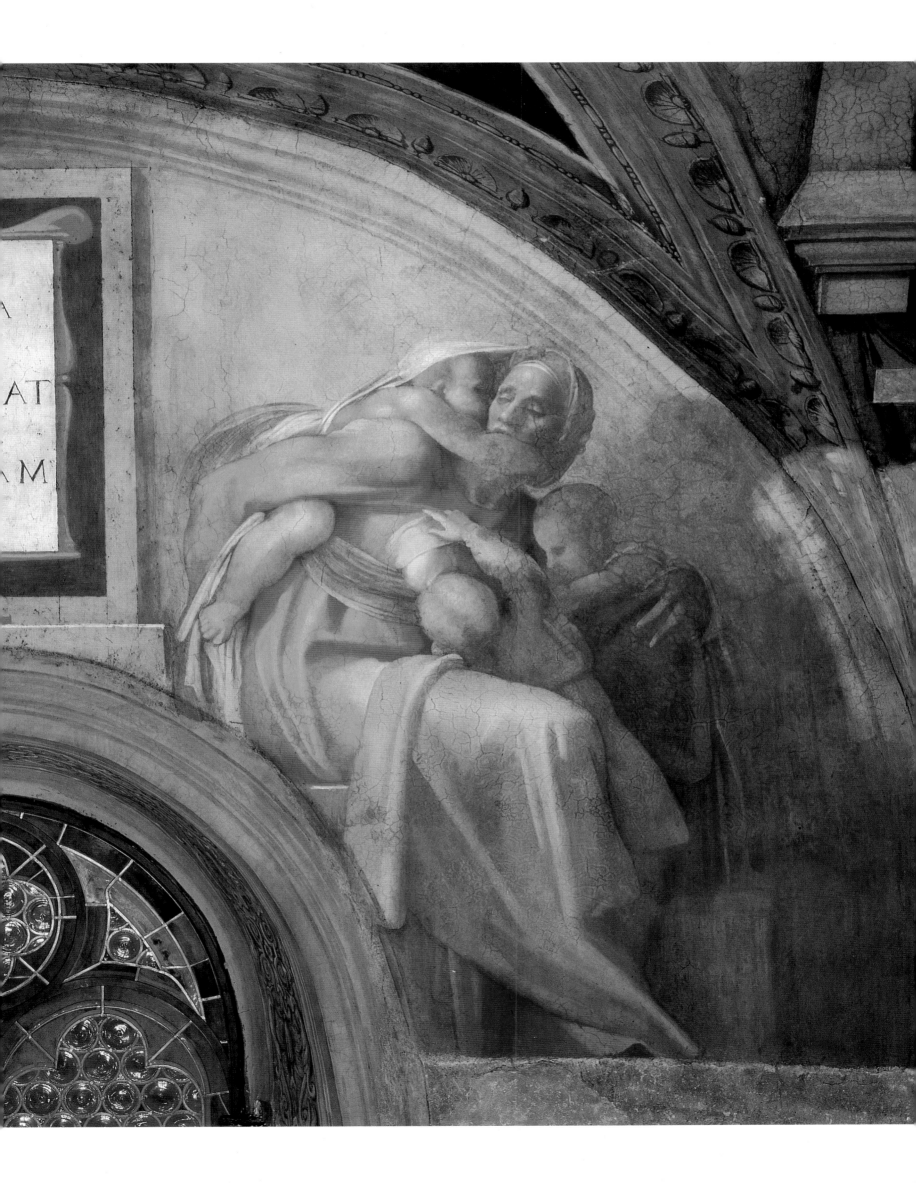

REHOBOAM • ABIJAH
Solomon begat Rehoboam. Rehoboam begat Abijah. Abijah begat Asa.
Matthew 1:7

Astonishing naturalness and a large variety of poses characterize the figures in the last lunettes, which are known to have been painted with great rapidity. In the Rehoboam-Abijah lunette, the seams between the *giornate* have not been identified; this probably means that Michelangelo added fresh *intonaco* as the work proceeded, without any interruptions.

On the left a woman is depicted in profile; she sits alone, gazing out into the chapel, leaning backward with her elbow on the back of the seat. This is a detail that is only found here, and it

toward the wall, is resting on the hand placed on his right knee; his other arm hangs down at his side. Behind him, a young boy seems to be trying to make him sit upright by grabbing his shoulder. The juxtapositions of bright colors in the woman's clothes—a green scarf over her head and shoulders, a violet-rose pinafore, a reddish-orange mantle with yellow ocher lining—are matched by equally rich, but more delicate, tones in those of the young man.

Considerable damage was caused by salification resulting from the seepage of rainwater. This led to corrosion and

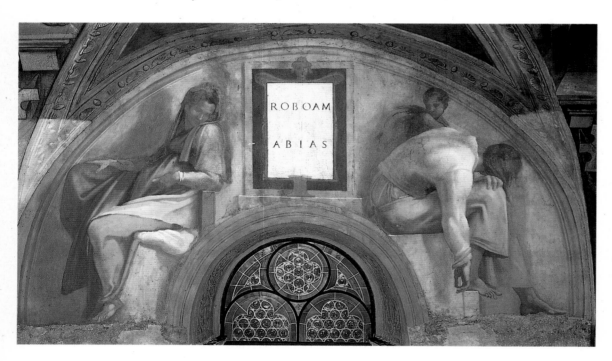

may be compared to the low step on which, on the other side of the lunette, the sleeping young man rests a foot. The woman's right arm and hand are stretched out on her leg, while her left hand points to the unborn child she is carrying in her womb.

The young man at right is seated bent forward in an attitude of complete abandon. His head, with his face turned

flaking of the layer of paint, especially in the upper part of the figure on the left. Furthermore, during the recent restoration, thick layers of glue were removed; these had been applied to conceal the salification, and had been repainted over the centuries in order to revive the modeling of the figures that had been obscured by salts, soot, and glue.

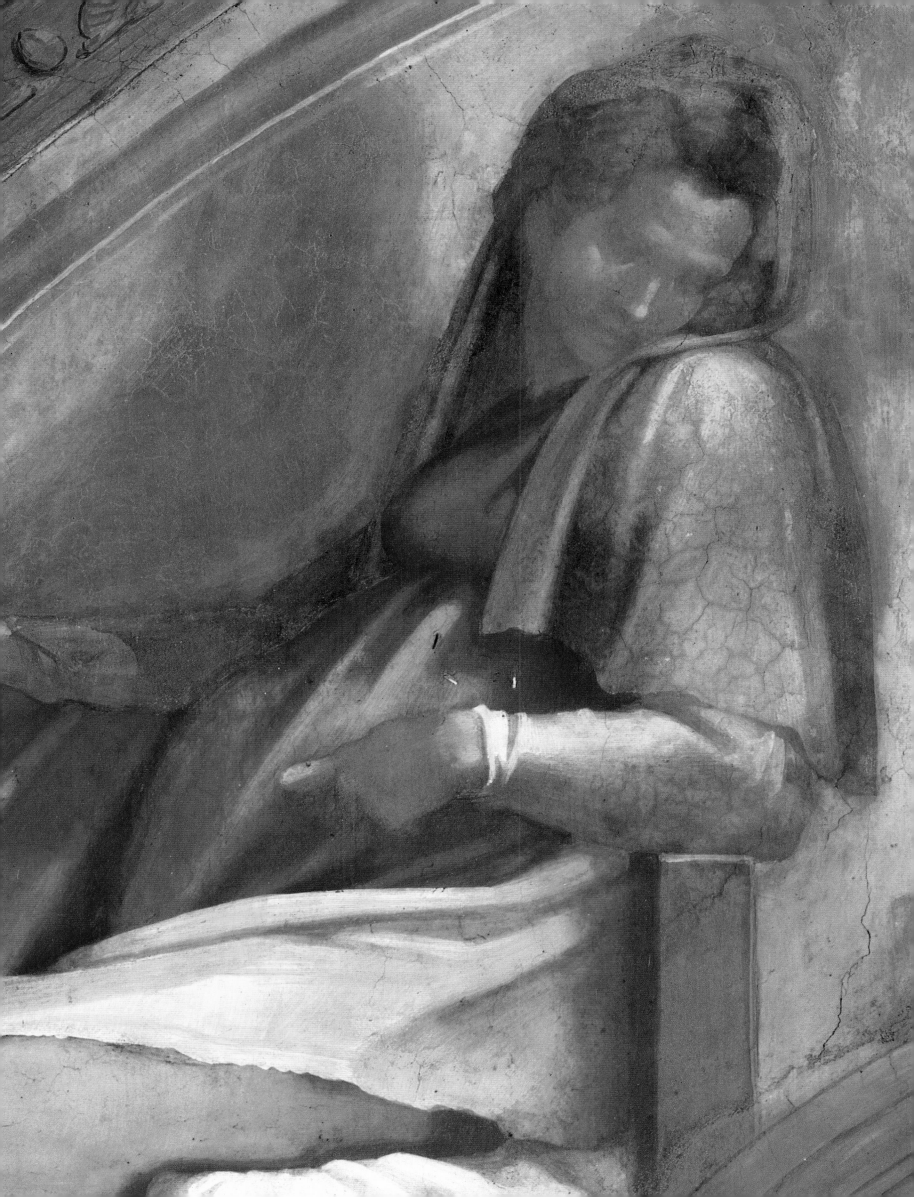

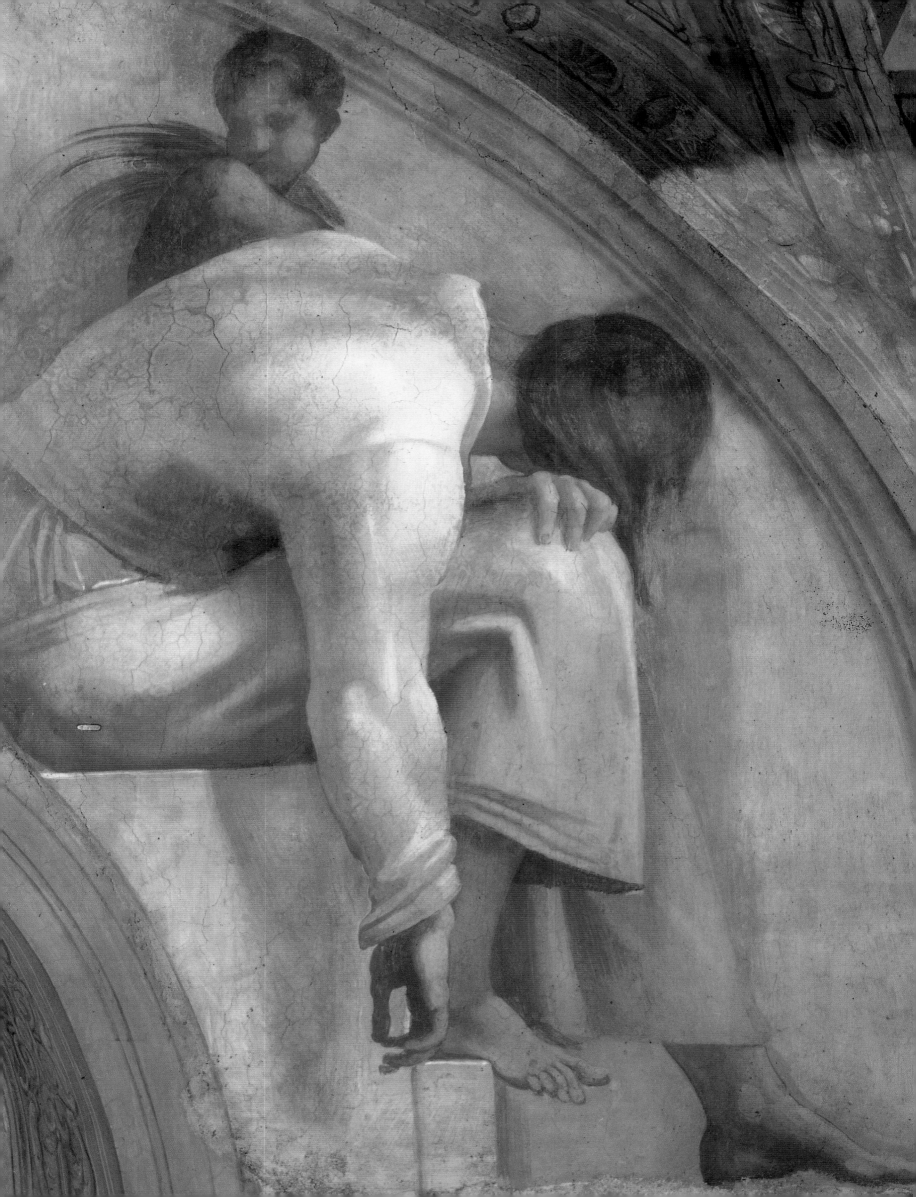

The figure of the young man sleeping was studied by Michelangelo in pen sketches on two sheets of the so-called Oxford sketchbook (in the Ashmolean Museum). This is comprised of eight sheets with drawings that are mainly related to the figures in the last lunettes and appear to be life studies. It seems that the artist omitted the stage of intermediate elaboration and the preparation of cartoons, proceeding directly from the small drawings in the sketchbook to the figures drawn on the *arriccio*.

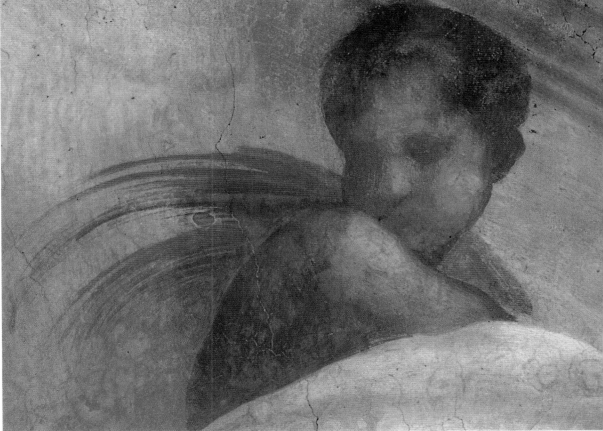

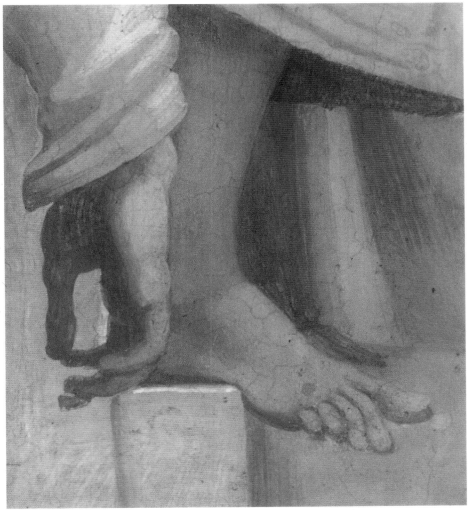

The figure of the boy in the background, behind the young man, appears to have been rapidly sketched out: the billowing cloak is rendered with two brushstrokes of red ocher.

JESSE • DAVID • SOLOMON

Obed begat Jesse. Jesse begat King David. King David begat Solomon by the wife of Uria. Solomon begat Rehoboam.

Matthew 1:5–7

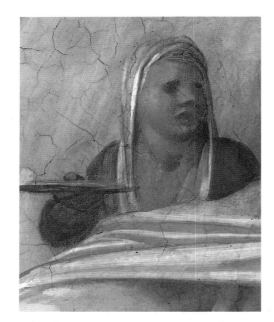

Traditionally it is believed that David is the principal figure on the left, while Solomon is the child with a veiled head behind him who holds out what may be a ritual offering on a small tray; Bathsheba is the woman on the right. If this is correct, then Jesse must be the child depicted, together with his parents, in the spandrel above.

David's pose—his head and torso are seen frontally, his pelvis and legs are turned slightly to the left—stresses his physical strength and his awesome left hand, he holds the edge of a white cloth, possibly also having a ritual function, spread over his knees. His hand, modeled with remarkable energy, and the folds of the lower part of the robe, emerge forcefully in the foreground. David's face, partly in shadow under his headdress, expresses great concentration, though he seems to have suddenly noticed something on his left. His beard and mustache are painted with a few bold brushstrokes. More severe tones are used for the clothes of the

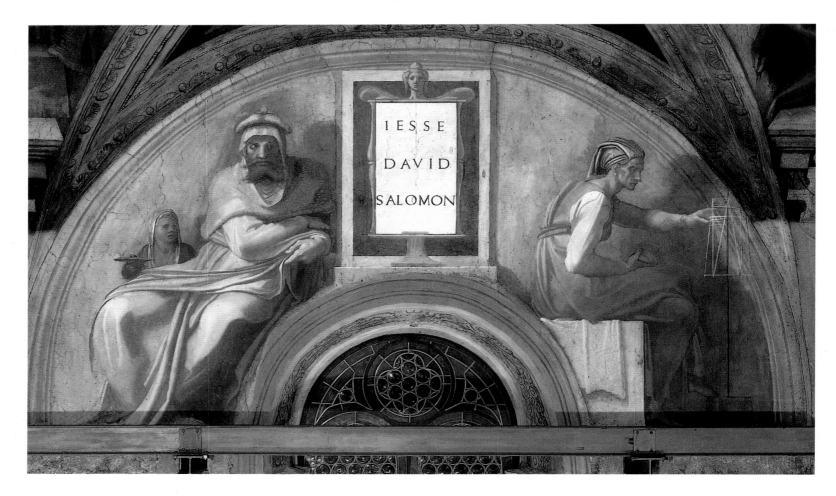

sense of dominion, and this is accentuated by the contrast with the minute figure of his son and the thin, bent one of the woman.

He is wearing clothes in Oriental style: a green cap-cum-hood hanging down over his shoulders, resembles the Arab *kaffiyeh*; the upper part of his robe is rose, the lower part yellow. His arms are folded across his chest and, with his woman, who, absorbed by her work on a wool-winder, is sitting sideways on and wearing a violet dress, girt above the waist by a green sash, over a white shirt with gray-blue shadows. Her headgear is also grayish, while the only bright touches are provided by the yellow ocher cloth covering the seat, and the red boots visible in the shadow at the bottom.

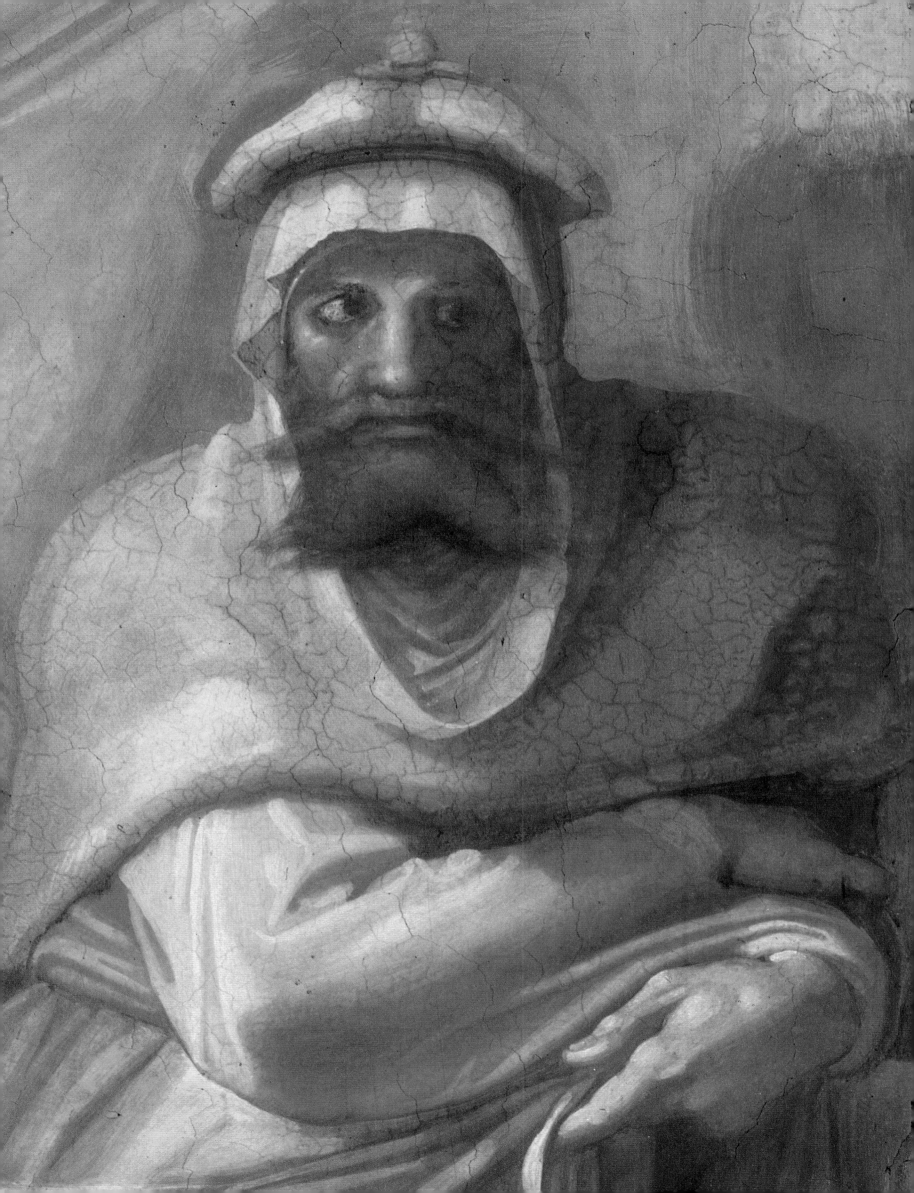

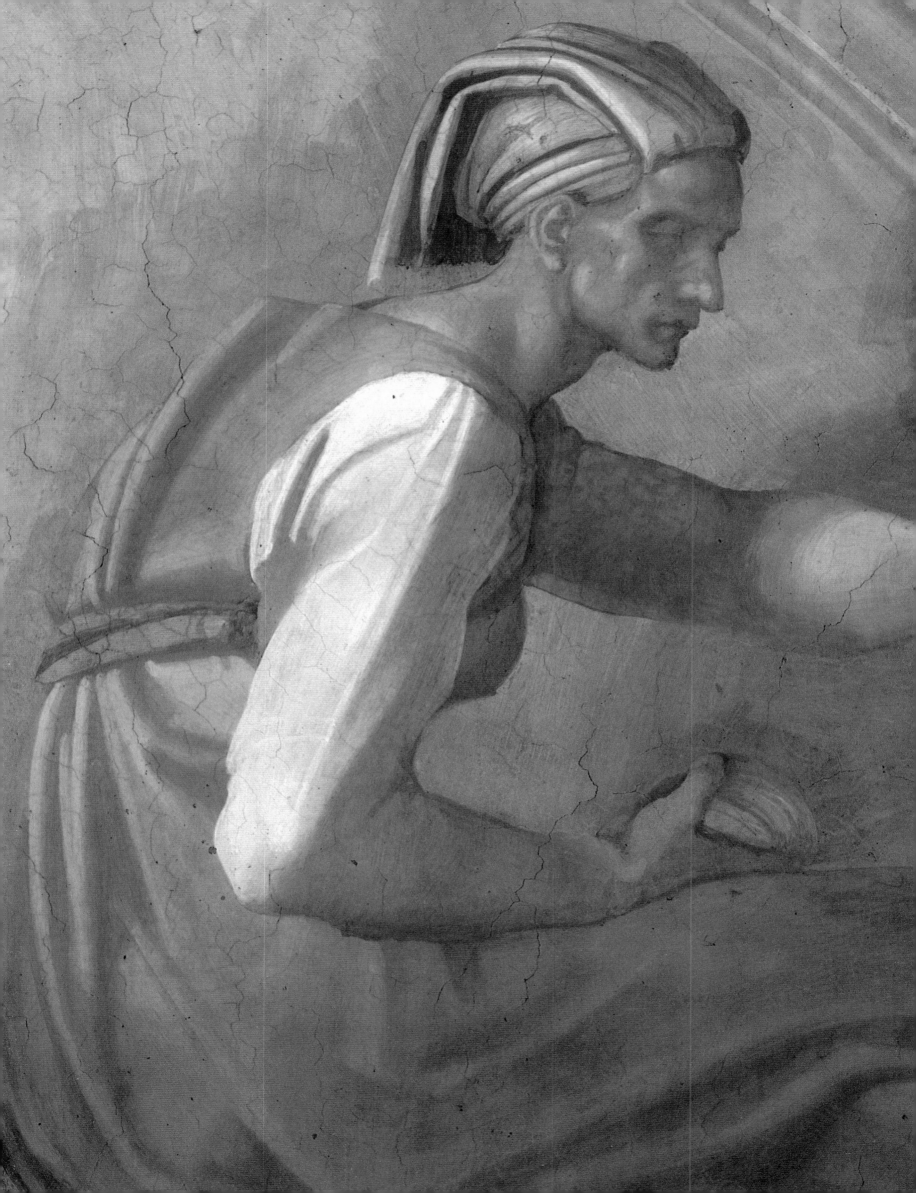

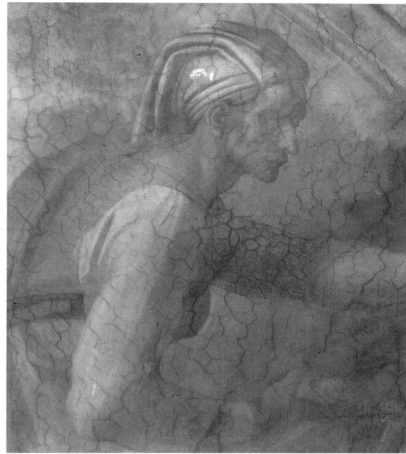

Before the restoration.

The careful modeling of the woman's face gives particular emphasis—from a perceptive point of view—to the details, but it makes the figure intensely expressive, with a sense of ineffable melancholy, concealed beneath an exterior of toughness and diligent attention to her work.

One hand holds the ball of wool, while the other, quickly sketched, is stretched toward the thread turning on the wool-winder. Although he does not attain the remarkable optical effect of Velázquez's *Spinners*, in his representation of this, the artist manages to convey a sense of rotation.

SALMON • BOAZ • OBED

Nahshon begat Salmon. Salmon begat Boaz by Rahab.
Boaz begat Obed by Ruth. Obed begat Jesse.

Matthew 1:4–5

On the basis of somewhat flimsy arguments, the figure on the right is usually held to be Boaz; his old age was, according to the Bible, gladdened by the birth of Obed, who is, therefore, depicted on the left with his mother, Ruth. The woman is represented with her eyes closed, as she tenderly cuddles the sleeping infant she has just finished nursing. A breast still protrudes from her clothing; in the past it was hidden

The serenity and sweetness of the woman, seen frontally and slightly turned toward the center of the lunette, contrasts sharply—also due to the dominant colors—with the old man depicted in profile on the right. He is sitting with his right arm placed on the seat, perhaps because he is restraining himself. Hunched up, his lips parted, his long beard jutting out in front of him, he glares angrily at the staff he is

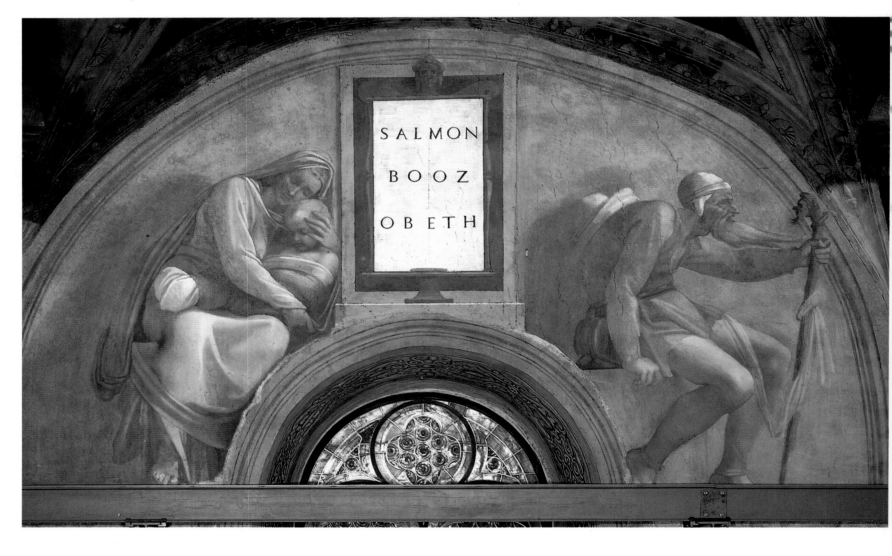

beneath repainting, but the recent restoration has revealed it once again. She is wearing a long rose tunic with whitish highlights formed by the folds and orange shadows. A violet-rose mantle envelops her knees, while her head is covered with a cloth falling onto her shoulders. The green of this is duller in tone than that of the shawl wrapping the infant.

holding in his outstretched hand. The top of the staff is carved in the shape of a small bearded head, with a fierce expression; bearing a strange resemblance to the man, it seems mock him. The harsh greenish-yellow of his short tunic, girt round the waist with a red sash, clashes violently with the rose of his hose. On his head he is wearing a cap with earflaps, while a white broad-

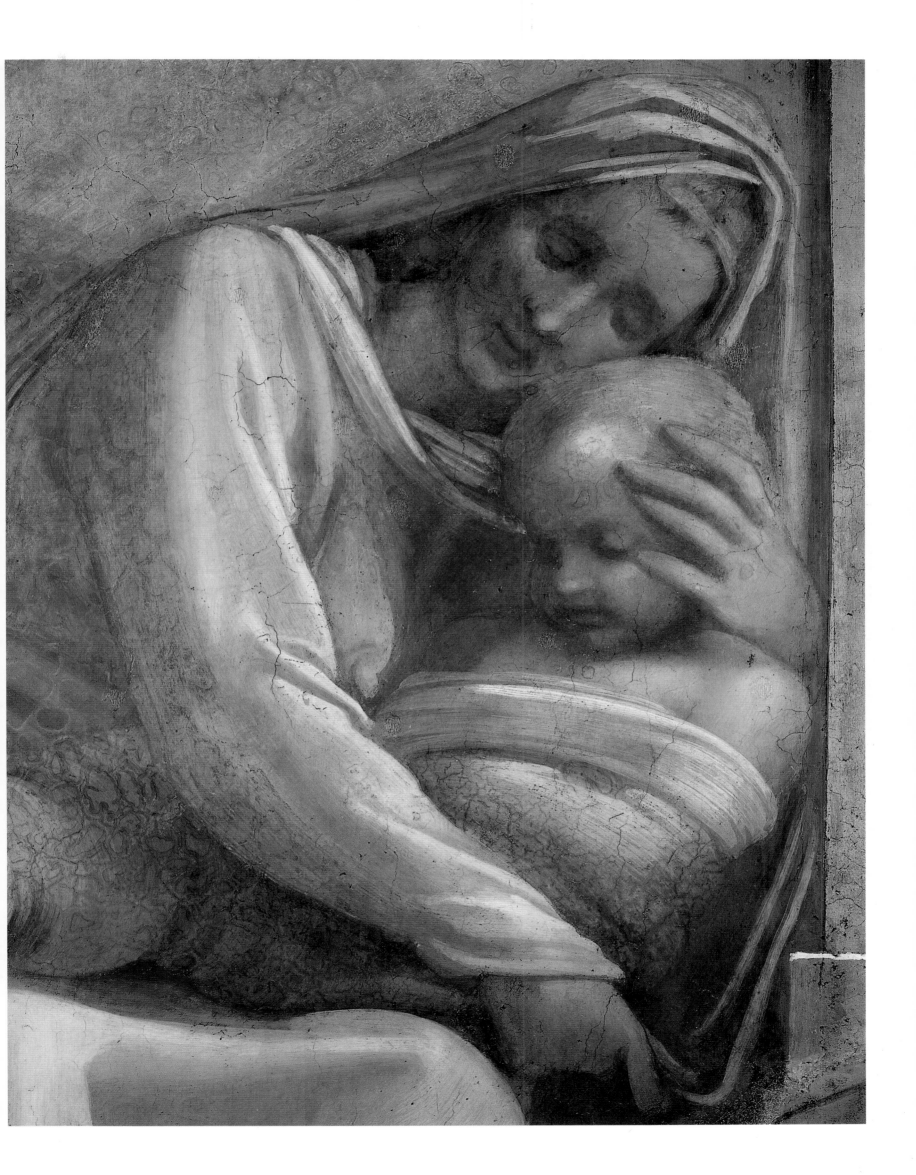

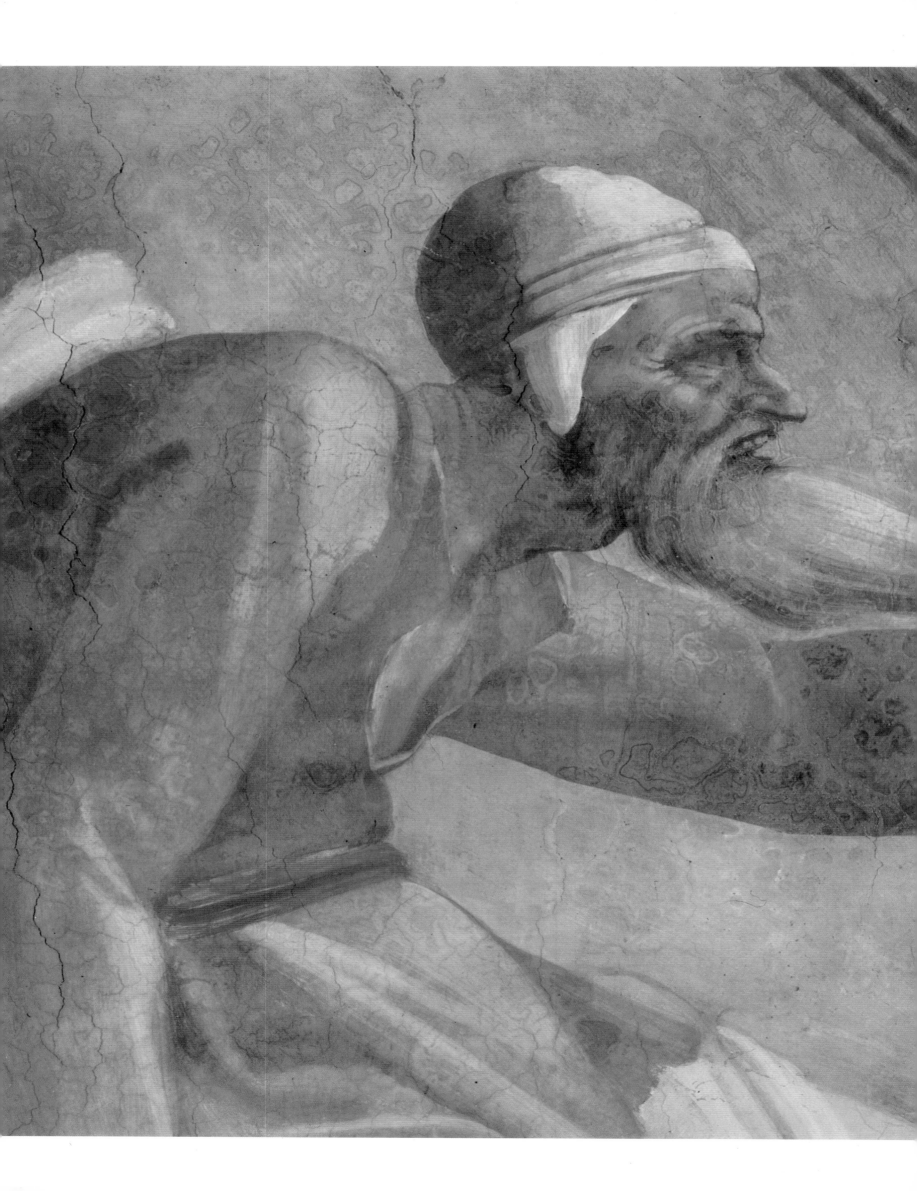

Once again, the poses of the two figures appear to be wholly natural, and they were probably drawn from life in minute sketches. A bent figure, very similar to the one of the old man, but facing left, appears on one sheet of the Oxford sketchbook and again—holding a staff and facing in the same

direction as in the fresco—in another one, in which the hand holding the staff has been studied. The group of the mother and child is recognizable in a drawing on yet another sheet in the same sketch-book, where there are also studies for the sleeping youth in the Rehoboam-Abijah lunette and for the woman combing her hair in the Amminadab lunette.

brimmed hat hangs down his back. To-gether with the water-bottle dangling from his waist and the staff, this seems to suggest he is a pilgrim.

This lunette was seriously damaged by rainwater, the application of glue, and past repainting, but the recent cleaning has allowed the colors to be restored to a condition approaching their original splendor.

71

NAHSHON

Amminadab begat Nahshon. Nahshon begat Salmon.

Matthew 1:4

The two lunettes at the ends of the side walls near the altar contain only two figures: a man, to whom the name inscribed on the tablet refers, and a woman. For the first time, in the Nahshon lunette, the two figures—seen alone and in profile—face in the same direction, without any concern for symmetry.

The same orientation was employed for the principal figures in the lost Abraham-Jacob-Isaac-Judas lunette. The woman is depicted standing, with one foot resting on the stone seat, looking at herself in an oval mirror that she is holding in her hand, her elbow resting on the knee of her raised leg. Her neck, on which a gold earring stands out. The pose of the woman, which is probably derived from a relief representing the muse Melpomene on a Roman sarcophagus—an example now in the Louvre has, however, only been known since the eighteenth century—was studied by Michelangelo in two small drawings in pen and one in black chalk in the Oxford sketchbook and, as a male nude, on another sheet at the Casa Buonarroti in Florence.

On the other side of the lunette, a youthful Nahshon, sits leaning back on the edge of the tablet, engrossed in reading the book open in front of him. His outstretched right leg rests on the

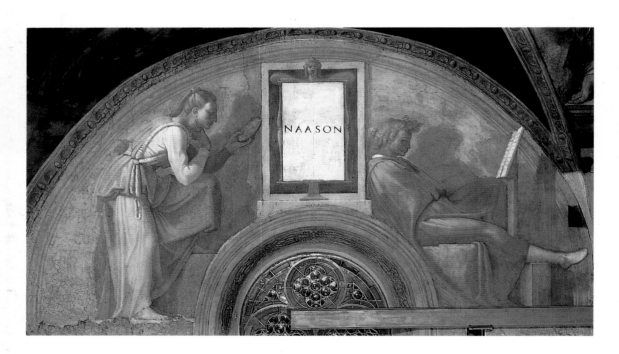

back and head are bent forward, following the curve of the top edge of the lunette. She is wearing a green overdress, tied over the shoulders, and a rose blouse with rose-orange shadows. The complex style of her blond hair, knotted on the top of her head, from where a long ponytail hangs, emphasizes her clean-cut profile and the delicate passages of light and shade on her wooden pedestal of the lectern holding the book, while the other one is bent, and his arms are folded. He is enveloped in an ample red mantle with gray-blue shadows and green lining and hood. The elegant nonchalance of the pose is well matched by the expression on his face—in shadow and framed by blond curls—which is that of a slightly sulky adolescent prince.

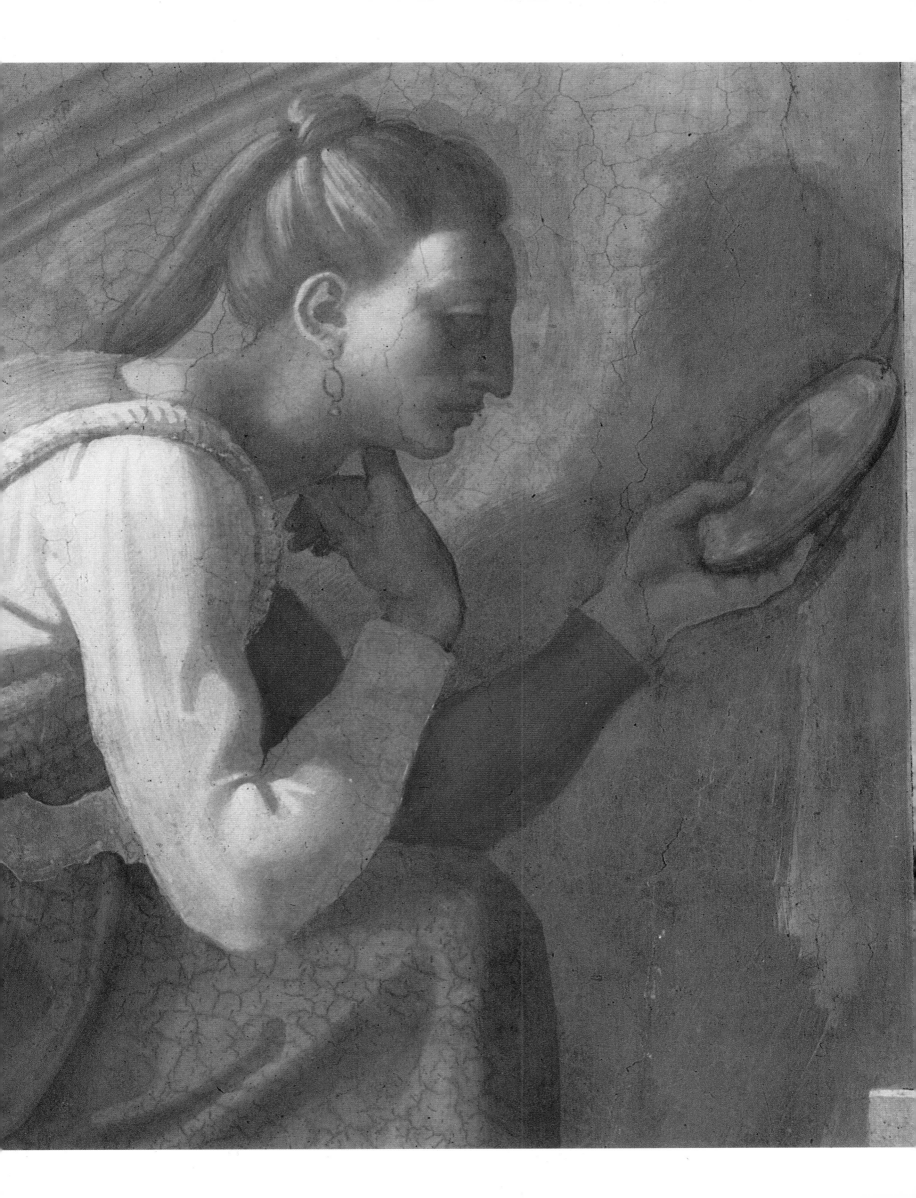

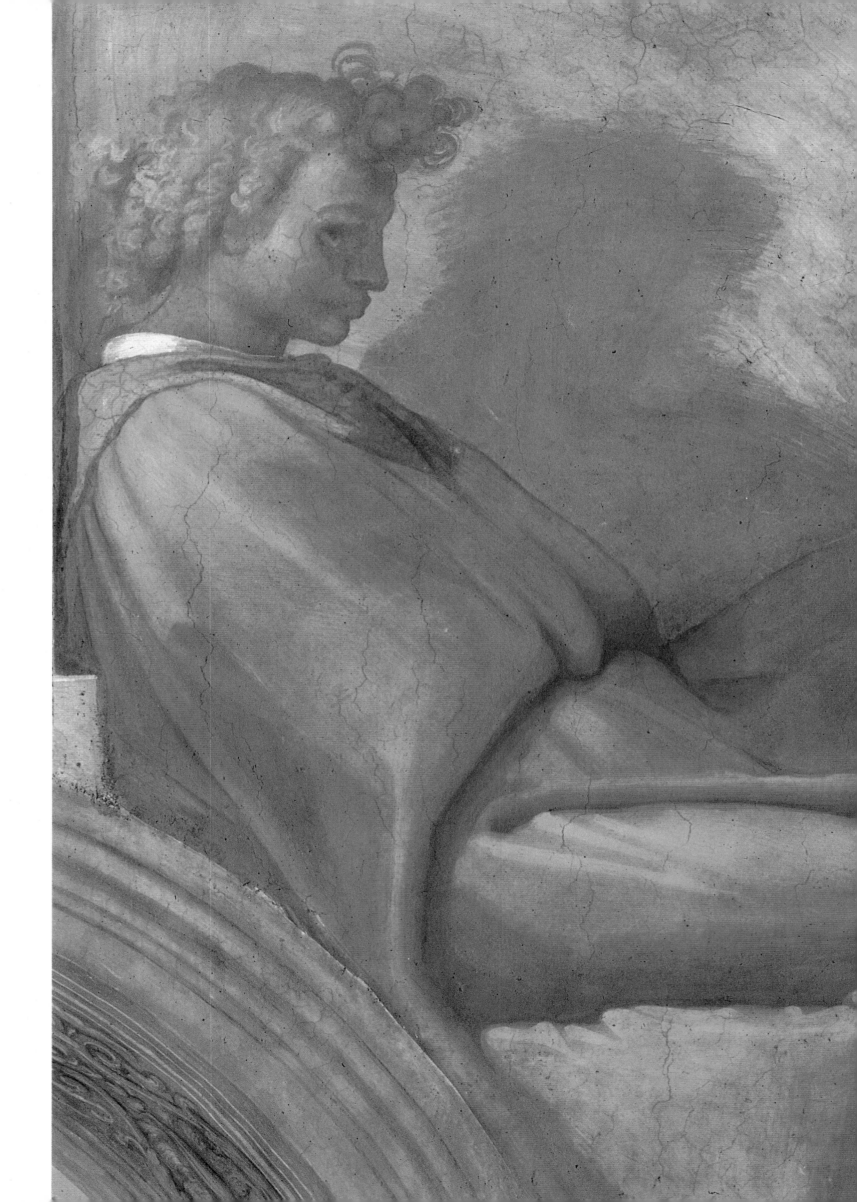

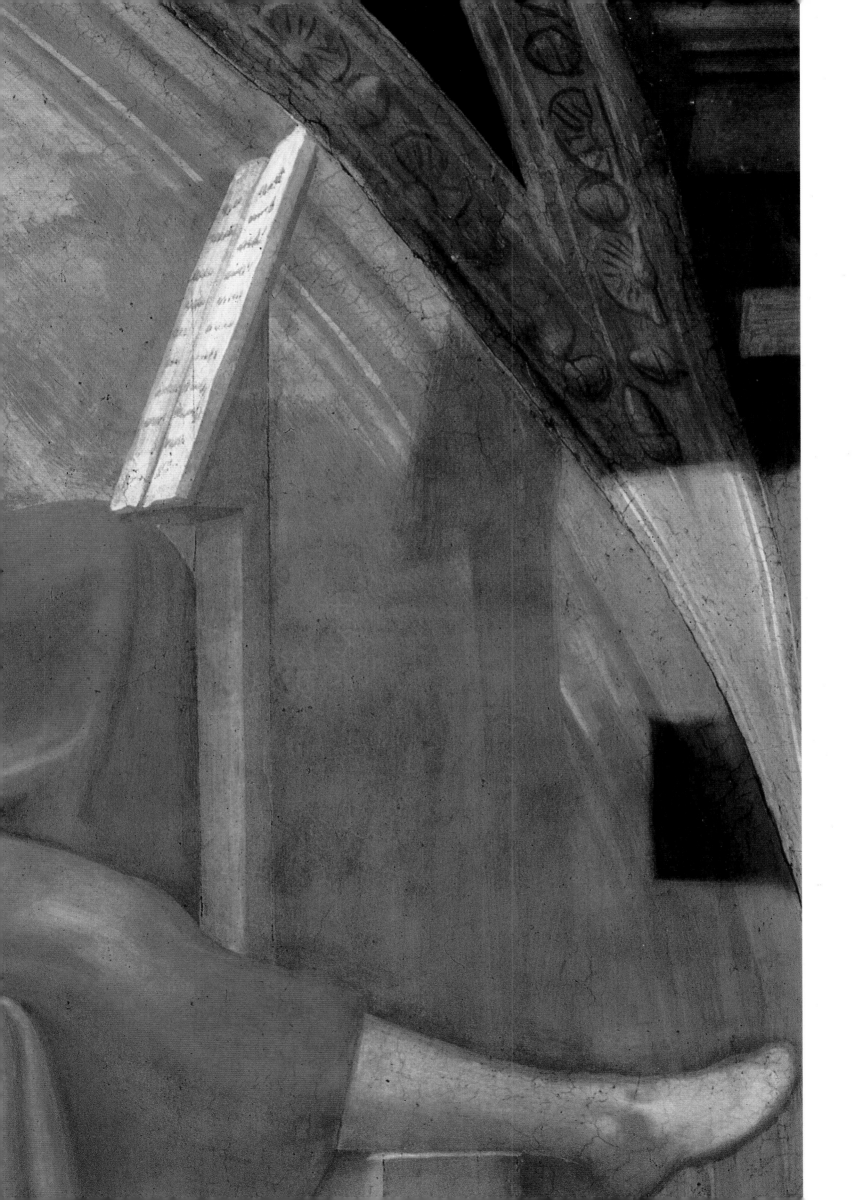

Before the restoration.

AMMINADAB

Abraham begat Isaac. Isaac begat Jacob. Jacob begat Judah and his brothers. Judah begat Phares and Serah by Thamar. Phares begat Esron. Esron begat Aram. Aram begat Amminadab. Amminadab begat Nahshon.

Matthew 1:2–4

There are only two figures, both of young people, in the lunette of Amminadab, the prince of the Levites, opposite the one of Nahshon. The man on the left is depicted frontally, sitting bolt upright with his feet together, his forearms resting on his legs, and his hands tightly intertwined, a gesture that seems to betray great interior tension, as does the expression on his face, with its strongly pronounced lineaments under

in the *Mocking of Christ* in the church of Gesù in Rome.

Like that of Amminadab, and many other figures in the lunettes painted at the end of the second phase of the frescoing of the vault, the position of the woman is uncommon, and was probably drawn from life. She is depicted seated, but turning around, her limbs twisted, and busy drawing an ivory comb through the long blond hair

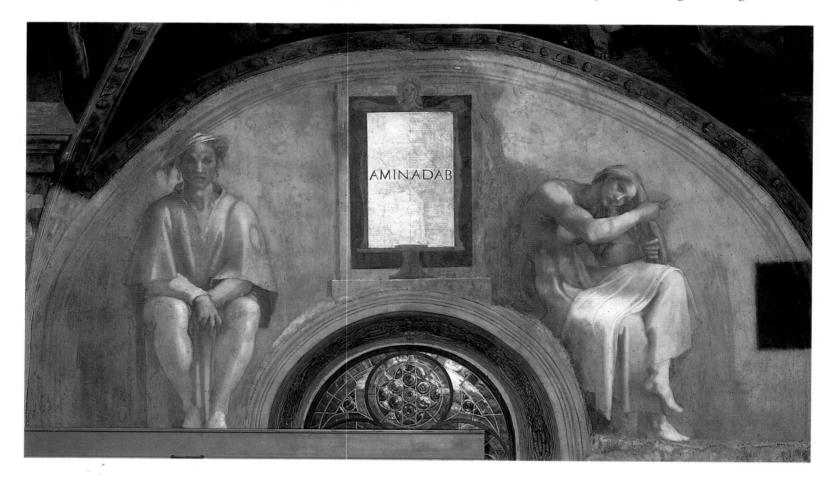

wiry hair held down with a white scarf. He is wearing a pale green cloak with reddish-orange shadows and tight gray-blue hose. From his ears hang two metal earrings of different shapes, quickly sketched with the point of the brush. This unusual pose, studied by Michelangelo in a drawing in the Oxford sketchbook, was repeated by other artists, especially by Giuseppe Valeriano

hanging down from her inclined head. The interplay of light and shade lends remarkable vivacity and immediacy to the figure. It is rendered with notable variations in tone on her face, her arm raised in front of her, her hand with the comb, and the foreshortened one holding up her hair, and also over the whole surface of the long rose red tunic and the white cloth spread over her knees.

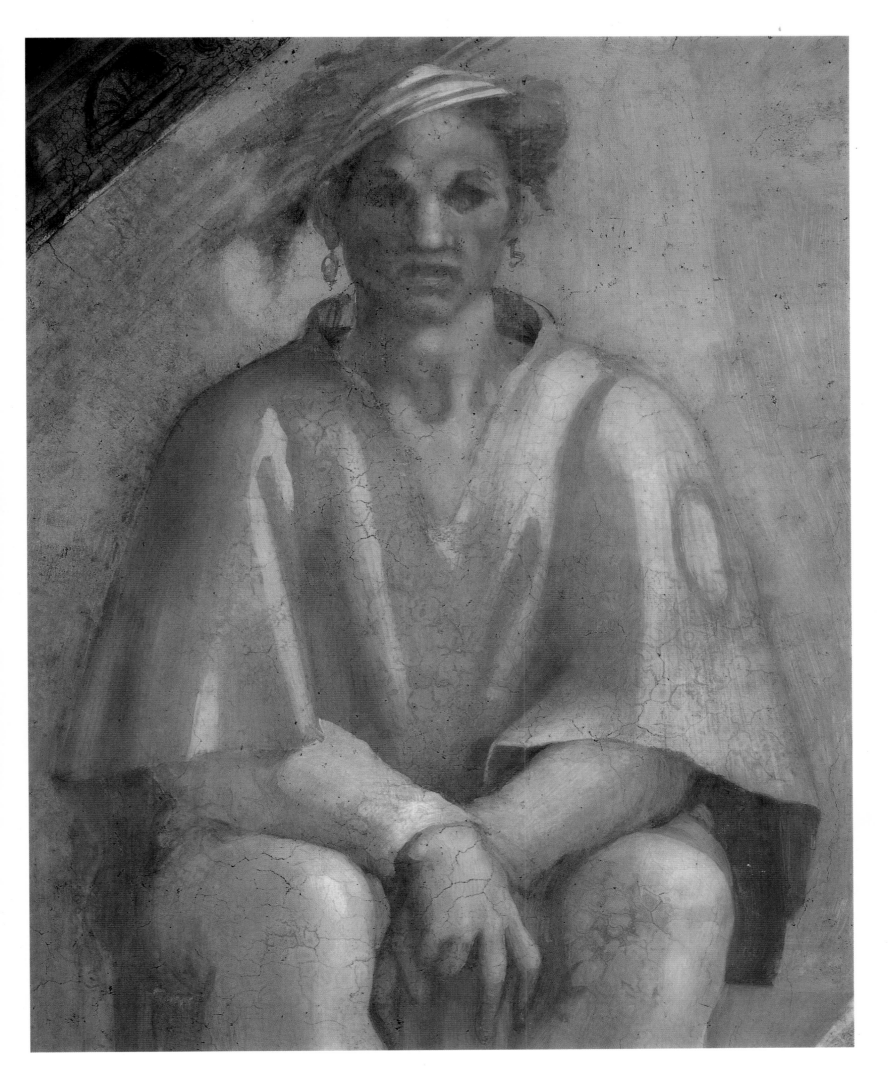

After the recent restoration, the figure of the woman is perfectly legible, despite the severe damage that the lunette suffered in the past as a result of considerable seepage of rainwater, application of glue, and clumsy repainting, as well as the opening of a crack due to structural faults in the wall. Only the restoration of the fresco in a darker tone, probably the work of Domenico Carnevali in 1564, has been retained; this is visible along the lower part of the woman's back.

In the last lunette, the fresco was executed so rapidly that the artist often painted on *intonaco* that was still soft, so his brush furrowed the surface, at times even leaving bristles embedded in the

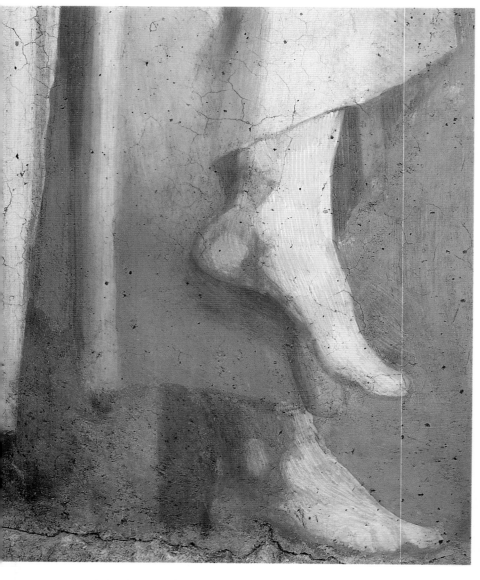

plaster. In some places—as in the woman's yellow stockings—the layer of pigment is extremely thin.

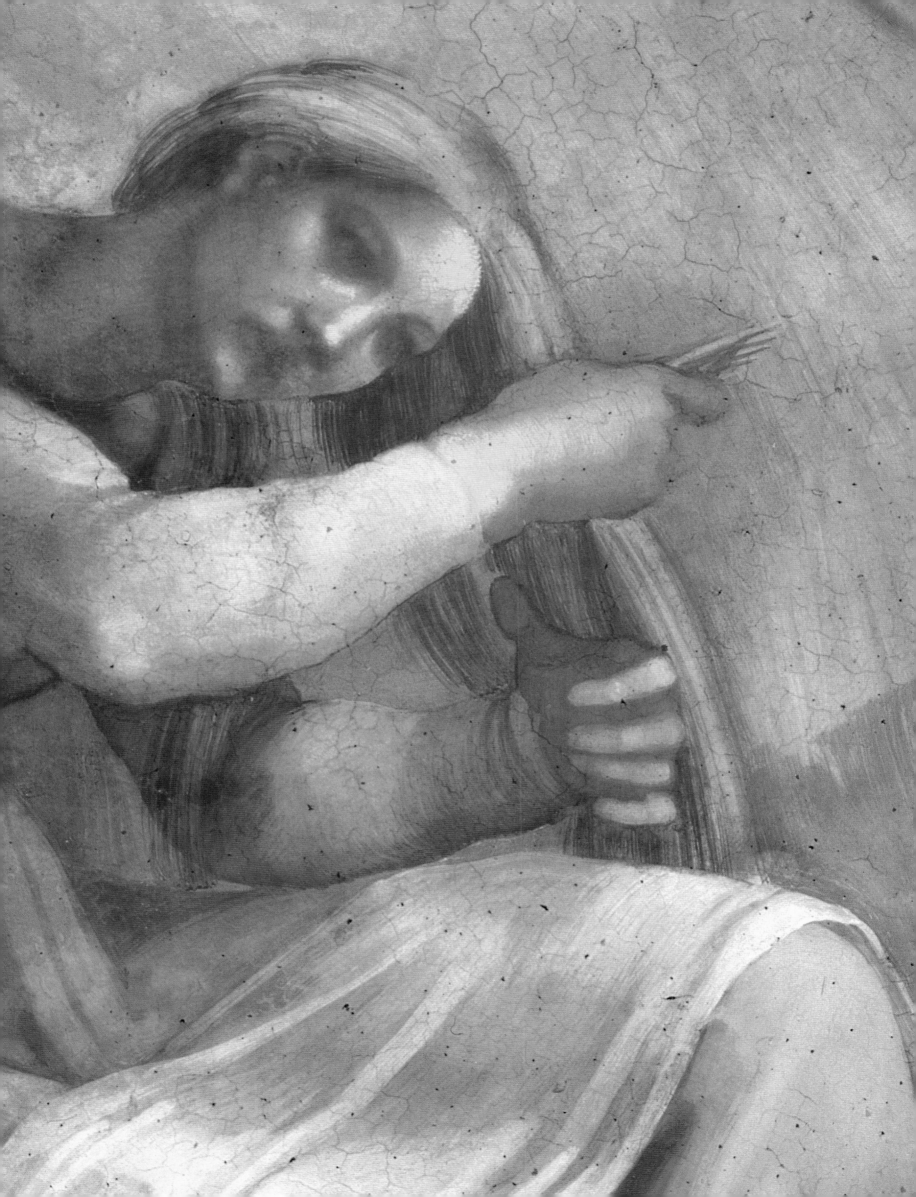

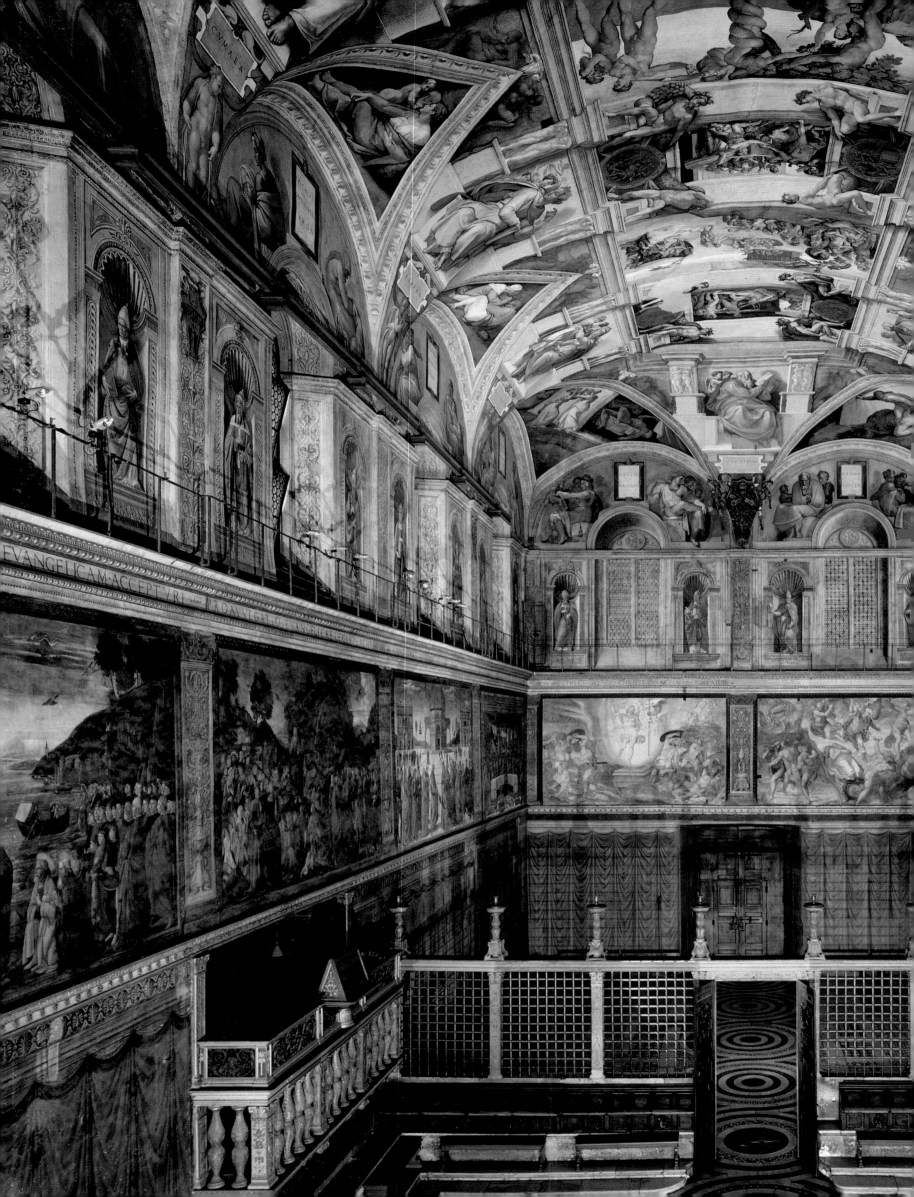

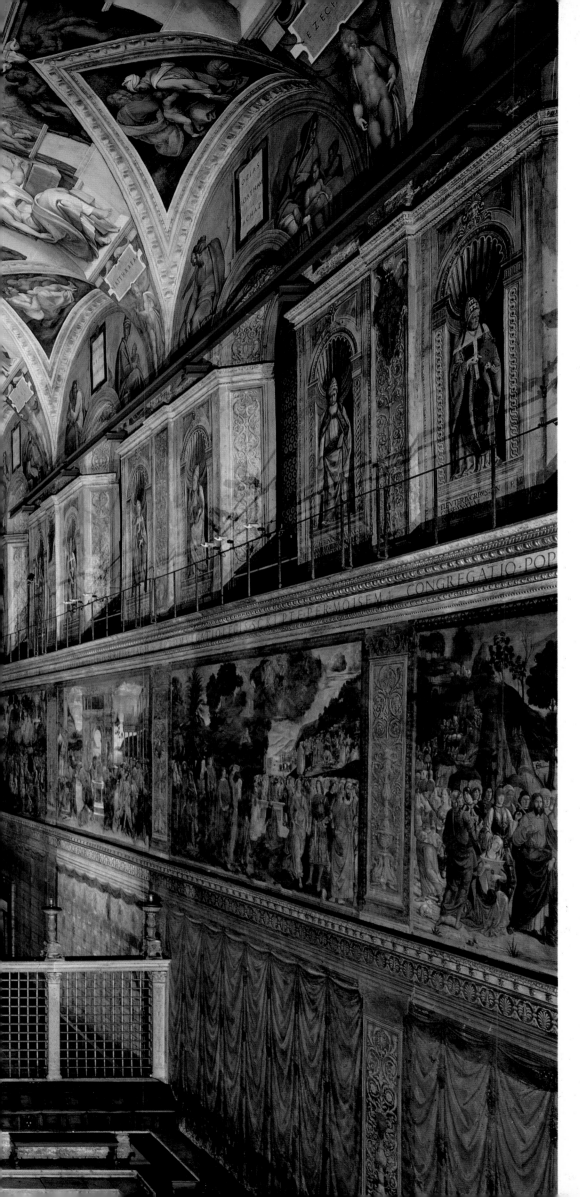

View of the interior of the chapel toward the entrance wall. After Michelangelo painted the ceiling of the Sistine Chapel at the invitation of Pope Julius II, it was radically different in appearance from the chapel that Sixtus IV had rebuilt and decorated. The artist did not overlook any element—beginning with a remarkable use of color—that could harmonize his frescoes with those of the fifteenth-century decorative cycle, especially the figures of the popes in the niches between the windows, immediately below the lunettes. The visitor's attention is at once attracted by the great power of the whole composition of the ceiling and the tremendous energy of the individual figures.

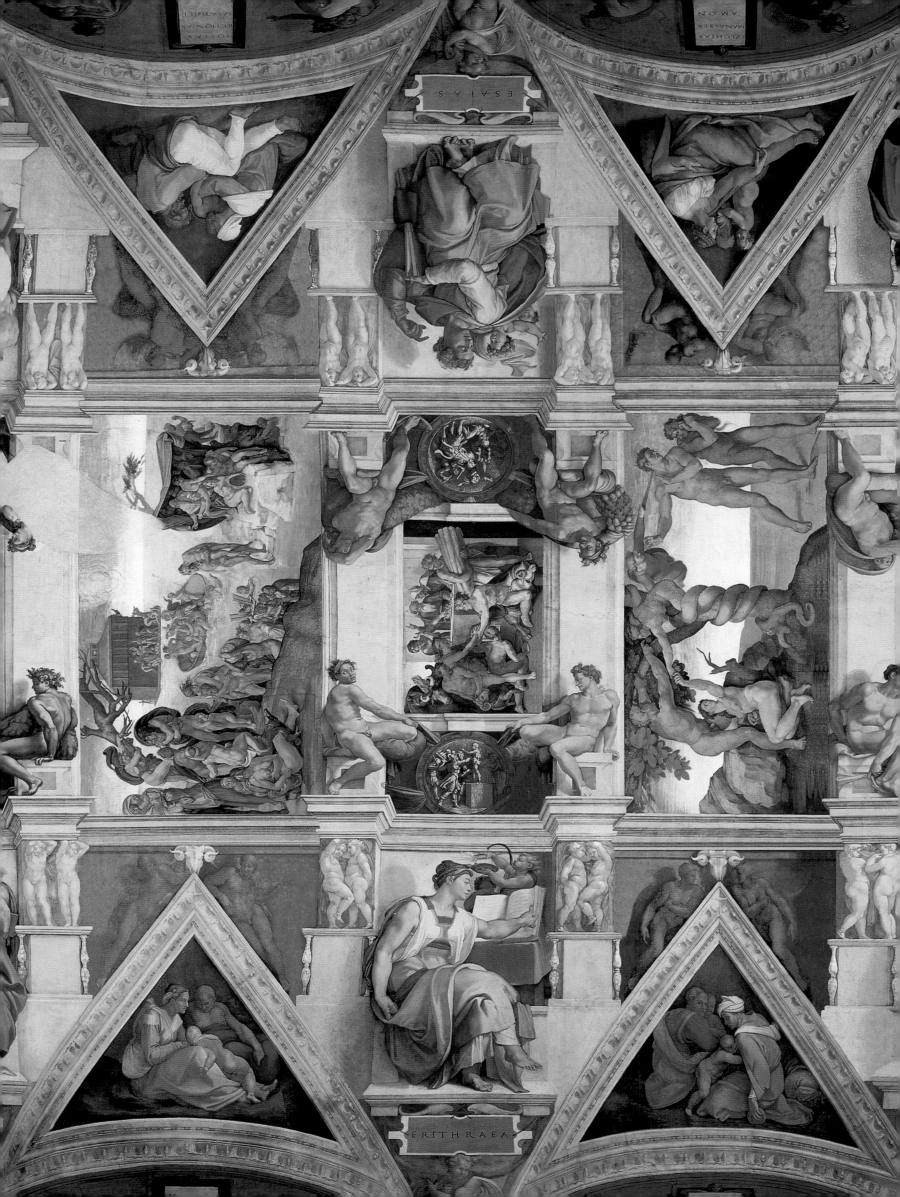

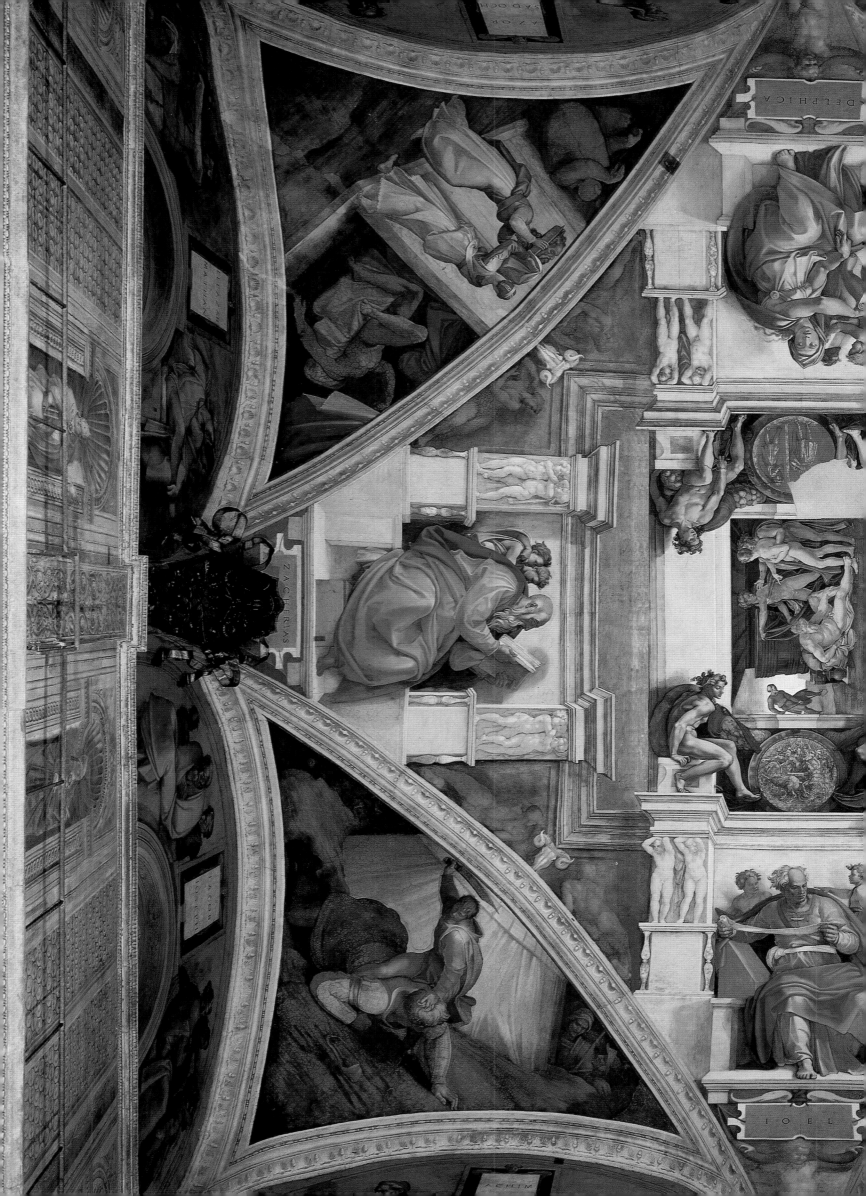

The Ceiling

"The opinion and expectations that everyone had of Michelangelo
drew the whole of Rome to see this thing. The pope also went there before the dust
raised by the dismantling of the scaffolding had settled."

Ascanio Condivi

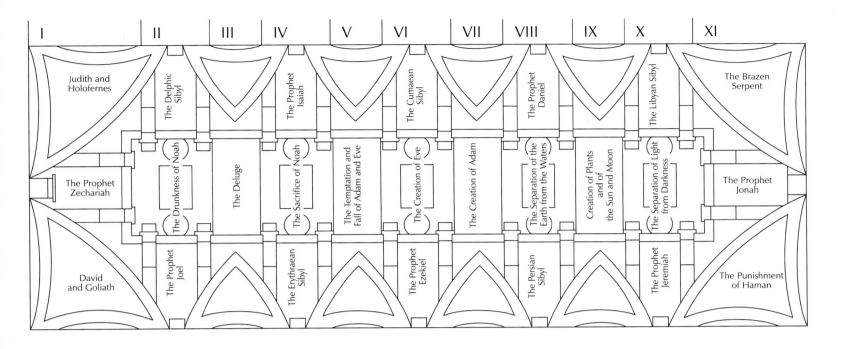

Section I
SPANDRELS AND PENDENTIVES

Above the entrance door to the chapel is the figure of the prophet Zechariah. In the two corner pendentives, the story of Judith and Holofernes and that of David and Goliath are represented.

Section II
FIRST BAY

The Drunkenness of Noah is painted in the center of the vault, between four figures of *ignudi* bearing garlands of oak leaves and acorns and the ribbons of the medallions painted to resemble bronze. On the sides are the Delphic Sibyl and the prophet Joel.

Section III
SECOND BAY

At the sides, two of the eight triangular spandrels, directly above the lunettes, contain family groups of the ancestors of Christ, while the Deluge is depicted in the large central panel. This is the first in chronological order of the biblical narratives to be frescoed by Michelangelo in the Sistine Chapel.

Section IV
THIRD BAY

In the center of the ceiling, the Sacrifice of Noah, between the four *ignudi* and two bronze medallions, is linked in a sort of triptych to the scenes depicted in the previous bays. At the sides are the Erythraean Sibyl and the prophet Isaiah.

Section V
FOURTH BAY

Between the two spandrels with groups of ancestors of Christ, the huge central panel contains, at the sides of the Tree of Knowledge of Good and Evil, the representation of the Fall of Adam and Eve and the Expulsion from the Garden of Eden.

Section VI
FIFTH BAY

Between the Cumaean Sibyl and the prophet Ezekiel, the Creation of Eve is depicted in the center of the vault. Around the central panel are the four figures of *ignudi* and the bronze medallions.

Section VII
SIXTH BAY

One of the largest panels in the vault is devoted to the scene of the Creation of Adam. In the triangular spandrels at the sides, other family groups continue the sequence of the generations before the Incarnation of Christ.

Section VIII
SEVENTH BAY

The Separation of the Earth from the Waters is the subject of the third scene, in chronological order, of the Creation painted in the center of the vault between the figures of *ignudi* and the bronze medallions. At the sides are the figures of the prophet Daniel and the Persian Sibyl.

Section IX
EIGHTH BAY

Between the triangular spandrels with the families of the ancestors of Christ, the Omnipotent is depicted twice in the central panel, creating the sun and moon and plants of the Earth.

Section X
NINTH BAY

The first scene in chronological order of the Creation depicts, between the figures of ignudi and the bronze medallions, the Separation of Light from Darkness. At the sides are the figures of the Libyan Sibyl and the prophet Jeremiah.

Section XI
SPANDRELS AND PENDENTIVES

Above the altar at the center of the end wall is the distraught image of the prophet Jonah. In the corner pendentives, which correspond with those on the entrance wall, are other scenes based on the history of the Jews: the Brazen Serpent and the Punishment of Haman.

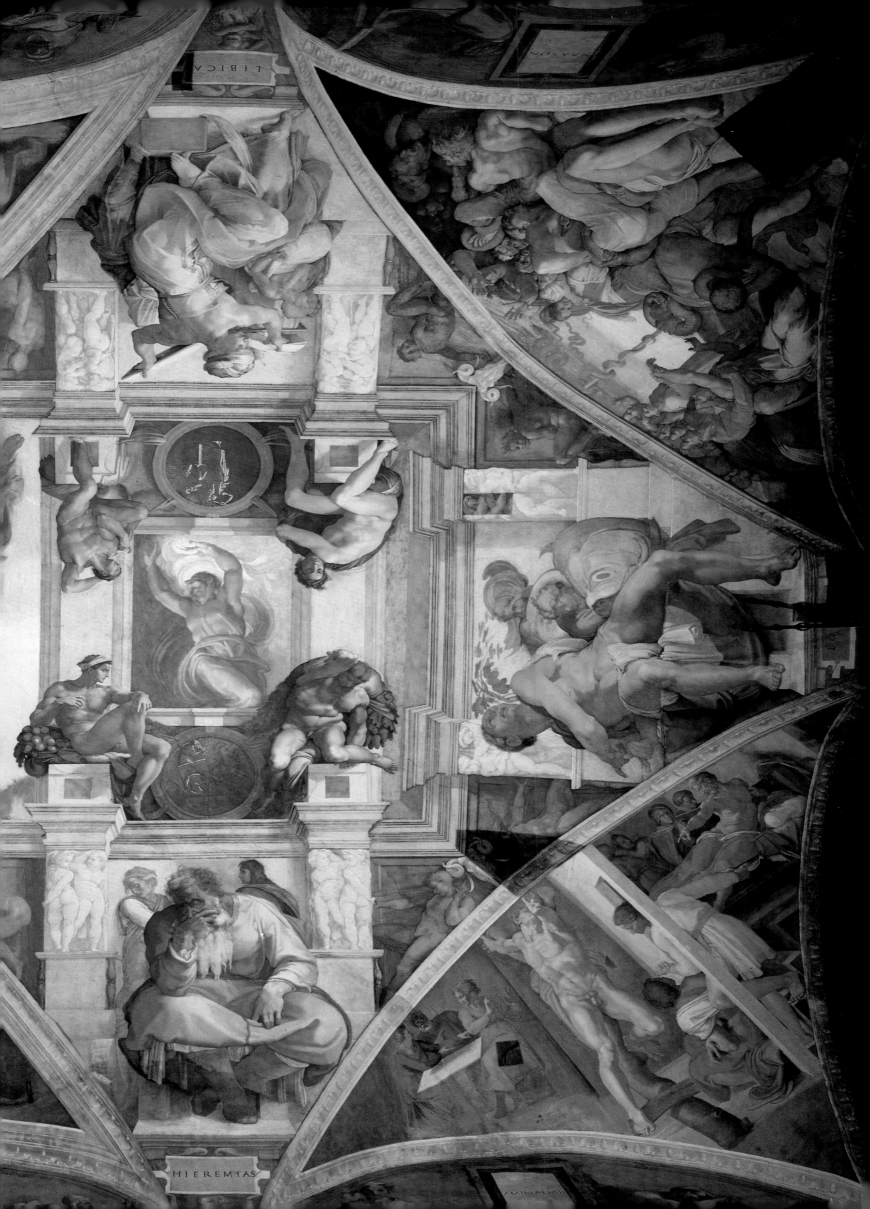

LIBICA

HIEREMIAS

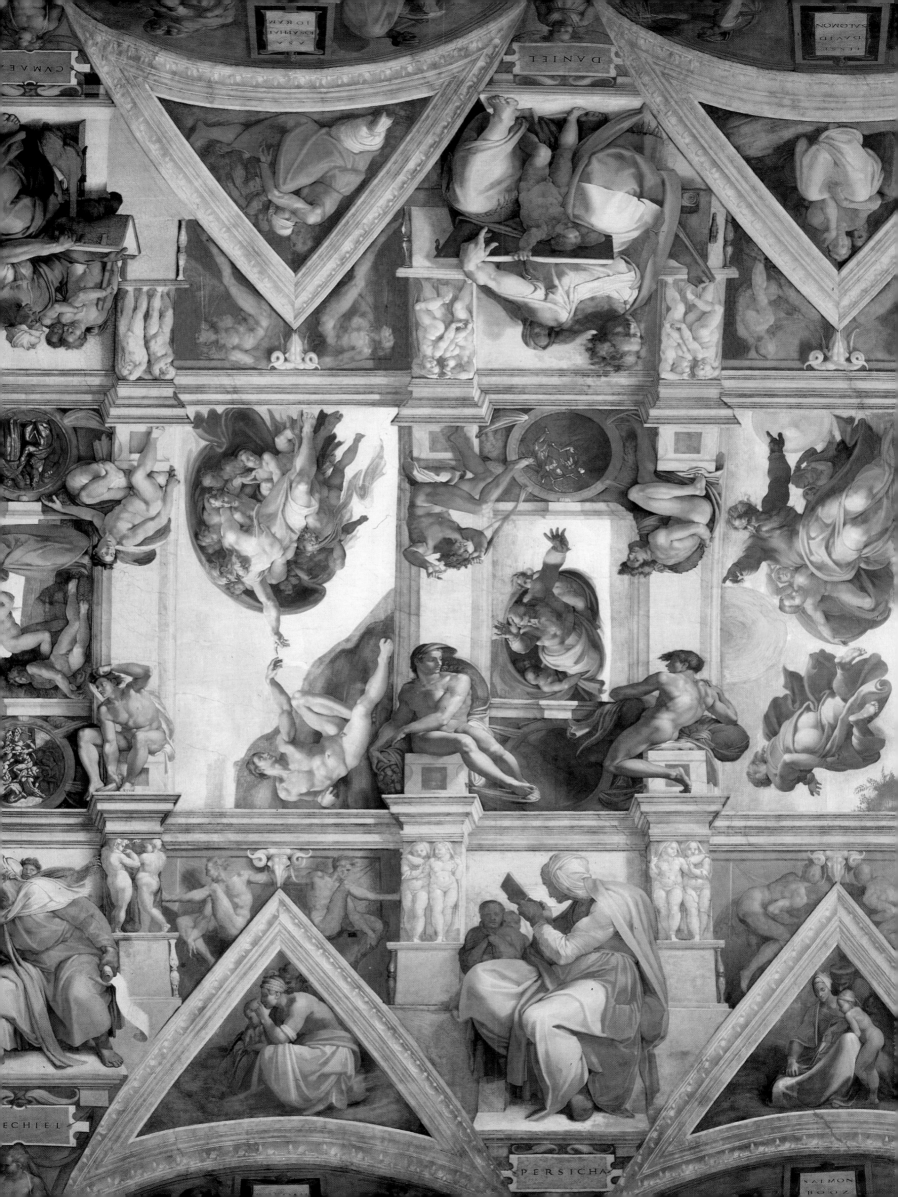

A pair of putti next to the throne of the Erythraean Sibyl.

Michelangelo himself left a detailed account of the beginning of work on the frescoes in the Sistine Chapel:

I remember as if it were today that, on May 10, 1508, I, Michelangelo the sculptor, received five hundred ducats from the treasury of His Holiness Pope Julius II. This was counted out by the chamberlain Messer Carlino and Messer Carlo degli Albizi as an advance for the painting of the vault of the Chapel of Pope Sixtus, for which I shall begin to work today in accordance with those conditions and covenants that appear in a document drafted by Monsignor R.mo of Pavia and undersigned in my hand.

Aside from the sketches for the composition, which were followed by the cartoons, the first part of the work involved the erection of the scaffolding and the preparation of the surfaces to be frescoed. These tasks were assigned to the "master of the wall" Piero di Jacapo Rosselli. On June 11 the papal master of ceremonies, Paris de Grassis, noted that the religious services were seriously disturbed by the dust caused by the fact that "work was being carried out on the high cornices in the chapel." Rosselli received the balance of the payment for his work on July 27, but it is likely that Michelangelo and his assistants only climbed onto the scaffolding to begin painting some time later, probably in late August or early September.

After the initial difficulties had been overcome, the work proceeded until the frescoes in the first half of the vault had been completed in August 1510. It was then suspended due to the lack of funds and the absence from Rome of Julius II who was engaged in the military campaign against the French.

In a letter to his brother Buonarroto, dated July or August 1510, Michelangelo wrote: "As usual, I am here, and I shall have finished my painting by the end of the coming week—the part I have already begun, that is. And, as soon as it is unveiled, I think I shall have my money, and I shall contrive to get leave of absence for a month. I am not sure whether this will be possible; I certainly need it because my health is poor." His hopes were in vain. On September 7, in fact, he wrote to his father: "I am still waiting for five hundred ducats from the pope, and he should have given me the same amount to make the scaffolding and continue the other part of the job. But he has departed without leaving any instructions. I have written a letter to him; I do not know what will happen." In the following weeks the artist went to see the pope in Bologna; and he returned there in December, without, however, managing to eliminate the obstacles to the resumption of work. It was only in June 1511 that Julius II returned to Rome. On August 15 the master of ceremonies, Paris de Grassis, commented with imperturbable mischievousness that "the pope went there both to see the new paintings that had just been unveiled, and for the purpose of divine worship." After the scaffolding had been reerected in the second half of the chapel, the work was resumed during the autumn; it was completed in October the following year, when Michelangelo wrote to his father: "I have finished the chapel that I was painting. The pope is very pleased with it, and the other things did not turn out as I had expected. I blame our times for this because they are very unfavorable to our art."

According to a later account by Michelangelo, the final program for the decoration of the vault was elaborated on the basis of a more limited project. In a letter sent to Gian Francesco Fattucci in 1523, referring to the complex vicissitudes of the commission, the artist recalls that "in the original project for the work there were twelve Apostles in the lunettes, and the rest was to be filled by ornaments as is customary. Then, having begun this work, it seemed to me that it would be but a poor thing; and I told the pope that if only the Apostles were depicted, it would turn out to be a poor thing indeed. He asked me why; I answered that it was because they were poor too. So he gave me a new commission to do whatever I liked so long as it satisfied me, and that I should paint down to the

narrative scenes below." Initially, therefore, the star-spangled sky of Sixtus IV's chapel was to have been replaced by the figures of twelve Apostles—on the pendentives, and not the "lunettes"—and geometrical panels in frames in the center of the vault, following a decorative model derived from antique ceilings. Two drawings relating to this project are now in the British Museum in London and the Institute of Arts in Detroit. The first shows the figures of the twelve Apostles enthroned in niches on the pendentives, in the position subsequently occupied by the prophets and sibyls. On the sheet in Detroit, the niches containing the thrones of the Apostles, which are opposite each other above the side walls, are linked across the vault by a system of decorative elements resembling arches, while between them are larger quadrangular panels. The "arches," which stress the structural tension of the vault and are a fundamental element in the division of the space, enclose small rectangular panels in the center and, at the sides, oval surfaces with figures set against them supporting their frames. The larger panels between the arches contain, in their turn, vast surfaces delimited by octagonal frames that were perhaps intended to be frescoed with narrative scenes rather than just ornamental motifs.

The scheme subsequently adopted by Michelangelo, after the program had been massively expanded, had its origins in the idea outlined in the Detroit drawing, albeit with substantial variations. It involved the accentuation of the motif of the arches and the extension of the fields contained in them; the abandonment of the octagonal frame for the larger intermediate fields, which became rectangular; and the switch from the static figures of the tablet-bearing putti to the much more dynamic ones of the *ignudi*. The latter, together with the prophets and the sibyls, mark the compelling reappearance in the vault of the Sistine Chapel of ideas and motifs deriving from the project for the tomb of Julius II.

In this scheme of divisions, the key elements are the thrones of the seers

flanked by plinths and colonnettes decorated with pairs of putti supporting the cornice running above the crowns of the spandrels, at about a third of the way across the curve of the vault. Beyond the cornice, the vertical

 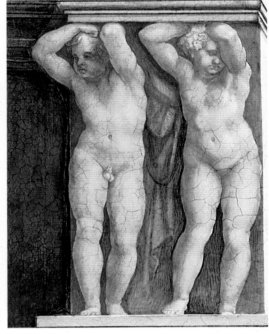

frames flanking the thrones are prolonged as the arches crossing the vault. They divide it into nine compartments in which the stories of Genesis—from the Separation of Light from Darkness to the Drunkenness of Noah—are represented as if they were seen above the space of the chapel, beyond and through the imposing structure of the painted architecture. In the five compartments above the thrones, the field of the narrative scenes is limited in size by the presence of four figures of *ignudi*, sitting on plinths and bearing garlands of oak leaves and acorns, and of two medallions painted to resemble bronze, with episodes drawn from the books of Genesis, Samuel, Kings, and Maccabees. Lastly, under the cornice and the thrones, in the spandrels and the lunettes at the tops of the walls, are depicted the forty generations of the Ancestors of Christ, from Abraham to Joseph, while the corner pendentives contain representations of biblical scenes associated with the theme of the divine protection of the Jews: Judith

A pair of putti next to the throne of the prophet Joel. Simulating stone reliefs, the putti appear to support the projection of the cornice. The figures are placed symmetrically at the sides of each throne, in graceful poses that at times resemble dances. They imitate and vary, with a fresh vein of creativity, the typical repertoire of Florentine Renaissance sculpture, from the singing galleries to the glazed terra-cottas.

and Holofernes, David and Goliath, the Brazen Serpent, and the Punishment of Haman.

The new decorative program was much more complex than the original one, especially from an iconographic point of view. Despite what the artist states in his letter, it is difficult to believe that the pope had really intended to grant him freedom to do whatever he liked. It is more likely that, as far as the program was concerned, Michelangelo was assisted by theologians in the papal court or, in any event, had submitted a preliminary project for the pope's approval. Prepared in a very short time, this would have originated together with the idea of the new divisions of the vault by means of painted architectural elements, and would have been further elaborated and adapted during the four years spent working on the frescoes.

Various suggestions have been made regarding the names of the artist's possible advisers or the drafters of the program, ranging from the Franciscan theologian Marco Vigerio della Rovere, a relative of Julius II (who elevated him to the rank of cardinal), to the very erudite prior-general of the Augustinians, Egidio da Viterbo. And numerous hypotheses have also been put forward with regard to the doctrinal sources, including the *Lignum Vitae* by Saint Bonaventure and *The City of God* by Saint Augustine. But, although there are still considerable differences of opinion concerning the interpretation of the cycle, there is substantial agreement about the reconstruction of the relationships between the various parts on the basis of the system of links and typological relationships elaborated over the centuries by scriptural exegesis. This is a system that is so complex and—from our point of view—so liable to contradiction, that the differences in interpretation are easily explained.

The tripartition of the basic iconographic motifs corresponds to the division of the vault into three areas, created by the painted architectural framework. In the center of the vault, the scenes from Genesis—their choice may have been inspired, as E. Steinmann has suggested, by the twelve prophecies in-

toned by the choir of the Sistine Chapel on Holy Saturday—are represented as visions, beyond the space of the chapel. In the intermediate area, the presence of the "seers" indicates a different level of meaning from the "historical" and literal one of the scenes from the Old Testament. These may be seen, therefore, as prefigurations of events in the New Testament, linked to the design of redemption that, thanks to their gift of divine inspiration, the prophets and sibyls saw in their visions and foretold. Hence, the Drunkenness of Noah may be interpreted as the prefiguration of the mocking of Christ, while the Deluge foreshadows the Baptism, the Sacrifice of Noah the Passion, and so on until the Separation of the Earth from the Waters, which prefigures the Last Judgment and the end of the world. In the lower area, the ancestors of Christ, bereft of the divine inspiration of the seers, represent, in the sequence of generations, the expectation of the Incarnation and Redemption. Lastly, the scenes on the pendentives reaffirm the providential design of the salvation of the Jews in relation to the prophetic visions of the scenes from Genesis.

The twenty figures of the *ignudi* are situated in the upper area of the vault. Although it is within the painted architectural structure, their prominent position—contiguous to the nine prophetic visions—means that they cannot be considered as ornamental elements, and suggests that their function is more than the merely heraldic one attributed to them by Vasari. They seem rather to have been conceived as angelic figures in the special acceptation of "intermediary spirits between men and the Godhead" suggested by Charles de Tolnay, who also elaborated an interpretation of the whole cycle in terms of Neoplatonic doctrines. He contrasted the oppressed existence, still spiritually unconscious, of the figures in the lunettes with the inspiration of the prophets and sibyls who, although they belonged to the human race, attained the gradual revelation of the divine nature. This revelation, up to the vision of the Supreme Being, is also offered to the viewer who approaches the altar look-

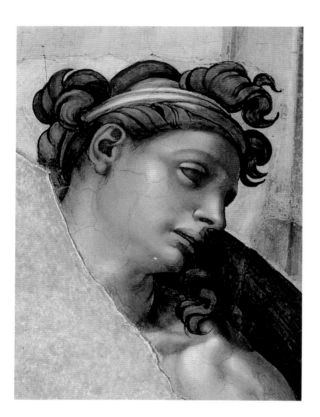

Detail of the head of the *ignudo* on the left above the Delphic Sibyl. A large part of the figure was destroyed by the detachment of *intonaco* as a result of the explosion of the powder magazine at Castel Sant'Angelo at the end of the eighteenth century.

ing at the scenes at the center of the vault, with the experience, through a double ascent, of the return of the soul to God as if to its own origin. Other explanations are based on the motif of the Tree of Life and the doctrines of Saint Bonaventure and Vigerio (Frederick Hartt), or else on the writings of Saint Augustine as interpreted by Egidio da Viterbo (E. Gordon Dotson). In this case, the scenes from Genesis are seen as the representation of the whole course of the history of humankind, from the Creation to the Last Judgment. Their viewing in reverse order—proceeding from the chapel entrance toward the altar—reveals, in terms of the prophetic allusions identified by Saint Augustine, the providential design thanks to which the City of God is freed from the corruption of sin.

Despite the differences, the various interpretations—none of which are exhaustive—appear to correspond, at least partially, insofar as they are based on a corpus of ideas and doctrines that had found currency in the circle of theologians and humanists of the papal court. And, in the opinion of J. O'Malley, another factor to be taken into account is the great evocative power of the sermons preached in the Sistine Chapel in the early sixteenth century. Taking the form of a panegyric, these extolled not only the goodness and dignity of God and Christ through their actions, starting from the Creation, but also the dignity of man, created by God "in his own image." This dignity was restored—at an even higher level than prior to the sin and the fall—thanks to the Incarnation of Christ.

In any case, on the ceiling of the Sistine Chapel, the system of meanings appears to wholly coincide with that of the visual images, and the elaboration of the iconographic program was closely linked to the creation of a formal structure. The artist was able to devise this by overcoming the difficulties connected with both the size of the surface (about 10,00 square feet) and the irregularity of the vault. This was supported by side walls that were not perfectly parallel; it was, moreover, multicentric. Without having recourse to either the illusionistic foreshortening of Mantegna, Melozzo da Forlì, and Bramante, or the divisions based on classical models, Michelangelo elaborated a totally new design by blending features derived from both systems. While Ascanio Condivi was right to contend that the area of the thrones of the seers was conceived as the vertical continuation of the walls, this was only true, as Johannes Wilde has observed, in a metaphorical sense, because the thrones and figures are seen as if they were situated above the side walls—but frontally, at the viewer's eye-level, without this appearing to be contradictory thanks to the effect of the curve of the vault. Moreover, the dynamic and non-illusionistic character of the ceiling—which lacks a single fixed viewpoint for the architecture, to which the foreshortening of the figures would have to be subordinated—was recognized by Vasari, who wrote: "In the compartments he did not employ any rules of perspective for foreshortening, nor any fixed vantage point, but he went about accommodating the compartments to the figures rather than the figures to the compartments."

The plan adopted produces an effect of total structural unity in which, however, the parts are clearly divided. This effect is the result of both the painted architectural structures and the dimensional, gestural, and rhythmic relationships that are established through the distribution of the figures not involved in the narrative scenes—the *ignudi*, the prophets, and the sibyls. And it is notably accentuated in the second half of the vault, after Michelangelo had been able to see from below the part he had frescoed up to then. In this way, the viewer is presented with a coherent, yet extremely complex, vision in which the different parts combine and interact within an incomparably rich system, enhancing each other with regard to both their meanings and their forms. Of particular significance in this respect is the range of colors adopted and the use of iridescent effects, with color changes that permit every detail determining the form and expressivity of the figures to be clearly visible from a distance.

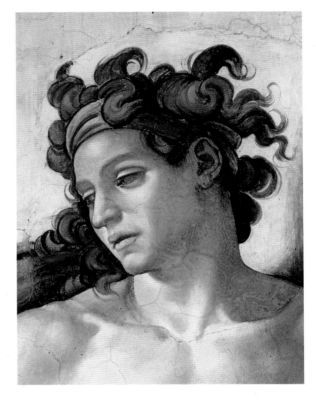

Detail of the head of the *ignudo* on the right above the Delphic Sibyl, next to the panel representing the Drunkenness of Noah in the first bay of the vault.

T HE SPANDRELS AND PENDENTIVES OVER THE ENTRY DOOR

Once the scaffolding had been assembled above the area next to the entrance wall and the surfaces to be frescoed had been prepared, in the late summer of 1508 Michelangelo began working on the ceiling, proceeding in the opposite direction to the chronological sequence of the biblical narratives in the central part of the vault. The first three scenes frescoed were the stories of Noah, probably starting with the largest, the *Deluge.*

The early stages of the work were fraught with difficulty. This is what Ascanio Condivi had to say on the matter:

Nor did he lack problems in this part, so that, after he had completed the

Above the door forming the main entrance to the Sistine Chapel—in its turn surmounted by the inscription with the name of the prophet Zechariah—the coat of arms of the della Rovere, with a papal tiara and oak tree bearing twelve gold acorns, commemorates the chapel's founder, Sixtus IV. His nephew, Julius II, commissioned Michelangelo to fresco the chapel.

pope sent [Giuliano da] Sangallo, who, when he saw the fresco, realized that the artist had added too much water to his lime, and for this reason, when the moisture ran down the *intonaco*, it had this effect. And after Michelangelo had been informed about this, the pope made sure that he continued, and his excuses were to no avail.

This problem, to which Vasari also referred, was caused by the use of *intonaco* made of lime and *pozzolana* instead of the more normal type made of lime and sand. Although the latter type dried more slowly, it subsequently gave excellent results regarding both the carbonation and the solidity of the *intonaco*.

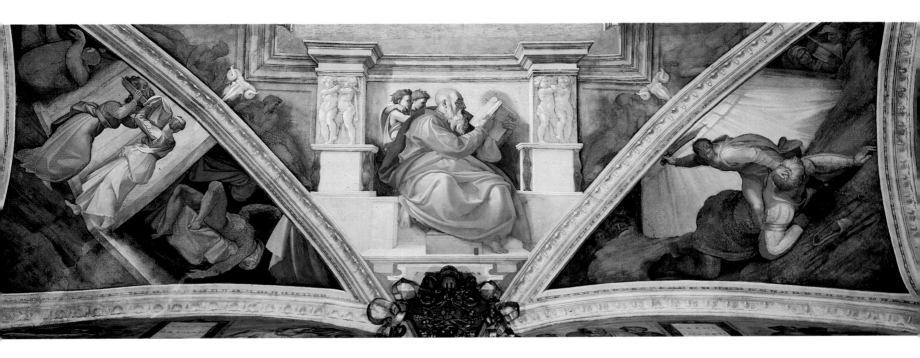

painting of the Deluge, the work was gradually covered with mold, so that the figures were scarcely distinguishable. However, thinking that this was a valid excuse for avoiding his obligations, Michelangelo went to the pope and said: "I have already told Your Holiness that this is not my art. What I have done is ruined; and if you doubt my word, send someone to see." So the

Aside from a certain initial lack of experience and the failure of the attempt to use a technique that was partially *a secco*, it is likely that Michelangelo's relations with the assistants sent from Florence were difficult, although, as we shall see later, Vasari's assertions in this respect do not correspond with the documentary evidence.

After the initial difficulties had been

93

overcome, the work began to proceed rapidly, although the artist continued to be profoundly discontented. Thus, on 27 January 1509 he wrote to his father: "I am still in a state of great perplexity, because it is now a year since I last had a gross from this pope, and it is hardly surprising that my work does not proceed in the way that I think it ought to. And this is the difficulty of this work,

The bronze-colored male nudes, on either side of a ram's skull, recline on the cornice of the pendentive in which the bible story of Judith and Holofernes is represented. On the other hand, the pairs of putti below the projection of the cornice delimiting the central part of the vault simulate groups sculpted in stone. They are placed, respectively, at the sides of the throne of the Delphic Sibyl (those on the left) and the prophet Zechariah (those on the right).

which is not, after all, my profession. I am wasting my time and not producing any results. May God help me." In fact, the letters written by Michelangelo during the four years he spent painting the ceiling of the Sistine Chapel frequently convey a sense of the immense effort required and the artist's gloomy solitude: "Here I am feeling very downhearted and greatly fatigued; I have no friends whatsoever, nor would I wish to have any; and I do not have sufficient time to eat as much as I need. However, let no one cause me any further trouble, because I have had more than enough."

Although the story that the artist was obliged to work lying down has been shown to be untrue, his working conditions were certainly very tough and uncomfortable. The light that entered through the tops of the windows was largely obstructed by the scaffolding, and lamps and candles provided illumination that was uncertain and variable in intensity. When painting the vault,

Michelangelo had to work with his head tilted back, and, as Vasari recounted, "These frescoes were done with the greatest discomfort ... it damaged his sight so much that he could no longer read or look at drawings if his head was not tilted backwards; his condition lasted for several months afterward...."

In the first section of the vault, proceeding from the entrance wall toward the altar, the prophet Zechariah is in the center, and the stories of Judith and Holofernes and of David and Goliath are represented in the corner pendentives.

Zechariah is seated on a marble throne, engrossed in leafing through a large book, with the upper part of his body shown in profile. His attitude seems calmer and more self-absorbed, and is less dynamic and agitated, than that of the other seers depicted on the walls of the chapel. He is wearing a yellow ocher robe under a light green mantle that is wrapped round his legs and is lined with a crimson cloth. Behind him, two small boys also look toward the book. Their figures—executed in a single *giornata*, the first of the whole group—are painted with very soft layers of transparent color, particularly evident in the rendering of the hair.

On the side walls of the chapel, five prophets alternate with the same number of sibyls, so that each prophet is paired with a sibyl on the opposite wall: the Delphic Sibyl and Joel, Isaiah, and the Erythraean Sibyl, the Cumaean Sibyl and Ezekiel, Daniel and the Persian Sibyl, the Libyan Sibyl, and Jeremiah. This studied parallelism alludes both to the theme of the universality of the message of Redemption and the idea of the perfect concordance of the Revelation in the Judaic world and in the pagan one, in view of the fact that, during the Renaissance, the prophecies of the Sibyls, collected in the *Oracula Sibyllina*, and also found in the writings of Lactantius and Saint Augustine, were invested with nearly as much authority as the Holy Scriptures.

The other two prophets—Zechariah and Jonah—are represented on the ma-

jor axis of the Sistine Chapel. This arrangement has a particular significance, too, since Zechariah, depicted above the chapel door that the pope solemnly passed through on Palm Sunday—recalling the regal entry of Christ into Jerusalem and beginning the ceremonies of Holy Week—was considered to be the main prophet of the Passion of Christ, while Jonah, placed above the altar, was usually thought to be the precursor of the risen Christ.

At the corners of the vault, two spandrels join to form the larger triangular fields of the pendentives, with one of the two vertices pointing downward rather than up. Their surfaces create notable difficulties from a compositional point of view, especially where it was necessary to paint narratives. In the pendentive to the left of Zechariah, the story of Judith is represented in a sort of irregular triptych, according to a compositional scheme previously studied by the artist in a black chalk drawing in the Teyler Museum in Haarlem, in which, however, the figures are arranged differently.

In the fresco, almost in the center and nearest to the viewer, the figures of the two women stand out in the bright light against the white wall placed obliquely in the background. Judith is portrayed as she is about to place a cloth over the severed head of Holofernes, which the maidservant is carrying in a tray held on her head. The biblical heroine's face is hidden because she is looking toward the darkened room on the right where, sprawled on the white sheets of the bed, the headless body of the general, depicted with complex foreshortening, appears still to be in a state of frenzied agitation.

While the figures of the two women were transferred from the cartoon onto the *intonaco* by pouncing, the outline of Holofernes' body, painted in a single *giornata*, was transferred by incision, while the sleeping soldier, crouching in the shadows in the left corner, was painted without a cartoon. In contrast with the brilliant colors of the figures of Judith and the maidservant in the center of the scene, at the sides, dark, funereal tones predominate.

In the pendentive on the right, out of the darkness a blinding light illuminates the figures of the protagonists—David and Goliath—locked in mortal combat, with a field tent in the background, while, in the corners on both sides, faces of soldiers may be discerned in the shadows.

The composition was carefully planned in order to neutralize, as far as

possible, the irregular shape of the field, dramatically forcing the predominant line of sight by means of the bold foreshortening of the two figures and the luminous convexity of the white tent, modeled with violet shadows. In the foreground, toward the lower vertex of the triangle, David's sling, lying on the ground, constitutes the starting point of the projection of the perspective along the central axis of the composition.

The representation, at the sides of the entrance wall, of Judith who has beheaded Holofernes, and of David vanquishing Goliath—a woman and a boy who delivered the Jews from the threat of terrible enemies, prefiguring the triumph of the Church—offers two examples of humility conquering pride, which may be related to the theme of "humiliation" foreshadowed in the nearby scene of the Drunkenness of Noah as the prefiguration of the Incarnation of Christ.

Two bronze-colored male nudes also recline on the cornice of the pendentive representing David and Goliath, while the pairs of putti are placed, respectively, at the sides of the thrones of the prophet Zechariah and Joel. Mirror symmetry is found in the poses of each pair of bronze male nudes, and also of the two pairs of putti flanking the thrones of each seer.

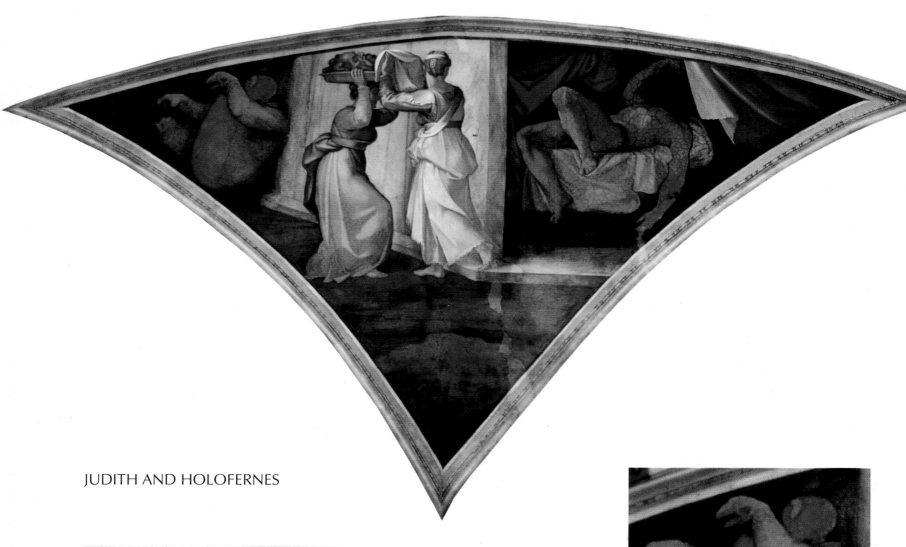

JUDITH AND HOLOFERNES

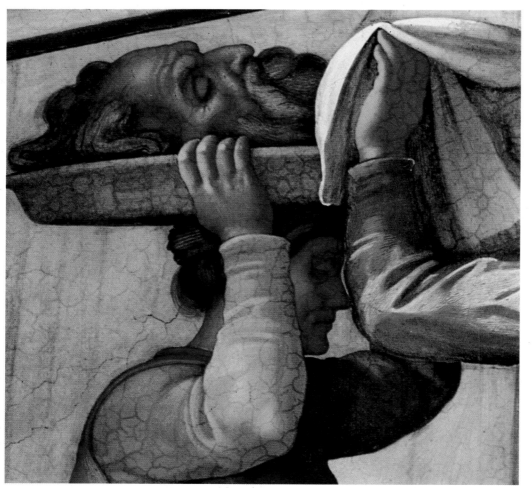

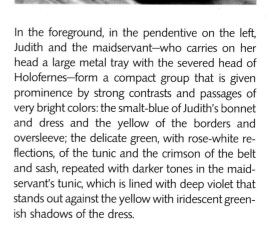

In the foreground, in the pendentive on the left, Judith and the maidservant—who carries on her head a large metal tray with the severed head of Holofernes—form a compact group that is given prominence by strong contrasts and passages of very bright colors: the smalt-blue of Judith's bonnet and dress and the yellow of the borders and oversleeve; the delicate green, with rose-white reflections, of the tunic and the crimson of the belt and sash, repeated with darker tones in the maid-servant's tunic, which is lined with deep violet that stands out against the yellow with iridescent green-ish shadows of the dress.

THE PROPHET ZECHARIAH

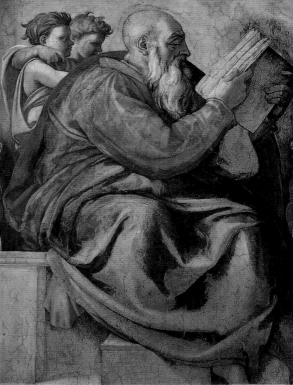

Before the restoration.

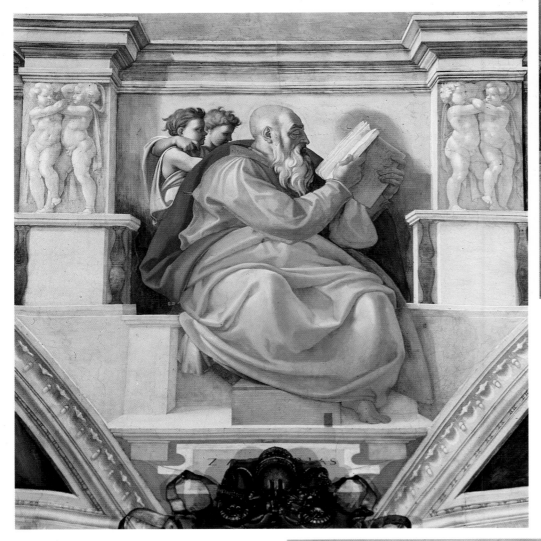

"Rejoice greatly, O daughter of Zion; shout, O daughter of Jerusalem: behold thy king cometh unto thee: he is just, and having salvation; lowly and riding upon an ass...."

Zechariah 9:9

The imposing figure of the prophet was extensively repainted, especially in the eighteenth century by Alessandro Mazzuoli. This repainting was removed during the recent restoration, while *pentimenti* by Michelangelo were identified and preserved. These were executed in fresco, in the lower part of the sleeve; in *mezzo fresco*, in order to extend the yellow tunic on the shoulder and back; and in tempera, on the neck. A black chalk study for the head, in which the profile is notably different, is in the Gabinetto dei Disegni e delle Stampe at the Uffizi in Florence.

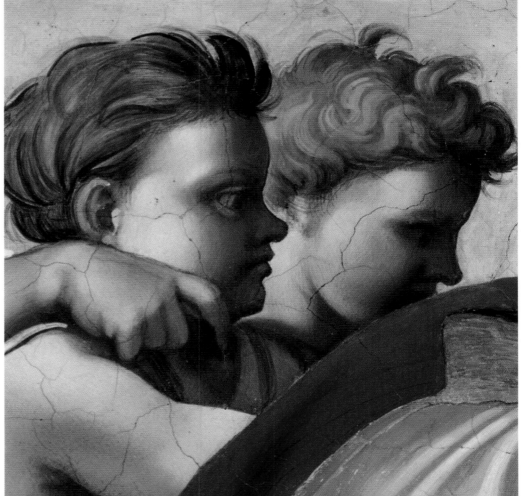

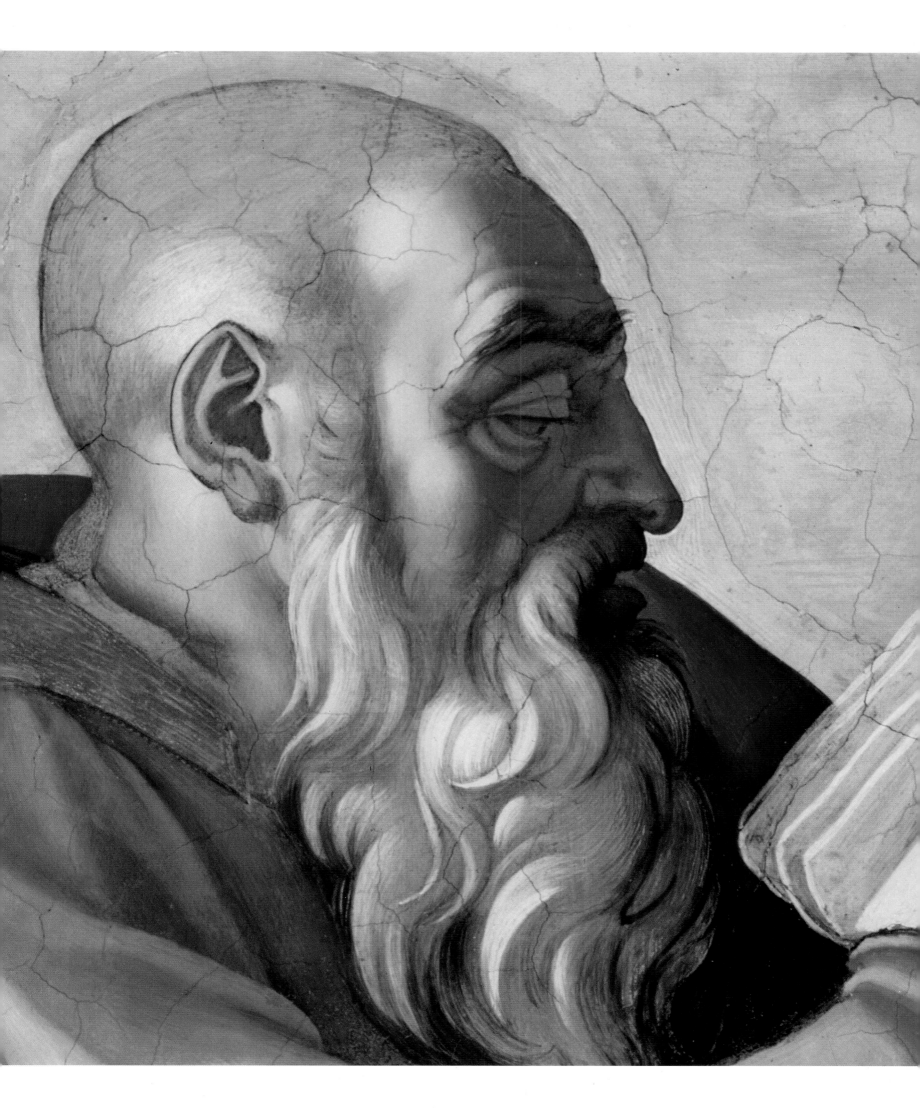

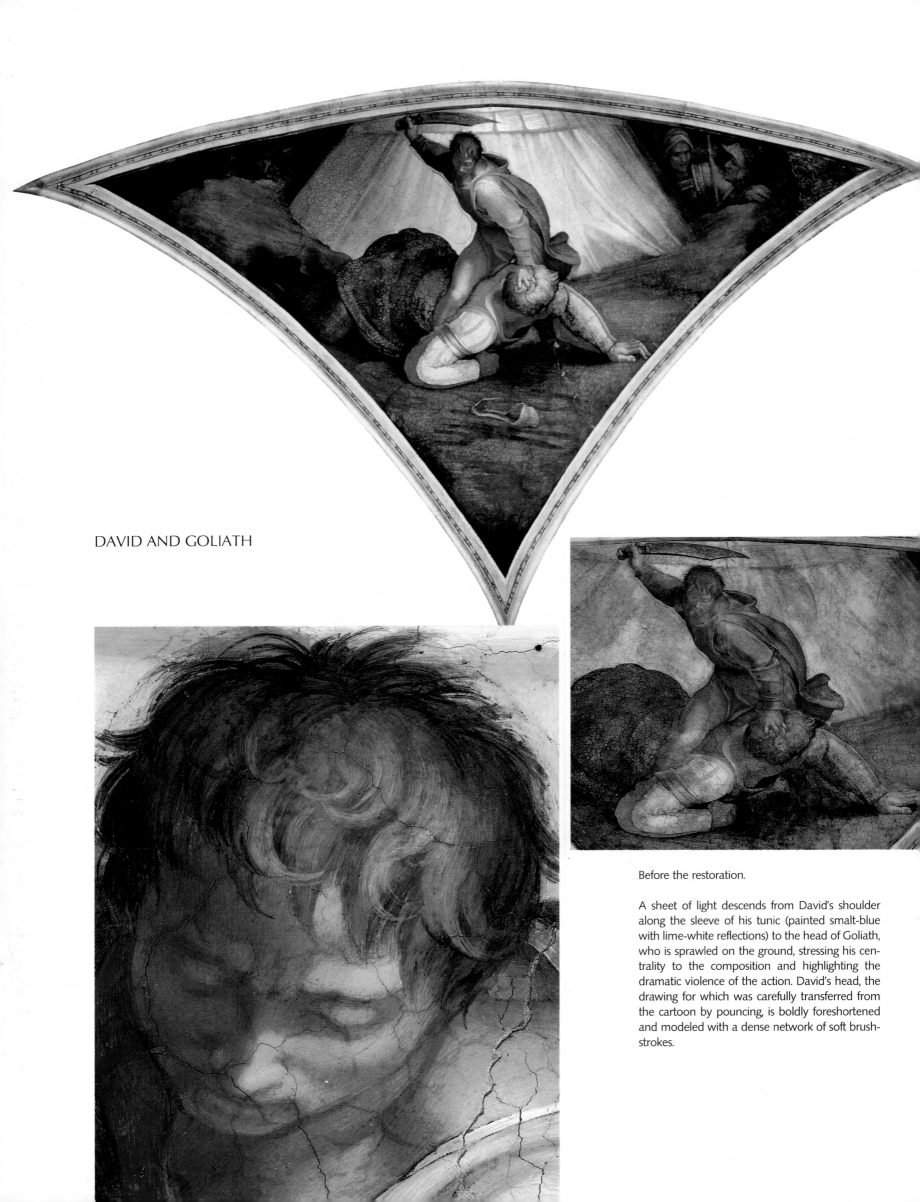

DAVID AND GOLIATH

Before the restoration.

A sheet of light descends from David's shoulder along the sleeve of his tunic (painted smalt-blue with lime-white reflections) to the head of Goliath, who is sprawled on the ground, stressing his centrality to the composition and highlighting the dramatic violence of the action. David's head, the drawing for which was carefully transferred from the cartoon by pouncing, is boldly foreshortened and modeled with a dense network of soft brushstrokes.

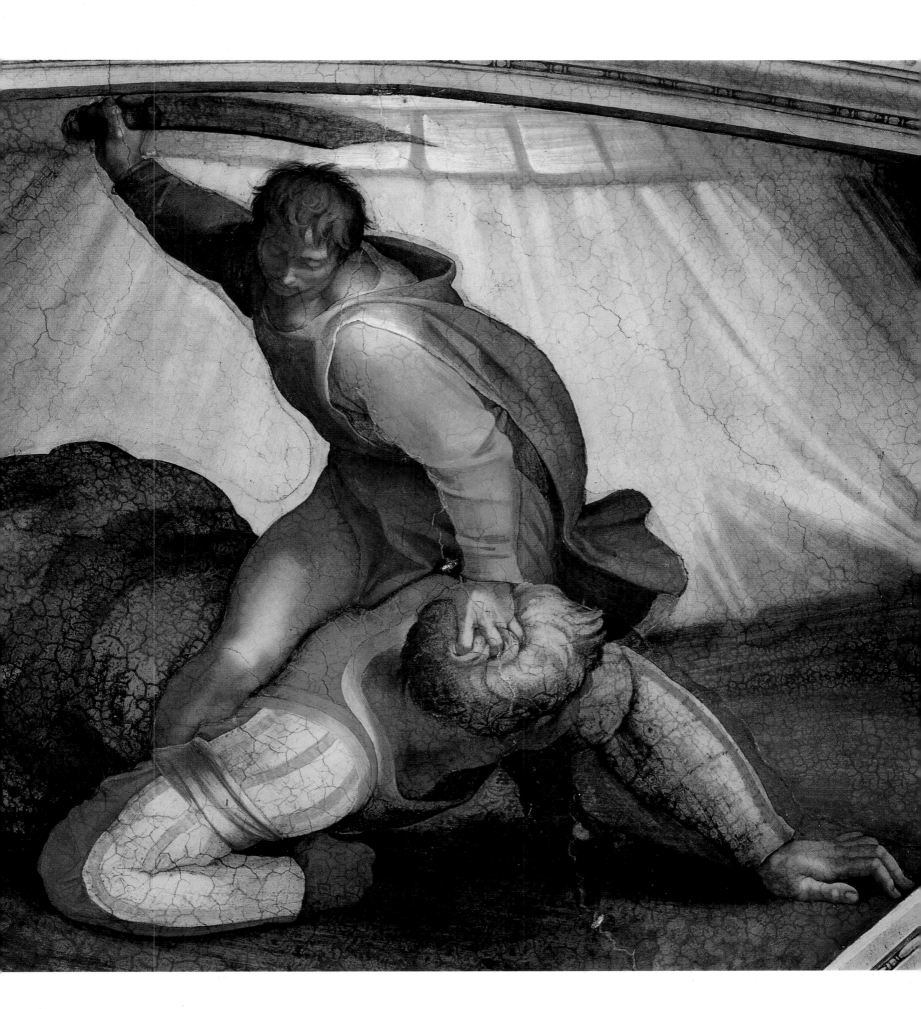

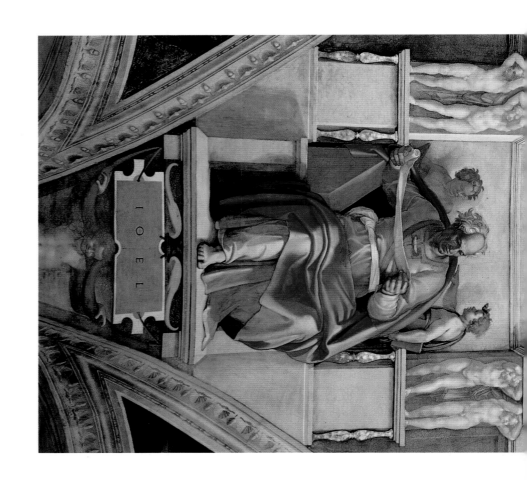

FIRST BAY OF THE CEILING

In the first bay, the Drunkenness of Noah is represented in the center of the vault: this is an episode that from the time of Saint Augustine onward was interpreted as the prefiguration of the mocking of Christ. Saint Augustine was also responsible for the tradition that Noah's planting of the vineyard—the scene depicted in the left background—foreshadowed the incarnation of Christ. The humiliation of the patriarch, caused by the fruit of the vine, alludes to the Word that humili-

his Chariot in Naboth's Vineyard, and the Murder of Abner. Lastly, at the sides of the vault are the Delphic Sibyl and the prophet Joel.

The four *ignudi* are the first figures of this kind that Michelangelo painted in the Sistine Chapel. Only the head, a shoulder, and the feet are now visible of one of the two *ignudi* on the north side. The rest of the body was destroyed by the detachment of *intonaco* caused by the explosion of the powder magazine at Castel Sant'Angelo in 1797. A six-

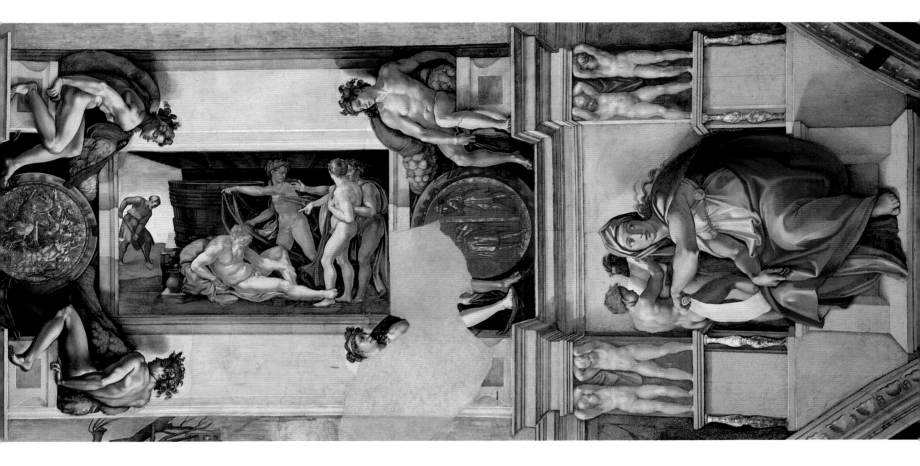

ates itself by agreeing to become incarnated in the "vineyard" of Israel.

At the sides of the central panel, four figures of ignudi bear garlands of oak leaves and acorns—allusions to the della Rovere family—and ribbons passing through the frames of the large gilded medallions. In them are represented scenes of Bidkar Throwing the Body of the Deposed King Joram from

teenth-century engraving shows that the figure was a mirror image of the one facing it, and it is likely that it was executed using the same cartoon reversed. The modeling of the *ignudi* in the first bay contains passages of chiaroscuro displaying greater contrast than those in the following bays. This lends them an air of hardness, especially if they are viewed from a distance.

103

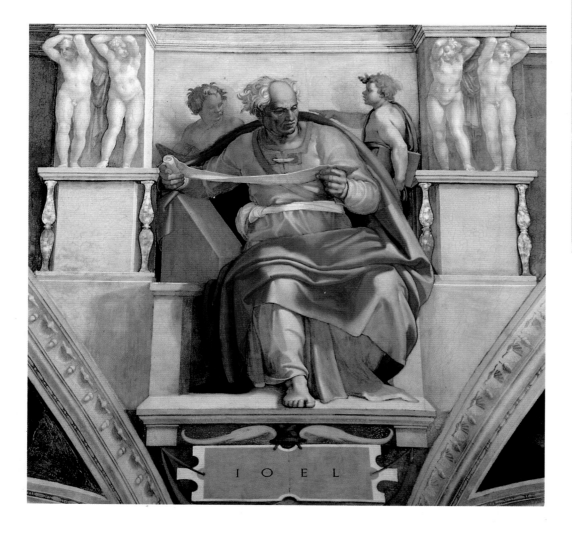

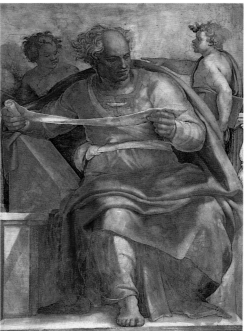

Before the restoration.

"The vine is withered, and the
fig tree languisheth; the
pomegranate tree, the palm tree
also, and the apple tree, even
all the trees of the field are
withered: for joy is withered away
from the sons of men."

Joel 1:12

Wearing an ash-blue tunic with pink reflections and a red mantle, Joel—the herald of terrible calamities on the earth and the darkening of the sun and the moon in the sky—is portrayed frontally, as he sits unwinding and reading a scroll. His intent face, framed by locks of white hair, and the pose of his body express energy, together with a degree of tension. Behind him, two boys converse; one of them holds a book bound in green. *Pentimenti* executed *a secco* have been identified along the sides and arms of the prophet.

104

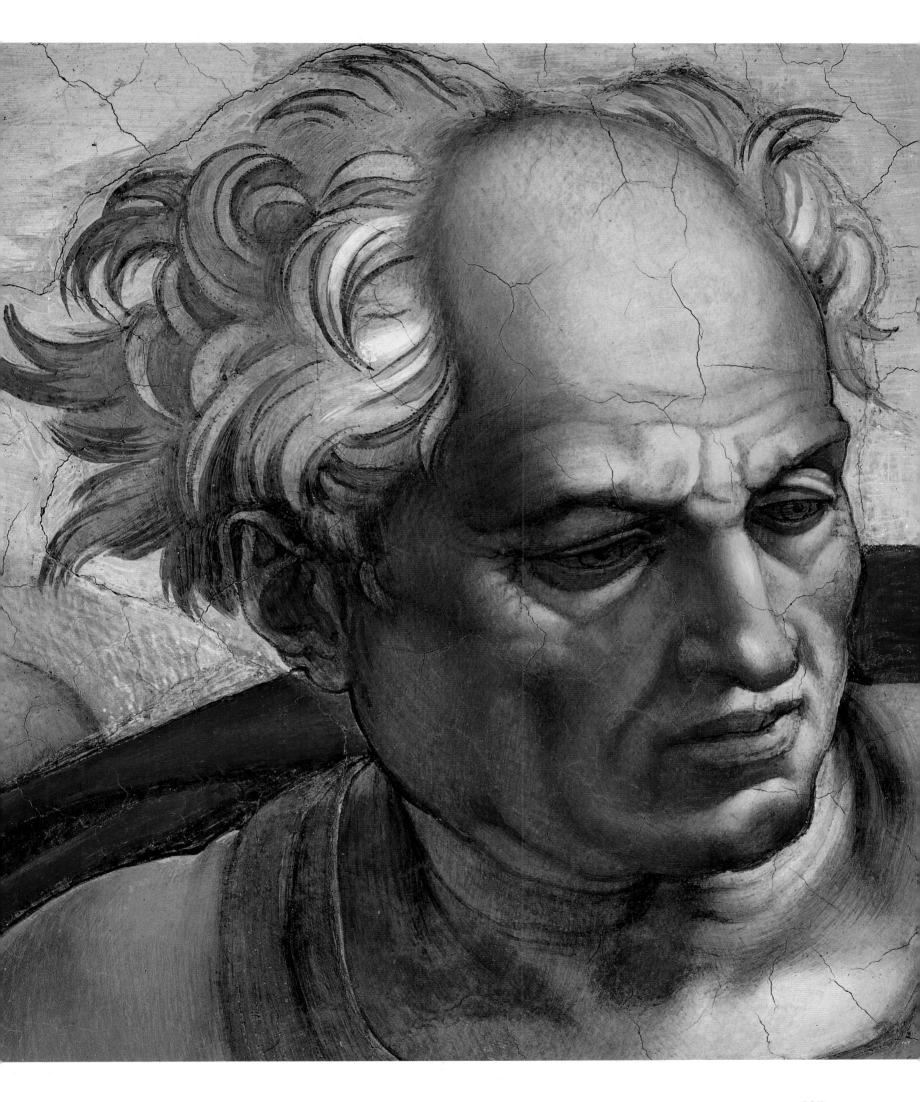

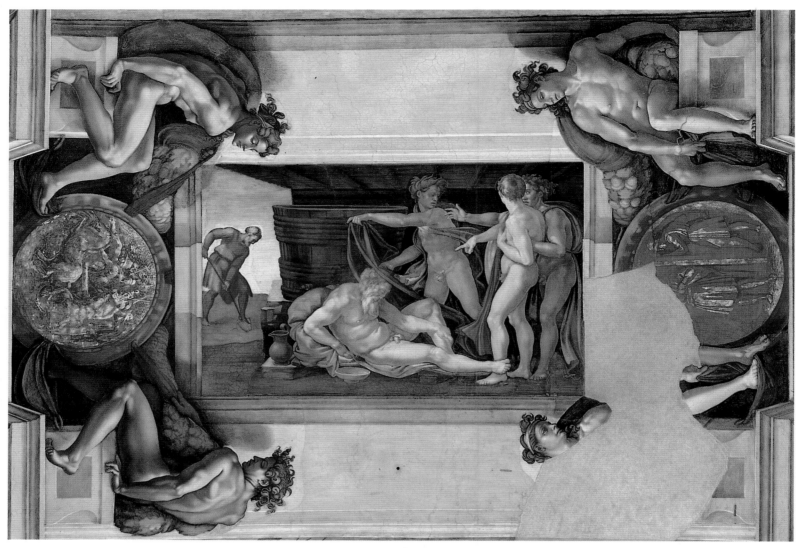

According to Genesis (9:22–23), Ham "saw the nakedness of his father, and told his two brethren who were without. And Shem and Japeth took a garment, and laid it upon both their shoulders, and went backward, and covered the nakedness of their father; and their faces were backward, and they saw not their father's nakedness."

In the wooden hut, next to the body of the drunken, sleeping patriarch, are a pitcher and a bowl. Behind stands a large vat. In the left background, Noah is depicted again in broad daylight, tilling the vineyard. The figure, dressed in a blood-red tunic, was painted rapidly in the last of the *giornate* spent on the scene, without a cartoon, and with very light glazes of color.

The pure gold leaf with which the figures in the medallions are heightened was applied *a secco,* with a mordant containing natural resins on a fresco background with golden ocher and burnt sienna, which serves as a halftone. The shadows are obtained with black lines painted in tempera. The unusual technique employed by the artist is largely responsible for the damage these paintings have suffered.

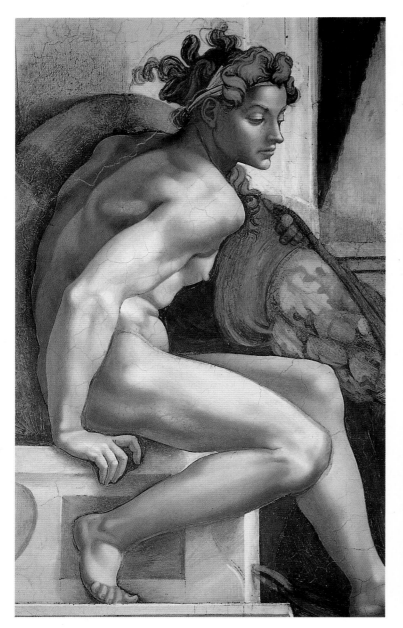

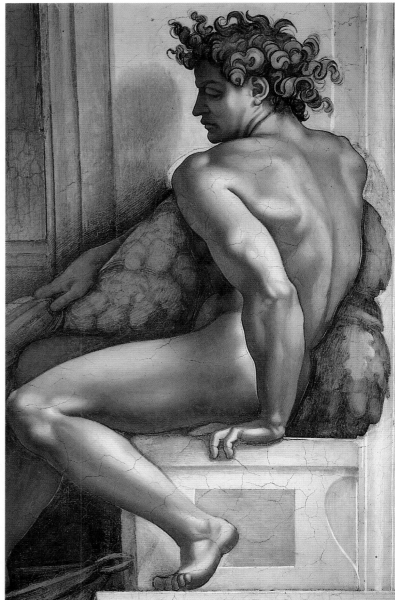

The poses of the two figures of *ignudi* above the prophet Joel are rigorously symmetrical. They are depicted seated in profile, each with a leg bent back, their arms resting on the plinths and their busts turned with the outside shoulder forward.

The plinths, unlike the elements of the painted framing cornice, are not foreshortened, and form a link with the figures seen frontally, concealing the sudden transition from a low viewpoint to one at right angles to the picture plane.

110

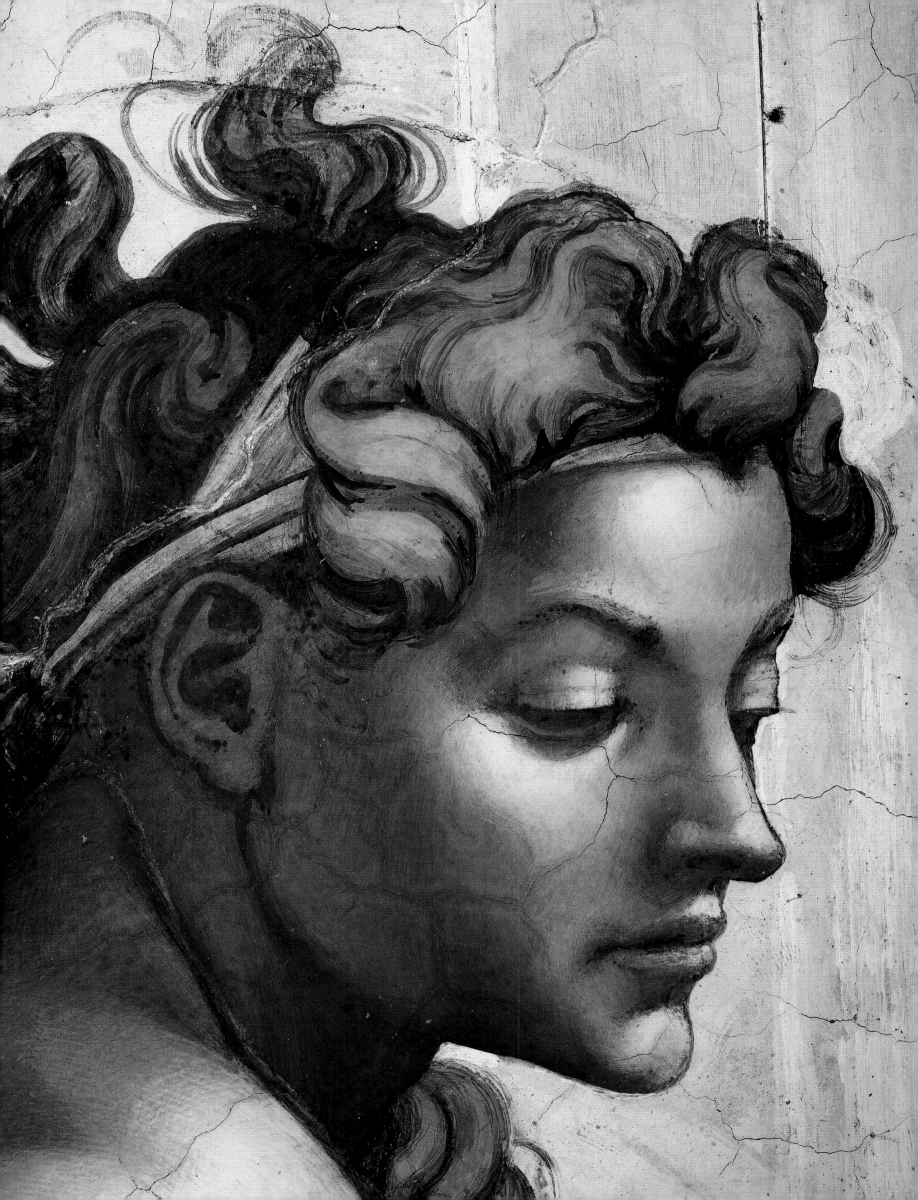

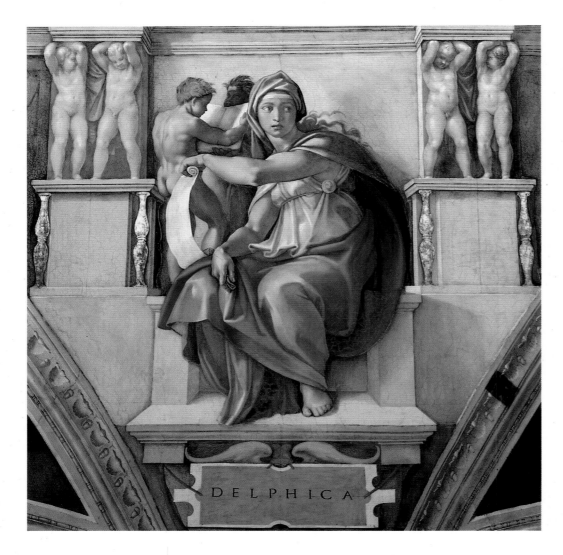

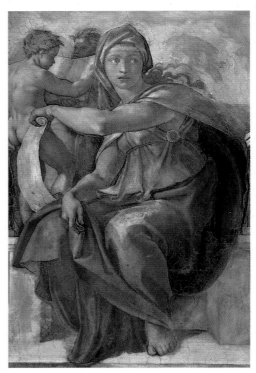

Before the restoration.

Unwinding a scroll with her left hand, the Delphic Sibyl seems to be turning her body toward the viewer. The effect of movement is accentuated by the swirls of the light blue mantle lined with yellow fabric with red shadows and the pattern of the folds of the light green tunic. The very refined colors are characterized by delicate tonal passages and enamel-like surfaces.

In the center of the face—seen frontally, half in the light and half in a moderate shadow—there are traces of a cross incised in the *intonaco* to mark the vertical axis of the oval and the alignment of the eyes.

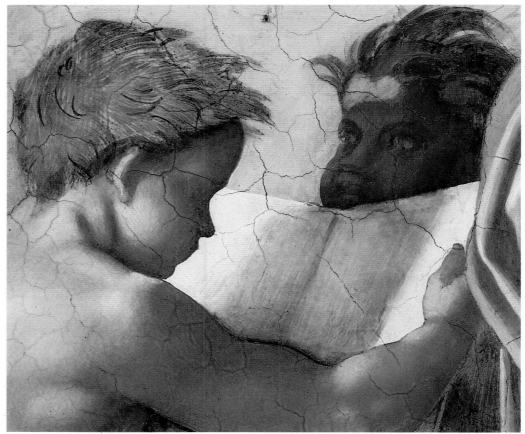

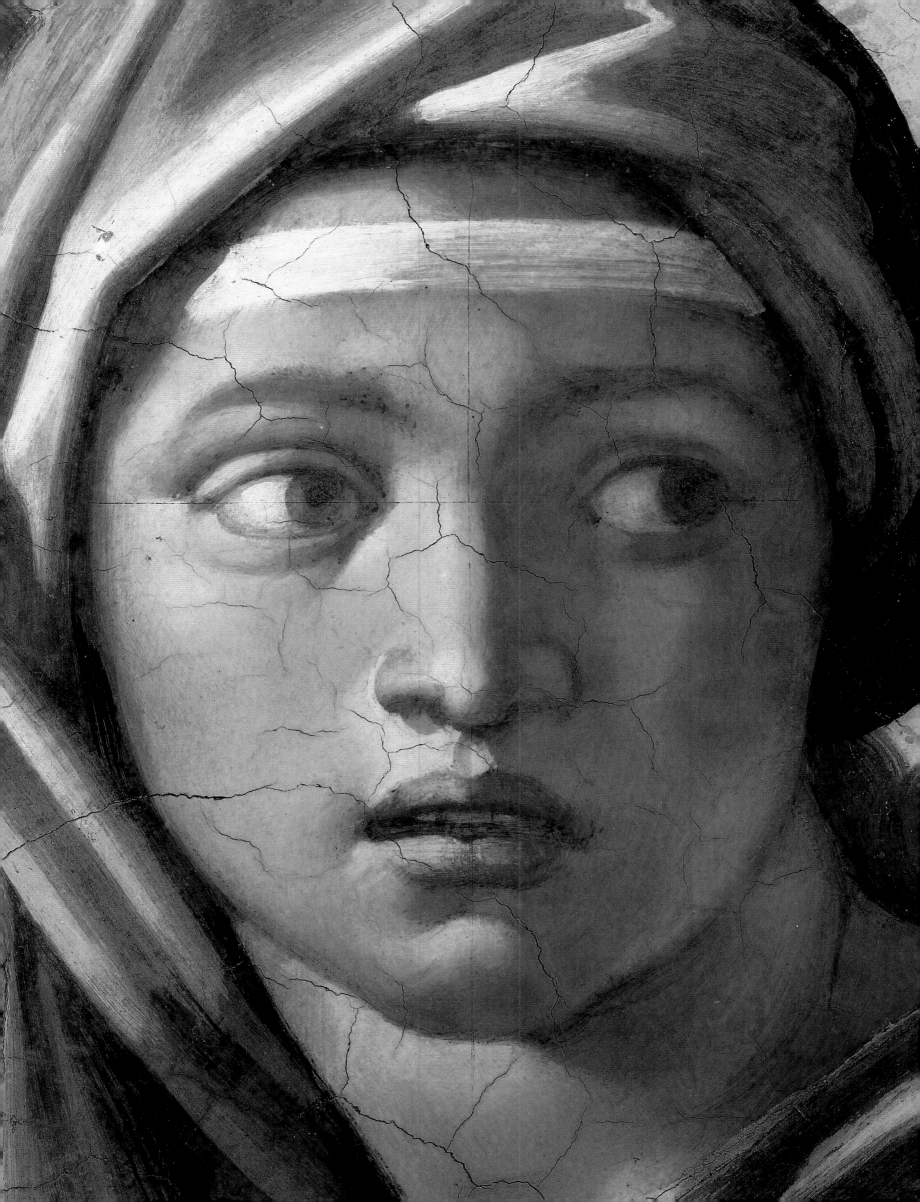

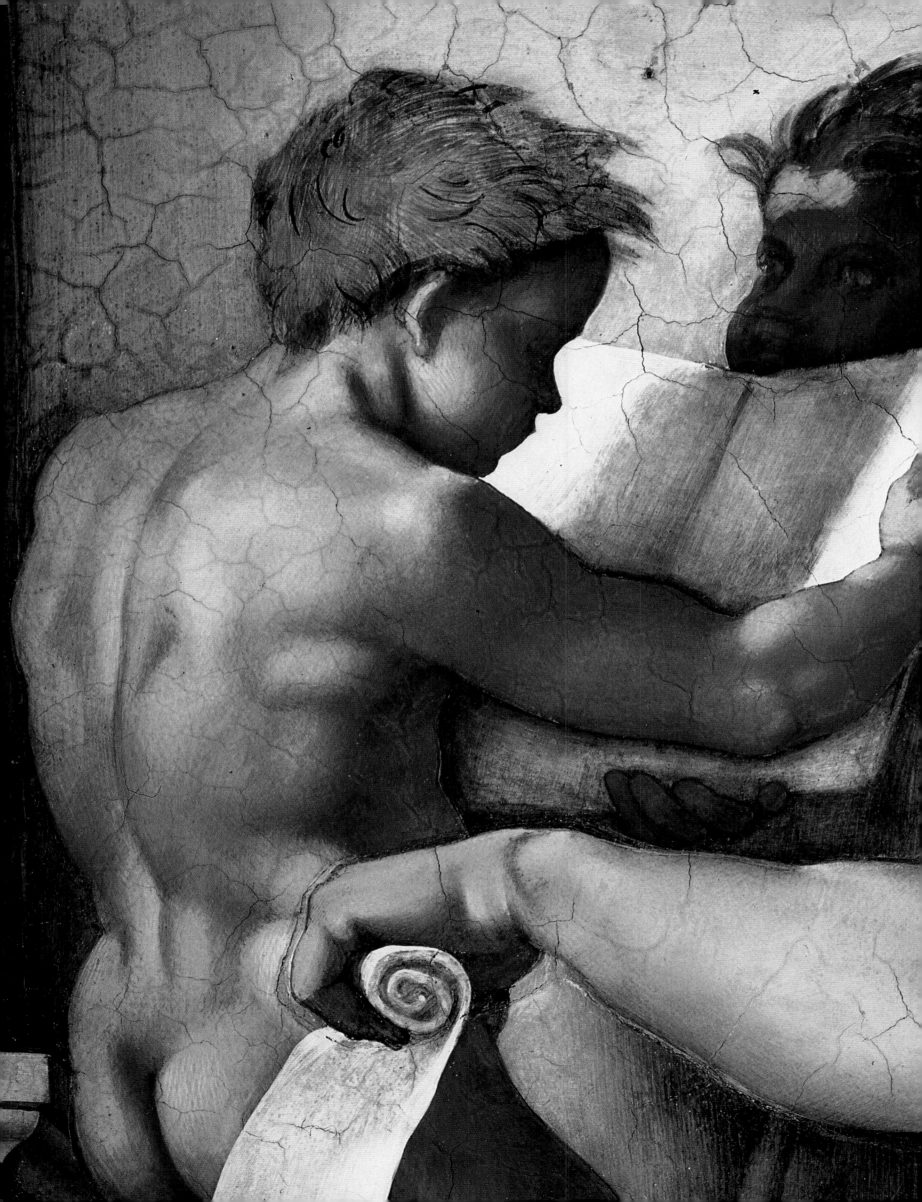

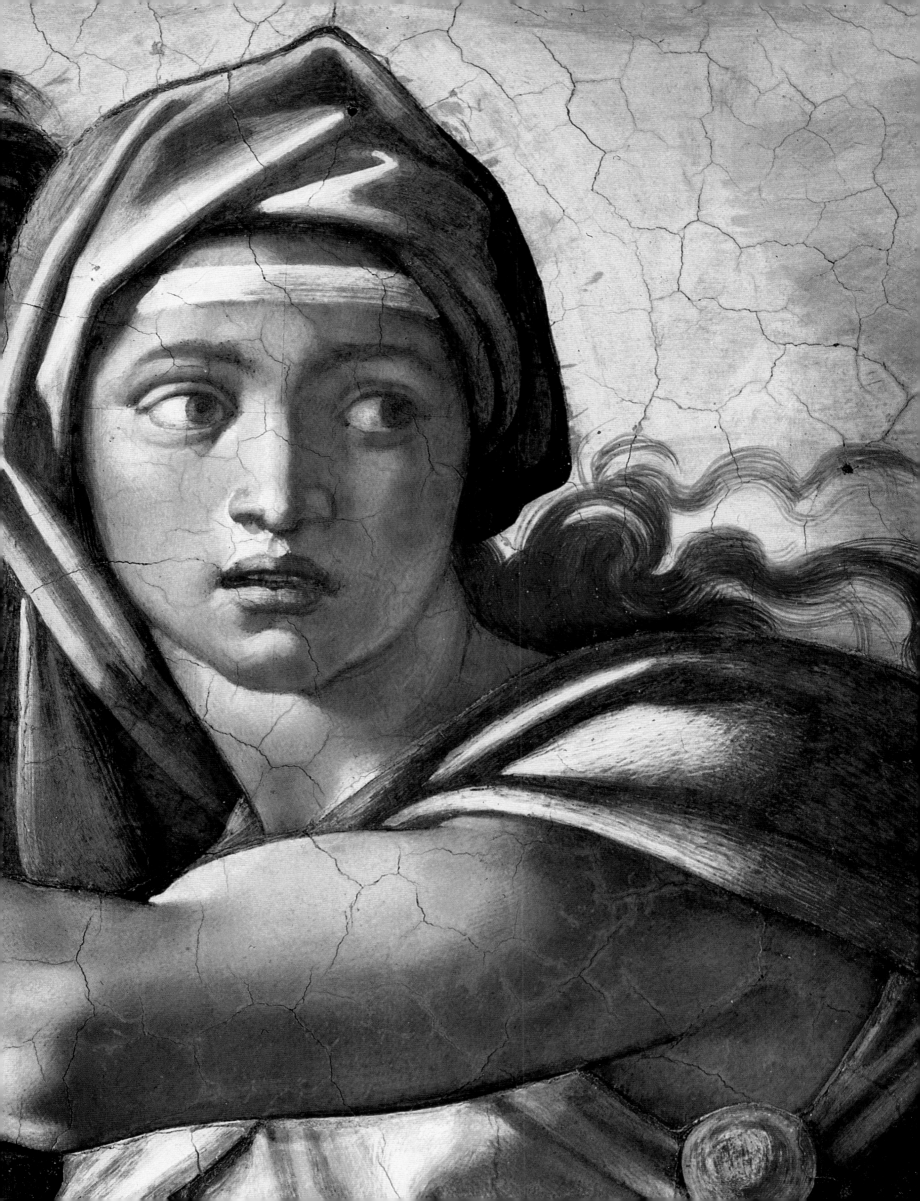

Second Bay of the Ceiling

According to Condivi, the scene of the Deluge was the first to be painted by Michelangelo on the vault of the Sistine Chapel. The differences in the quality of the execution between the various parts of the fresco indicate that initially the artist had to face difficulties both of a technical nature and with regard to his relationship with his assistants. In this respect, Vasari recounts that Michelangelo

began and completed the cartoons; then wishing to color them in fresco, but lacking the necessary experience, he brought some painters who were friends of his to Rome from Florence to assist him in the project and also to see their method of working in fresco, in which some were skilled; these included Granacci, Giuliano Bugiardini,

open it to them or even see them at his home.

As a result of this attitude, it appears the assistants resigned themselves to returning to Florence "in disgrace."

Aside from the question of Michelangelo's supposed lack of experience of the fresco technique—which cannot have been so serious, however, considering his apprenticeship in Ghirlandaio's workshop—Vasari's assertions have been partially confuted by studies made of the documents, as well as of *I Ricordi di Michelangelo* and Michelangelo's letters. The names of the painters brought from Florence correspond—including Bastiano da Sangallo, called Aristotile, who was also a skilled architect and perspectivist—but Iacopo di Lazzaro, called Indaco Vec-

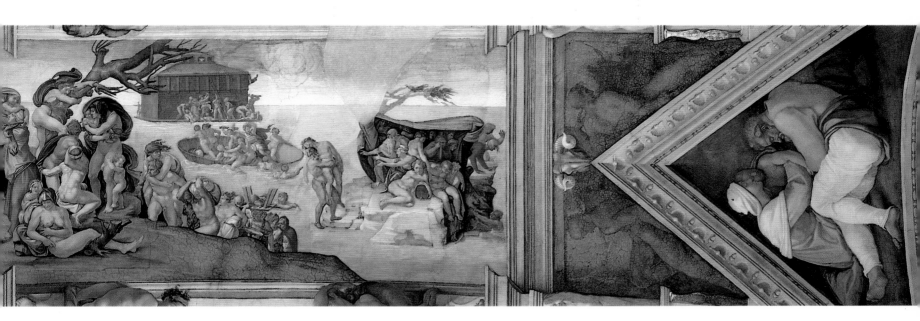

Jacopo di Sandro, the elder Indaco, Agnolo di Donnino, and Aristotle; and after starting the project, he had them begin a few things as a sample of their work. But when he saw that their labors were far from what he wished to achieve and failed to satisfy him, he decided one morning to pull down everything they had done. And closing himself in the chapel, he would not

chio, only came to Rome at a later date, probably to replace Iacopo di Sandro, who left the city at the end of January 1509 because of irreconcilable differences. Michelangelo was subsequently on friendly terms with the others, especially Francesco Granacci and Giuliano Bugiardini: this would have been unthinkable if Vasari's account were completely true.

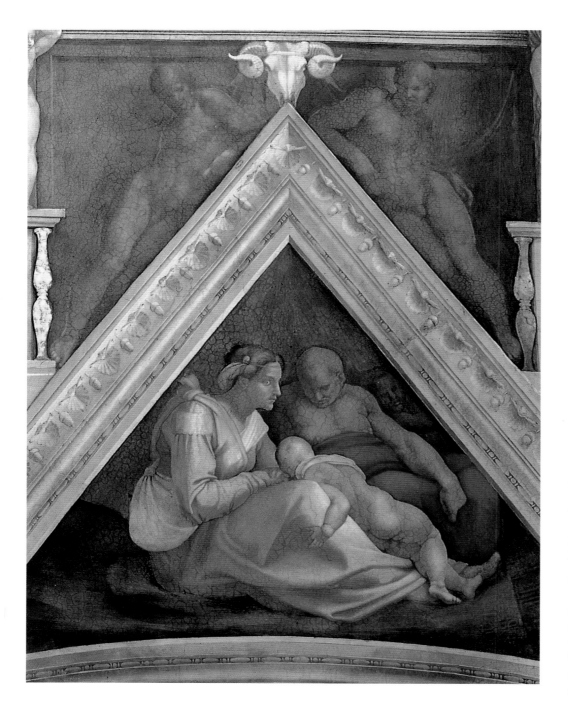

It is generally believed that Zerubbabel is depicted here, together with his parents and a brother. Occupying the triangular fields between the thrones of the prophets and the sibyls, above the lunettes, the eight spandrels of the side walls contain family groups with figures seated or reclining on the bare ground, in poses that seem to draw on the theme of the flight into Egypt.

who used only rough cartoons and were given a certain amount of freedom, were entrusted with the highest areas—which, naturally, were the ones furthest away from the viewer—in the Sistine Chapel, the assistants had a subordinate role and were carefully supervised by Michelangelo. They used very precise cartoons, in some cases even for the framing cornices. In the first stage of the work, Michelangelo on his own frescoed all the figures of prophets, sibyls, and *ignudi*, as well as those in the lunettes, which were painted without cartoons.

For the panels in the center of the vault, the situation changed radically in the last scene in the first stage of the work—the *Fall of Adam and Eve and Their Expulsion*—and then with the *Creation of Eve*. These scenes, in which the number of figures is decreased—although they are enlarged—were executed more rapidly, in fewer *giornate*: the thirteen *giornate* of the Drunkenness of Noah and the twelve of the Sacrifice of Noah were reduced to four in the Creation of Eve. Moreover, from the latter fresco onward, the *ignudi*, which up to then had always been painted after the central scenes, were painted first. These are all clear indications of a drastic reduction in the use of assistants, to whom only the less important parts were entrusted. It was probably only then that the more talented assistants returned to Florence and were replaced by others, such as Giovanni Trignoli and Bernardino Zacchetti, who were more suitable for the modest tasks assigned to them.

Clear evidence of the initial crisis is found in the break between the figures partially painted *a secco*, or, at any rate, not in *buon fresco*, in the first *giornate*—those crowded onto a rocky islet on the right—and the others frescoed subsequently. These are two distinct stages from a technical point of view and, in many cases, as regards the quality of the execution as well. It is possible that parts of a first version were destroyed because they were considered unsatisfactory, and redone in *buon fresco*. Nonetheless, in the second part, too, there is a noticeable lack of homo-

All the assistants came from Ghirlandaio's workshop, with the exception of Agnolo di Donnino and Bastiano da Sangallo, who had worked with Cosimo Rosselli. Until at least the last few months of 1509 they worked in the Sistine Chapel, and their presence is evident in the first three biblical scenes, as well as in the decorative frames, the fictive reliefs at the sides of the thrones of the prophets and sibyls, and the tondos of the first bay.

Unlike what happened in Ghirlandaio's workshop, where the assistants,

geneity between the parts painted with greater boldness and self-assurance and others in which the artist appears to be more concerned with diligently following the outline transferred from the cartoon. These parts are executed somewhat clumsily and modeled less vigorously, while the texture of the brushwork is definitely not up to Michelangelo's usual high standard. The differences in the quality of the execution do not, however, manage to attenuate the effect of the imposing composition. Over sixty figures, mostly nude, represented in an extraordinary variety of poses, are grouped and distributed along diagonal axes on the surface and in depth, conferring a strongly dynamic tension on the scene and making the different planes clearly distinguishable, even from a distance.

In the doctrine of the typological relationship between the Old and New Testaments, the Deluge was considered to prefigure baptism, while the Ark was the symbol for the Church itself. The lustral water of the baptism removes the original sin, while that of the flood cleansed the world of sinners. Noah was saved from the water by the wood of the Ark, just as the wood of the Cross offers salvation to those who are in the Church. According to the interpretation given by Ugo da San Vittore to the biblical story, three different patterns of behavior may be distinguished in human beings: while the righteous take refuge in the Ark (the Church) and find salvation therein, the damned attempt to assail it, and others are lost due to their excessive attachment to worldly things, and seek safety carrying their possessions with them.

In fact, in the foreground of the fresco, the latter seek to flee from the threat of the rising waters by crowding onto the rocky islet on the right or by wearily climbing up to the high ground on the left. In the distance, the wicked, having reached the platform surrounding the Ark, hurl themselves against the vessel from which they have been excluded. Lastly, those who have reached a boat that is about to capsize, between the Ark and the hill in the foreground, are also engaged in a fierce struggle. The

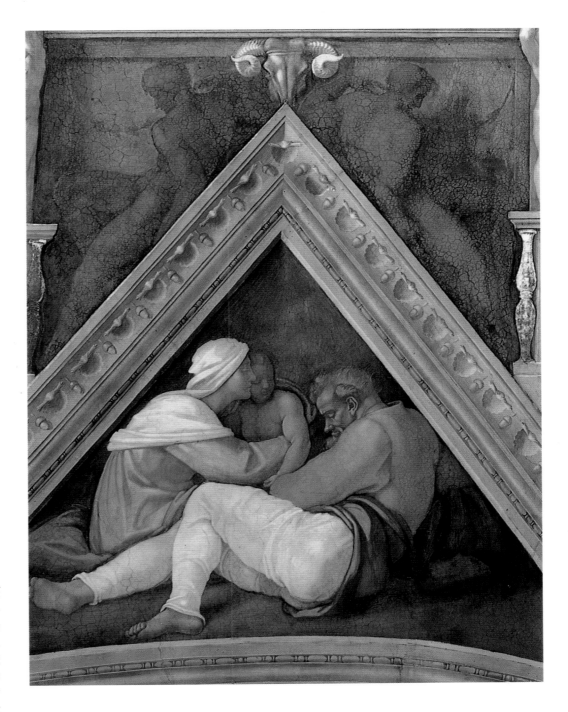

scenes of violence are countered by the behavior of those who do not seek their salvation at the expense of others, but display compassion and a profound sense of solidarity toward the weakest individuals who have been overwhelmed by the same calamity. As Edgar Wind has rightly observed, "never before has sin revealed itself with a more human semblance when faced with destruction," and, in effect, many of the protagonists of the Deluge appear to be painfully aware of their destiny rather than overcome by terror.

The spandrel above the Josiah-Jechoniah-Shealtiel lunette probably depicts Jechoniah's family with Shealtiel's son. The poses of the figures, together with the nocturnal atmosphere, bring to mind the definition that Saint Paul gave of the ancestors of Christ as "pilgrims" and "strangers on earth," on their way toward the promised land.

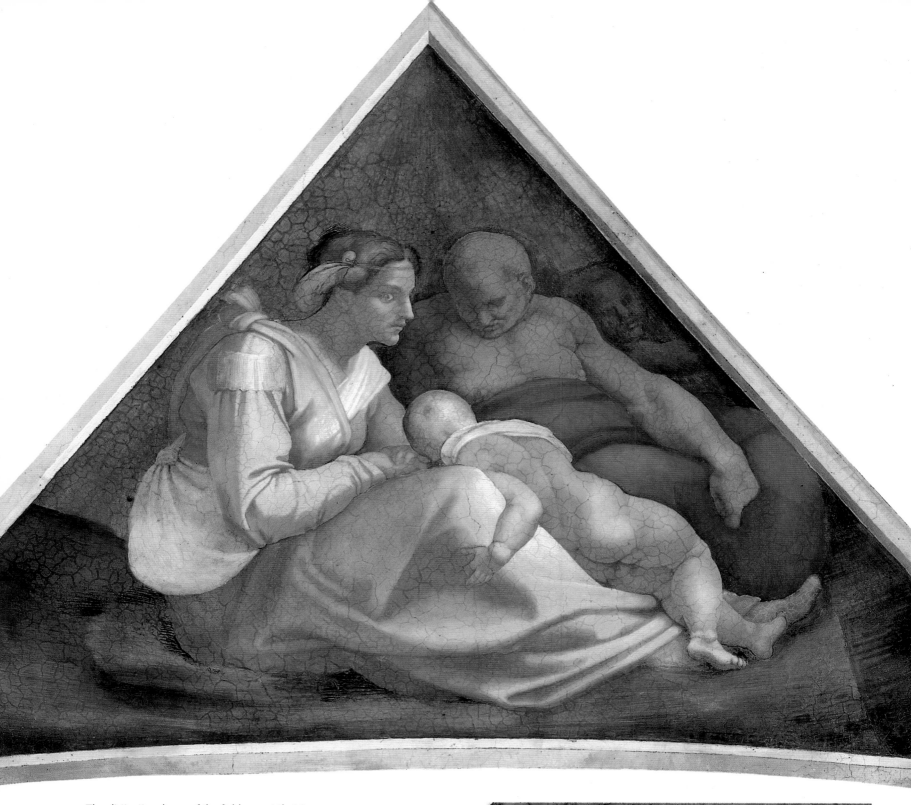

The distinctive shape of the field meant that it was necessary to have a series of slight variations of the way the three or four figures comprising each family group were arranged.

Painted in three *giornate*, in the foreground of the Zerubbabel spandrel there is the figure of a young woman sitting on the ground, with a sleeping child in her lap. The old man behind them is also asleep, while in the background the head and arms of another child may be discerned in the shadows. The woman, who is wearing a light green dress with iridescent violet shadows and an orange mantle tied on her shoulder, has a white haversack hanging down her side.

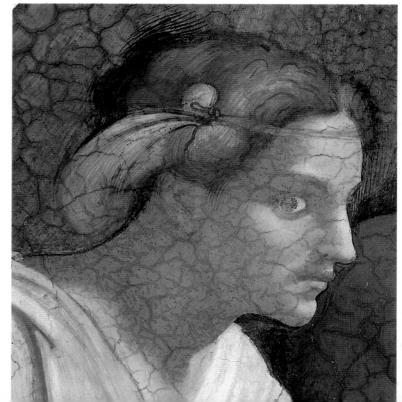

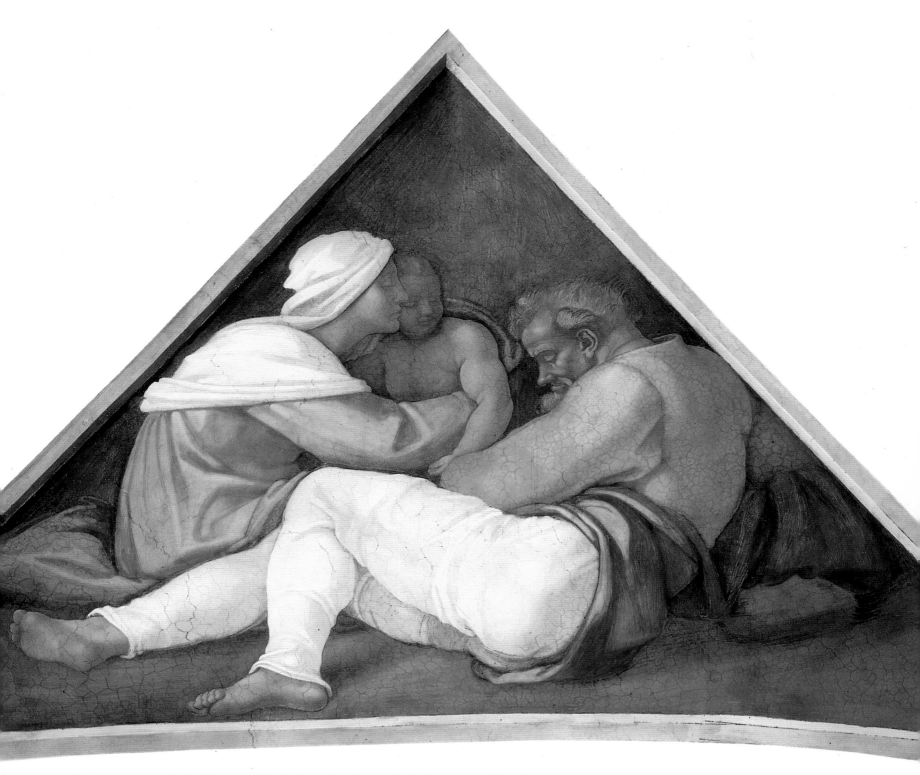

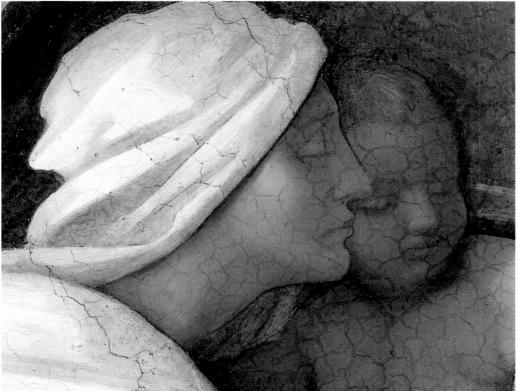

The group was painted in only two *giornate*; the cartoon was transferred onto the *intonaco* by pouncing, as was the case in all the other spandrels. Reclining on the ground, looking away from the viewer, the barefoot man in the foreground is wearing a yellow shirt and white trousers that are tight around the ankles, creating a strong contrast with the shadows in the background. Behind him is a seated woman, seen in profile, with her head wrapped in a white scarf falling onto her shoulders and a violet tunic. She tenderly puts her face close to that of the child she is holding in her arms.

121

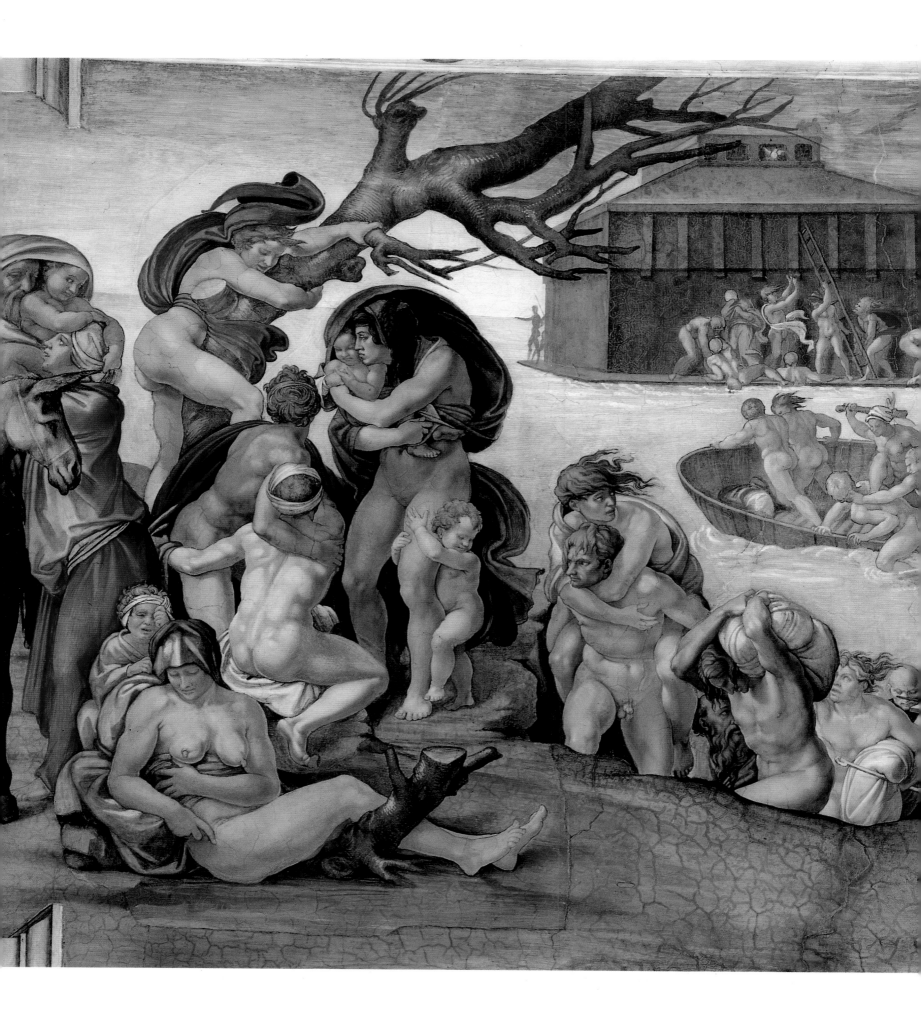

From the very moment the first half of the vault was unveiled, the scene of the Deluge greatly impressed many of the visitors to the Sistine Chapel. Of the early descriptions, that of Vasari was particularly incisive: "Various dying men appear, frightened by the horror of those days, and search as best they can for different ways to escape with their lives.... Michelangelo shows the compassion of many others, helping one another climb up to the summit of a rock seeking safety. Among the figures is one who has embraced a half-dead man and is trying as best he can to save him, a figure Nature herself could not have depicted any better."

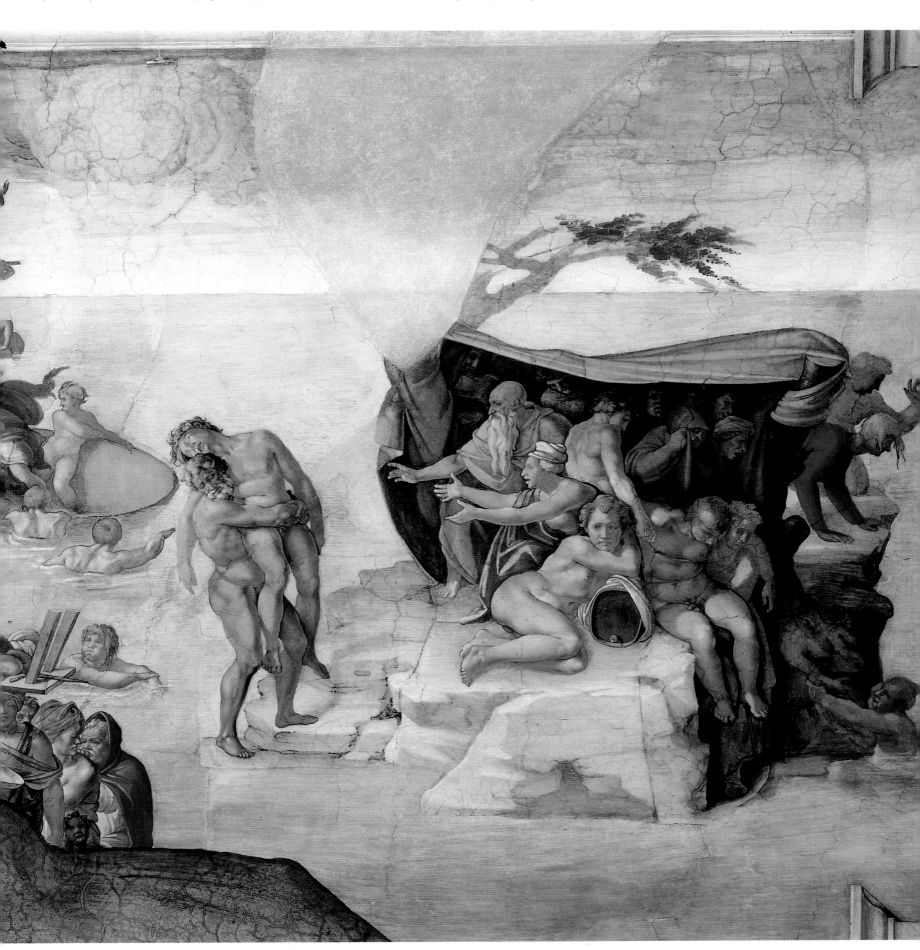

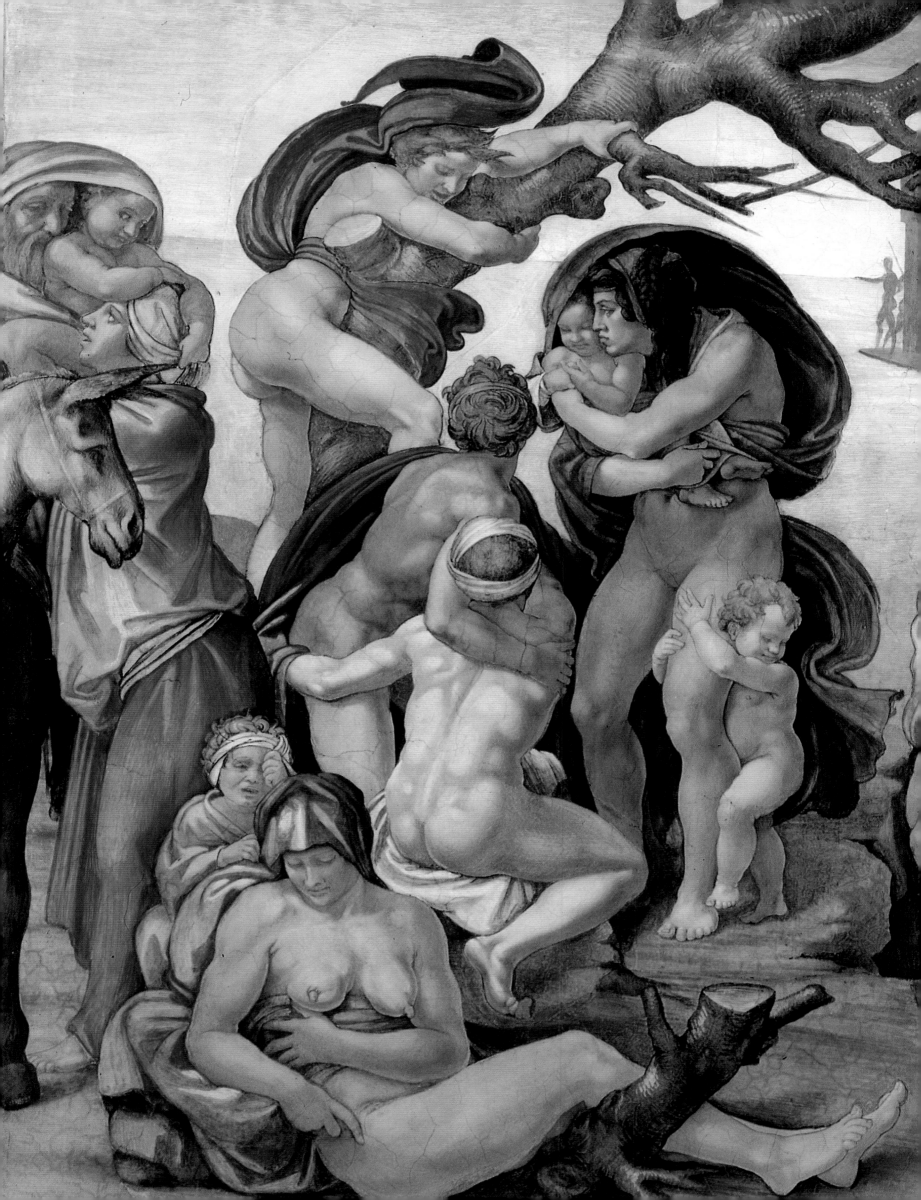

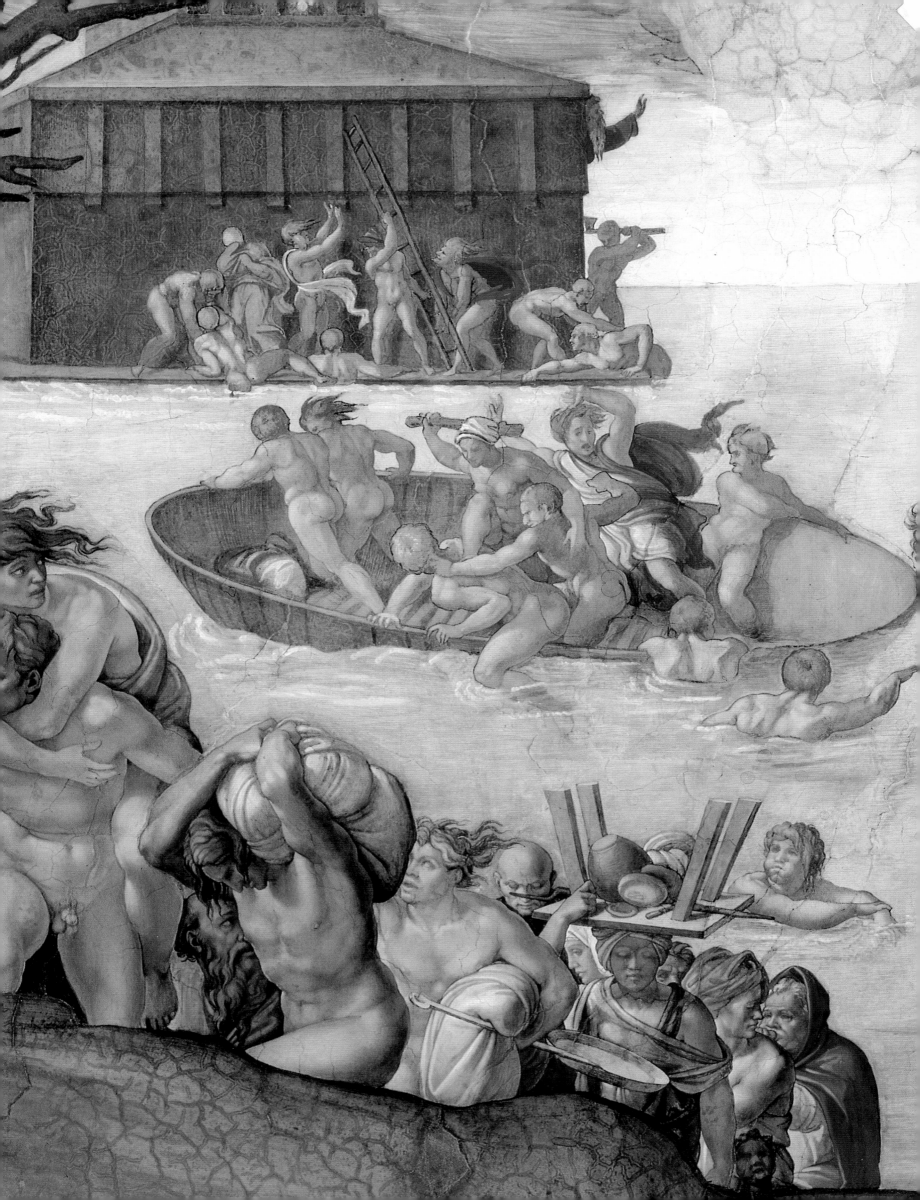

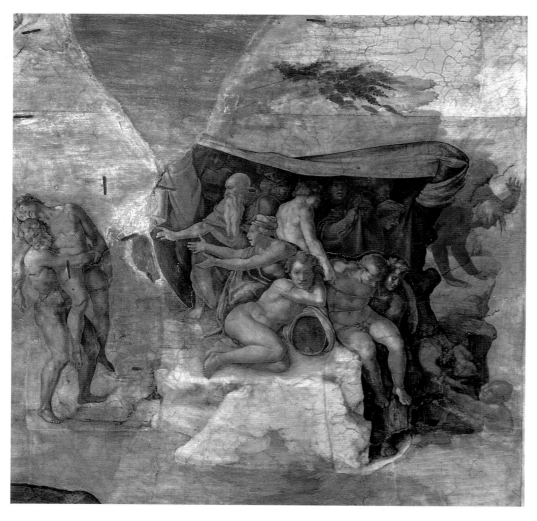

Before the restoration.

The field of the fresco is crossed by wide cracks resulting from the settlement that took place during the sixteenth century, while the loss of *intonaco* that caused the large lacuna in the sky was caused by the explosion of the powder magazine at Castel Sant'Angelo at the end of the eighteenth century. The group on the right, with men and women seeking safety by crowding onto a rocky islet, was painted in the first five of the twenty-nine *giornate* required to complete the *Deluge*. Uncertainty in the execution and technical imperfections have been noticed in many of the figures, suggesting that they are probably not the work of Michelangelo. The youth in the foreground, leaning on a small barrel, was not painted in *buon fresco*, and in the two figures immediately to the right there are various finishing touches *a secco*. In these figures, as in those behind them, it is possible to detect the hands of assistants who used cartoons prepared by Michelangelo.

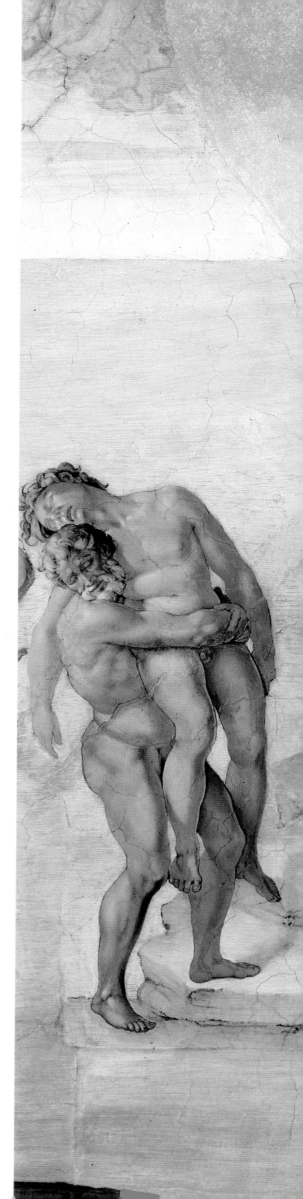

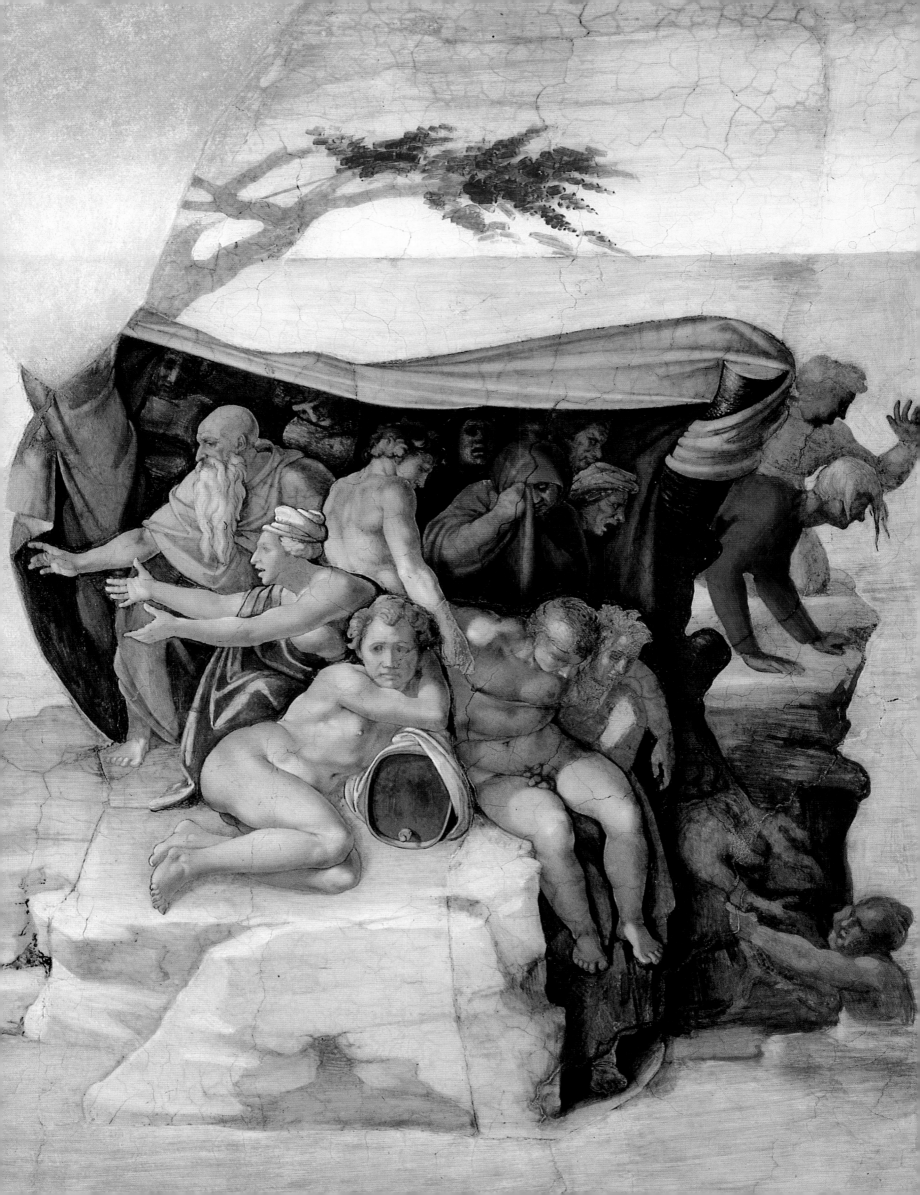

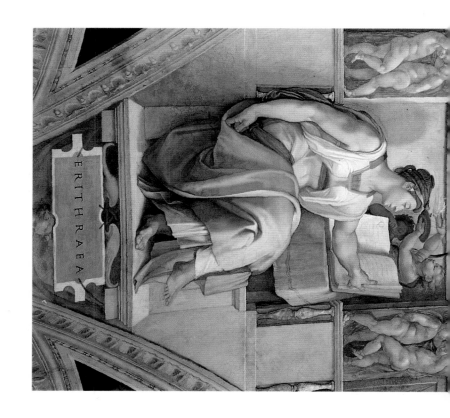

THIRD BAY OF THE CEILING

In the center of the vault, between pairs of *ignudi* with medallions, the Sacrifice of Noah is depicted; on the left is the Erythraean Sibyl and, on the right, the prophet Isaiah.

In the central panel, the composition of which is derived from those of classical reliefs, Noah celebrates the sacrifice on an altar seen cornerways on, assisted by other figures. In the chronological sequence of the biblical narration, the Sacrifice ought to follow and not precede the Deluge, but, apart from considerations relating to the typological interpretation of the scene, it is pos-

of light and shade—than in those of the preceding bay. Moreover, their poses are no longer wholly symmetrical. In fact, in the two figures on the left, only the lower part of the body is symmetrical, while the twisting of the bust and the head are expressions of *contrapposto*. The right arms of both are, however, extended toward the center in order to hold the ribbon supporting the medallion. On the other hand, the two *ignudi* on the right—splendid preparatory drawings for these are to be found in the Gabinetto dei Disegni e delle Stampe at the Uffizi and in the

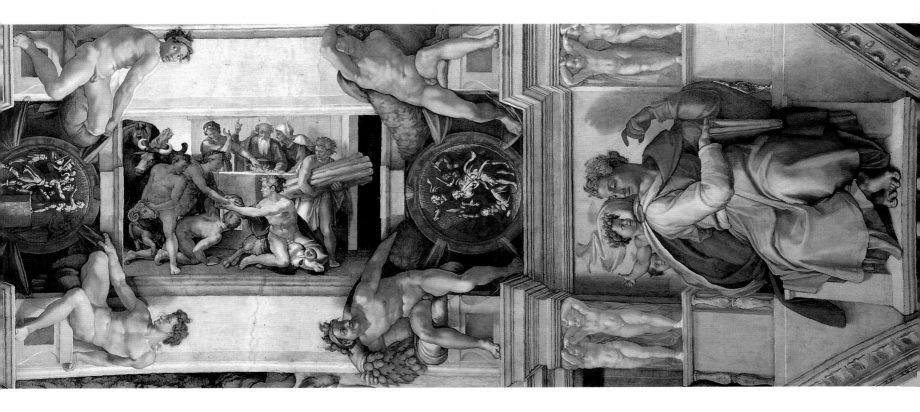

sible that Michelangelo preferred to reserve one of the largest panels in the ceiling for the Deluge.

In the medallions, the Destruction of the Statue of the God Baal and the Killing of Uriah are depicted. The *ignudi* are painted with greater fluency and the modeling is more delicate—with greater attention being paid to the reflections and the subtle effects

Louvre—lean out toward the exterior, and the only difference between them appears to be the position of their arms.

In the following bays these figures continue with "their beautiful and varied poses, for some are sitting, others are turning around, and still others are holding up garlands of oak leaves and acorns." (Vasari).

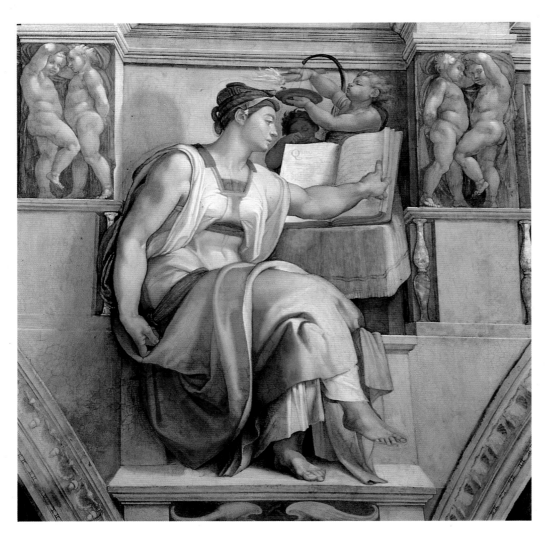

Turning to leaf through the large book on the lectern, the sibyl is wearing a white tunic with greenish reflections under a red bodice. The orange mantle lined with green is folded over her legs. Behind the lectern, one of the two small boys lights a lamp, while the other rubs his eyes, as if he has just woken up.

Minor *pentimenti* are visible in the foreshortening of the feet and ankles and the line of the lower eyelid.

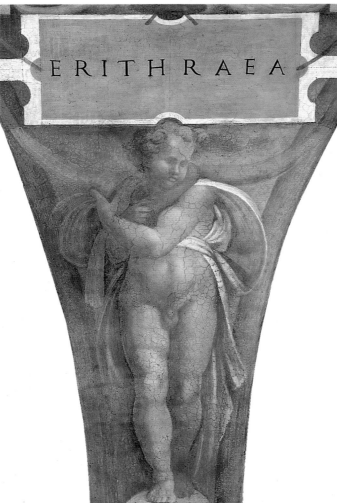

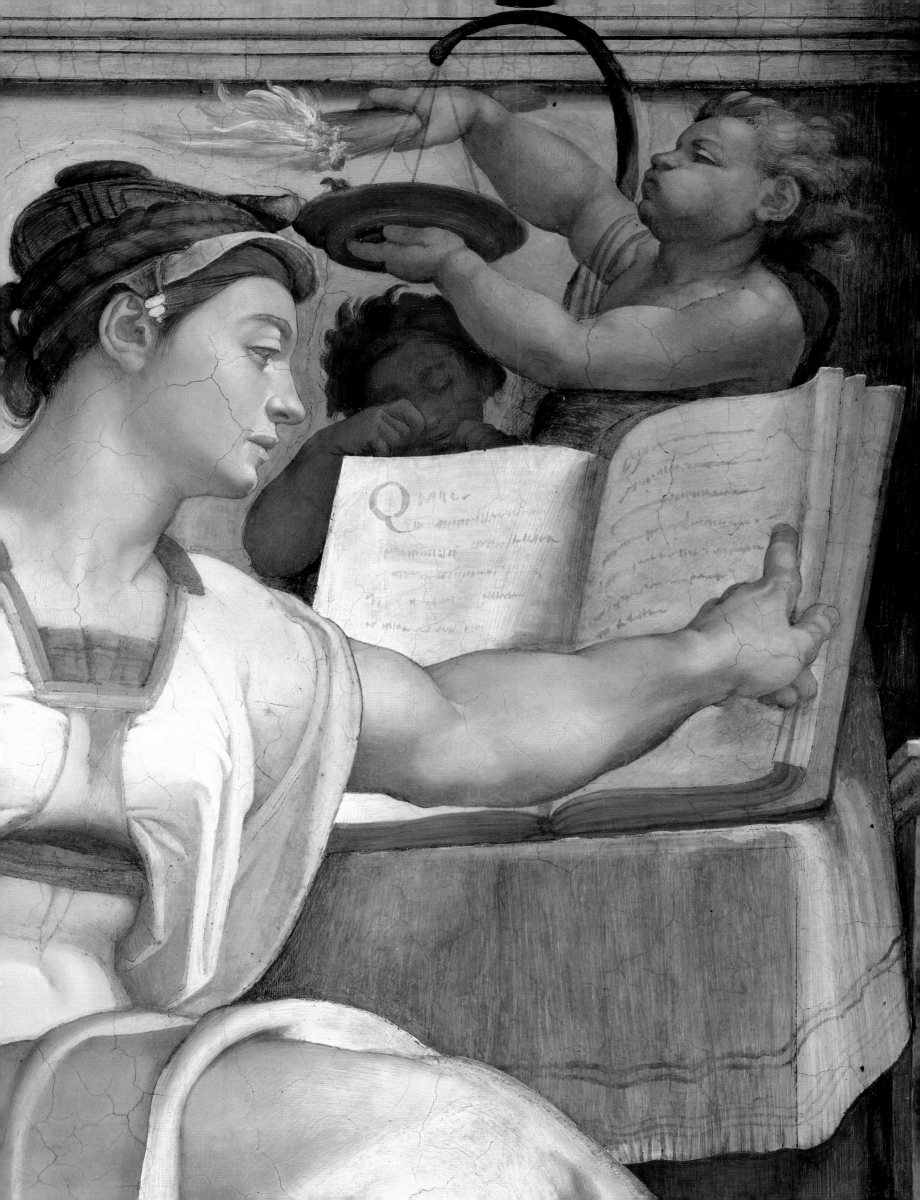

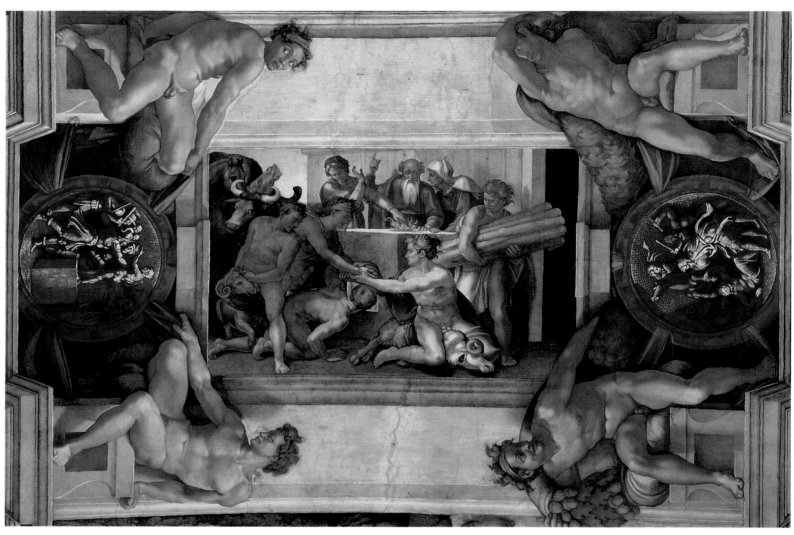

In the scene of the Sacrifice, the figures of the youth dragging the ram and the one taking the viscera of the animals were painted by Domenico Carnevali around 1568, after the original figures were lost as a result of the detachment of the *intonaco* caused by instability in the structure of the vault. The precision of the reconstruction suggests that Carnevali was able to make a tracing of the original figures before the fragments of damaged fresco became detached (or were deliberately removed). The darker tones of the two figures—compared to those of the others after the recent cleaning—indicate that around 1568 the frescoes on the ceiling had already been darkened by deposits of dust and soot.

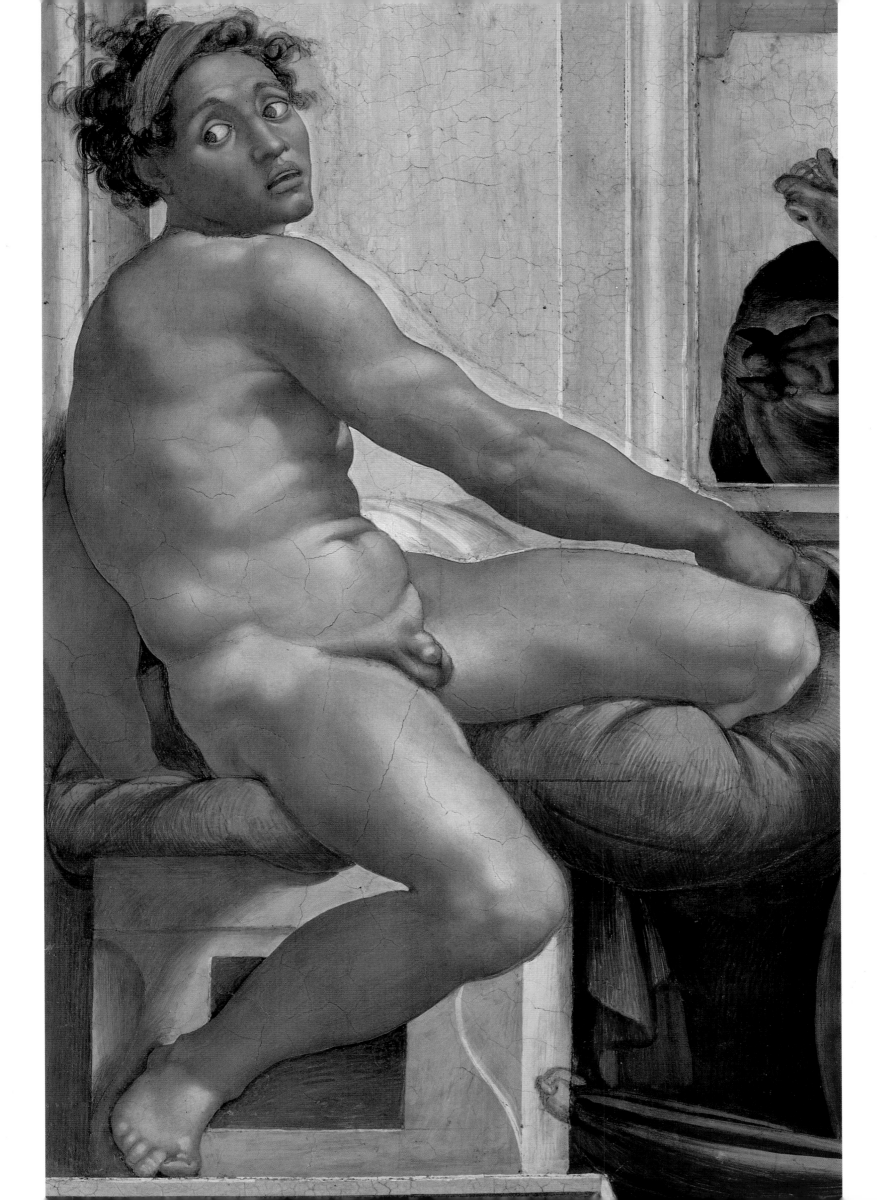

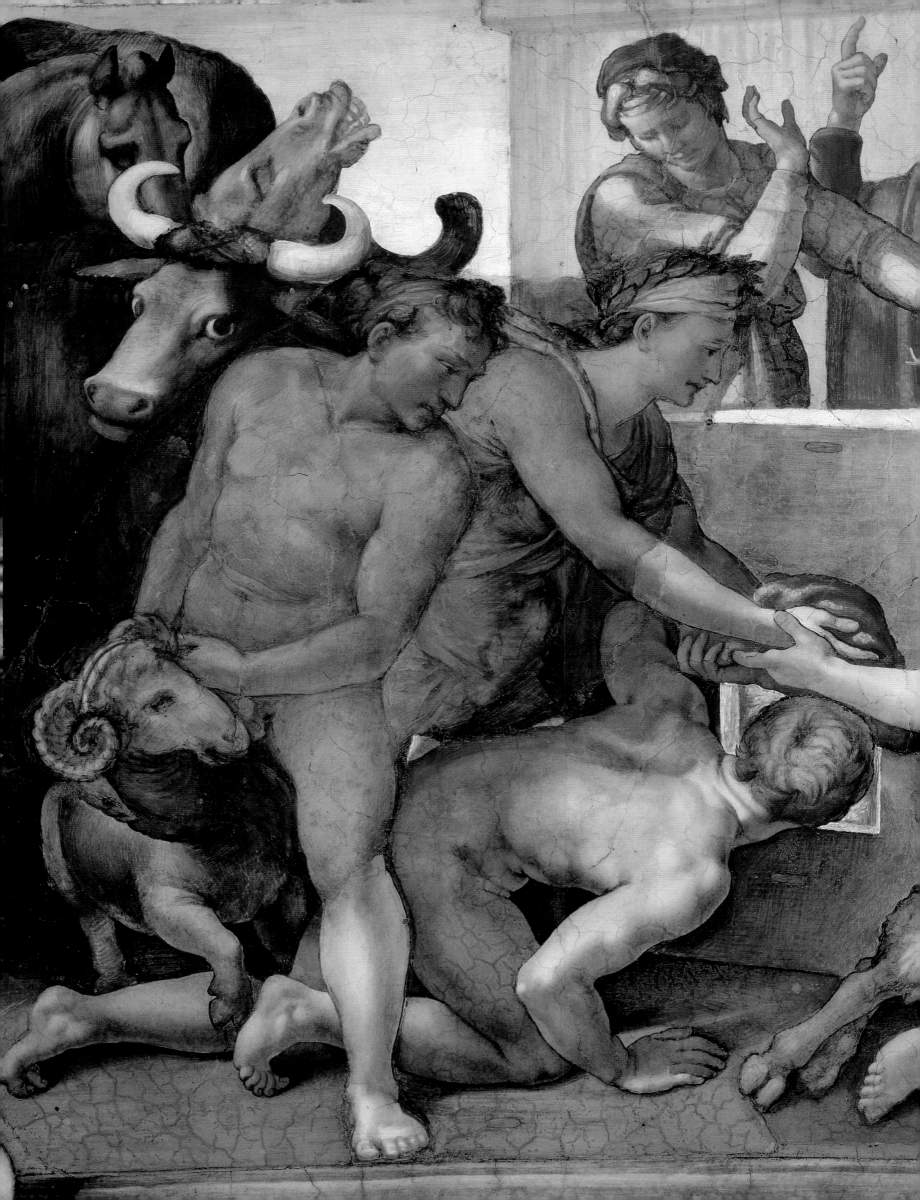

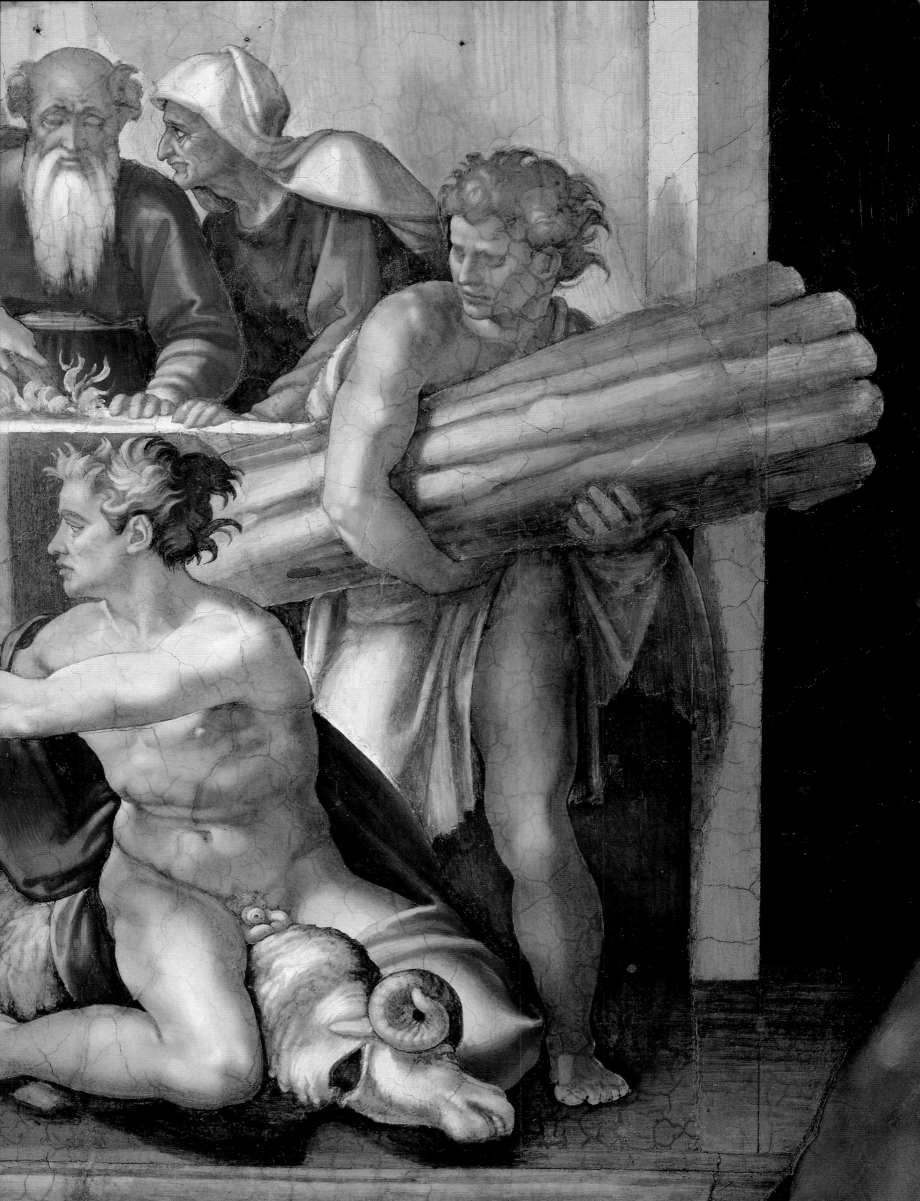

In the center, Noah officiates at the sacrifice. Giving thanks to the Lord for his salvation from the waters, the patriarch is wearing the same blood-red tunic that he wore when he was tilling the vineyard in the background of the *Drunkenness of Noah*. The work of assistants has been detected in the figure of Noah's wife on the right, surrounded by rigid outlines and modeled in a cursory manner, and also in the one—derived from a relief representing the story of Meleager on a Roman sarcophagus—of the youth on the left who, lighting the fire under the altar with a torch, shields his face from the heat with his hand.

Before the restoration.

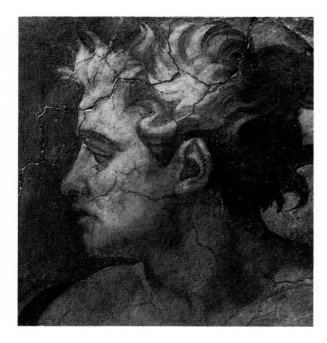

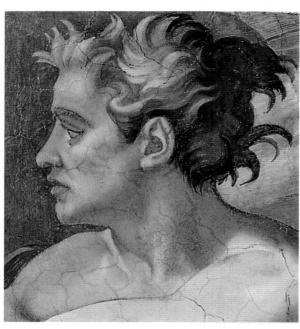

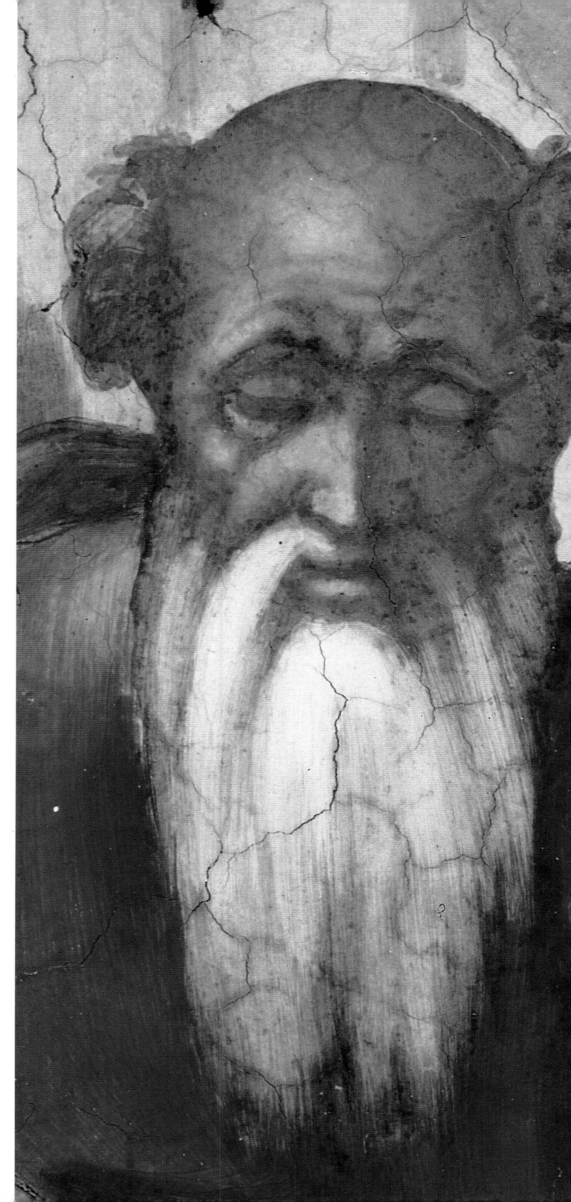

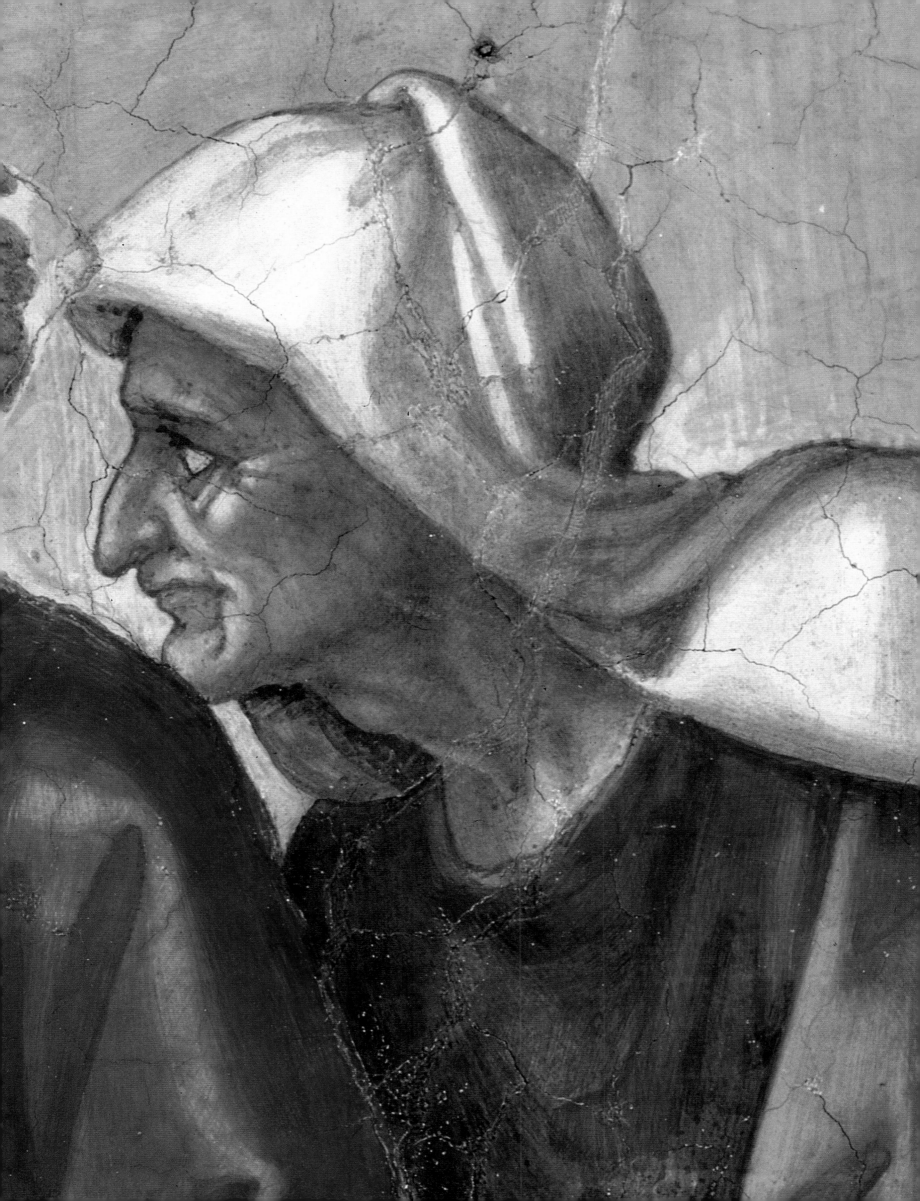

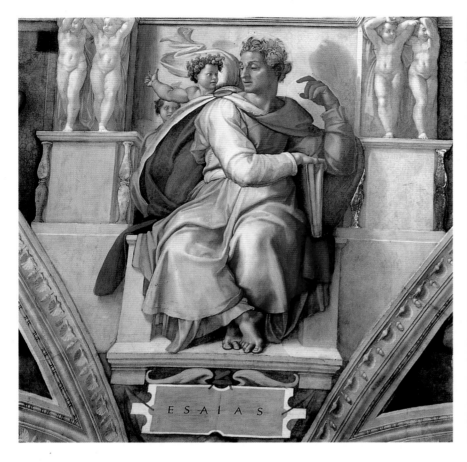

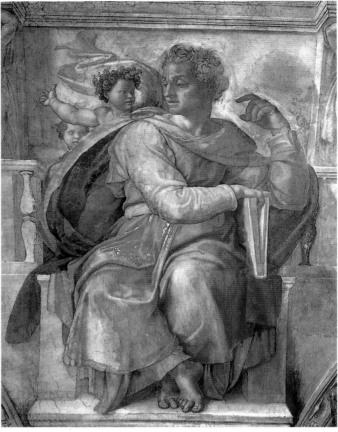

Before the restoration.

A prophet of the Passion, Isaiah has interrupted his reading of the book, which he keeps open with his right hand. As if his attention were being attracted by the boy behind him, he turns his face to the left with an anguished expression. However, his eyes are not focused on anything: the vision that disturbs him is an interior one, and his tension is expressed by the way he contorts his limbs, which is reflected in his head, shoulders, arms, and crossed feet. This movement is stressed by the arc of the blue mantle lined with green and the folds of the grayish-white robe and rose tunic.

As Gianluigi Colalucci has observed, the remarkable light quality of the gray hair is obtained by shading the curls with very dark brown—the effect is rather like the shadows a sculptor creates in marble with a drill—and by painting the locks with a mixture of black and lime white.

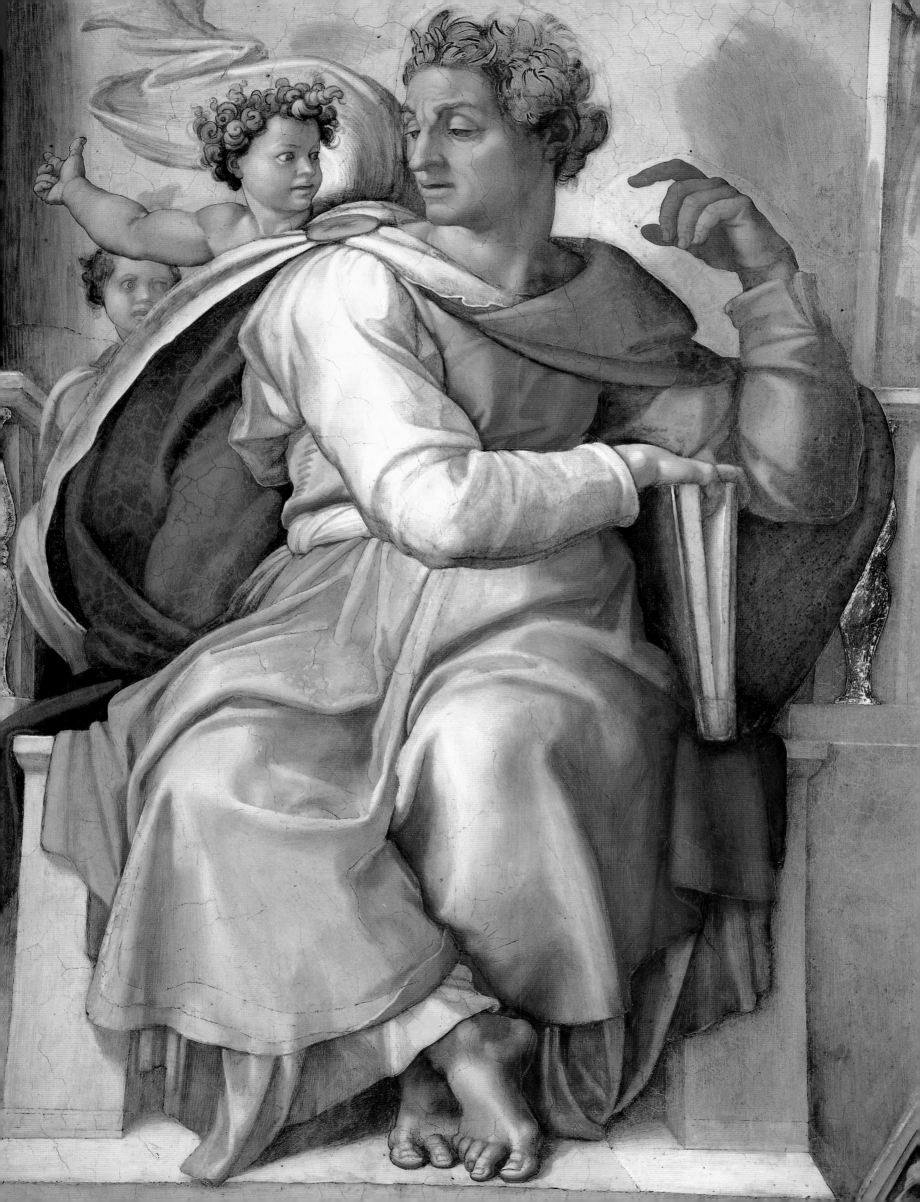

FOURTH BAY OF THE CEILING

In the central panel—between the spandrels—Michelangelo painted the two scenes of the Temptation and Expulsion of Adam and Eve from the Garden of Eden. Like the following scene—the Creation of Eve—the fresco was executed during the first stage of the work, although the rapid transformation of the artist's style is evident, with a drastic reduction in the use of assistants. Not only did the number of *giornate* decrease, while the size of the figures increased, but the structure of the composition became simpler and more powerful, the gestures more direct and peremptory. On the left, in a space delimited by the leafy boughs of the tree standing out against the bright sky, and the moderate diagonal formed by the rocks, beyond the trunk of a dead tree, a colloquy of gestures takes

contracted and suddenly aged, their drawn faces vividly expressing their remorse and anguish.

The scenes in the center of the ceiling are in reverse order to the historical sequence. In the typological interpretation of the scene, the Tree of Knowledge of Good and Evil—in a dominant central position between the two episodes of the Temptation and the Expulsion—foreshadows the theme of the Passion as the figure of the Lignum Vitae and the Cross, which, through Christ, became the instrument of redemption. Besides, as J. O'Malley has observed, the "theology of the Renaissance," which inspired the sermons in the form of panegyrics delivered by preachers in the Sistine Chapel, considered the Fall to be an event that had almost the same importance as the

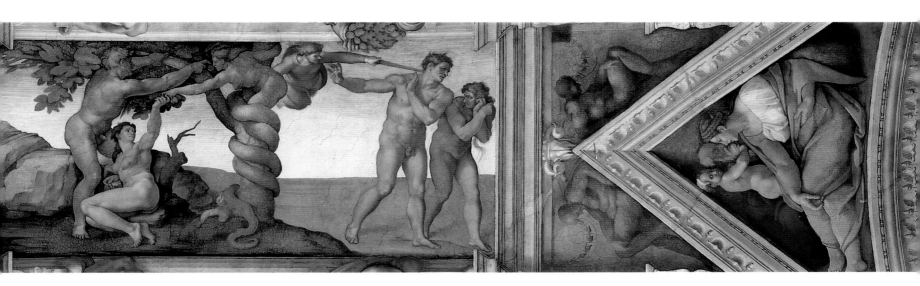

place between the tempting serpent—which has assumed the appearance of a woman—and Adam and Eve, with their youthful, athletic bodies, bathed in a rosy light. On the right, an angel extends his sword to show the sinners the way to exile from the Garden of Eden. In a desolate landscape, Adam and Eve set out toward their destiny of pain and death, their bodies

Creation and the Incarnation in the history of mankind. Although it was catastrophic, it was celebrated as *felix culpa* (happy fault) in a hymn—the so-called "Exultet"—that had a central role in the liturgy of Holy Saturday: "O felix culpa, quae talem ac tantum meruit habere Redemptorem" (O happy fault, which was rewarded with a Redeemer of such greatness).

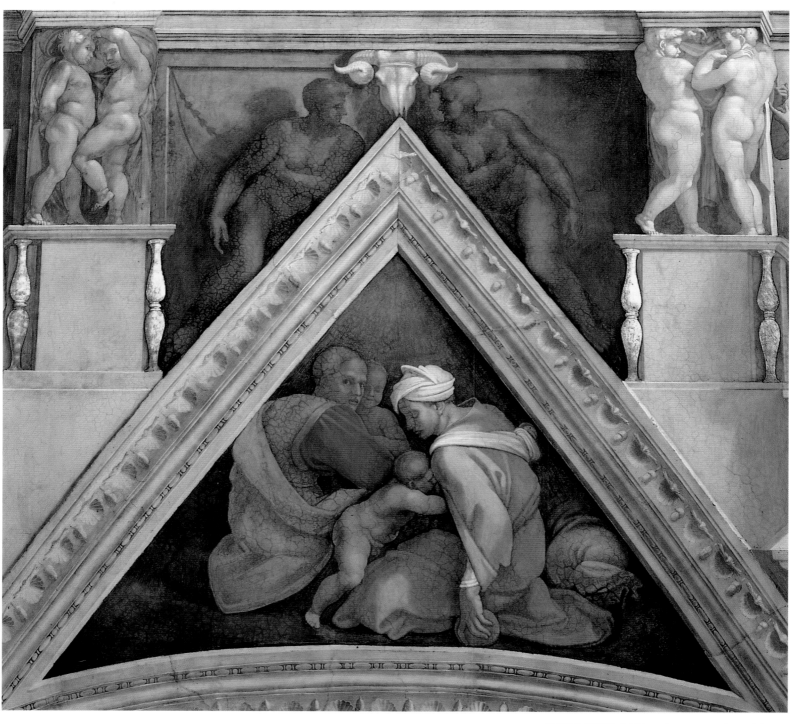

This spandrel, which is above the Uzziah-Jotham-Ahaz lunette, was painted in two *giornate*, while only one was required for the two bronze-colored male nudes reclining on the cornice. Together with the child leaning toward her breast, the woman kneeling in the foreground forms a pyramidal group with the axis slightly to the right of that of the triangle constituted by the spandrel. The space on the left is occupied a little further back by another seated figure who also clasps a child, while on the right there is the foreshortened representation of a large sack. The colors of the clothes, especially the woman's pale pink mantle with iridescent green and yellow shadows, stand out against the gloomy, nocturnal background.

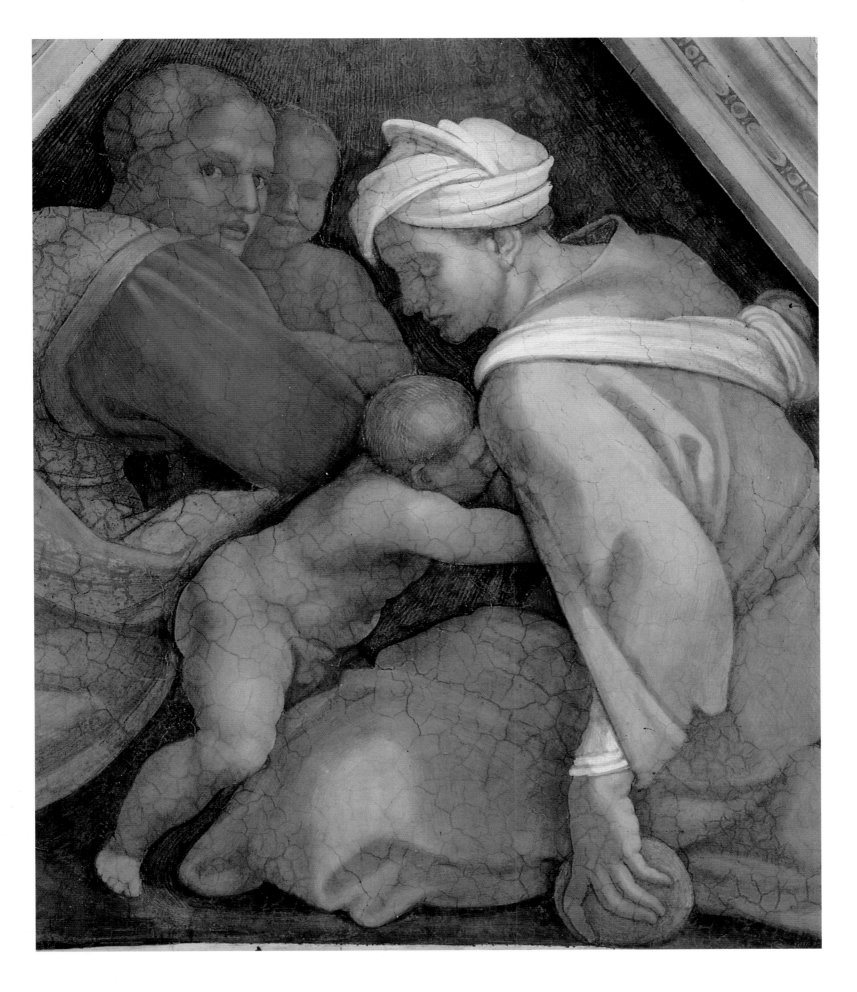

Like the preceding one, this spandrel, situated over the Hezekiah-Manasseh-Amon lunette, was painted in two *giornate*. One other *giornata* was needed for the bronze nudes, which are represented symmetrically with their backs toward each other, as if they were asleep. All of the space in the

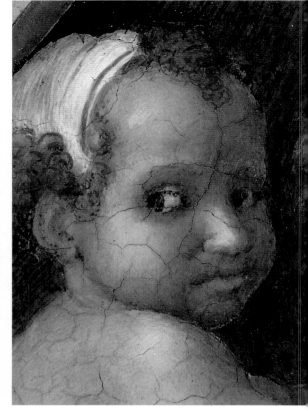

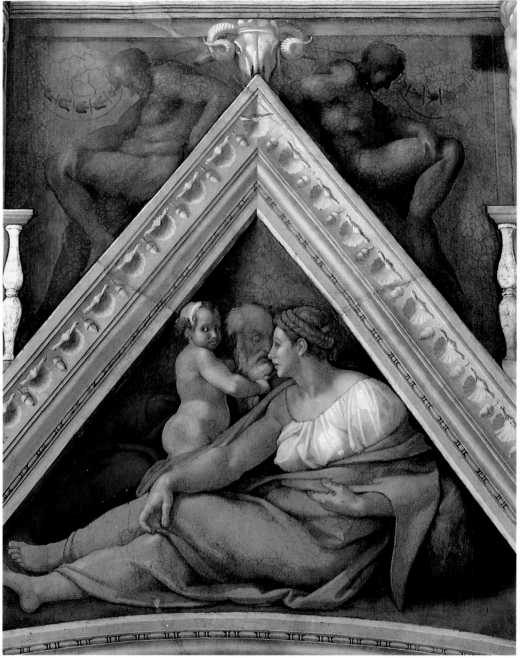

foreground is occupied by the figure in profile of the woman seated on the ground. Behind her, there is the figure of a child and the head of an old man emerging from the shadows. A bright light, however, gives prominence to the woman's green mantle with iridescent yellow shadows, her white shirt, and the violet scarf falling from her shoulder along her right arm, heightening the contrast with the figures behind.

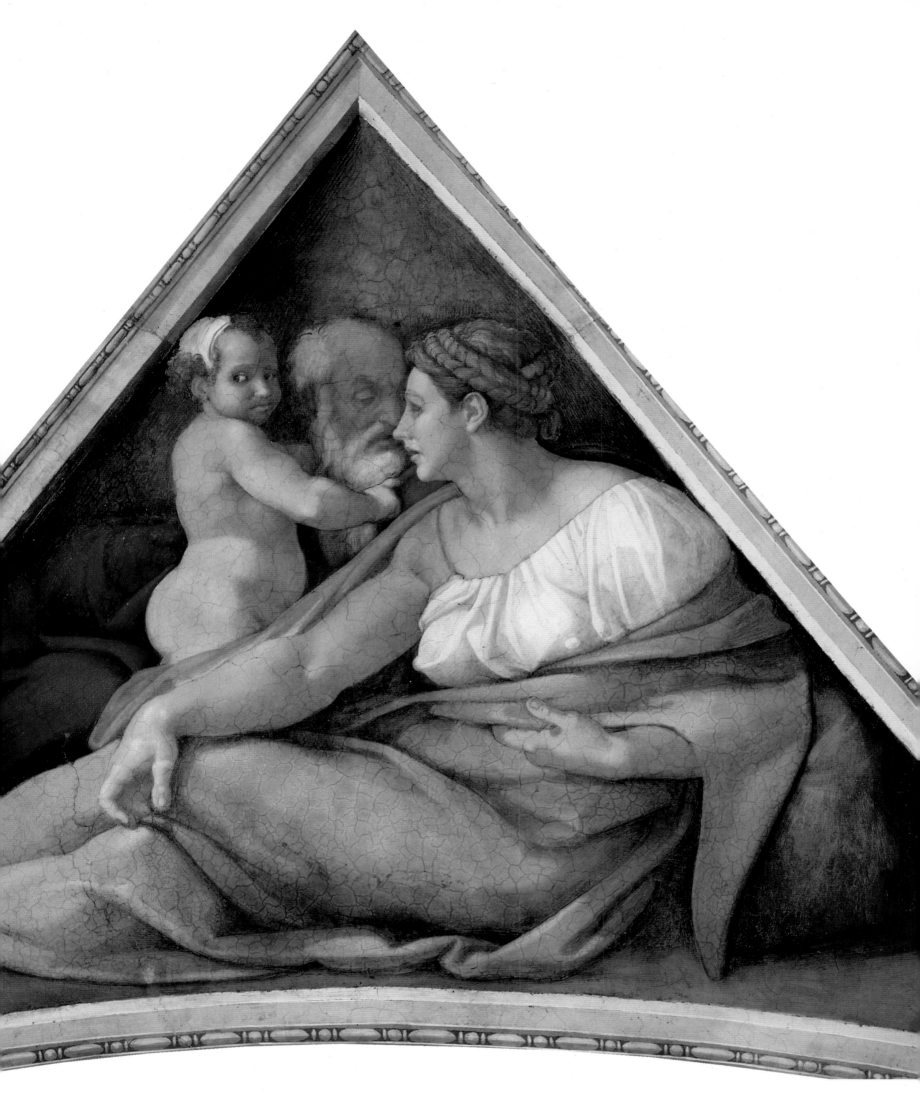

145

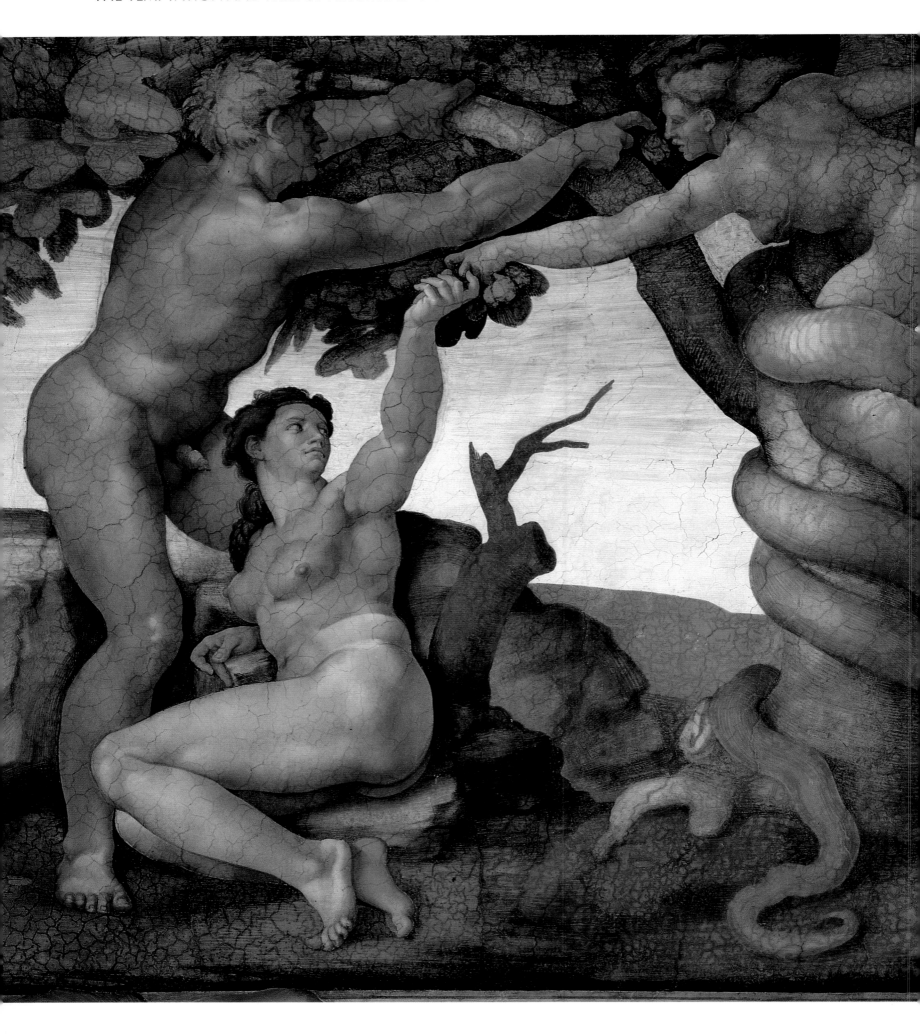

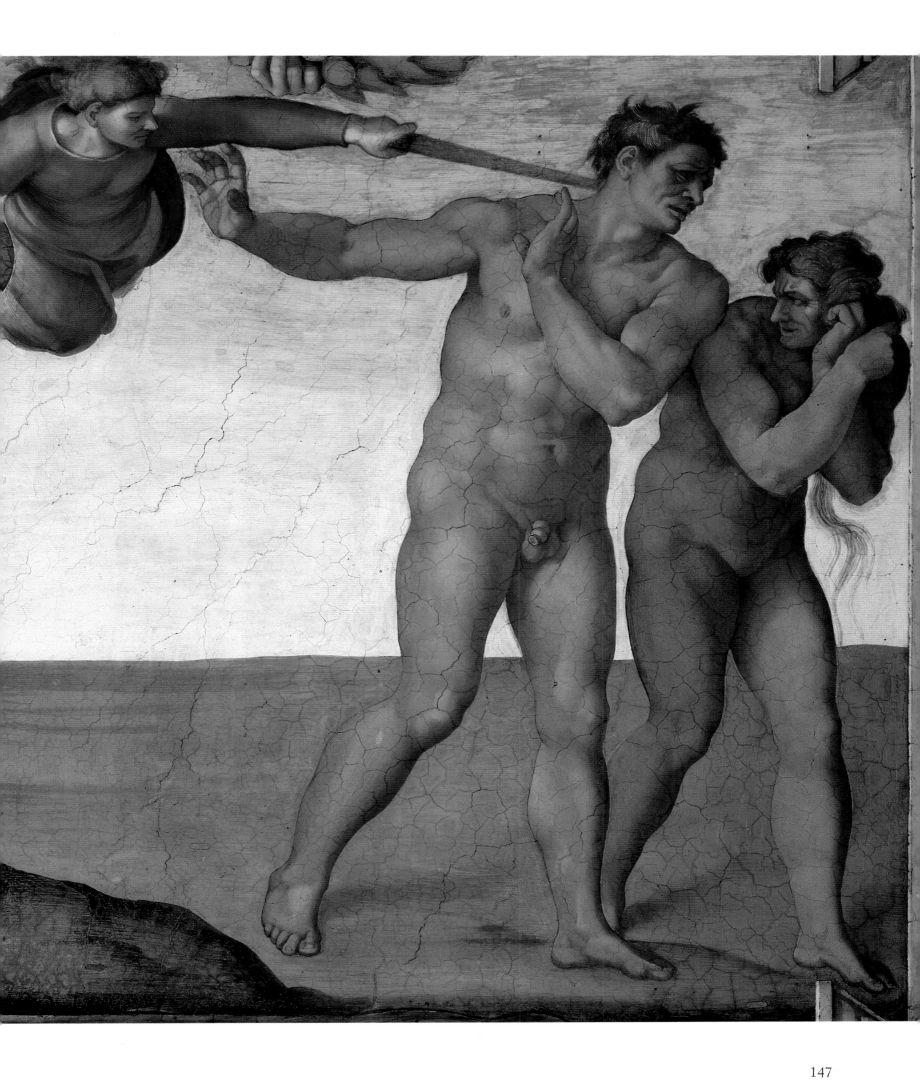

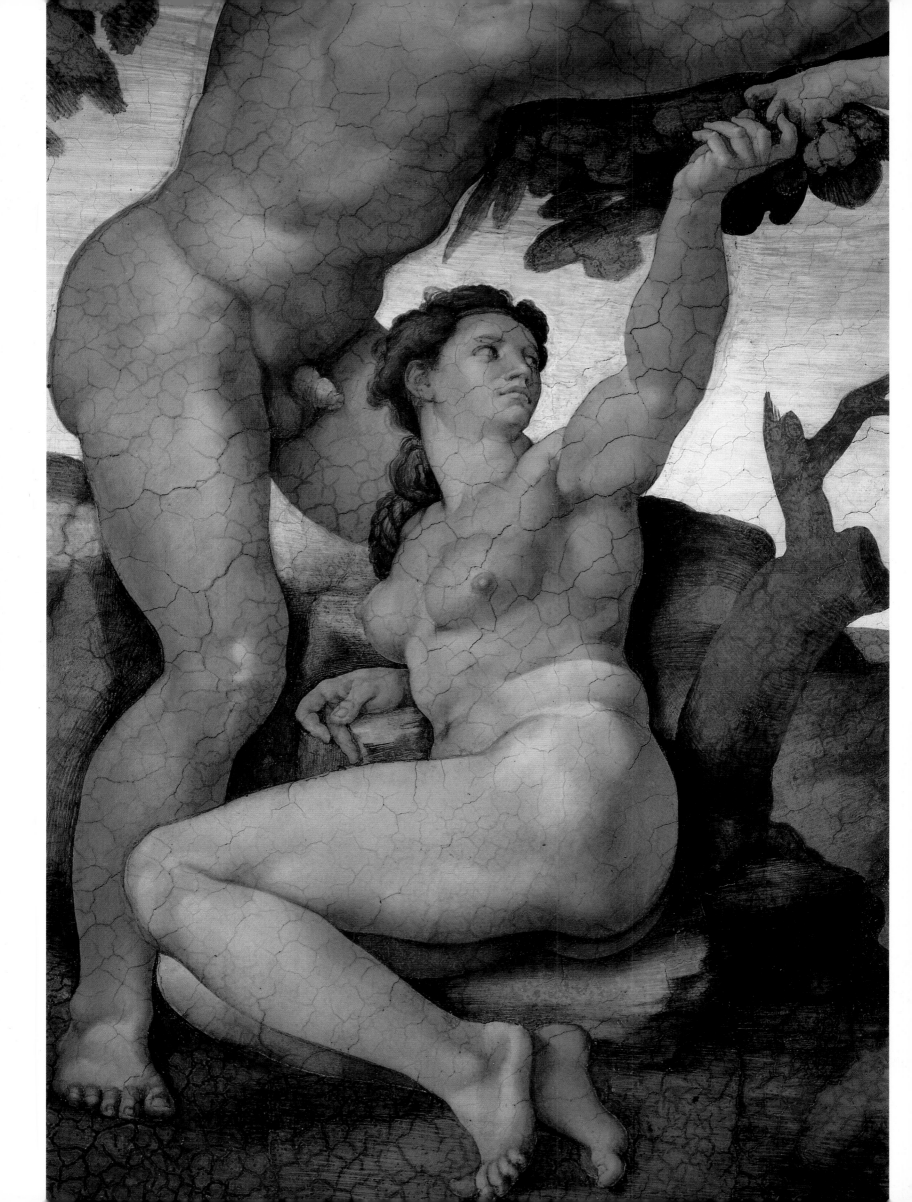

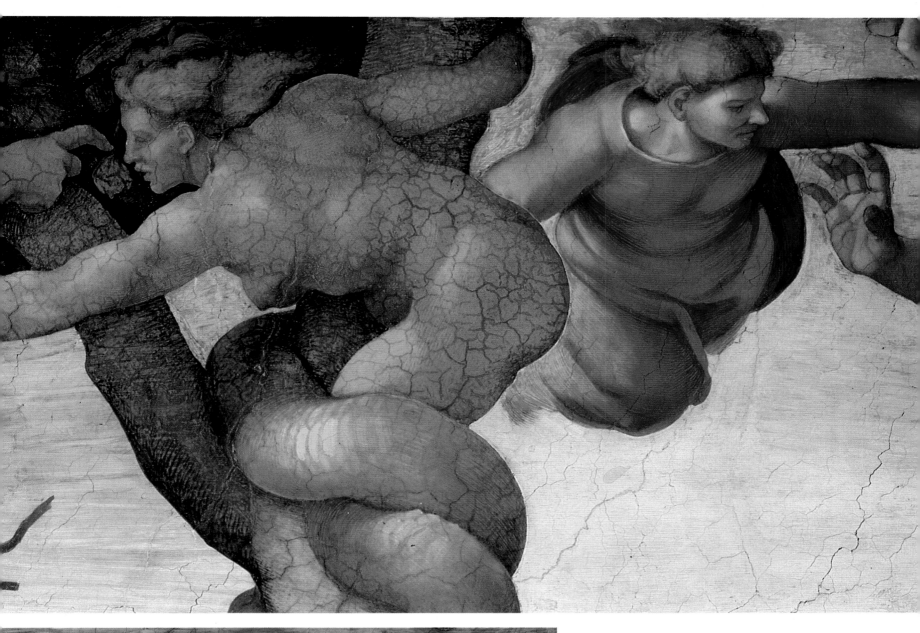

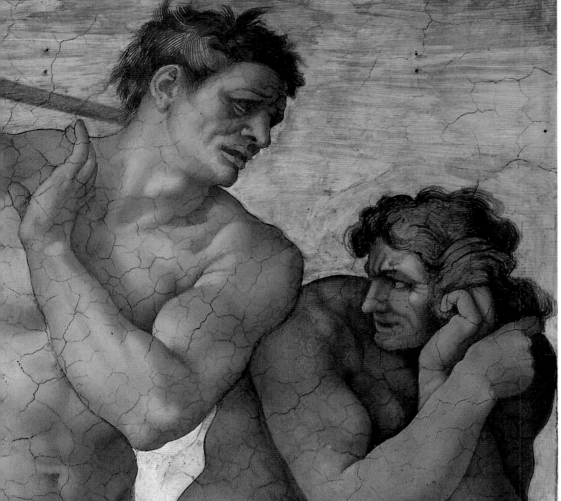

Michelangelo painted the central panel in thirteen *giornate*, beginning with the top left corner, where the foliage of the tree, painted with wide, fluid brushstrokes, stands out against the smalt-blue sky. The cleaning has restored the contrast between the warm tones of the flesh and the cool ones of the sky, the foliage, and the tree trunk in the scene of the Temptation. It also reveals the diversity of the modeling: for instance, Eve's foreshortened body is rendered with soft, light passages of chiaroscuro, while that of the tempter is painted with more rigid brushstrokes that create a dense texture, particularly evident in the coils of the serpent's tail, with scales of green changing to yellow in the highlights and red in the shadows. In the scene of the Expulsion, the red of the angel's robe has recovered its brightness, while the flesh tones of Adam and Eve were obtained "with glazes of raw umber and *terre noire* over a base tone of ocher, raw umber, and white" (Gianluigi Colalucci).

149

FIFTH BAY OF THE CEILING

Vasari's succinct but vivid description of Michelangelo's *Creation of Eve* outlines the complex meanings of the scene. Of the nude Adam and Eve, he says: "One [is] almost dead from being imprisoned by sleep, while the other comes alive completely reawakened by the benediction of God. The brush of this most ingenious artisan reveals the true difference between sleep and awakening, as well as how stable and firm His Divine Majesty may appear when speaking in human terms."

Michelangelo painted the scene in the center of the vault, immediately be-

of the Lord appears for the first time. He is also present in all the scenes above the "presbytery," but not in the four previous ones. The central position of this scene creates a further division in the nine scenes in the ceiling. This is in addition to the pattern created by the alternation of larger and smaller panels, and the arrangement by subject: three stories of the Creation of the world, three of Adam and Eve—from the Creation to the Fall—and three of Noah, presented as the second Adam, saved *from* the flood, *through* the flood, seen as the symbol of the baptism.

yond the screen that originally divided the interior of the chapel into two almost equal parts. During the sixteenth century, this was moved about five meters toward the entrance in order to enlarge the "presbytery," the area reserved for the liturgical ceremonies in the presence of the pope. Proceeding from the entrance of the chapel toward the altar in the *Creation of Eve*, the figure

The central position of the scene above the area before altar—the Sanctum Sanctorum—may be explained by the fact that Eve was often thought to prefigure the Virgin, who, in Christian theology, is herself considered to foreshadow the Church. According to an interpretation that dates back to the writings of the Fathers of the Church and was widespread in the Renais-

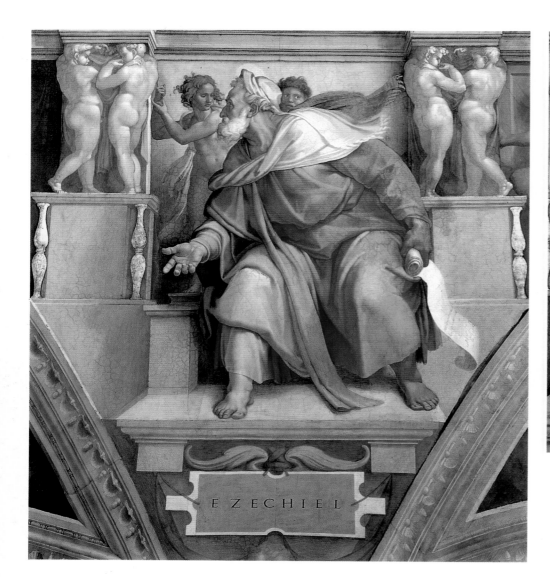

E Z E C H I E L

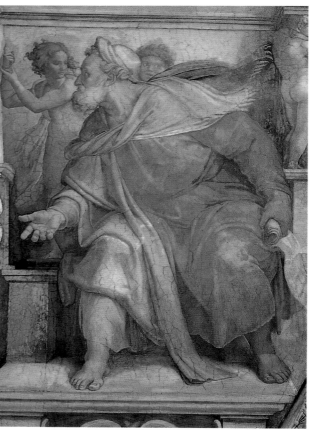

Before the restoration.

The vigorous figure of the prophet stands out clearly against the light background. It is painted with clear brushstrokes, strong contrasts of light and shade, and color accords between the bright red of the tunic and the colder tones of both the cloth wrapped around his head and shoulders, and the mantle. The profile of the head is depicted in detail, accentuating its expressiveness, while that of the youth he appears to be addressing is rendered with soft glazes of color. The plasticity of the figure is magnificently represented by the sculptural modeling, as well as by the neck and head, hands, and feet.

sance, the creation of Eve from Adam's rib alludes to the creation of the Church from the blood and water issuing from the side of Christ on the Cross.

These various levels of meaning are confirmed by the presence of the prophet Ezekiel and the Cumaean Sibyl at the sides of the scene. Among the prophecies of Ezekiel is that of the birth of the Virgin and the vision of the temple corrupted by sin and abandoned by God, followed by the construction of a new temple to which the Lord would return and from which a miraculous river bearing fertility would pour forth. Particularly significant, however, is the position of the Cumaean Sibyl, with whom was associated Virgil's fourth Eclogue, with the promise of the coming of a new generation from heaven that would lead to the resumption of

the Golden Age: "Now is come the last age of the song of Cumae; / The great line of the centuries begins anew. / Now the Virgin returns, the reign of Saturn returns; / Now a new generation descends from heaven on high." It was mainly on poems like this—interpreted as the prophecy of the birth of the Redeemer during the reign of Augustus—that the idea that the whole of antiquity should be seen as a period of preparation for the Gospels was founded. This belief was widespread in the Renaissance, and was linked to the attempt to reconcile classical culture with Christian doctrine. Thus the conviction was engendered that, although God revealed himself more directly through the prophets of the Old Testament, fragments of the Revelation were also communicated to the pagan world

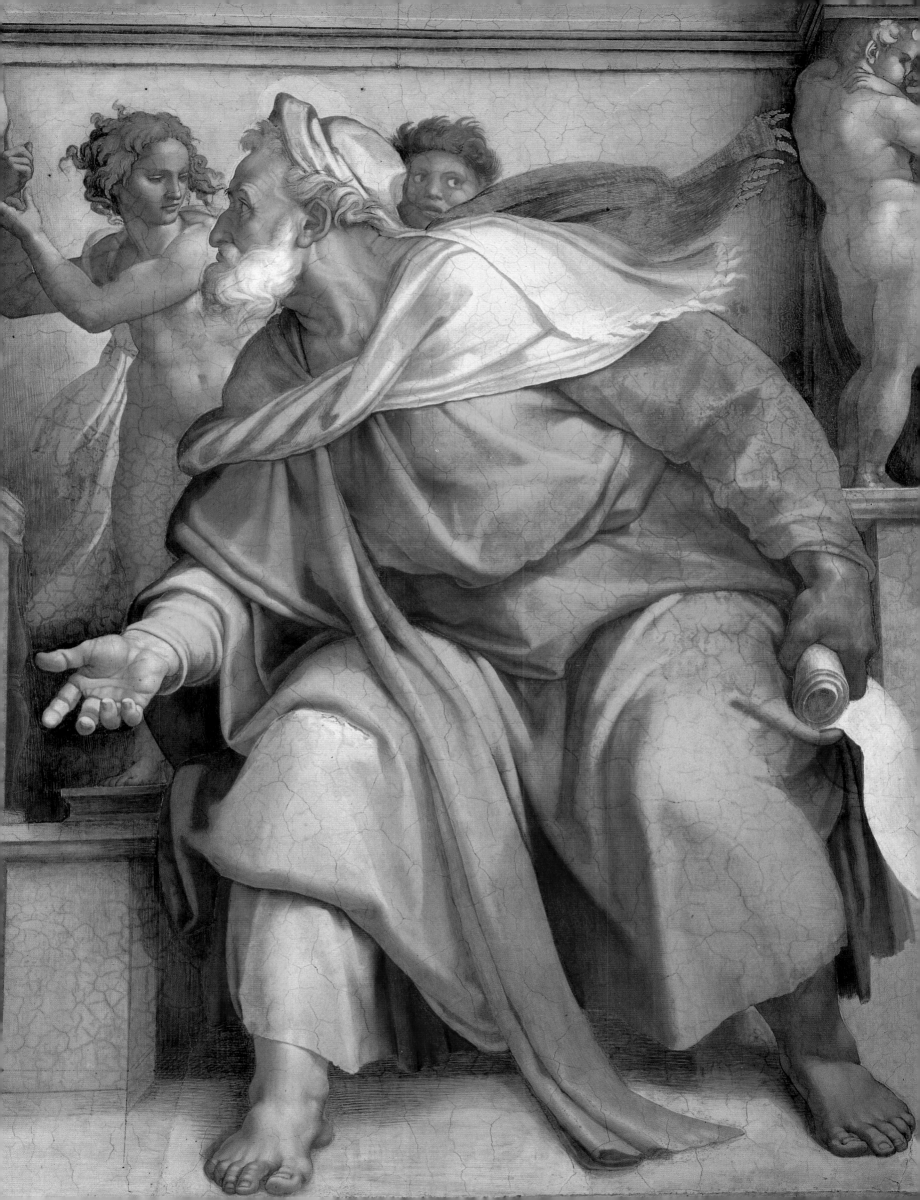

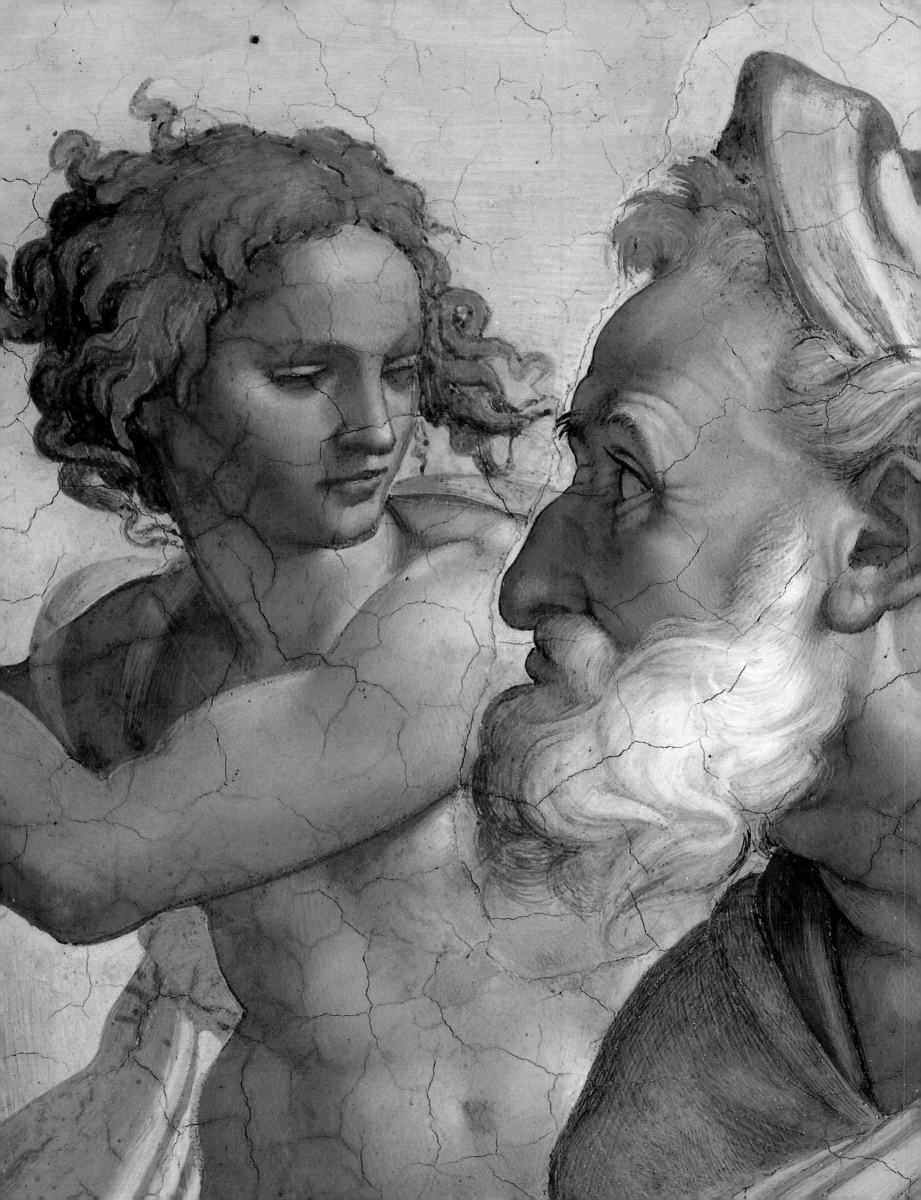

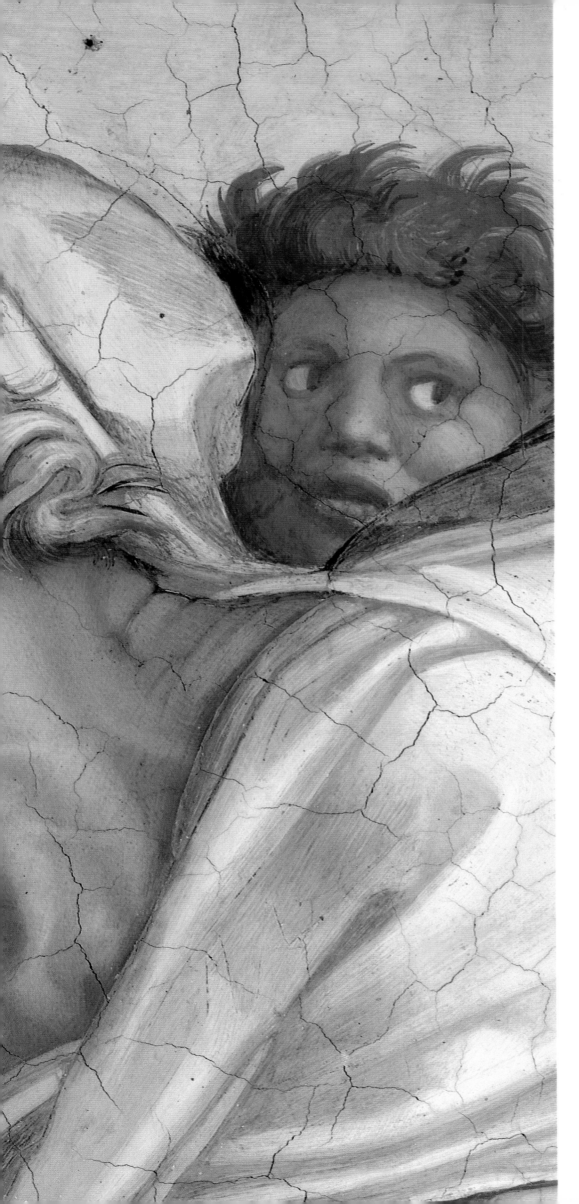

through the sibyls, priestesses, and seers.

At the sides of the central scene, in the four *ignudi* who hold the yellow ribbons interwoven with the bronze-colored medallions, the use of *contrapposto* with a variety of the gestures and poses has now replaced the symmetrical arrangement of the figures. The relationship between the figures, placed opposite each other in pairs, is based on increasingly free and complex rhythmical correspondences, with rotating movements and pronounced bending of the limbs. In contrast to the first bays, where the *ignudi* were always painted after the central panels, from the *Creation of Eve* onward, Michelangelo painted them before beginning the associated narrative scenes. This change may be linked to other modifications made in the second stage of the work, after the scaffolding had been dismantled and re-erected in order to paint the other half of the vault, and, above all, after the artist had been able to observe from floor level the part he had painted thus far. Not only was the size of the figures increased—this was also the case with the prophets and sibyls—but, in the second half of the ceiling, the *ignudi* tend to extend over the frames of the narrative scenes, sometimes encroaching on them, and they have greater plastic and dynamic impact.

Thus the architectural framework and the painted figures appear to be better integrated, with a polyphony that is more compact in its form. This, moreover, corresponds perfectly to the development of Michelangelo's vision as a sculptor, from the projects for the tomb of Julius II to those for the facade of San Lorenzo and the Medicean tombs in the New Sacristy.

The subjects of the scenes painted on the bronze-colored medallions are a matter of debate: the one surmounting the figure of the prophet Ezekiel might represent the Destruction of the Tribe of Ahab, Followers of Baal, or, according to a different interpretation, the Death of Nicanor; the one above the Cumaean Sibyl depicts either David before the prophet Nathan, or Alexander before the High Priest of Jerusalem.

155

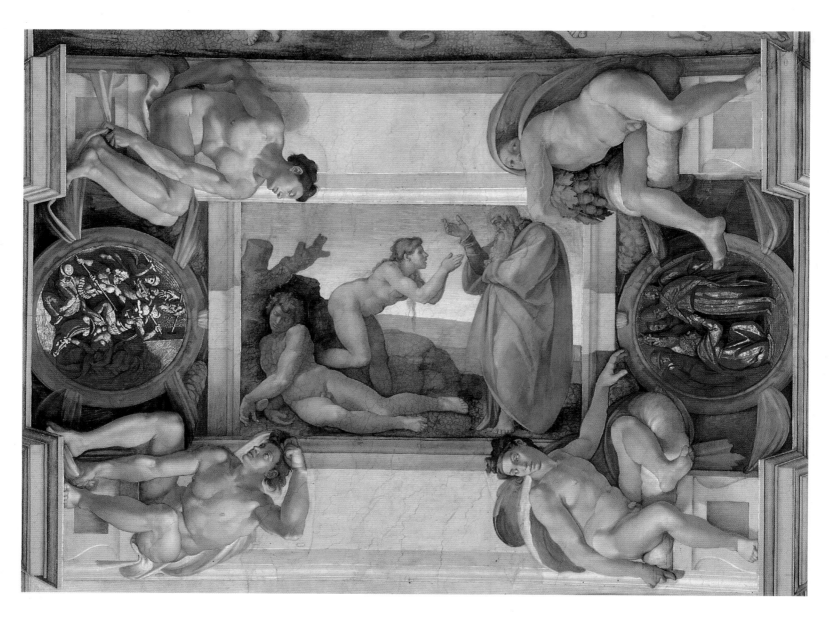

The central scene was painted in four *giornate*, starting from the head of the sleeping Adam, his arm, and part of the tree; then continuing with the rest of his figure; then with the figure of Eve, and the landscape in the background; and concluding with the figure of the Creator. The cartoons were all transferred by pouncing. *Pentimenti* have been found around Adam's head, in the branches of the dead tree, and in Eve's body and hair.

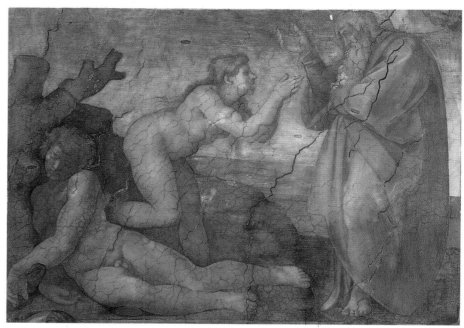

Before the restoration.

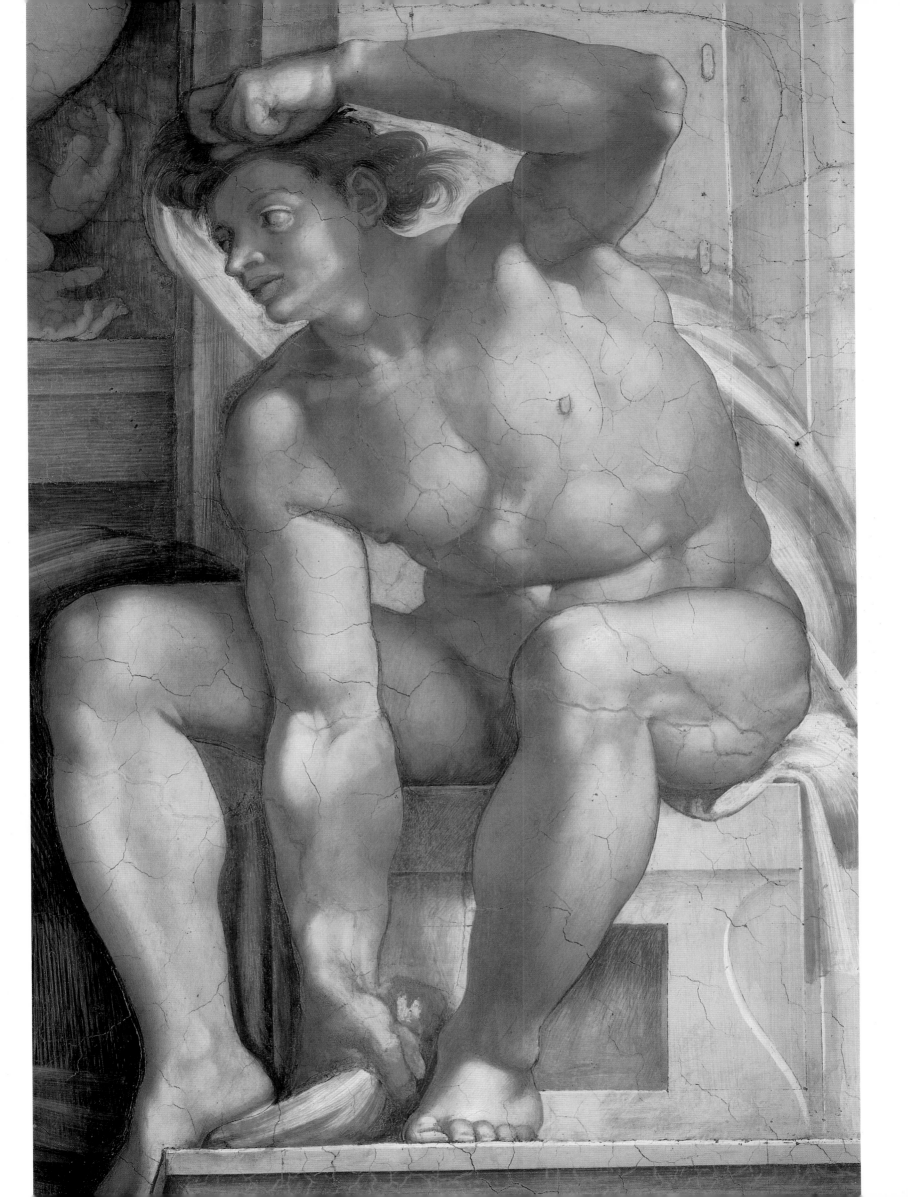

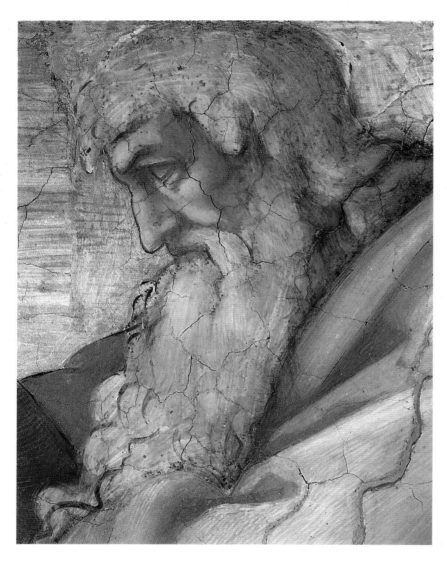

In response to the gesture and intense gaze of the Creator, Eve appears to rise from the rocks behind Adam rather than from his body, extending her joined hands. The bodies of the couple appear to be those of adolescents, in contrast to those depicted in the scene of the Fall and Expulsion. The figure of the Lord, wrapped in a voluminous violet mantle that only allows a glimpse of the red tunic he wears in the other scenes of the Creation, draws on an iconographic tradition dating back to Giotto and Masaccio, from which it is differentiated, however, by the blond hair and beard framing the face.

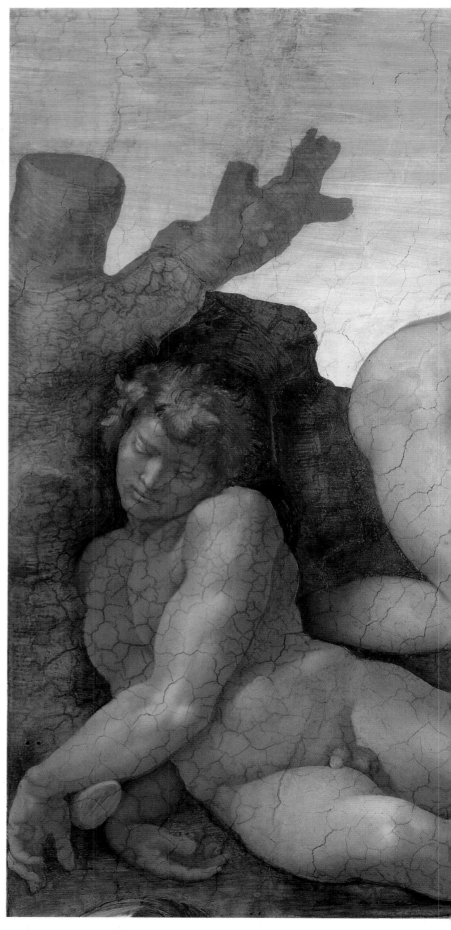

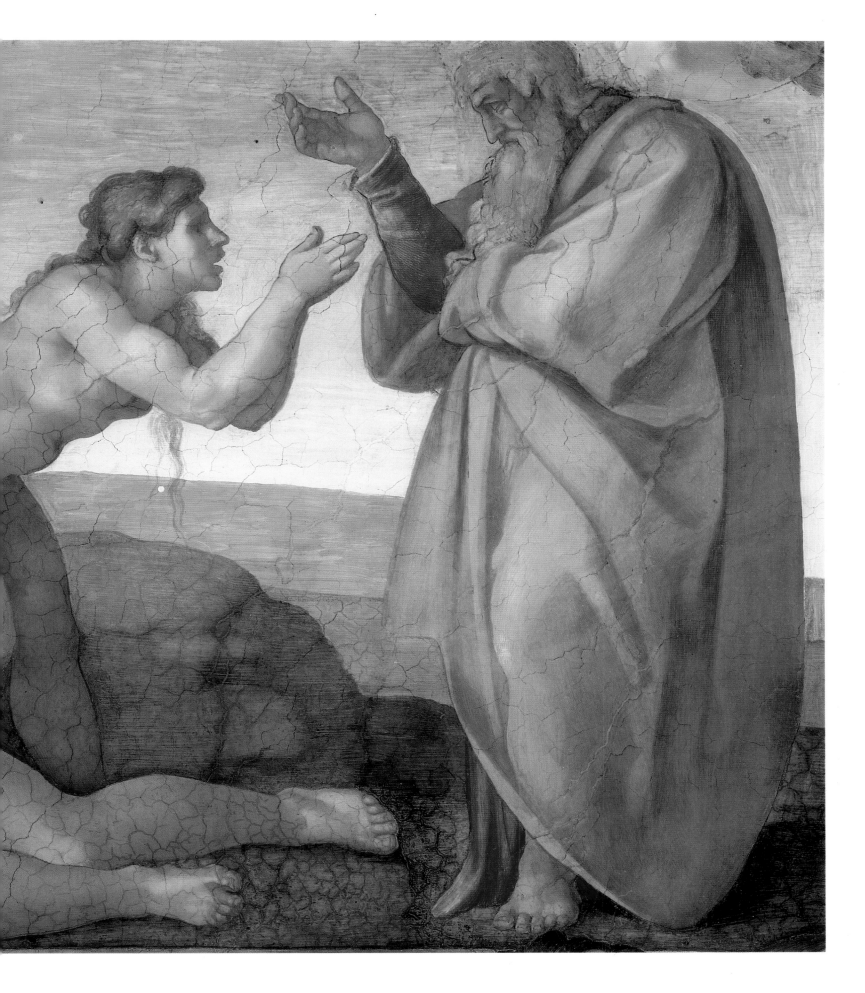

The Cumaean Sibyl is depicted as a massively built old woman, with a dark complexion and a wrinkled face, completely absorbed in the difficult task of deciphering the meaning of what she is reading in the large book, which rests next to her on the side of the marble throne. This figure, with its sculptural majesty, was painted in seven *giornate*.

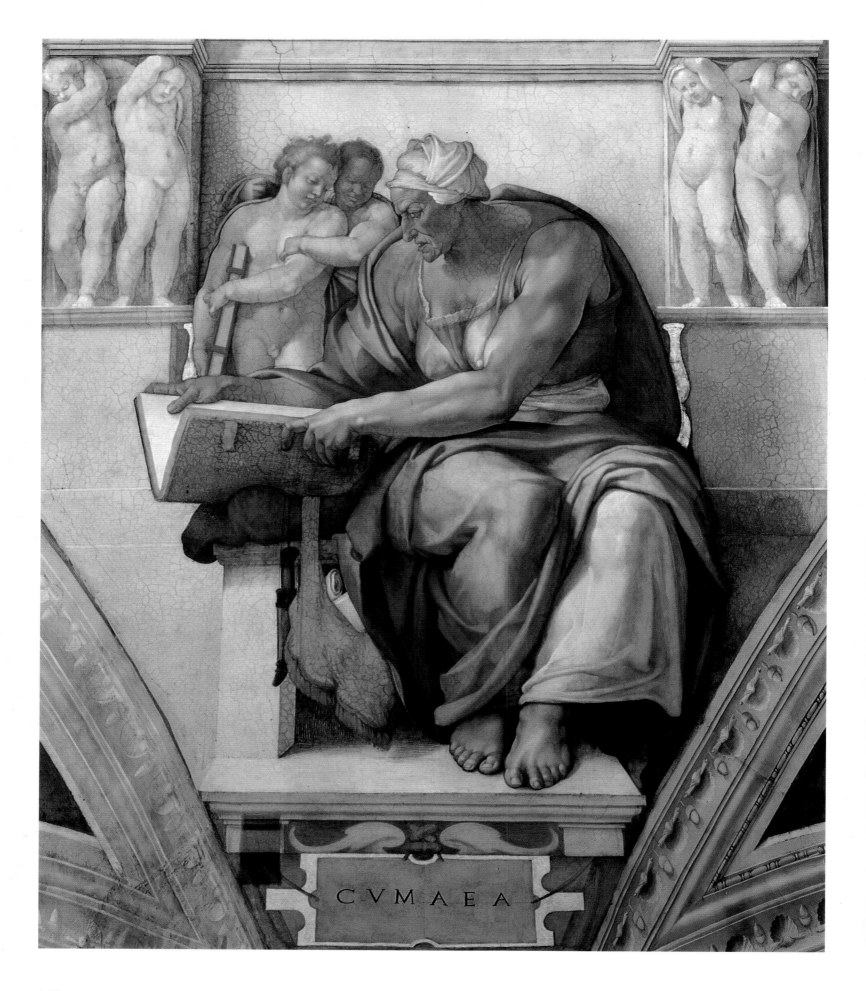

CVMAEA

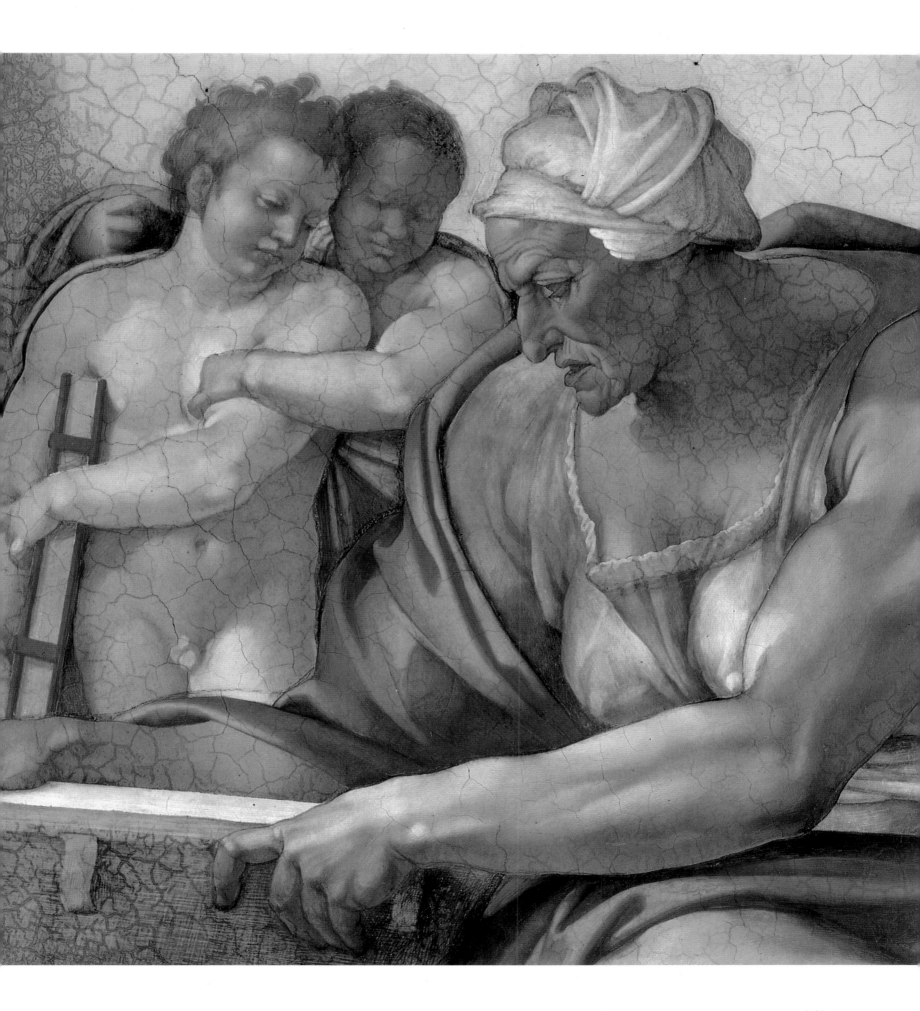

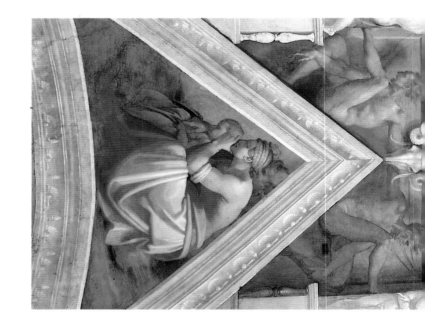

Sixth Bay of the Ceiling

Perhaps the best-known of the scenes in the Sistine Chapel, the Creation of Adam must also have aroused particular admiration among the artist's contemporaries, who discerned in it the materialization of one of the highest ideals of Renaissance culture: the "dignity" of man, created by God "in his own image." The famous *Oratio de hominis dignitate* by Giovanni Pico della Mirandola was one of the texts most frequently quoted in the sermons that the preachers delivered in the papal chapel, and the exaltation of the spiritual faculties of man was never separated from that of the beauty of the human body, "the mirror of God" and the culmination of the Creation. Although the bodies of the *ignudi* also

rather by the brush and design of a mere mortal." Seen against an indistinct natural background that is only just hinted at, as if it were the dawn of the world, the youthful, athletic figure reclining on a grassy slope, almost on the edge of an abyss, seems as if he is about to rise from the ground. He holds out his arm toward that of the Lord, who, borne aloft amidst a flight of angels, stands out brightly against the shell of shadow of his huge purple mantle. The remarkable invention of the outstretched arm and the forefingers about to meet becomes a metaphor for the vital energy that passes from the Creator to the creature fashioned in his image, awakening his heroic vigor. The body of Adam, for which there is a

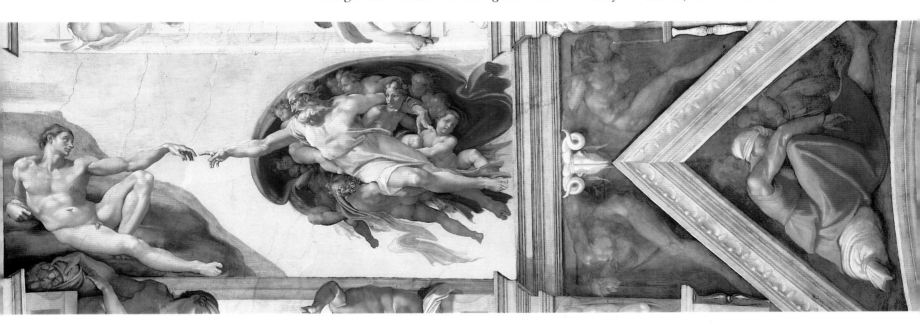

express this ideal through the series of continuous variations in their poses and the positions of their limbs, the figure of Adam, at the instant of the Creation, becomes its supreme manifestation.

Vasari describes Adam as "a figure whose beauty, pose, and contours are of such a quality that he seems newly created by his Supreme and First Creator

magnificent study in black and red chalk (now in the British Museum in London), is rendered with great softness with passages of chiaroscuro, but also with strong sculptural emphasis. His adolescent face, seen in profile, still lacking a definite expression, contrasts with the mature, intensely energetic one of the Lord, with his gray hair and long beard streaming in the air.

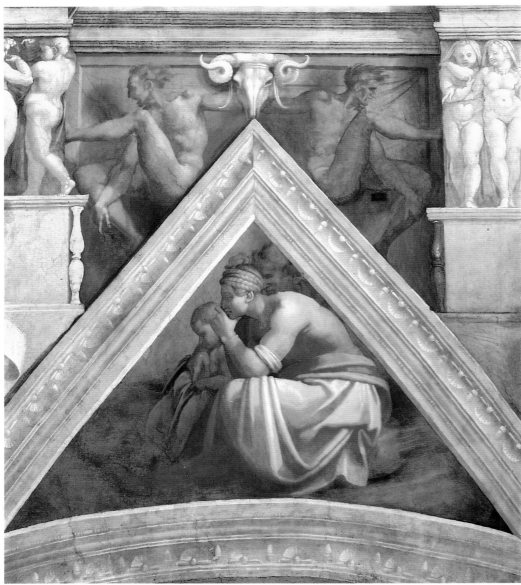

In the spandrel above the Rehoboam-Abijah lunette, Michelangelo painted a family group in two *giornate*. The woman, seen in profile, is seated in the foreground, in an absorbed attitude, her chin resting on her hand; with her other arm, she embraces her child. Behind her, the gray-haired head of a male figure emerges from the shadows. Above, on each side of the ram's skull, the bronze nudes no longer take the form of motionless, reclining figures, but are howling demons who struggle furiously in almost acrobatic positions in the restricted space enclosing them. Although their poses are perfectly symmetrical, their hair seems to be blown in the same direction, as if by a sudden gust of wind.

Before the restoration.

Above the opposite spandrel, on the other hand, the nudes seem to be bent forward and enchained. As he proceeded with his work, the variations on this theme seem to have stimulated the artist to make his creations increasingly difficult.

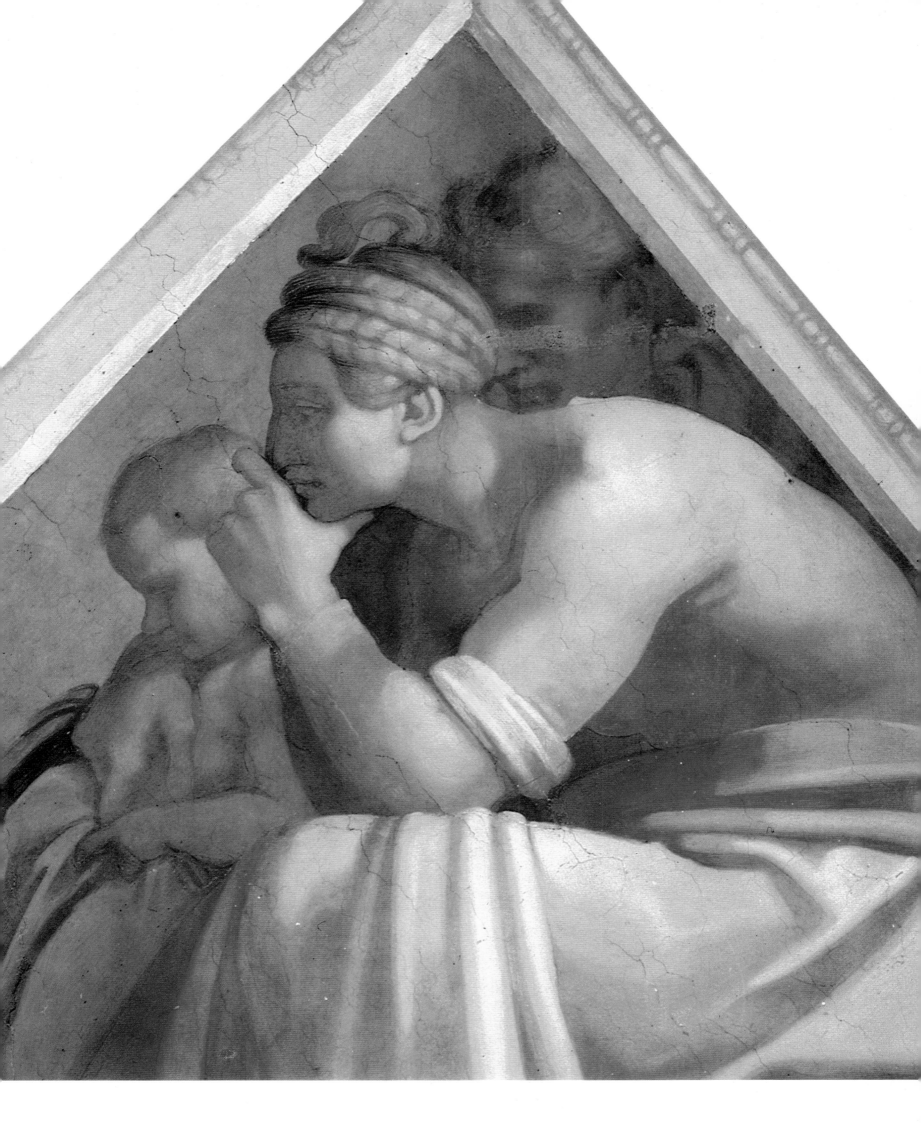

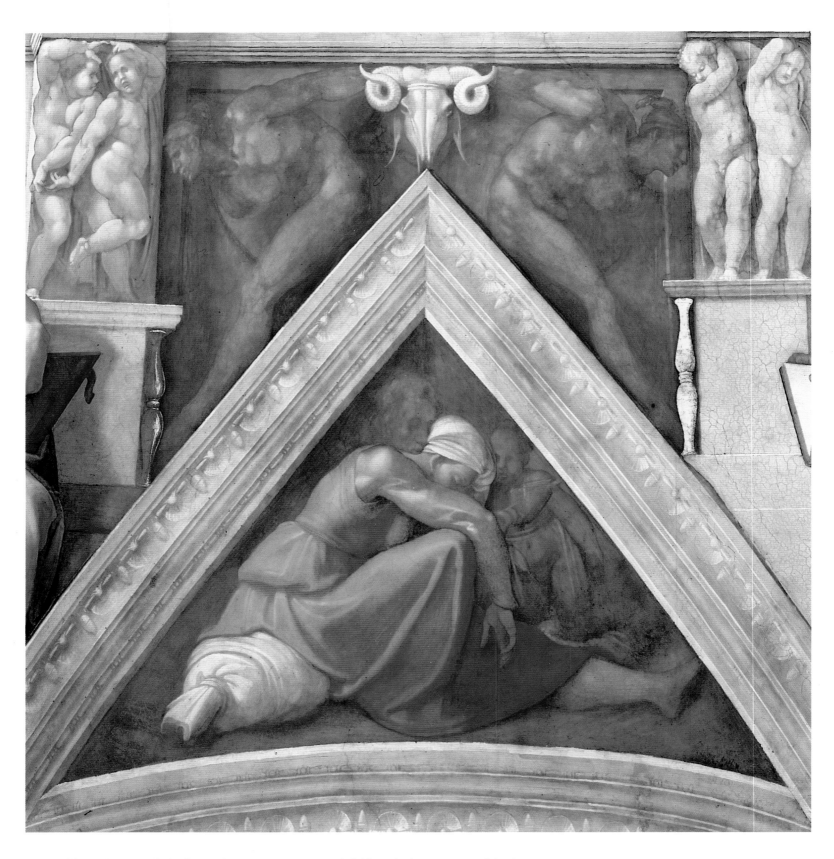

The field of the spandrel above the Asa-Jehoshaphat-Joram lunette is almost entirely occupied by the figure of the sleeping woman, seated in the foreground on a white sack. The brightness of the colors of her robe contrast with the shadows in the background, which shroud the figures of the man and child. With the exception of the lower right corner, the spandrel was executed in just one *giornata*. The cartoon was transferred to the *intonaco* by incision, with rapid, short strokes.

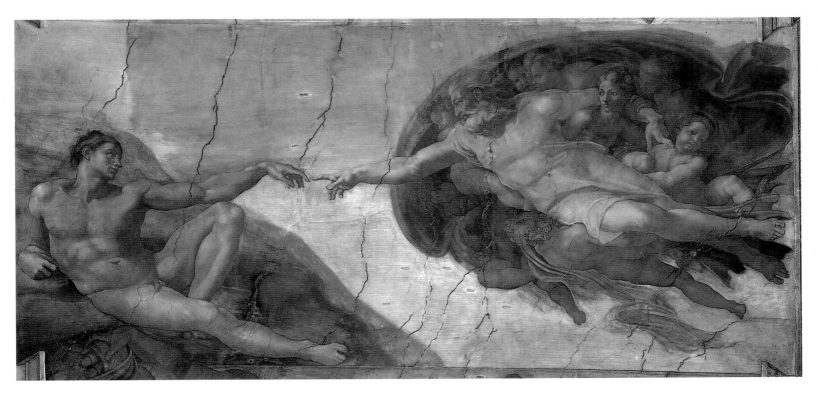

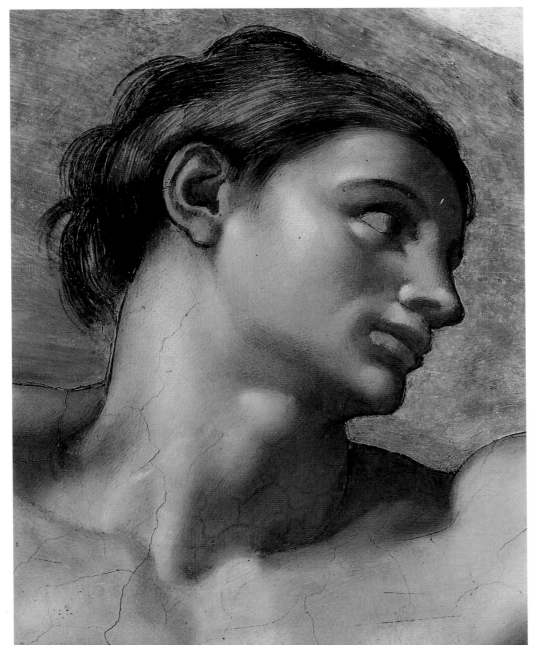

Before the restoration.

Before the recent restoration, the darkened glues covering the surface of the sky and heavy repainting had largely canceled the sense of vast space that characterized the scene, obliterating the tonal values in the modeling of the bodies and in the bright figure of the Creator, which originally stood out clearly against the concave of shadow of the large purple mantle. Not only has the cleaning revealed the brilliance of the original color harmonies, but it has also restored the impression of cosmic space.

The fresco was executed in sixteen *giornate*, starting from the right with the group with the Lord and angels, where the cartoons were transferred to the *intonaco* by pouncing, with direct incision in the pink tunic. On the other hand, the drawing of the figure of Adam, which had been studied with particular care, was transferred entirely by indirect incision.

167

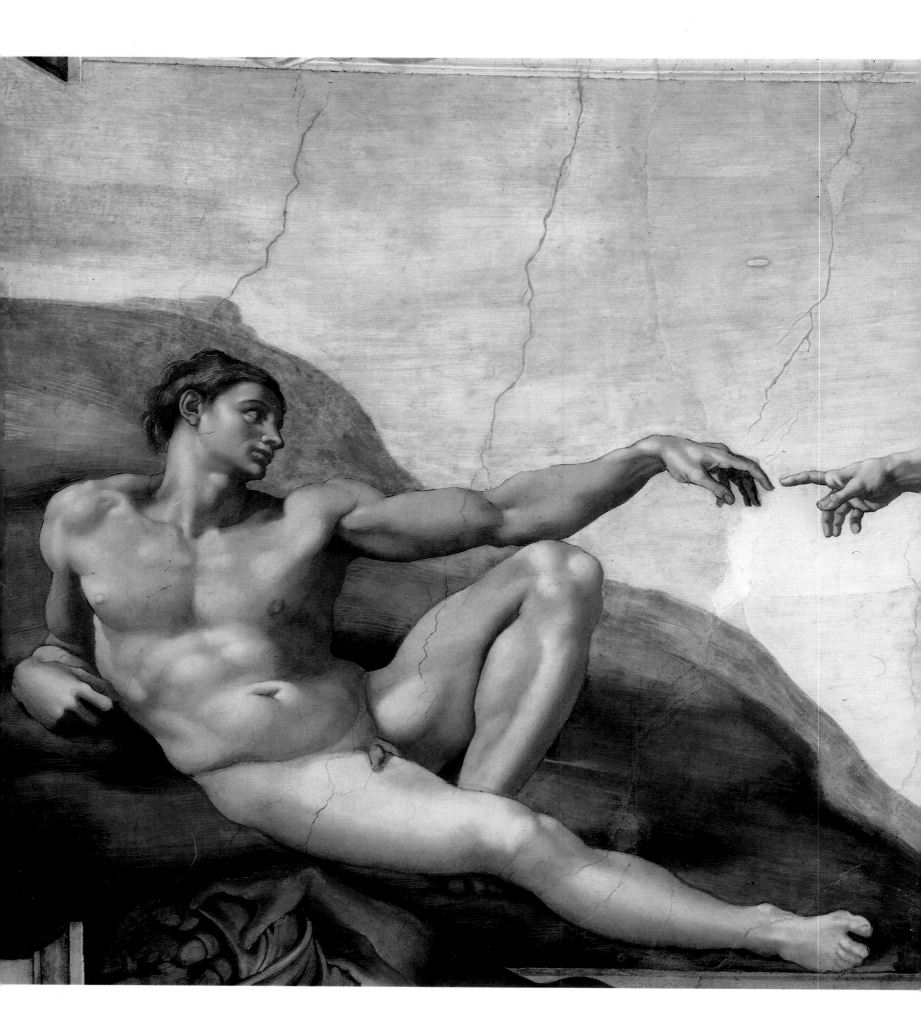

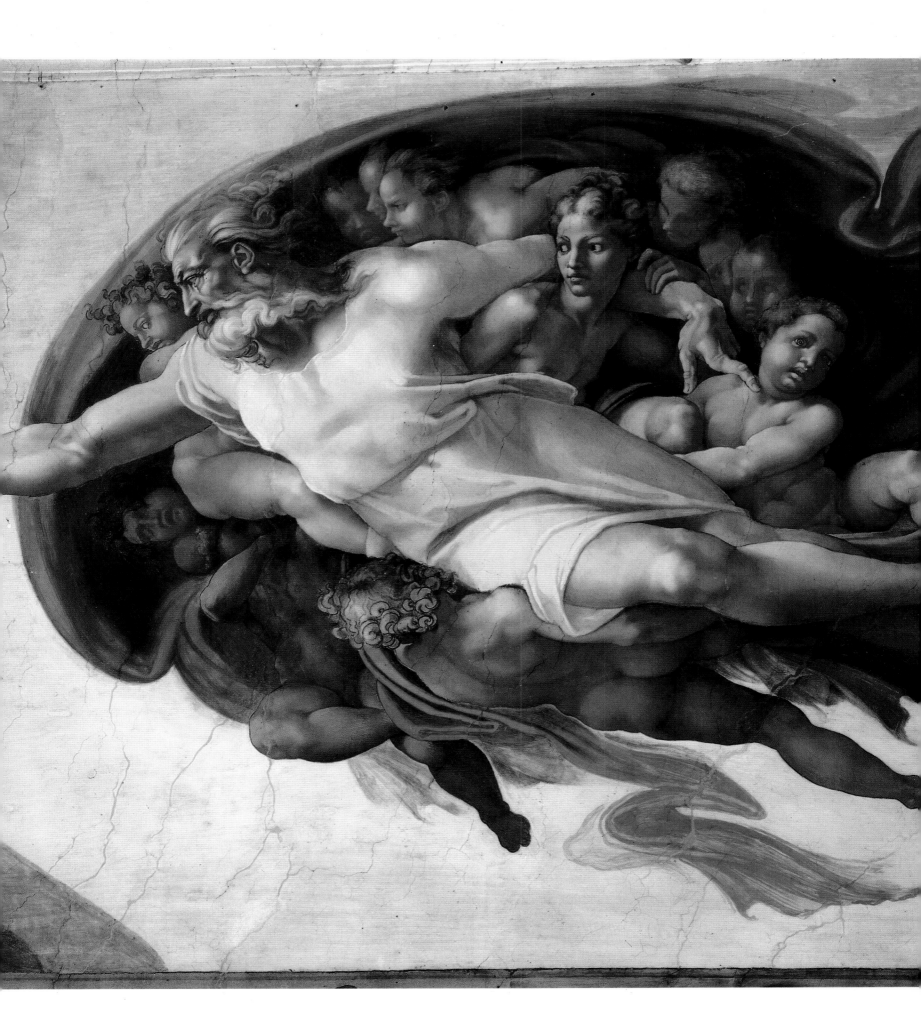

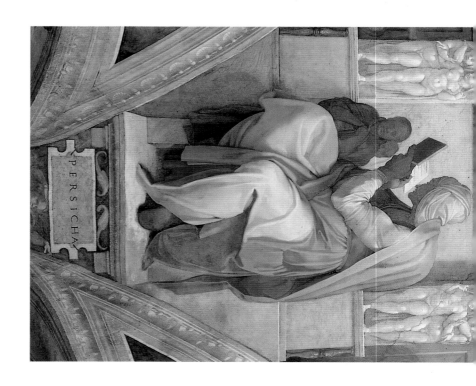

SEVENTH BAY OF THE CEILING

The last three scenes painted by Michelangelo in the center of the vault evidently form a triptych representing the Creation. Proceeding toward the altar wall, the artist first frescoed the scene of the Separation of the Earth from the Waters; then—in one of the largest panels—the double scene generally known as the Creation of the Sun, Moon, and Plants; and lastly, the Separation of Light from Darkness.

Naturally, the chronological sequence starts from the last of the above-

explanation of a symbolic nature, but it was probably dictated, first and foremost, by the need to reserve the field of the largest panel for the scene that required most space for its representation. A common element in the three scenes is the figure of the Lord soaring through boundless space. Although God also appears in flight in the *Creation of Adam*, he is near to the strip of land on which Adam reclines, while, in the *Creation of Eve*, his feet rest firmly on the ground. Some writers have sug-

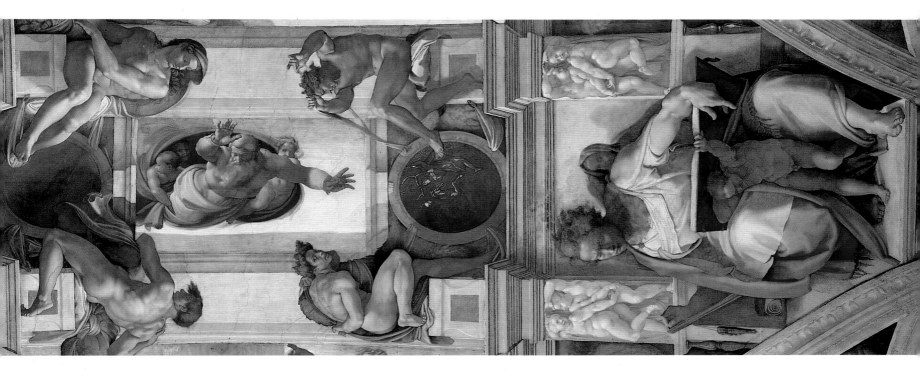

mentioned scenes, which begins the account in Genesis. However, the events depicted in the panel immediately after this refer to the third and fourth days of the Creation, while the Separation of the Earth from the Waters took place at the beginning of the second day.

As in the case of the Deluge and the Sacrifice of Noah, the failure to respect the chronological order may have an

gested that the closely-linked nature of the three scenes of the creation of the world is an allusion to the Trinity. However, according to the typological interpretation based on the texts by Saint Augustine, they refer to the Church's mission in the world, the second coming of Christ, and the Last Judgment, foreshadowed in the Separation of the Earth from the Waters.

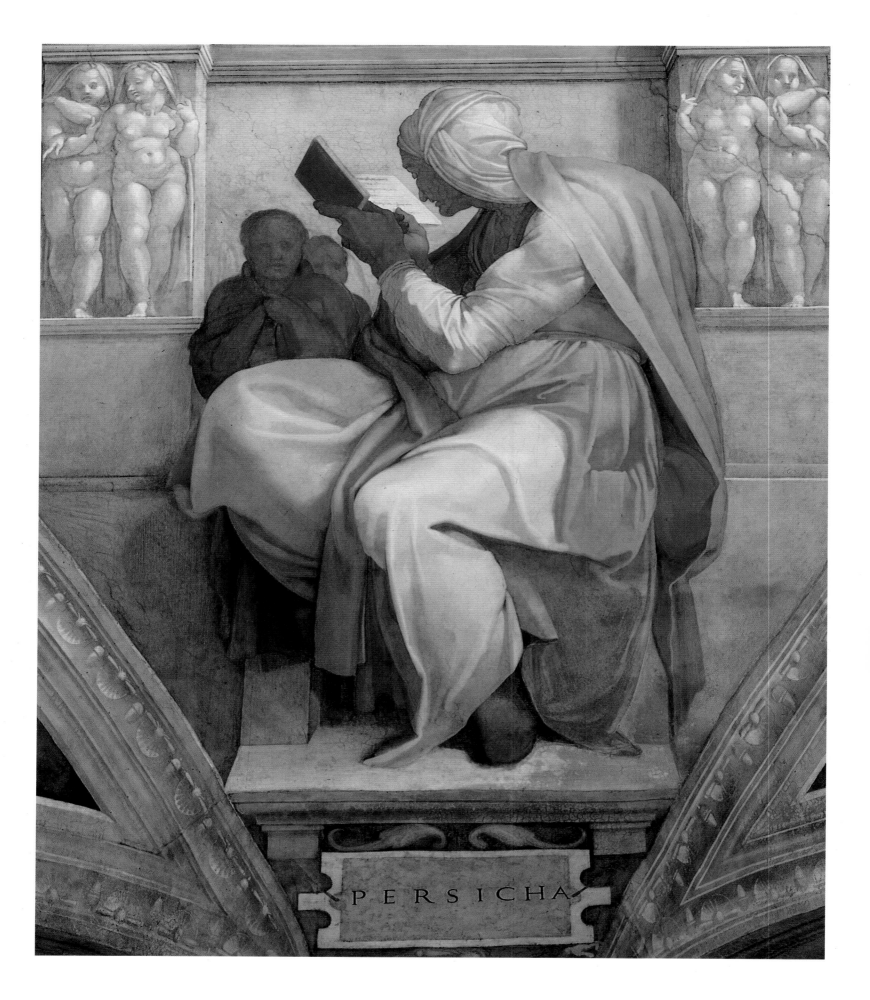

PERSICHA

Together with the Incarnation of Christ—reference to this had already been made in the Sistine Chapel, in the frescoes painted during the pontificate of Sixtus IV—the Creation "in the beginning" was one of the themes most frequently dealt with in the sermons delivered in the chapel. As J. O'Malley has observed, when they analyzed the achievements of their divine hero, in order to glorify him," the preachers were struck, first and foremost, by the fact that "he had created the splendor of the material universe, and the pre-eminence given to this event permitted them to use all the rhetorical devices at their disposal to describe to the congregation, with vivid details, the beauty of the sun and the moon, the bounteousness of the earth, and the variety of the flora and fauna. O'Malley also mentions that in one of these sermons it was stated that when God created the universe, he constructed a magnificent temple and then he decorated it with such skill that all those who saw it admired its beauty and were astounded by its size. Evidently, these are metaphors that must have been particularly welcome to the ears of those such as Julius II, engaged in the renewal—also with regard to the monumental buildings and the works of art—of Rome, the heir to the splendors of classical antiquity and the center of Christendom. And Vasari himself, describing the scene of the Creation, asserts that "to demonstrate the perfection of his art and the greatness of God, Michelangelo depicted God dividing the light from the darkness in these scenes, where He is seen in all His majesty ... in a demonstration of love and creative energy."

In the *Separation of the Earth from the Waters*, the Lord flies over the gray-blue expanse of the waters, soaring aloft in his large billowing mantle together with his retinue of angels. His notably foreshortened figure seems to be launched from the left toward the viewer. Behind the Creator, the sky is clear and bright, while on his other side it has turned grayish-white.

Although the range of colors is very limited, the scene is rich in delicate tonal passages. The gradations of violet that distinguish the tunic from the mantle, and the parts in the light from those in the shade, act as a counterpoint to the cold tones—whites, blues, and grays—of the sea, sky, and the Lord's hair and beard, while the golden-yellow of the hair of the two putti forms a stronger contrast. The tendency to use colder, more subdued colors that may be observed in the second half of the ceiling, especially in the narrative scenes in the center, is part of the general simplification of the compositions—which themselves become more monumental—and the shift in the artist's focus of interest from the representation of individual details toward their subordination to the overall effect. At the same time the differentiation, from the point of view of the technique of execution, between the figures of the prophets, sibyls, and *ignudi*, painted with dense, blended brushstrokes, in order to obtain extremely smooth surfaces, and the narrative scenes in which the figures, conceived as being more distant—beyond the imposing structure of the painted architecture—have rougher surfaces, painted with interlaced brushstrokes, with effects that have been compared to those obtained by sculpting marble with a claw chisel. This is a process developed by the artist, especially in the last stage of the work, that was intended both to heighten the illusionistic effect of the greater or lesser distance of the figures from the viewer, and, probably, to distinguish the scenes from Genesis, conceived as "visions," from the "sculptural" figures of prophets, sibyls, and *ignudi*.

At the sides of the central scene, the absorbed figure of Michelangelo's *Persian Sibyl*, regarding which Vasari acutely observed that Michelangelo, "besides enveloping her in draperies ... wished to show that her blood was already frozen with the passing of time," contrasts with the strong tension of his *Daniel*. This is related to the crescendo of psychic activity that characterizes the sequence of prophets, from the calm meditation of Zechariah to the gloomy despondency of Jeremiah and the distraught attitude of Jonah.

THE PERSIAN SIBYL

While the closer they are to the altar, the more the figures of the prophets are agitated, some of the sibyls, especially his *Cumaean Sibyl* and *Persian Sibyl*, are depicted as elderly women engaged in

Before the restoration.

the laborious task of deciphering the contents of sapiential books. Turning toward the wall in order to allow more light to fall on the page, with a rotation that brings her knee and right elbow into the foreground, the Persian Sibyl is depicted in *profil perdu*. Sober harmony governs the juxtapositions of colors: white for the sleeve and scarf; light green for the tunic; and rose red for the mantle. Behind her, slightly blurred and seen frontally, are the motionless figures of two putti.

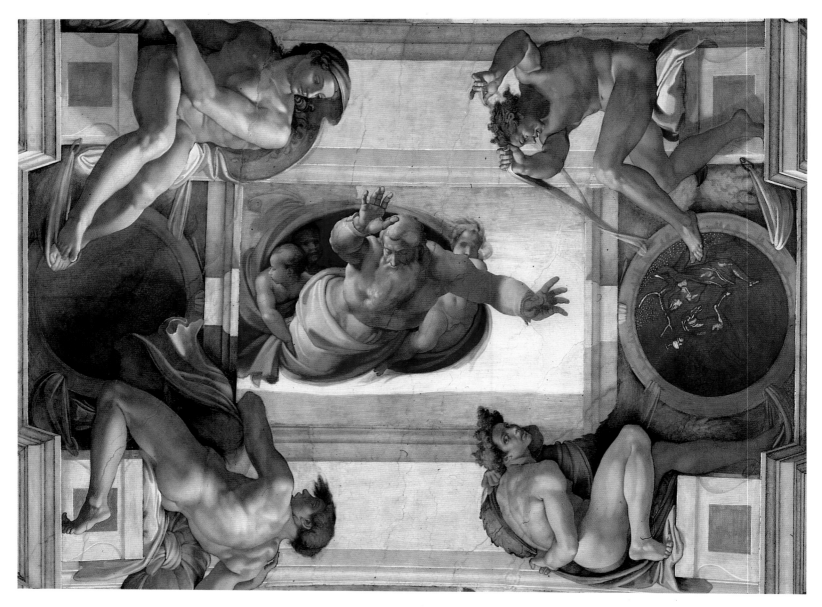

The poses of the pairs of *ignudi* also become gradually more dynamic and agitated. The two above the Persian Sibyl bend backward in opposite directions (a study for the one on the right is to be found in a splendid red-chalk drawing now in the Teyler Museum in Haarlem), while one of those above the *Prophet Daniel* bends forward, casting an apprehensive glance at the viewer, and the other raises his arms in a movement reminiscent of Hellenistic sculptures of dancing fauns. One of the medallions is not decorated; the other represents the Death of Absalom.

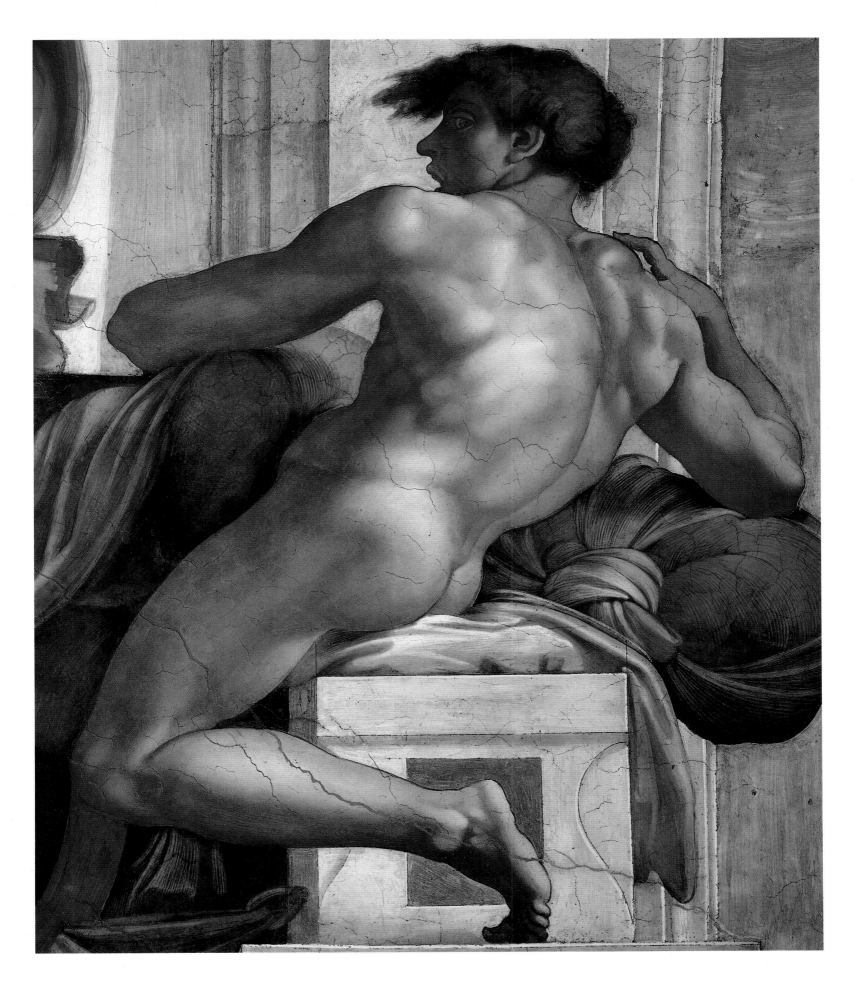

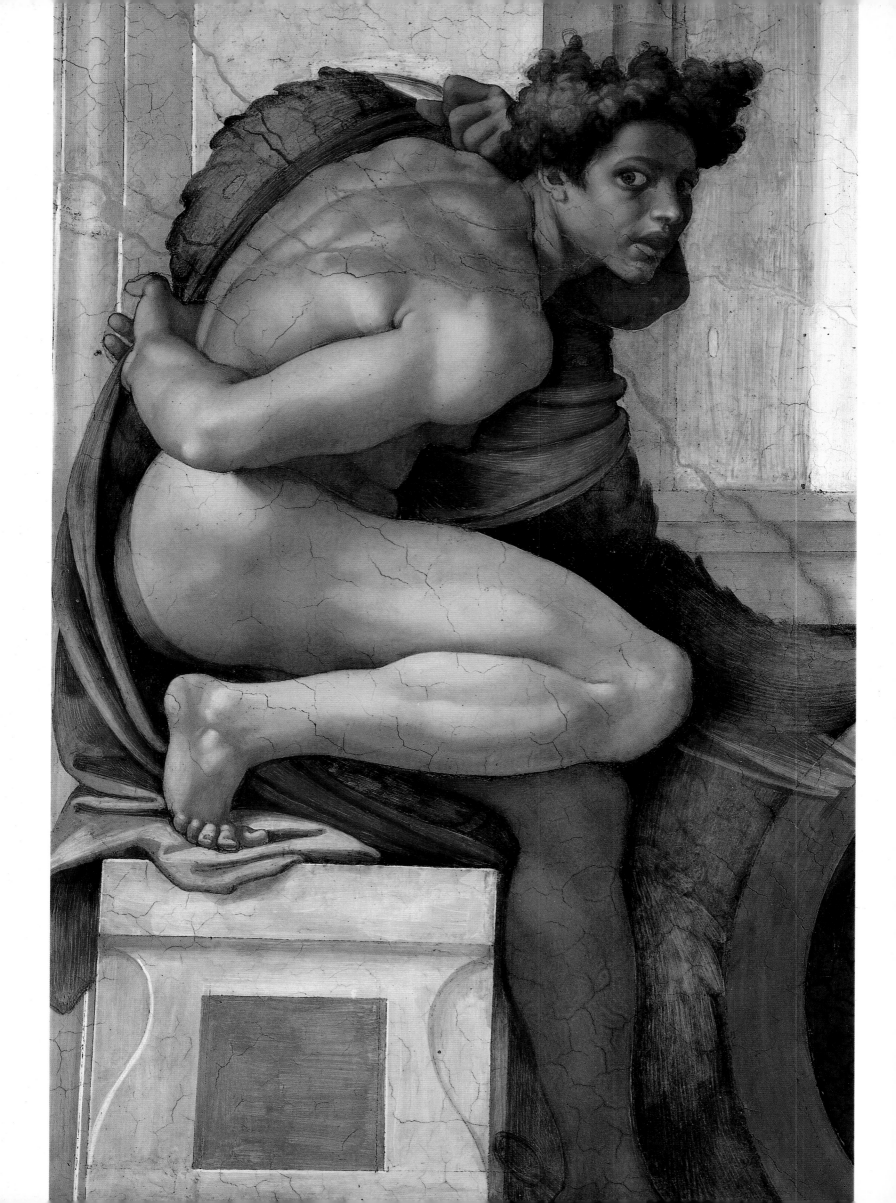

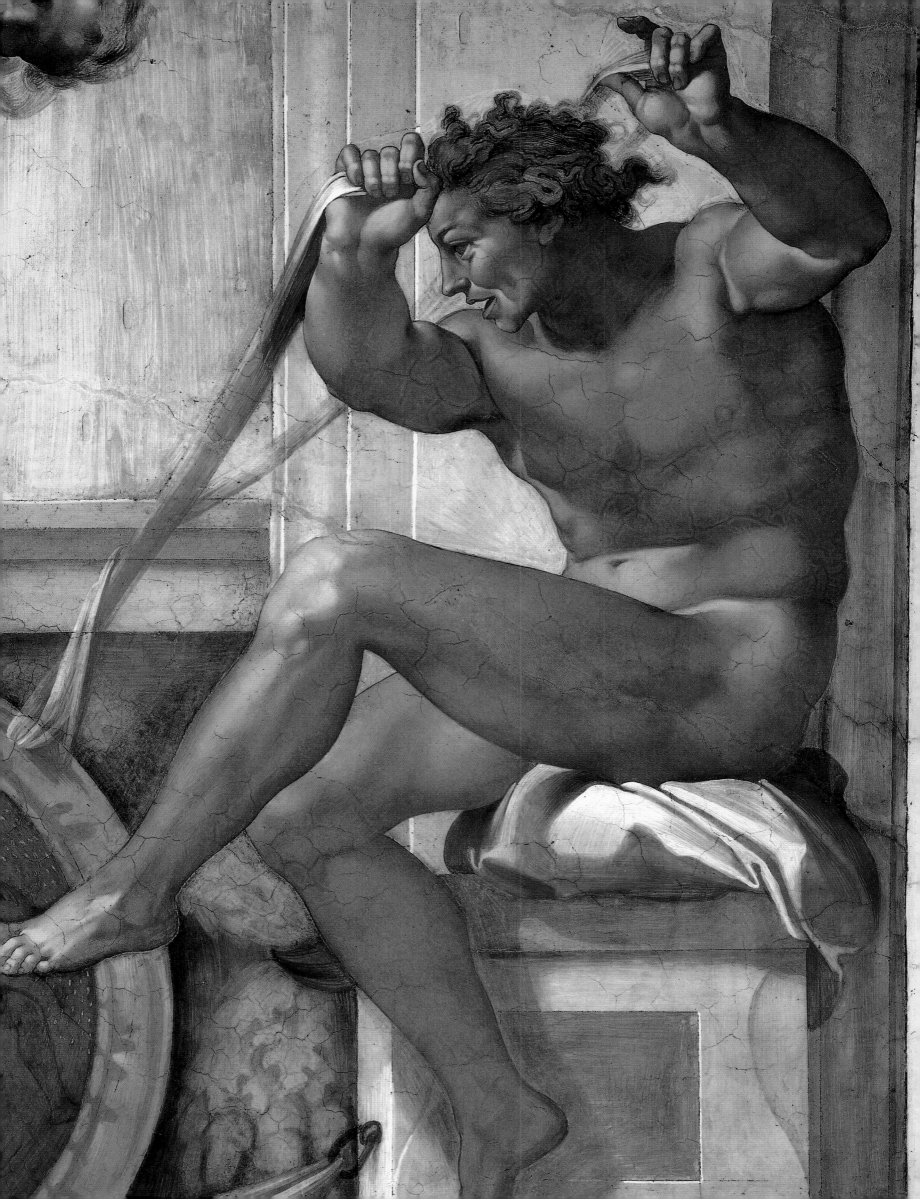

"And God said, Let the waters under the heaven be gathered together unto one place, and let the dry land appear: and it was so. And God called the dry land Earth; and the gathering together of the waters called he Seas."

Genesis 1:9–10

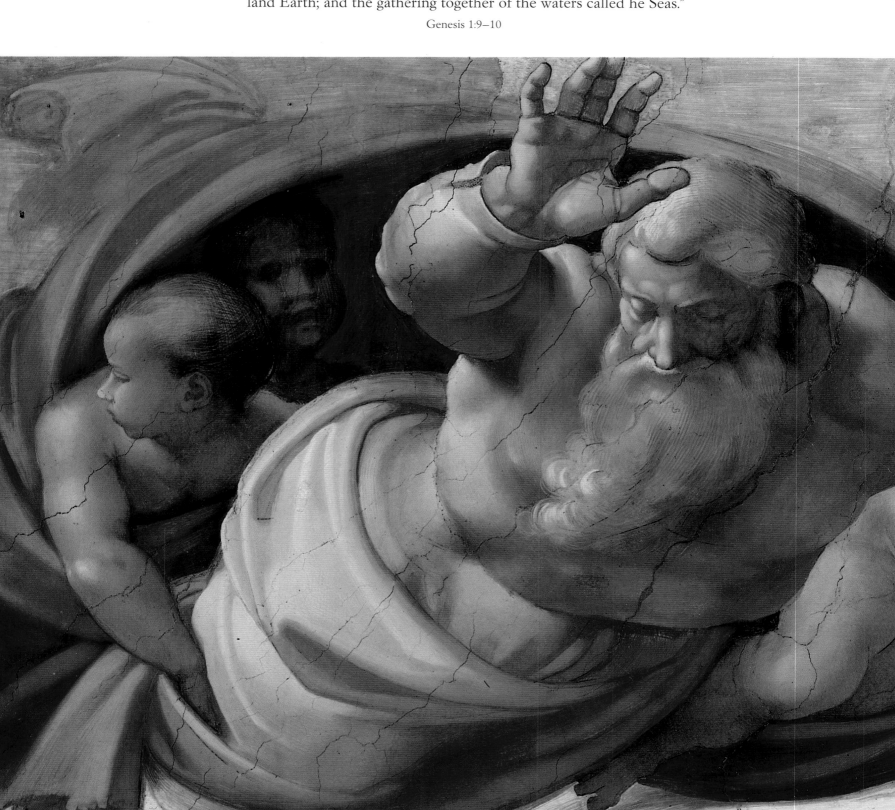

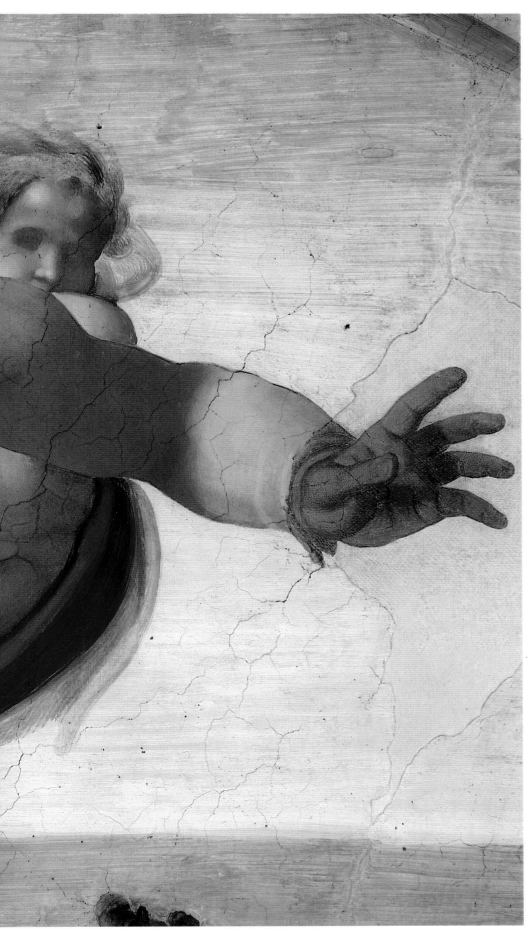

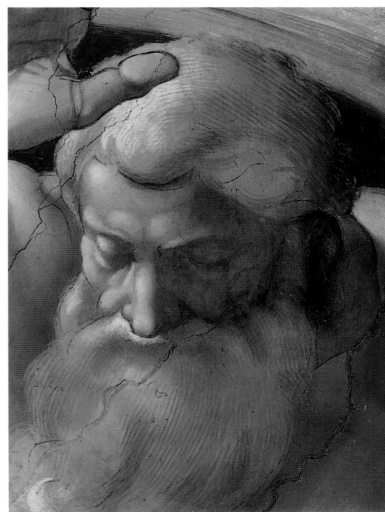

The foreshortened figure of the Lord is described by Vasari: "He is seen flying on the vault, a foreshortened figure which continually turns and changes direction as you walk through the chapel." It makes an essential contribution to the remarkable impetus of the scene, as does the device of the outstretched arms, with the imperious gesture of the hands, and the radical simplification of the illustrative elements. Unlike what happened with the biblical scenes previously painted in the center of the vault, in the three stories of the Creation, Michelangelo transferred the cartoons to the *intonaco* with indirect incision and adopted the same speed of execution that is found in the lunettes.

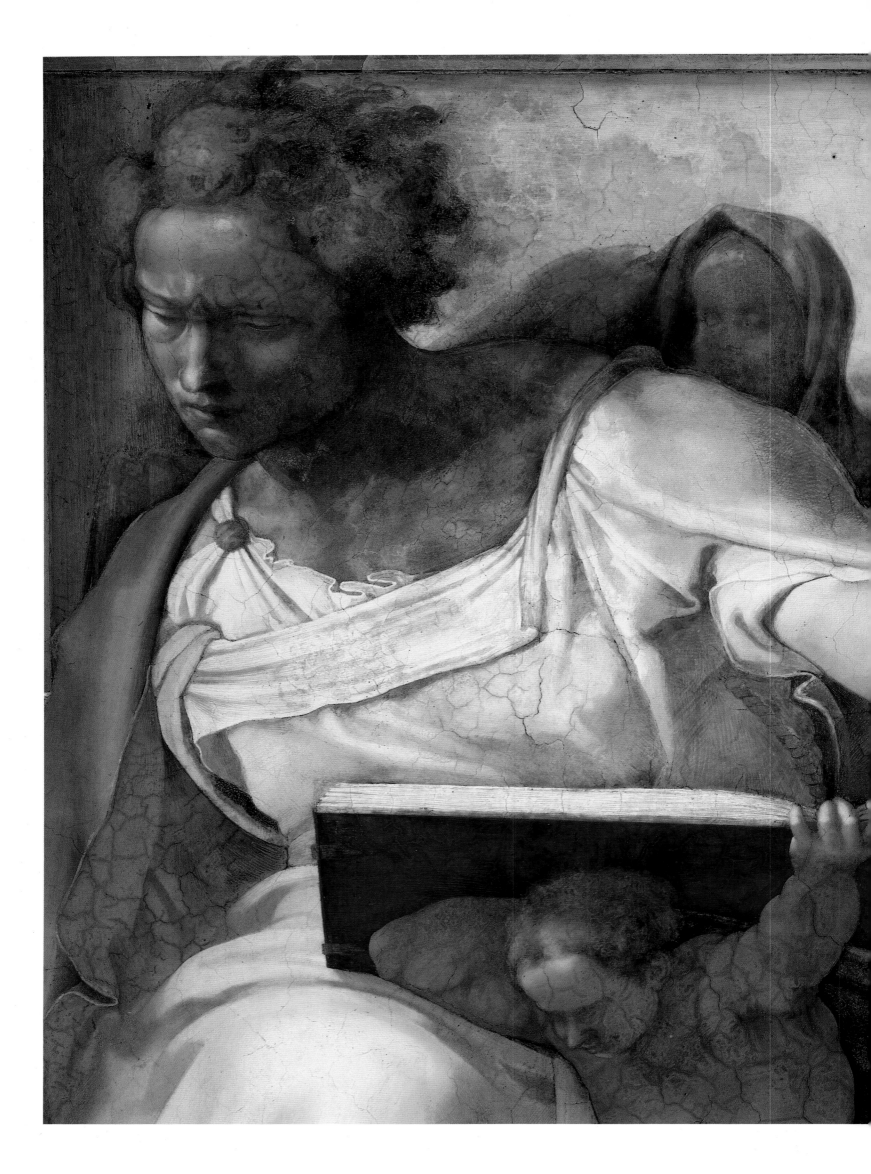

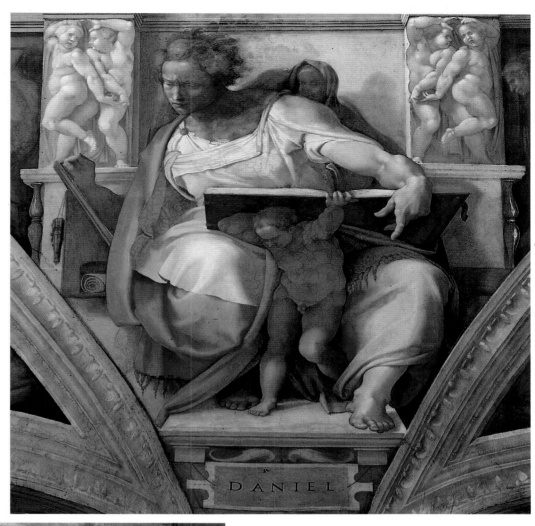

DANIEL

The figure of the prophet Daniel, engrossed in reading and writing, but with the signs of deep interior anxiety, was seriously damaged by water seepage and subsequent heavy retouching. The mantle enveloping the prophet's left leg was largely repainted, probably by Alessandro Mazzuoli. The recent restoration has revived the delicate color accords of the clothes, based on white and light blue, bright yellow, green, and violet with rose shadows.

181

Eighth Bay of the Ceiling

In the frescoes painted by Michelangelo in the Sistine Chapel, the act of Creation is mainly expressed through the metaphor of flight, in a movement charged with energy, like a violent wind, a vortex unleashed by mysterious forces. Only in the *Creation of Eve* does the figure of the Creator appear to be static. In all the other cases, the breath of life is transmitted by a figure whose power manifests itself through conspicuous dynamism and pronounced foreshortening seen against a boundless sky.

In the *Creation of the Sun, Moon, and Plants*, the figure of the Lord appears twice: on the right, as he is about to give shape, with his outstretched arms, to the incandescent disk of the sun and

axis of the field, and the whole of the right part is dominated by the figure of the Creator who, surrounded by four children, moves impetuously toward the viewer. On the left, in a more restricted field, and further back from the picture plane, the Creator is depicted once again—notably foreshortened and seen from behind—as he heads toward the earth, going away from the foreground. Together with the strong contrasts of light and shade, the movement in opposite directions of the two figures heightens the dynamic tension of the scene and conveys a sense of immediacy.

The reasons why two phases of the Creation were represented in a single panel—and why these two, in particu-

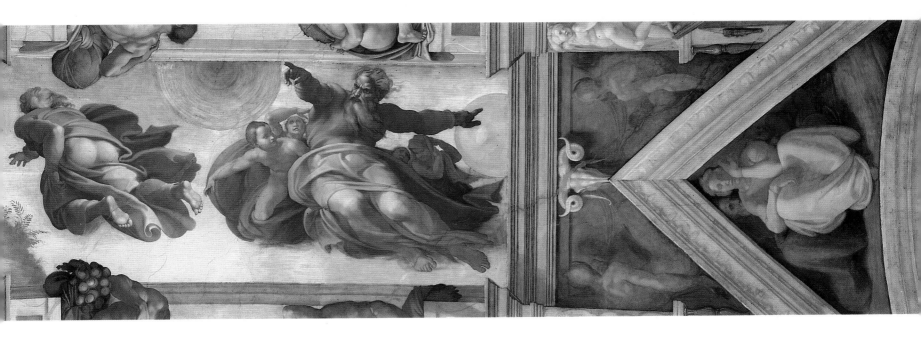

the cold one of the moon; and, on the other side, as, with an imperious gesture, he summons forth tufts of grass and the first bushes from the bare earth. The scene is divided unequally: the great disk of the sun—the only element of color that stands out clearly from the more subdued tones of the clothes, flesh, and the grayish white background of the sky—is to the left of the central

lar—are still not entirely clear. But the composition conceived by the artist, with the simultaneous representation of the same figure in two contrary poses—one seen frontally, the other from behind—allows us to imagine that a secondary objective, at least, was that of displaying his skill as a sculptor in depicting the same figure from different viewpoints.

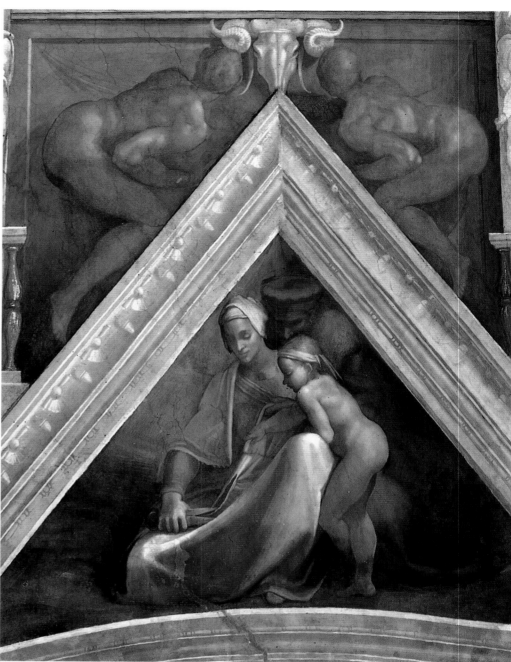

Before the restoration.

This spandrel above the Salmon-Boaz-Obed lu-
nette was painted in two *giornate*. The family group
fits perfectly into the triangular field and the figures
appear, for once, closely linked by the interplay of
gestures and glances, focused on the woman's
dressmaking activity. The bronze nudes in the fields
above the cornice are depicted bent forward in an
odd, uncomfortable pose, as if they were trying to
peep upward.

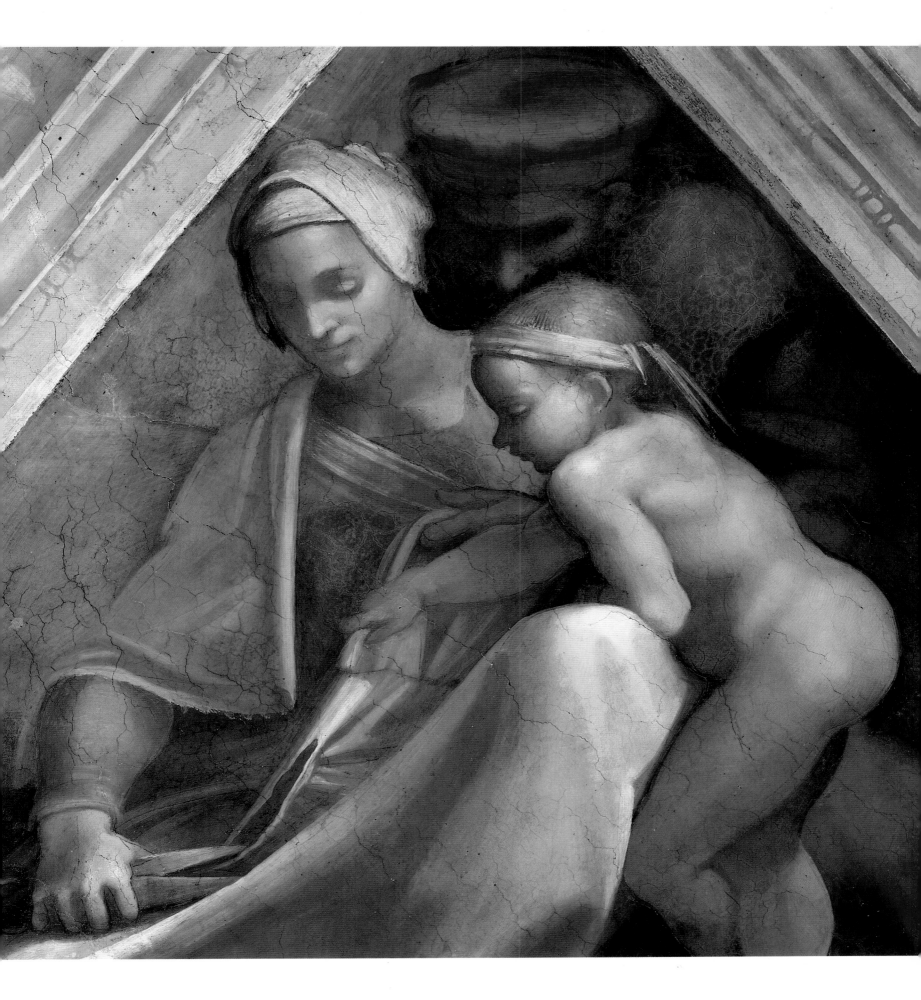

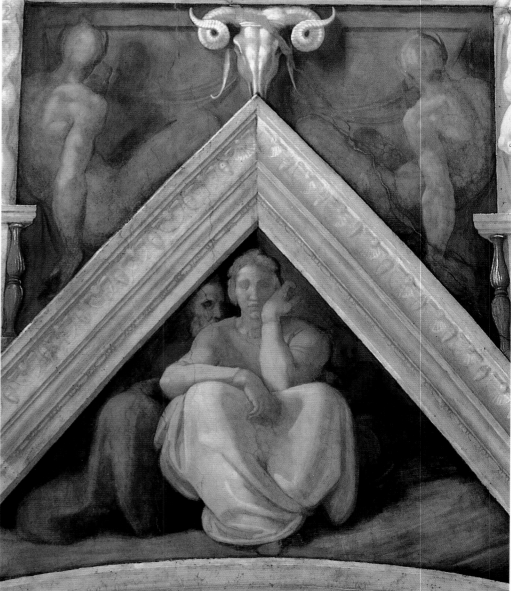

In the spandrel situated above the Jesse-David-Solomon lunette, the absolute immobility of the enigmatic figure depicted frontally provides a striking contrast to the activity of the woman in the opposite spandrel. Placed precisely on the axis of the triangle, she appears to be deep in meditation and totally extraneous to the two figures—a man and a child—that may be discerned behind her in the darkness. The spandrel was painted in only one *giornata*, except for the bottom right corner. The bronze nudes, with their backs turned toward the viewer, seem to be looking upward, like those above the opposite spandrel.

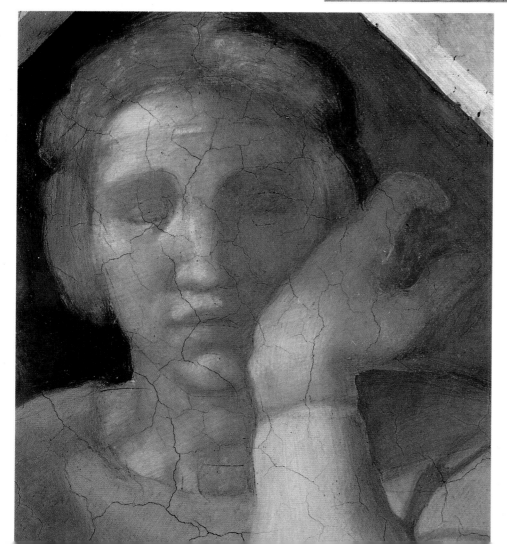

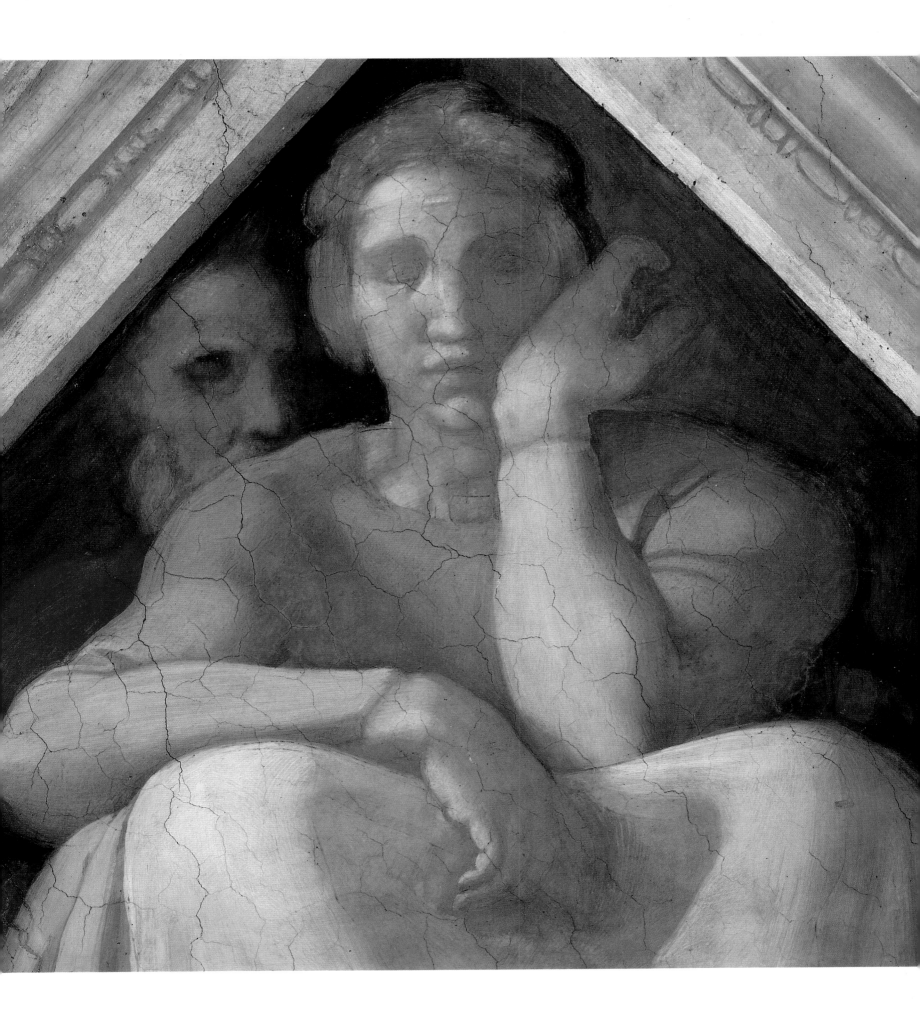

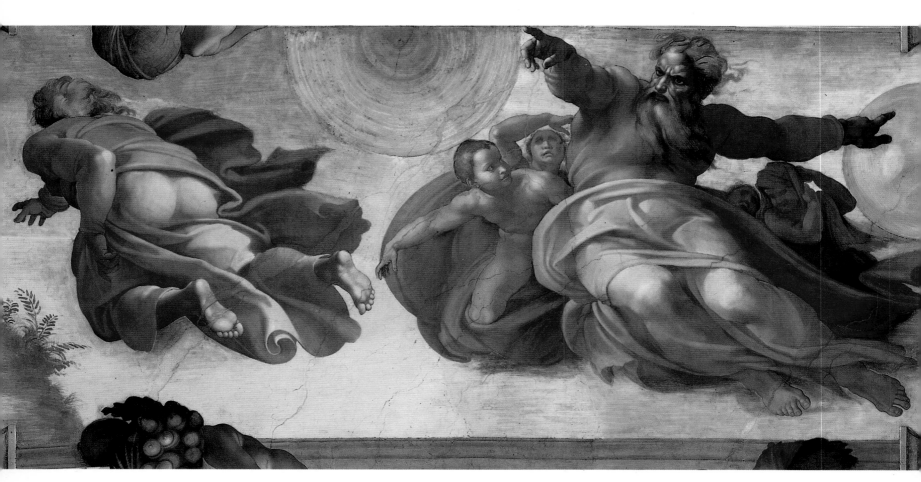

Before the recent restoration, the surface of the fresco, crossed by deep cracks, was darkened by layers of glue and heavy repainting. The cleaning has revealed delicate gradations of gray and violet—for example, in the tunic and mantle, or in the rendering of the shadows, which also appear to be partially luminous due to the intense light bathing the group of God and the angels. Michelangelo painted the scene in seven *giornate*, starting from the top right corner and transferring the cartoons to the *intonaco* exclusively by means of indirect incision. The disks of the sun and the moon were drawn directly onto the *intonaco* with a compass.

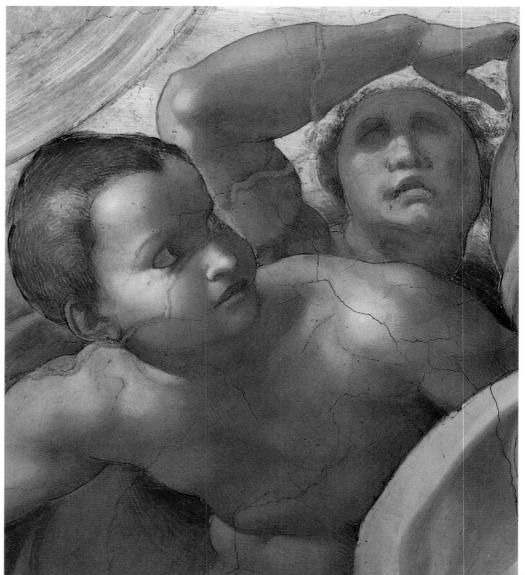

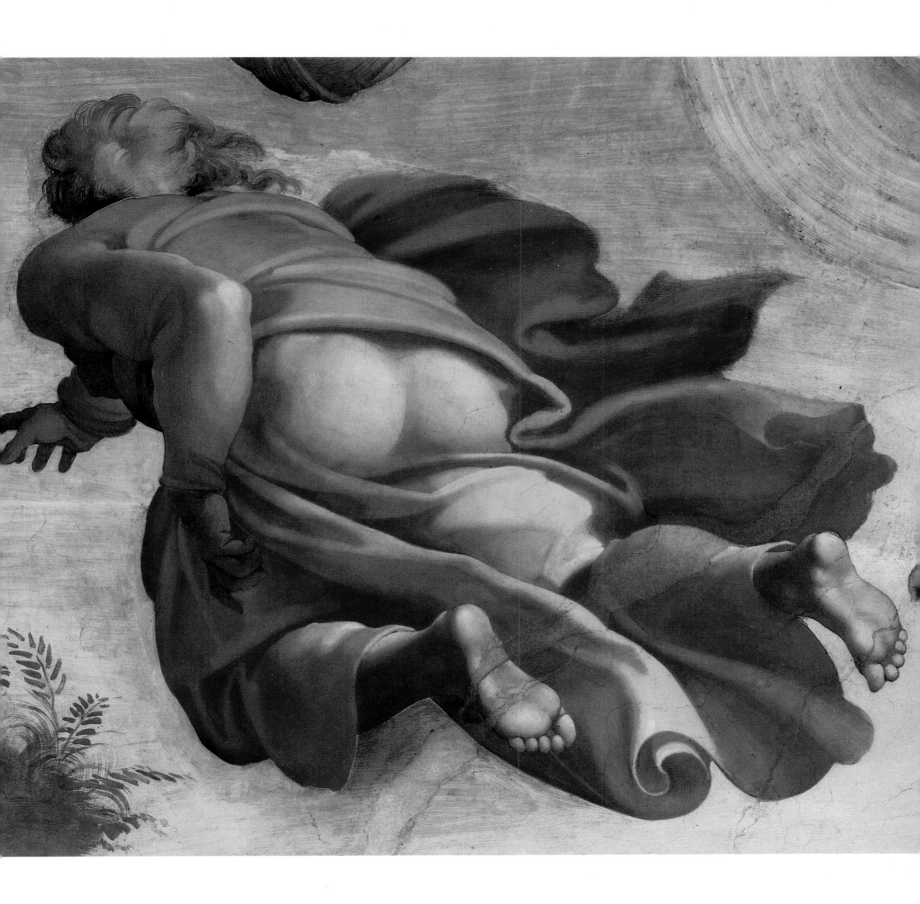

"And God said, Let the earth put forth grass, herb yielding seed, and fruit tree bearing fruit after its kind, wherein is the seed thereof, upon the earth."

Genesis 1:11

"And God made the two great lights; the greater light to rule the day, and the lesser light to rule the night: *he made* the stars also."

Genesis 1:16

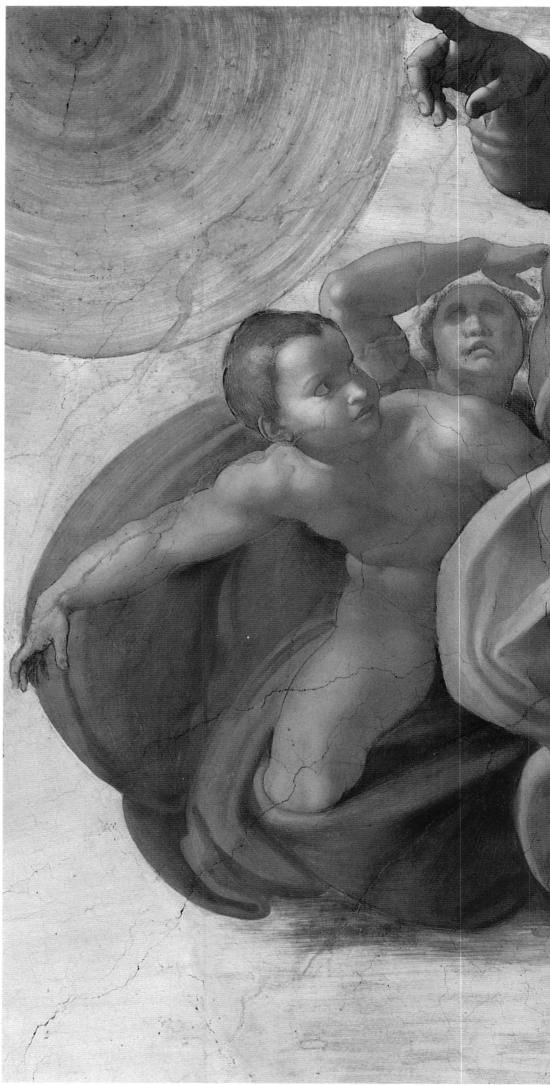

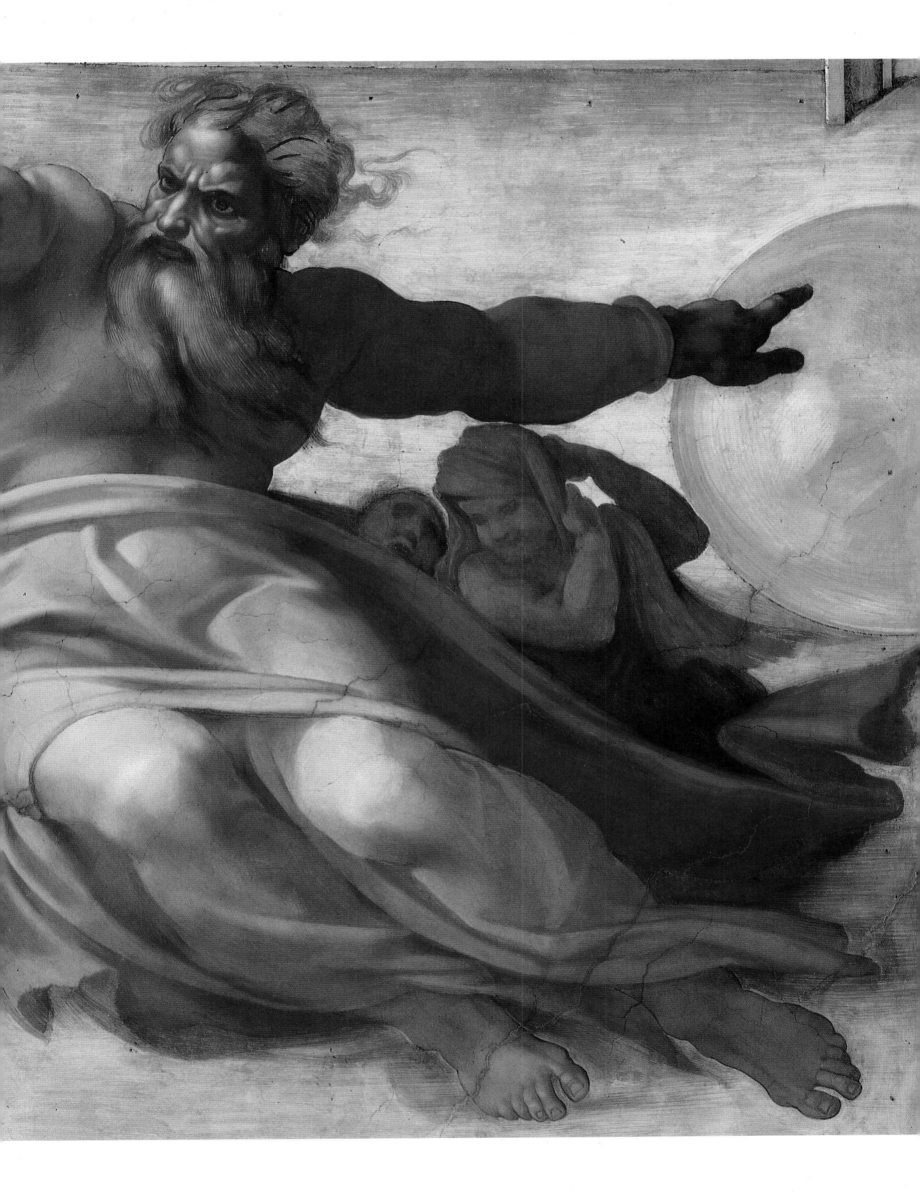

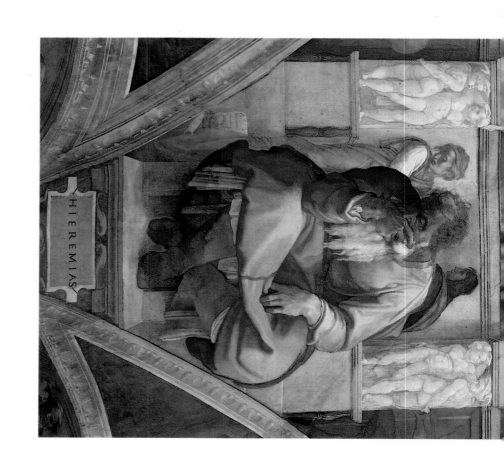

NINTH BAY OF THE CEILING

The beginning of the Creation with the Separation of Light from Darkness is marked by the figure of God, seen from below, as he launches himself into infinite space with his arms raised, allowing spirals of light to sweep aside the darkness.

Darkened for centuries by layers of glue and repainting intended to conceal the damage caused by loss of *intonaco*, the original colors are extremely sober and are based on gray, white, and rose-violet, with gradations from dark to light executed with great care. Michel-

from the typological interpretation of the central scene as an allusion to the end of the world, it is possible to identify a thread linking all the figures in the bay to the same meaning. In fact, the sacrifice of Isaac prefigures that of the Redeemer, while Elijah's ascent foreshadows the Ascension of Christ. The gesture of the Sibyl is generally interpreted as the closing and putting away of the huge book, while the prophecies of Jeremiah include the new covenant that the Lord intended to make with his people: "I will make a new covenant

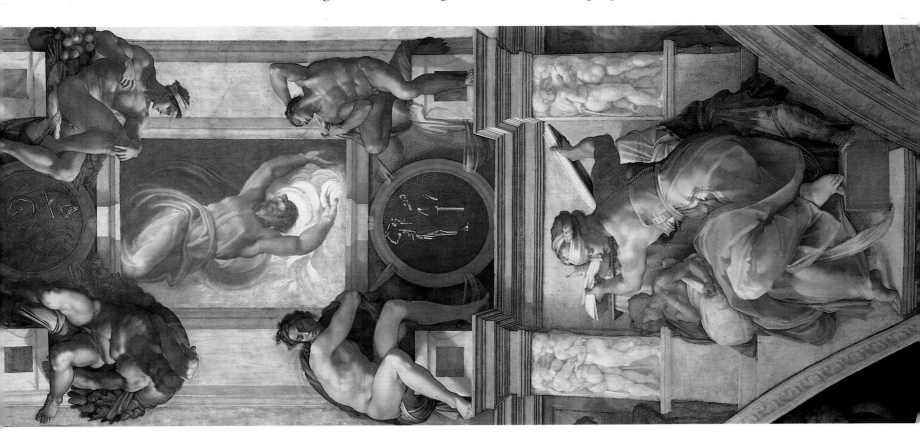

angelo painted the scene in only one *giornata*, transferring the cartoon onto the *intonaco* by means of indirect incision.

Above the cornices, the four *ignudi* bear medallions representing the Sacrifice of Isaac and Elijah Ascending to Heaven on the Chariot of Fire. At the sides are the figures of the prophet Jeremiah and the Libyan Sibyl. Starting

with the house of Israel and with the house of Judah: Not according to the covenant that I made with their fathers in the day that I took them by the hand to bring them out of the land of Egypt; which my covenant they break.... I will put my law in their inward parts, and in their heart will I write it; and I will be their God, and they shall be my people" (Jeremiah 31:31–33).

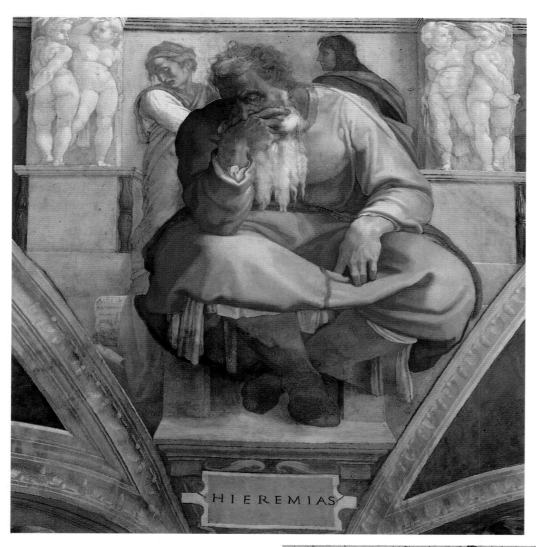

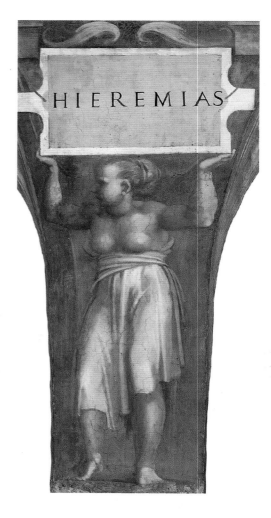

Deep in sorrowful meditation and oppressed by the terrible anguish of his ominous predictions, Jeremiah leans forward, resting his bowed head on his hand and his elbows on his spread knees. The expression of the attendant on the left is also woeful, while the one on the right was repainted in the past, together with part of the prophet's hair, following serious damage caused by seepage of water.

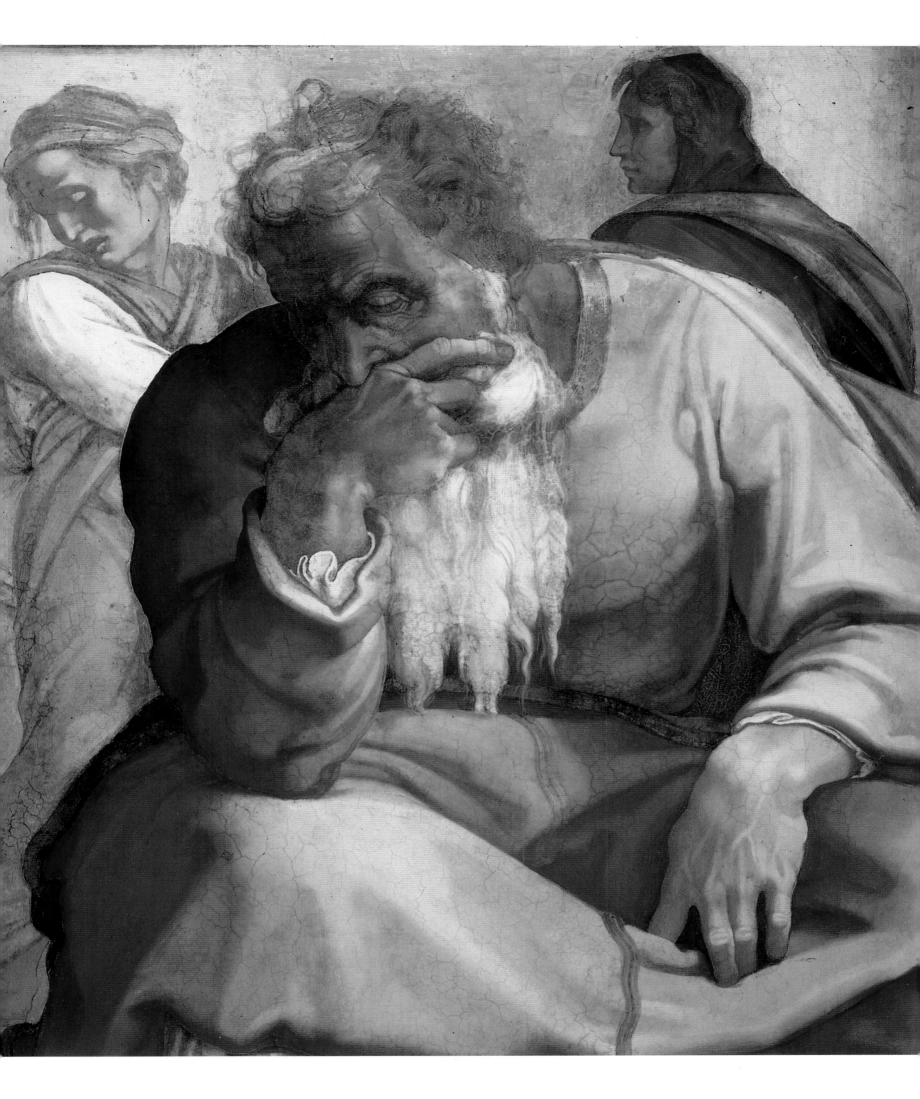

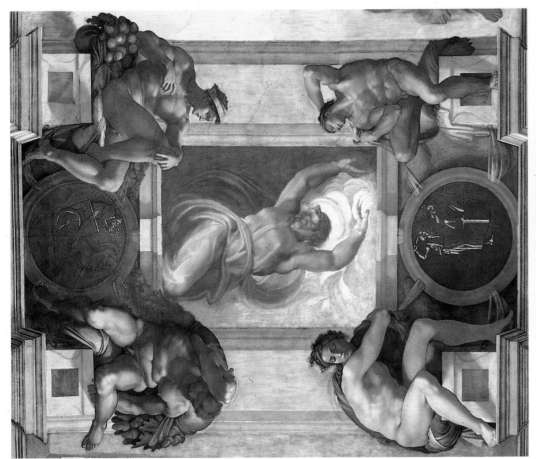

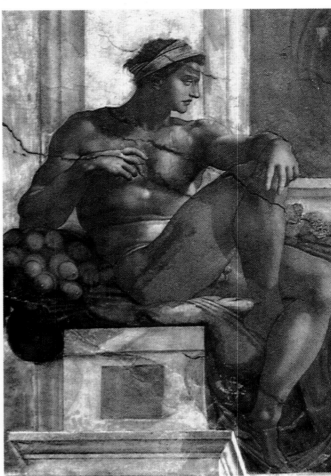

Before the restoration.

The poses of the four *ignudi* are very different from each other, without any attempt being made to obtain an effect of symmetry. Thus, the one above Jeremiah at the left, with a classical profile and a meditative attitude, contrasts sharply with the ungainly movement of the one the right, who, laden with foliage and acorns, is throwing himself forward, his face in the shadow. On the opposite side, the two figures bend toward the center, but with their torsos and heads rotating in opposite directions with clearly distinct movements, splendidly rendered thanks to the artist's skilled use of perspective. Each figure was painted in four *giornate*, except for the one on the left above the Libyan Sibyl, which required three.

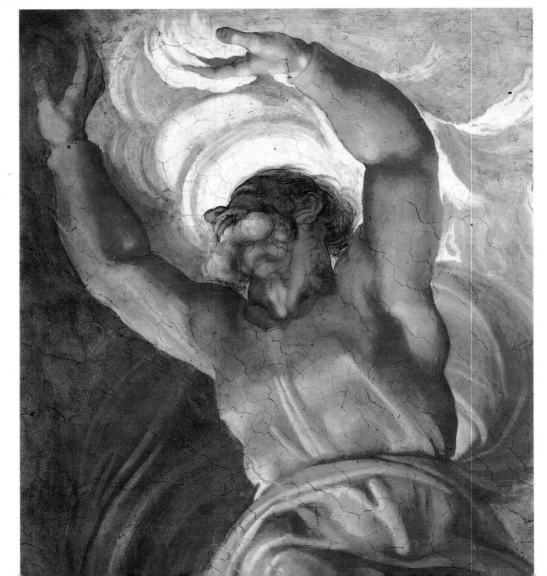

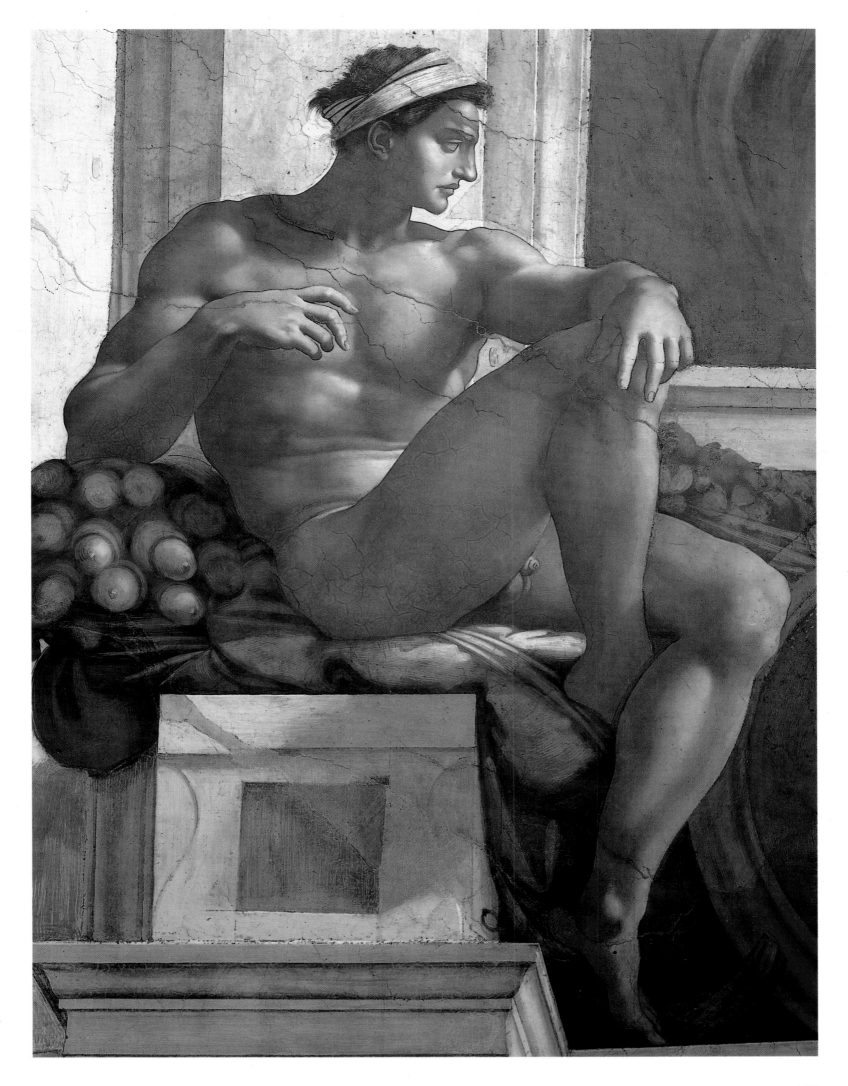

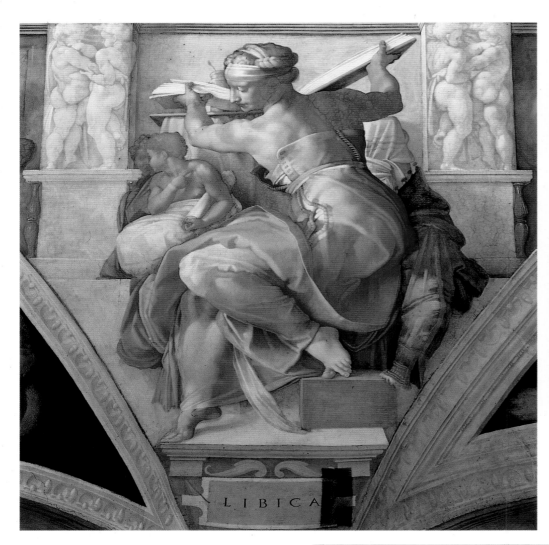

Before the restoration.

The complex, almost serpentine, rotation of the young sibyl, who seems to be rising from her seat, gives prominence to the remarkable richness, elegance, and delicacy of the juxtapositions of color. Thus, the light violet of the ribbon tied around the sibyl's head is placed next to the yellow ocher of the braid; the deeper, brighter yellow of the bodice, bordered with gray-blue and open at the sides, is next to the red ocher of the lining and the light violet of the robe, which resembles that of the ribbon. The figure was painted in seventeen *giornate*, three more than those required for the prophet Jeremiah.

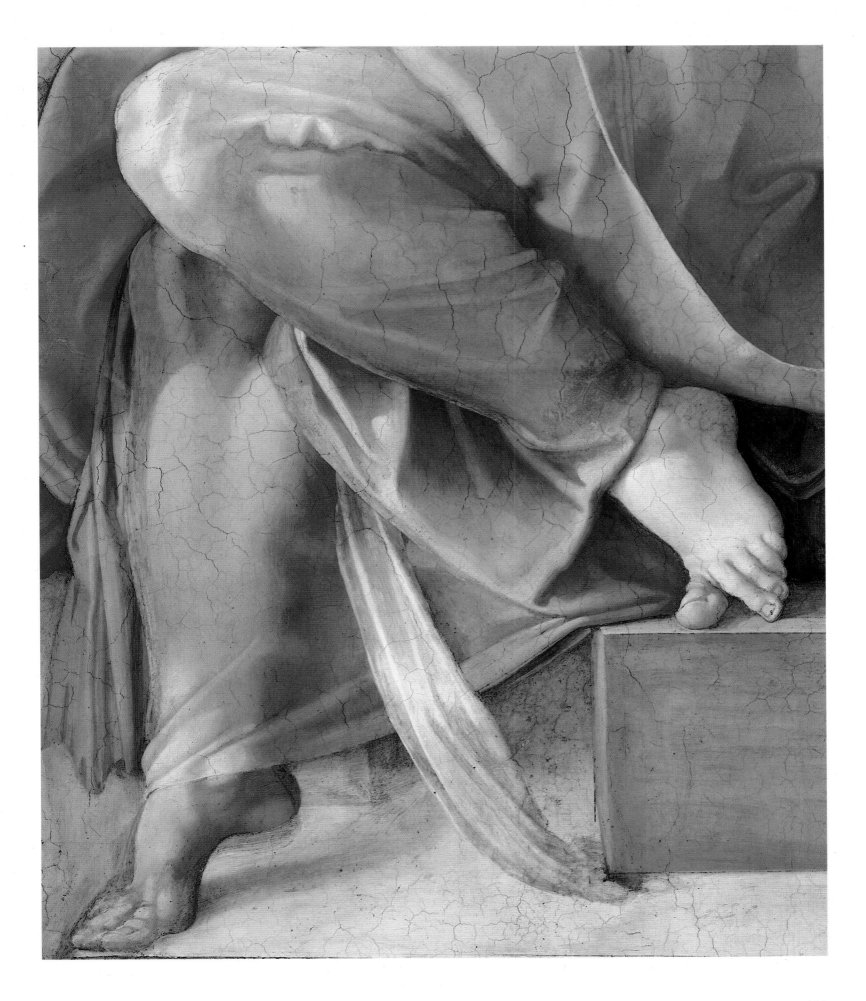

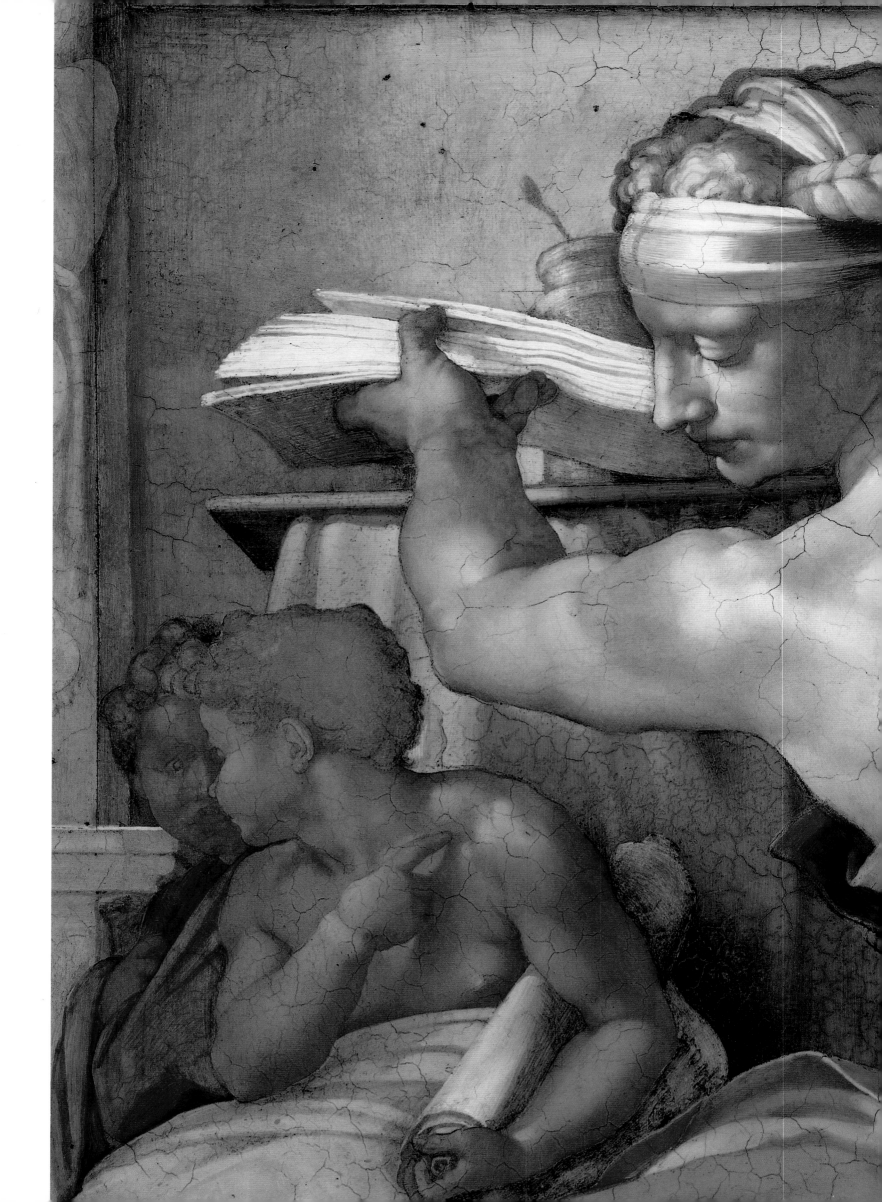

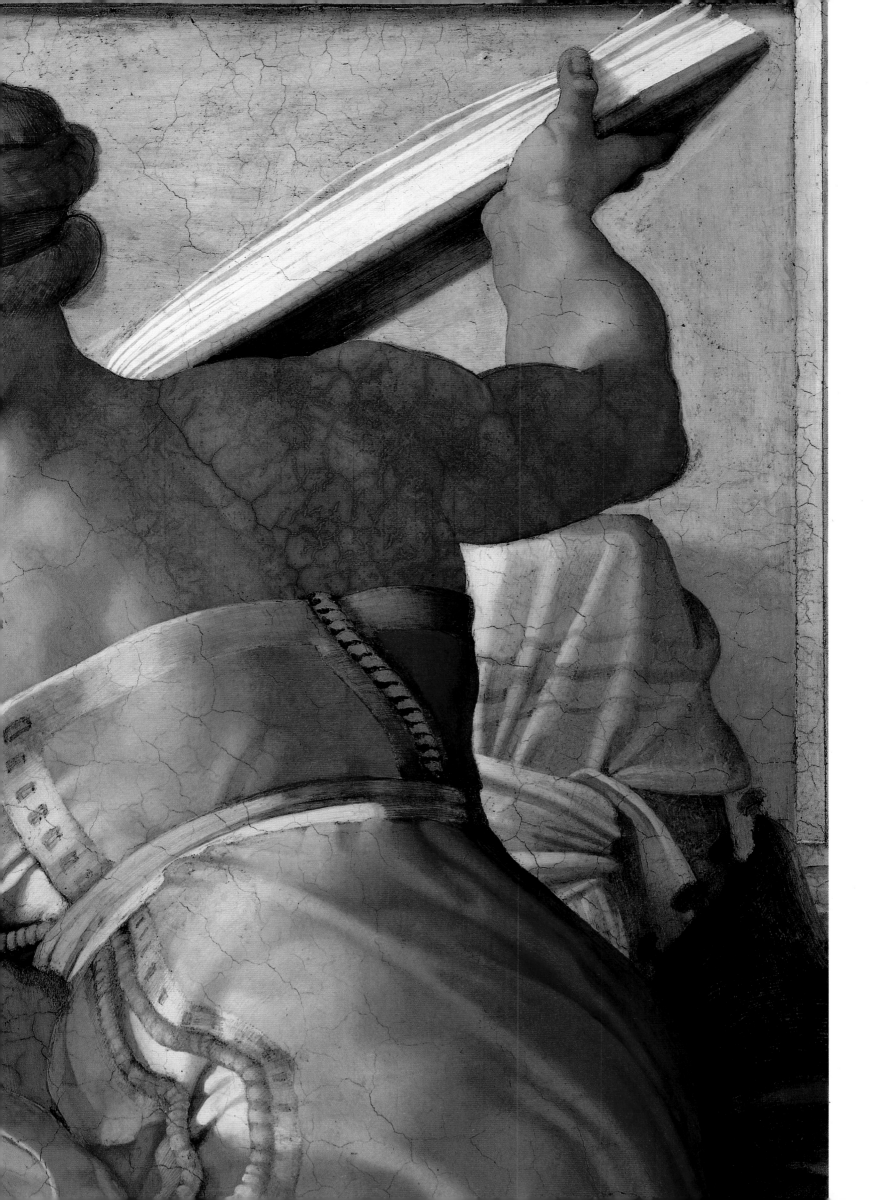

ABOVE THE ALTAR WALL

"But who will not admire and remain astonished upon seeing the magnificence of Jonah, the last figure in the chapel? There, through the power of art, the vault that by nature moves forward curving along the wall, is pushed up by the appearance of this figure turning in the opposite direction so that it seems straight, and then, conquered by the art of design, along with light and shadow, it truly seems to turn backwards." With these words, Giorgio work" that was able to give the maximum prominence to the "knowledge" the artist had "of principles and the use of line in creating foreshortenings and perspectives." Placed in a dominant position, directly above the altar, the figure of the prophet must have immediately attracted the attention of all those who entered the Sistine Chapel from the Sala Regia through the ceremonial door situated at the end of the chapel—especially before the *Last Judg-*

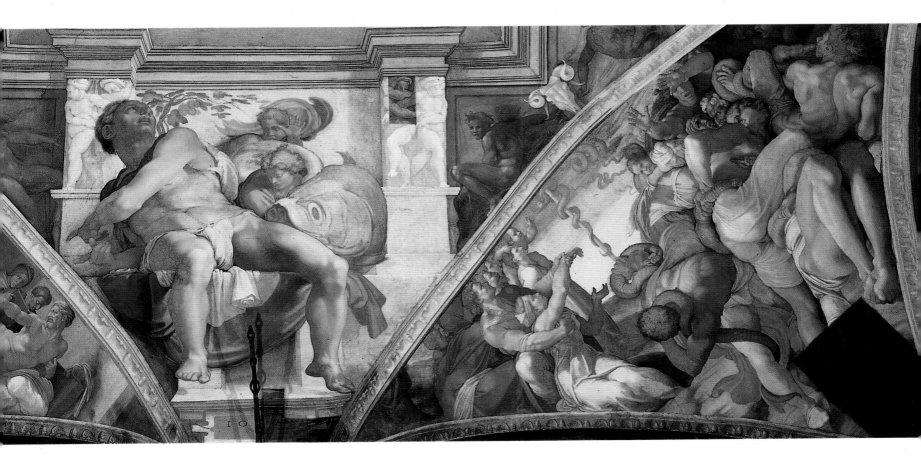

Vasari expresses the astonishment and admiration of his contemporaries—especially the artists—for the remarkable illusionistic virtuosity used by Michelangelo to paint the prophet Jonah. This allowed him to almost cancel the effect of the curve of the vault through the foreshortening of the body leaning backward. Ascanio Condivi also described the figure as "a stupendous *ment* was painted. With the body dramatically twisted backward along an oblique axis, the figure of Jonah not only constitutes an astounding example of the overcoming of the extreme difficulties of art, but it is also a compelling manifestation of the terrible disruption caused by the prophetic fury. At the same time, it provides a magnificent conclusion, on both the formal and the

expressive levels, to the sequence of figures of seers, one of the most fundamental elements in the polyphonic—yet totally coherent—structure of the frescoes painted by Michelangelo on the vault of the chapel.

The prophet's naked legs are thrust forward, while his torso leans backward; it is clothed in a light violet jerkin, with green shadows, that is so close-fit-

In the corners of the ceiling, the shape of the narrow fields reserved for the bronze nudes, at the sides of the ram's skull, makes the arrangement of the figures more difficult. It has been observed that the quality of the painting of the two nudes is poor. Here the reclining figures each raise an arm and a leg toward the small fictive pilasters on which pairs of putti are depicted in intertwined postures.

ting as to allow the musculature to show through. Jonah's left shoulder is pushed forward, but the arm is bent backward on the opposite side of his body; his head follows the slope of his body, with his face turned up toward the Creator as he separates the light from darkness. His clothes appear to be much humbler than those of the other prophets. No books or scrolls are in evidence, but he is the only seer looking up toward God. Beside him, with two acolytes, is a representation of the whale in whose belly he remained for three days.

The scenes painted in the pendentives at the sides of Jonah are also characterized by the use of pronounced foreshortening. This is the case with the tangled group of Israelites who, in the scene of the Brazen Serpent, writhe in the throes of death, and, above all, with the crucified figure of Haman, which, as might be expected, attracted Vasari's attention: "The figure of Haman himself is foreshortened in an extraordinary manner, since Michelangelo depicted the trunk holding up his body and his arm coming forward so that they seem alive and in relief rather than painted, just like the leg that he pushes out and other parts of his body that turn inward: a figure that is certainly the most beau-

tiful and difficult among many beautiful and difficult figures." The almost obsessive use of foreshortening in the frescoes on the end wall is certainly related to the perception of the whole decorative cycle, which is mainly seen from the principal axis of the chapel followed by those entering from the Sala Regia and proceeding toward the altar.

In the irregular field of the pendentive on the left is the story of Esther, Ahasueras, and Haman. On the right of the pendentive, the king sends Haman to provide royal apparel for Mordecai, who is sitting at the king's door. On the left, Esther reveals Haman's plot to Ahasueras. The whole fresco is dramatically dominated, in the central scene, by the punishment of Haman. The daring foreshortening of the body, which literally cuts through the picture plane, is reinforced by that of the white frame of the door leading into Ahasueras' room. In the pendentive on the opposite side, the mass of bodies poisoned by the snakes—with "the extremely beautiful heads shown screaming and turned up in despair." (Vasari)—occupies the whole of the right part, spreading toward the center. The survivors are grouped on the left, eyes and arms turned imploringly toward the salvific image of the brazen serpent.

The fresco of Jonah, the scenes in the pendentives, the panel with the Separation of Light from Darkness, and the figures of the seers linked to them, are closely related from an iconographical point of view. The prophet, placed above the altar on which the Eucharistic sacrifice was celebrated, prefigures the risen Christ. In the Gospel of Matthew (12:38–40), we read that when the scribes and pharisees asked him for a sign, Jesus told them: "An evil and adulterous generation seeketh after a sign; and there shall be no sign given to it but the sign of Jonah the prophet: For as Jonah was three days and three nights in the belly of the whale; so shall the Son of man be three days and three nights in the heart of the earth." The Mass commemorated and renewed the sacrifice of Christ for the salvation of humankind by associating "his holy Passion, his Resurrection from the

dead and his glorious Ascension to heaven." Moreover, the Sistine Chapel was dedicated to the Virgin of the Assumption, and above the altar was the fresco by Perugino representing the Assumption of the Virgin, which, as J. O'Malley rightly observes, "is the first fruit of the ultimate perfection achieved by Christ, because it reflects the Resurrection and Ascension of Christ and prefigures the happy destiny of all the redeemed, the resurrection of the flesh." Once again, in the words of Christ, the Brazen Serpent prefigures the Crucifixion: "And as Moses lifted up the serpent in the wilderness, even so must the Son of man be lifted up." (John 3:14) The healing from the snake-bites alludes to the thaumaturgic and salvific power of the cross. In the other pendentive, Haman, who, according to the biblical account was hanged, is put to death on the cross, defeated and punished as the persecutor of the Jews. Lastly, the theme of the Redemption brought about through the Incarnation and the sacrifice of Christ was linked to that of the Last Judgment by means of both the contrast between the two groups in the Brazen Serpent fresco, and Jonah's gaze turned toward the scene of God separating light from darkness.

During the last stage of the work, Michelangelo had to proceed with great speed, adopting a faster, more resolute technique, since he was being continually urged to complete the work by Julius II, who, in fact, died only four months after the unveiling of the ceiling. The accounts of both Condivi and Vasari agree on this point. Vasari relates how the artist

sometimes complained that because of the pope's haste he was not able to complete it in his way as he would have wished, since the pope importunately demanded to know when he would finish; on one occasion among others, Michelangelo replied that the work would be finished "when it satisfies me in its artistic details." "And We," remarked the pope, "want you to satisfy Us in Our desire to see it done quickly." Finally the pope threatened that if

Michelangelo did not finish quickly, he would have him thrown down from the scaffolding.

Vasari also recounts, "When the chapel was uncovered, people from everywhere wanted to rush to see it, and the sight of it alone was sufficient to leave them amazed and speechless." This probably refers, in particular, to

the milieu of the artists, including Raphael, Perin del Vaga, and, above all, Pontormo, Rosso Fiorentino, and Beccafumi. In fact, at the time when the first half of the ceiling was unveiled, Raphael paid homage to Michelangelo by portraying him as Heraclitus in the School of Athens. It should not be forgotten, however, that, long before the *Last Judgment* was painted, the frescoes did not fail to arouse criticism and negative reactions of a "moral" nature. Eloquent testimony of this is found in the episode recounted, once again by Vasari, with regard to pope Adrian VI, who "had already begun ... to let it be known that he wanted to demolish the chapel of the divine Michelangelo, saying that it was a public bath of nudes. And scorning all the excellent painting and statues, he described them as the lewdness of the world, and disgraceful and loathsome things."

Leaning on arms extended behind them, the two bronze nudes, arranged symmetrically, bend their backs and legs as if they were huddling in the limited space allotted to them. On the face of the figure on the left, which is in the light, an expression of suffering is evident. Like all the other bronze nudes, these were painted directly, without being transferred from the preparatory cartoon.

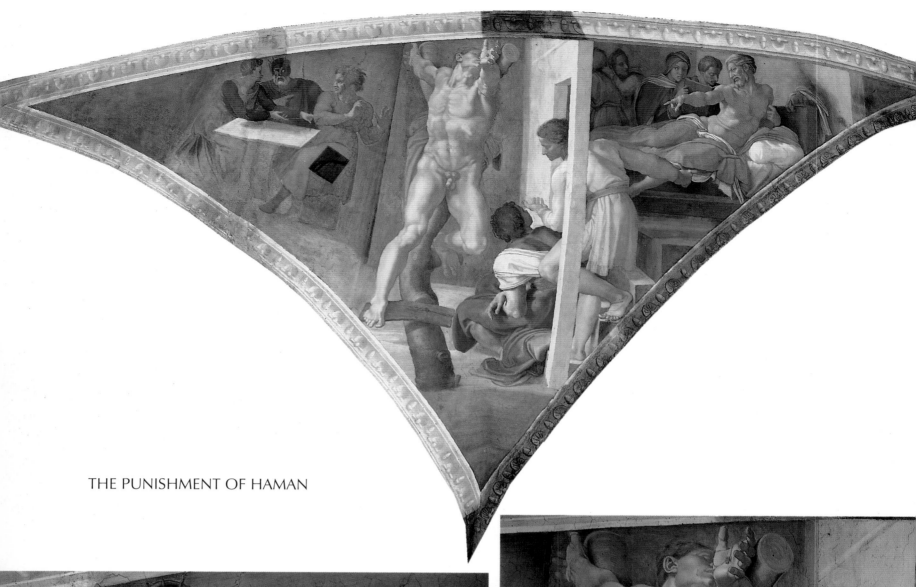

THE PUNISHMENT OF HAMAN

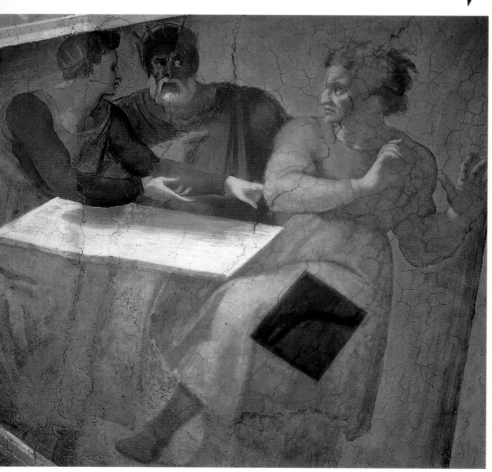

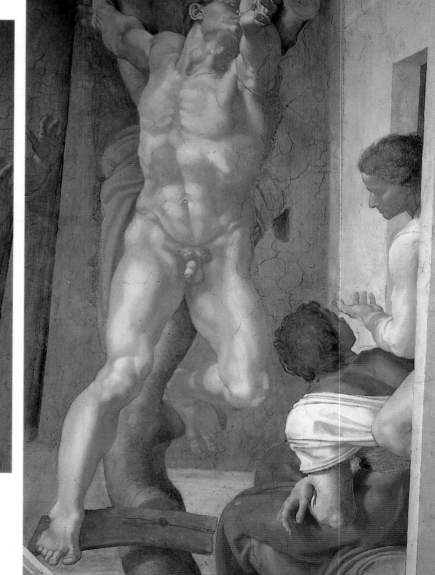

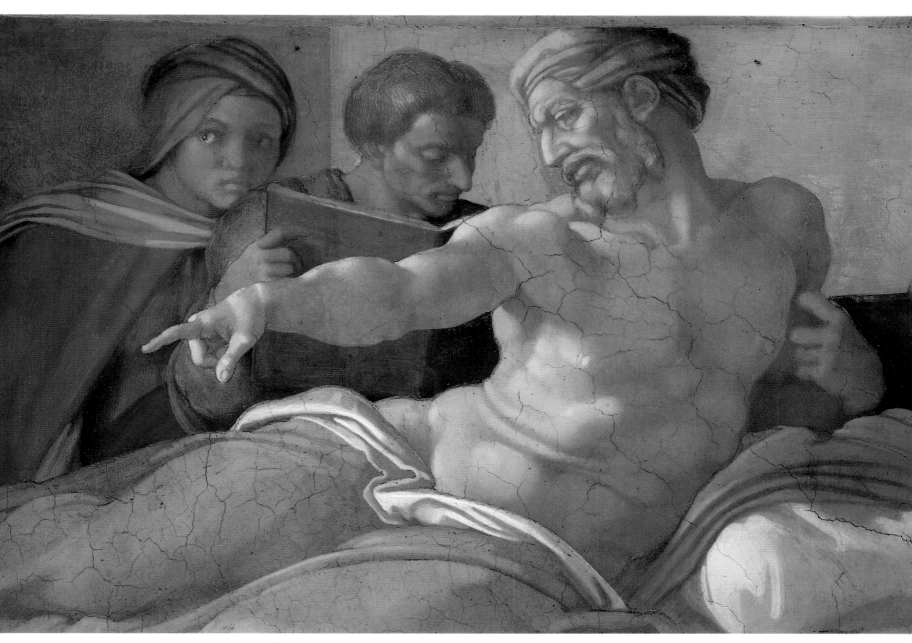

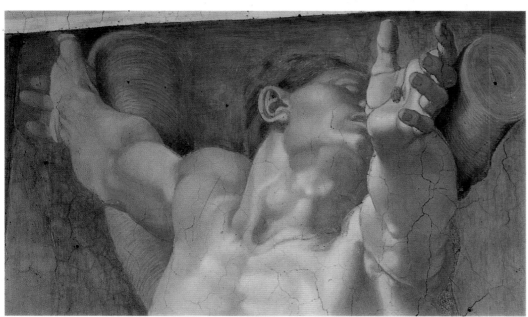

The pendentive, crossed by a crack that caused the detachment of *intonaco*, was restored, with repainting of the missing parts, first by Domenico Carnevali about 1570, and then by Alessandro Mazzuoli between 1710 and 1712. Together with the applications of glue, the repainting modified the color accords of the original. Michelangelo painted the whole scene in twenty-one *giornate*, three of which were required for the figure of Haman. The cartoon for the latter was transferred to the *intonaco* by indirect incision; this required particular care because of the very complex foreshortening. Two sheets with red chalk studies for the same figure are in the British Museum in London and the Teyler Museum in Haarlem.

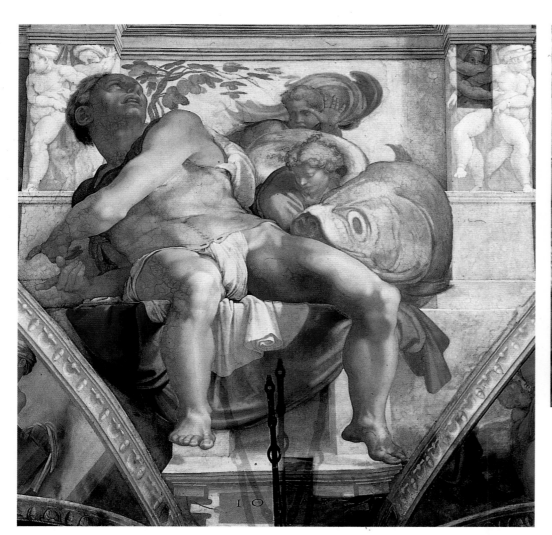

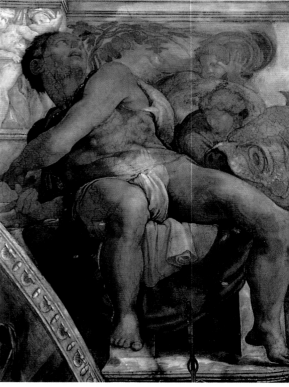

Before the restoration.

The figure of the prophet—together with those of the two attendants and the whale—was painted in ten *giornate*. *Pentimenti* executed *a secco* have been identified, especially in Jonah's legs. These were intended to correct and heighten the effect of the foreshortening, while those on the cornice above the throne modified the incidence of the light. Together with different tones of green and red—from pink to darker shades—the whites, the rosy reflections, the gray of the whale, the pink ocher of the flesh, and the yellows of the acolytes' hair compose a complex, vibrant symphony of color.

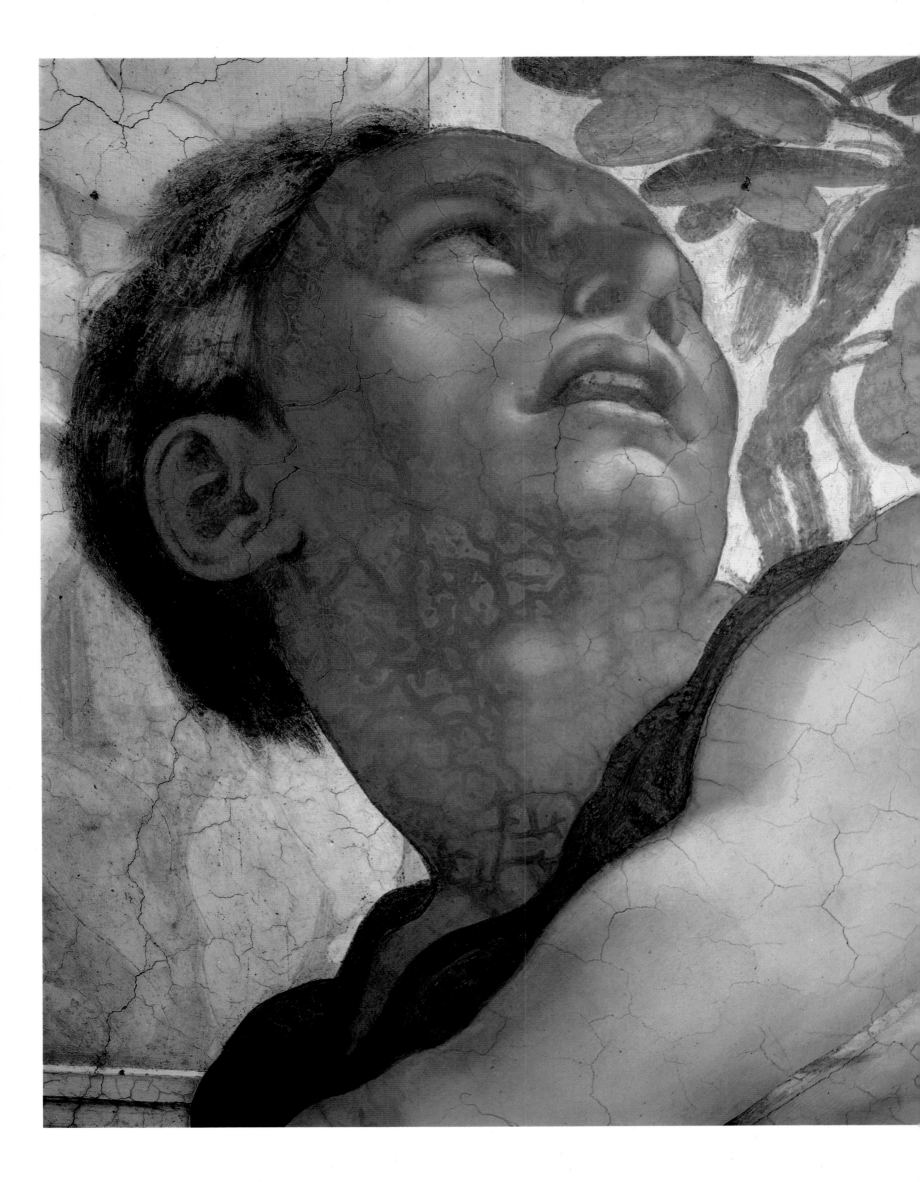

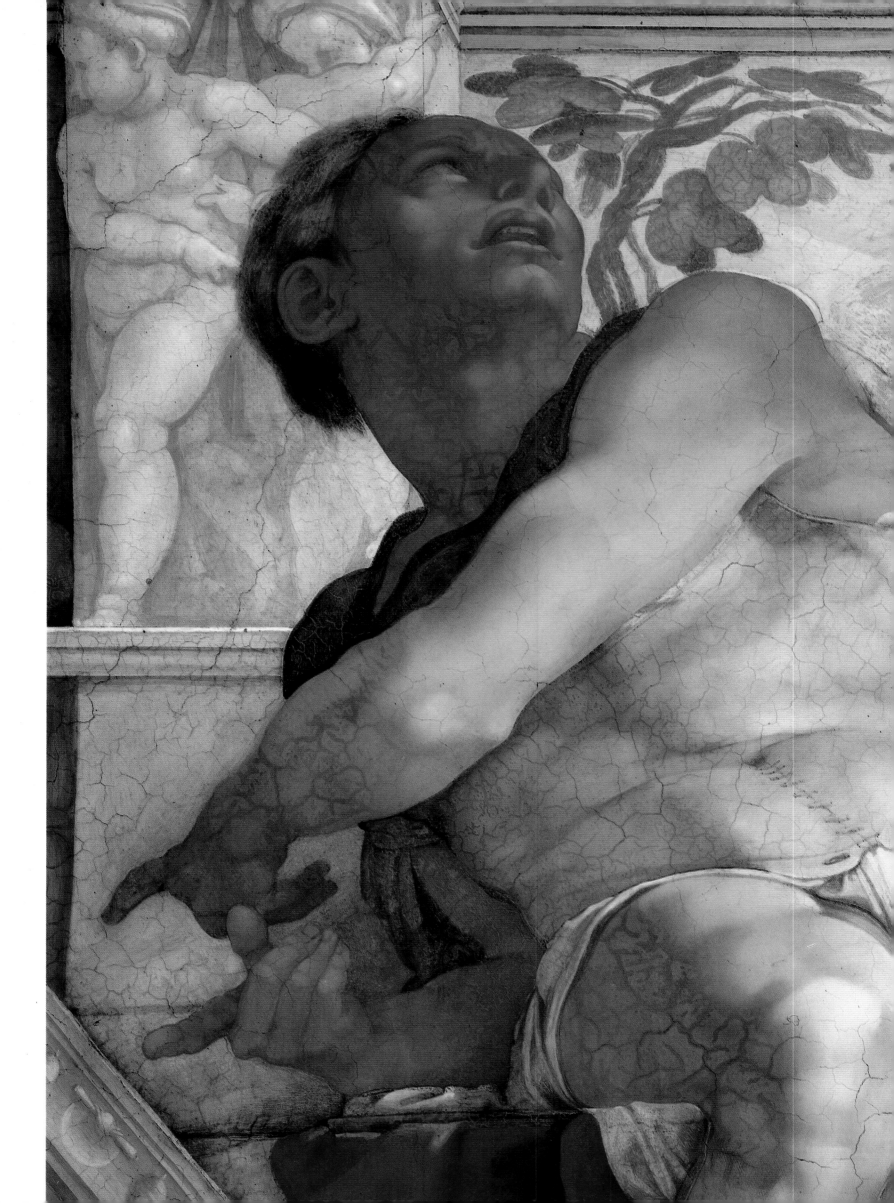

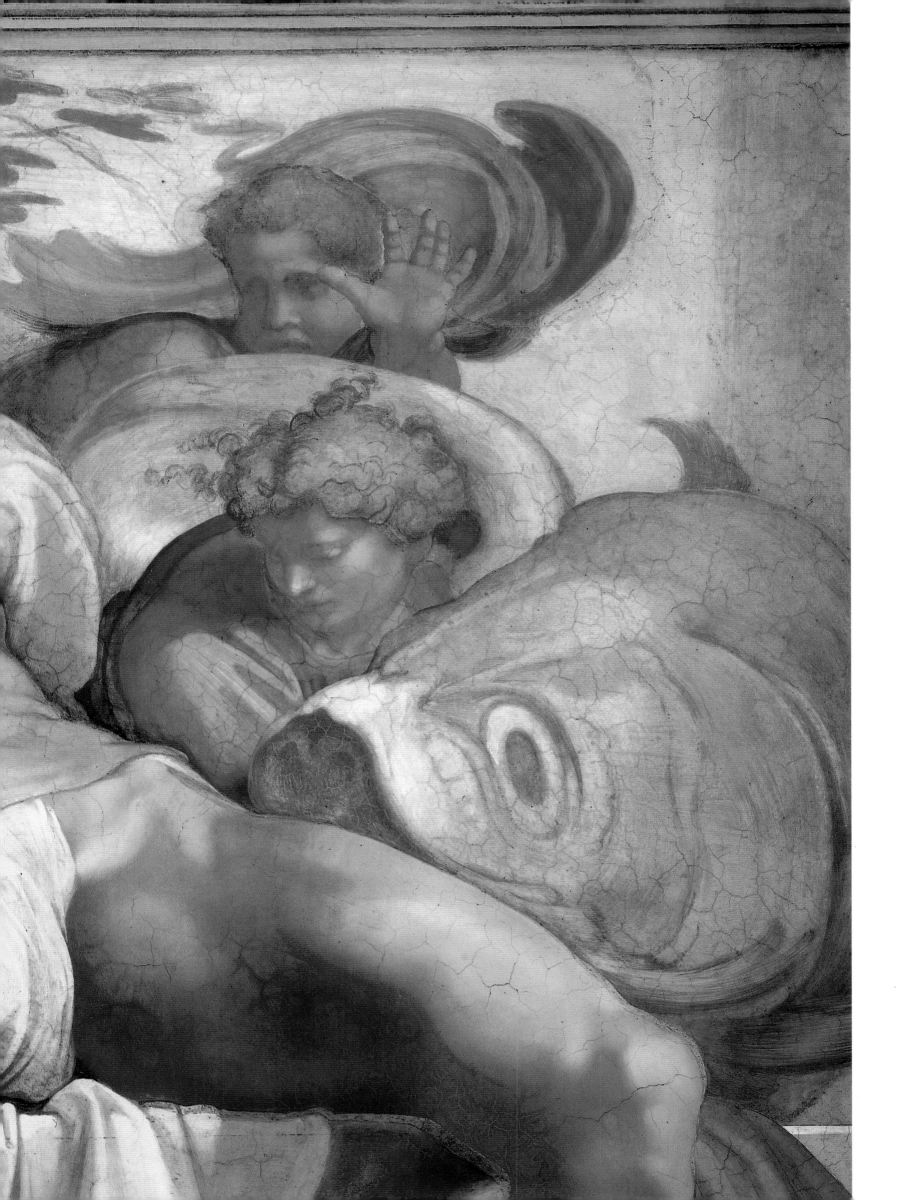

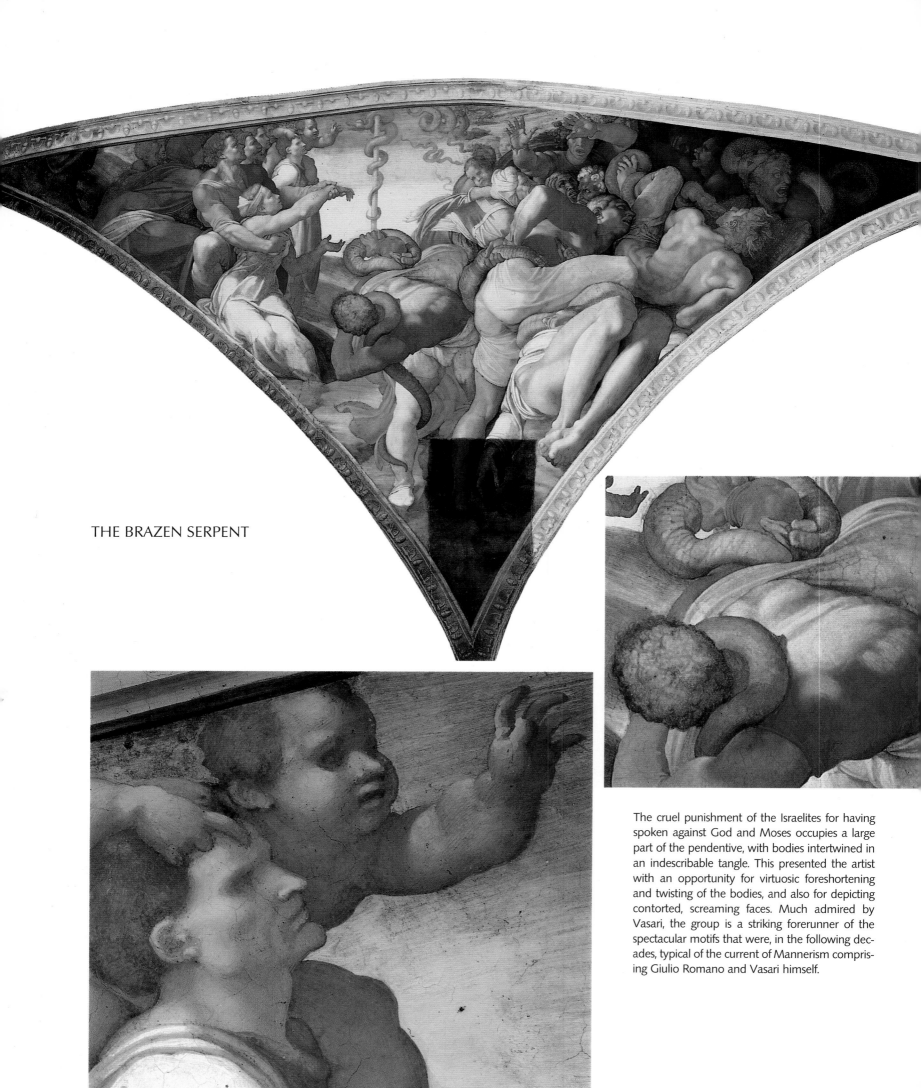

THE BRAZEN SERPENT

The cruel punishment of the Israelites for having spoken against God and Moses occupies a large part of the pendentive, with bodies intertwined in an indescribable tangle. This presented the artist with an opportunity for virtuosic foreshortening and twisting of the bodies, and also for depicting contorted, screaming faces. Much admired by Vasari, the group is a striking forerunner of the spectacular motifs that were, in the following decades, typical of the current of Mannerism comprising Giulio Romano and Vasari himself.

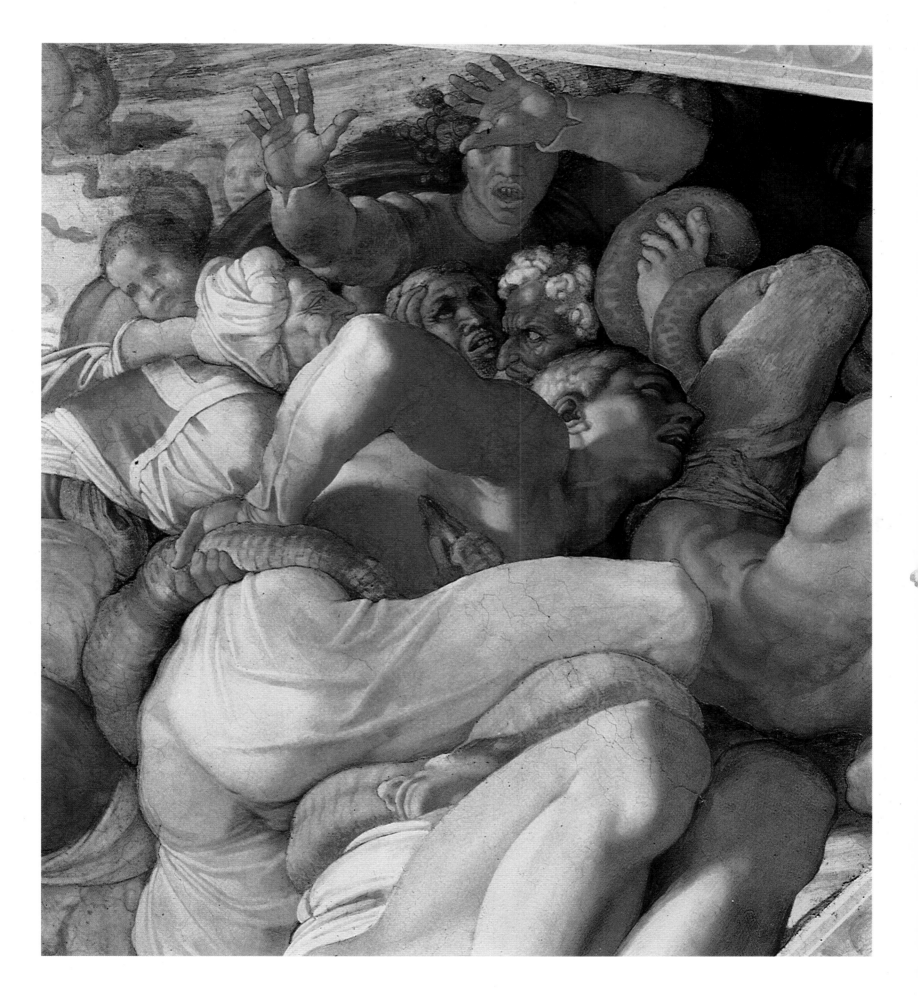

The Last Judgment

Having failed all attempts to convince Paul III to reconsider the scheme of his predecessor Clement VII to adorn the end wall of the Sistine Chapel with a painting representing the Last Judgment, Michelangelo sought whatever means possible to procrastinate and put off the actual commencement of the fresco. Once the preparatory work on the wall was completed—a task that also entailed the closure of the two windows and the construction of a brick lining with an overhang of almost a half *braccio* at the crown of the wall—a disagreement broke out between Michelangelo and Sebastiano del Piombo over the method for preparing the surface to be painted. Their difference of opinion was most likely prompted by the latter artist's concern (shared by the pope himself) regarding the sheer physical effort involved in frescoing the immense wall, a daunting task for the sixty-year-old Buonarroti. Vasari points out in his life of Sebastiano del Piombo:

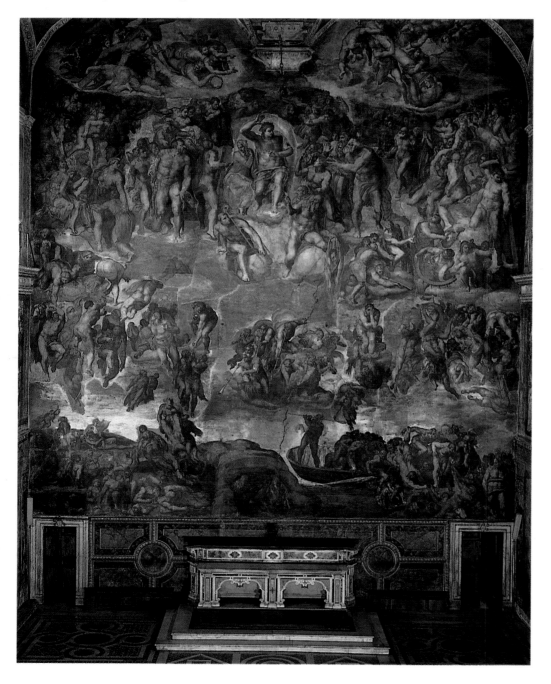

> As noted earlier, Bastiano was much beloved by Michelagnolo: but it is also true that, charged with painting the facade of the papal chapel, wherein lies Buonarroti's *Last Judgment*, there rose between them a disdain, given that Sebastiano had convinced the pope that Michelagnolo should paint in oils, where the latter preferred to use fresco. Michelagnolo would say neither yea nor nay, and dressed himself in the manner of Fra Sebastiano, Michelagnolo remained several months without embarking on the work. However, as he was stimulated [by the idea], he finally stated that he would only work in fresco, and that oil painting was a womanish thing for the well-to-do and idle such as Fra 'Bastiano. Thus, having scraped off the surface crust applied upon the friar's orders, Michelangelo had a layer of *arriccio* laid on so that he might begin frescoing, and duly set about his task, though not forgetting the slight he perceived from Fra Sebastiano.

Records of payment confirm that the *incrostatura* or surface layer ordered by Sebastiano was indeed removed upon Buonarroti's express wish, between January and March 1536. Commence-

Before the restoration.

214

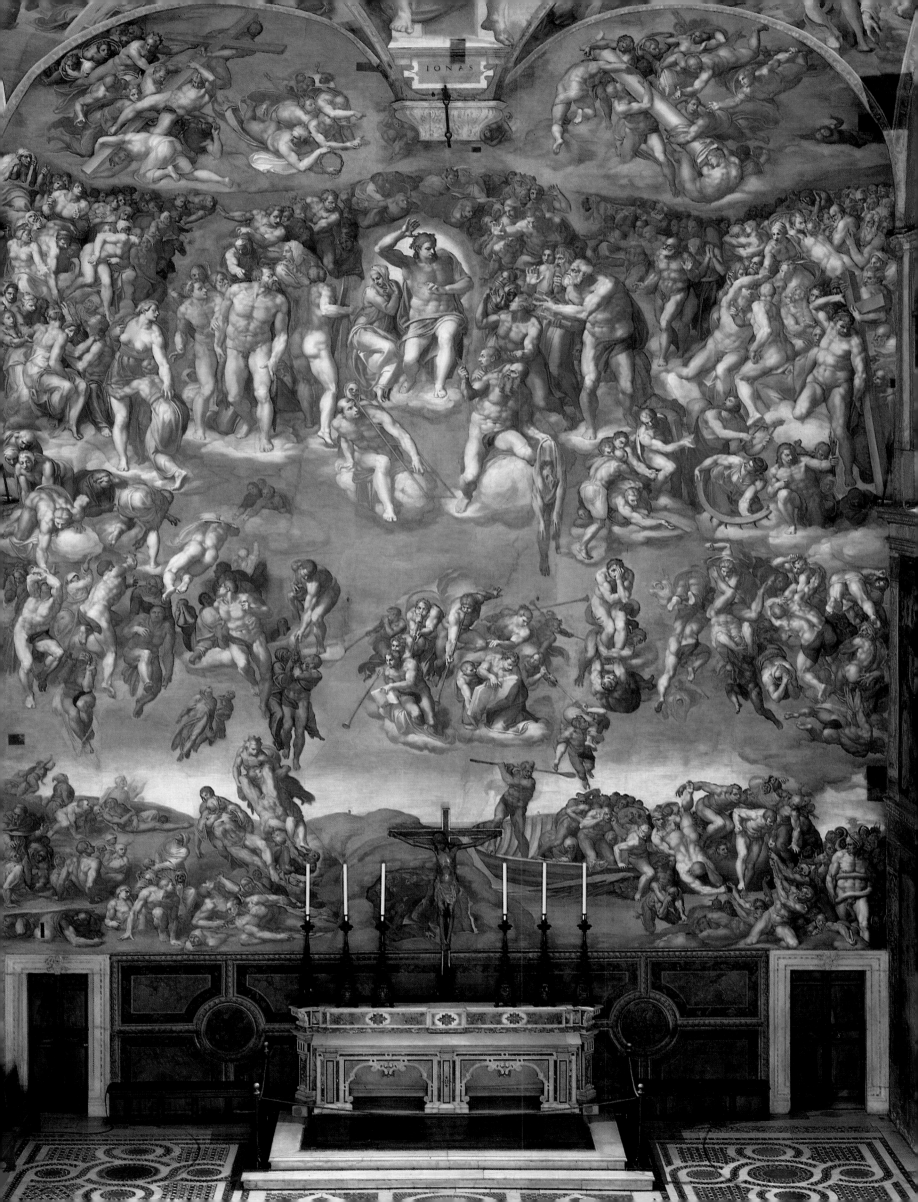

ment was nonetheless delayed a few months, during which Michelangelo purchased such colors as met with his complete satisfaction—especially ultramarine blue. Michelangelo finally climbed the scaffolding during that

Study in black chalk (Bayonne, Musée Bonnat; 7 x 9½ in. (179 x 239 mm)) of a group of the blessed featured in the crown surrounding Christ in the *Last Judgment*, close to the Virgin. As in other instances, rather than isolated figures the artist has studied the motion and groupings of different characters with close contextual links.

summer, and the fresco was exposed to view on the eve of All Saints' Day 1541.

The extant composition sketches—a sheet in the Musée Bonnat, Bayonne, and one at Casa Buonarroti, Florence—show the artist rapidly straying from the iconographic schemes with which he was familiar; by the second sheet he has transformed the theme of the ascension of the blessed into a surging tumble of figures, interwoven as if in a battle, not dissimilar in movement to the tormented fray unfolding in the lower register, wherein the reprobates are being driven ever downward to the infernal abyss. The

traditional hierarchical structure of the Judgment scene was thus refuted and dramatically overturned, giving rise to a far more dynamic composition in which great emphasis is given to the forceful interweaving and contrasts of the individual figures or groupings. Subsequently, however, Michelangelo decided to fill the entire end wall with the representation of the Last Judgment, eliminating cornices and dividing members, almost encroaching on the vault and walls on either side, throwing wide the chapel to achieve a space with an existence of its own, even a kind of second reality, of incommensurable vastness stretching beyond the neat, ordered environment of the observer. The sense of spatial depth in which the figures appear to move as if propelled by inexorable upward and downward movement is endorsed by the luminous backdrop of sky, painted in lapis lazuli blue and enhanced with harsh foreshortenings of the bodies, complex dovetailing of limbs, sudden breaches, proportional gaps, and shifts in hue and degrees of light and shadow. The true impact of these effects can now be fully admired after the restoration.

Even before it had been completed, Buonarroti's fresco sparked widely varying reactions by his contemporaries. For some it was worthy of boundless, unconditioned admiration. For others it was scandalous; it drew harsh criticism—even invective—for its formal outlook and its "immodesty." The attacks came from all quarters, from within and without the papal court: from the papal *ceremoniere*, or minister, the most finicky Messer Biagio da Cesena, the writer Pietro Aretino, the theologian Ambrogio Catarino, and the ecclesiastic Giovanni Andrea Gilio—not to mention insults from anonymous sources and the accusations of obscenity, lewdness, and disrespect for the established historical and doctrinal truth. The barrage of reproach and opprobrium, sometimes spiced with more specific faultfinding in the fresco's formal design, snowballed with such intensity that there were even imputations of heresy.

While the recurrent instigations to

destroy the fresco were not successful during Paul III's rule, nor under the pontificate of his successor Julius III, nonetheless, opinion of the artist and his later work turned against him, especially under Paul IV and Pius IV—a period in which Buonarroti seriously risked being dragged before the Holy Office. New accusations of immodesty led eventually to a decision of the committee of the Council of Trent on January 11, 1564, which decreed the "correction" of the parts of the fresco deemed indecent. The artist entrusted with the censorship was Daniele da Volterra who, being a fervent admirer of Buonarroti, limited himself to adding discreet draperies to cover the nudity of certain figures, but was required to repaint Saints Catherine and Blaise almost entirely; these figures had been the object of the harshest attacks on the part of the fresco's detractors. Volterra's corrections were not enough to assuage the critics, however, nor to obviate later, more drastic interference with Michelangelo's paintings, nor even to dispel appeals for the destruction of the *Last Judgment*.

Vasari's exalted description of the formal aspects of the fresco in the first edition of the *Lives* was countered by the harsh criticisms from Venetian writer Ludovico Dolce in his *Dialogo della Pittura*—opinions that were endorsed by a broad spectrum of artistic circles, not just those of Venice. The ideals of harmony, grace, and variety, epitomized by the art of Raphael, were systematically reproposed against the work of Buonarroti, and the expressive intensity of the *Last Judgment* was indicted for its "lack of that moderation and pondered appropriateness without which nothing can possess grace, nor be proper" ("mancanza di una certa temperata misura e certa considerata convenevolezza, senza la quale niuna cosa può aver grazia é istar bene"). Even the representation of the human body in movement and in an infinite variety of attitudes, which Vasari saw as the perfection of art, was denounced as a monotonous display of virtuoso anatomical representation: "Once you have seen one of Michelangelo's figures, you

have seen them all" ("Chi vede una figura di Michelagnolo, le vede tutte"). In the second edition of his *Lives*, Vasari, who had already stressed the exceptional quality of Michelangelo's execution, replied to the disparagers, "And besides every beautiful detail, it is extraordinary to see such a work painted and executed so harmoniously that it seems to have been done in a single day and with the kind of finish that no illuminator could ever have achieved" ("Et oltre a ogni bellezza straordinaria è il vedere tanta opera sì unitamente dipinta e condotta, che ella pare fatta in un giorno e con quelle fine che mai minio nessuno si condusse talmente")—thus presenting his critique of the outstanding plasticity of the artist's vision and his conception of the image as a unitary architecture of figures, together with the marked expression of human feeling conveyed by the dramatic accentuation of the motion and attitudes of the figures.

While such polemics are a thing of the past, in more recent times the underlying meanings of Michelangelo's fresco have undergone widely contrasting interpretations. Some observers consider them to be in line with the contemporary doctrines of the Roman church, forming an ominous reminder of the fragility of human nature and its proneness to sin. Others have detected influences of the internal currents of reform pervading the Western Church, or hints of anti-clericalism reminiscent of quattrocento reformer Girolamo Savonarola, or even traces of the teachings of the followers of Juan de Valdés or Martin Luther. Attempts to attribute an univocal definition of the meanings underlying the fresco on the basis of prescribed doctrines are doomed to failure: subjecting the work to strict analysis from a single point of view merely generates ambiguities and contradictions that ultimately impede any viable global interpretation.

There is evidence that the artist's spiritual circumstances affected his choice of imagery, formal values, and iconography. Other factors must include the influence of Vittoria Colonna and Cardinal Pole, who had been deeply involved in the spiritual dilemmas of this period of religious contention. There is also Michelangelo's own reaction—of which traces can be found in his poems—to the terrible crisis that had seized Christianity, a cataclysm that risked undermining the very aspirations and ideals that had nurtured the art of the Italian Renaissance.

In the fresco, the personal drama of the individual assumes dimensions of an authentically universal nature. In Michelangelo's reworking of the traditional iconography representing the Apocalypse or "end of the world," this shift takes place in the dissolution of order and the formal balance that reflected the notion of an immutable structure, a structure that admitted neither doubts nor hesitations; here Michelangelo effectively achieved the dramatic awareness of a breach, of the collapse that heralded a new and lacerating awareness of the individual's responsibility of choice, and his anguished uncertainty regarding the ultimate destiny. In this sense the impression of Michelangelo's *Last Judgment* in the Sistine Chapel is genuinely catastrophic, and the very structure of the composition that overwhelms the modern observer (not to mention the artist's contemporaries) imposes an overarching emotional fervor on the individual elements of the painting, which may collectively even appear incoherent and contradictory, being relics of a previous, deeply reworked image.

This mixture of exaltation and violent censure on the part of Michelangelo's contemporaries, together with the tendency to interpret and construe readings of a unilateral kind centered on particulars, betrays a common, deepseated disquiet. This uneasiness, more or less consciously, has led to a collective process—whether as accusations of obscenity or lack of orthodoxy or as offense at the work's decorum and standards (even artistic standards), that seems bent on belittling or even exorcising the very significance of the painting, namely, its sense of unutterable catastrophe, the vision of the undoing of a suffering humanity. After the collapse of the last intellectual and moral refuges, these souls can only await with trepidation the fulfillment of that promised "resurrection of the righteous" in the presence of the Son of Man, who returns on the clouds amid the apocalyptic scenario.

Study in black and red chalk (London, British Museum; 15¼ x 9⅞ in. (385 x 251 mm)) of various groups of figures, with an emphasis on the damned struggling to keep from falling into the abyss. The sheet contains inventions that come very close to the final representation, exploring motifs that were present in Michelangelo's overall sketch of the composition (Florence, Casa Buonarroti).

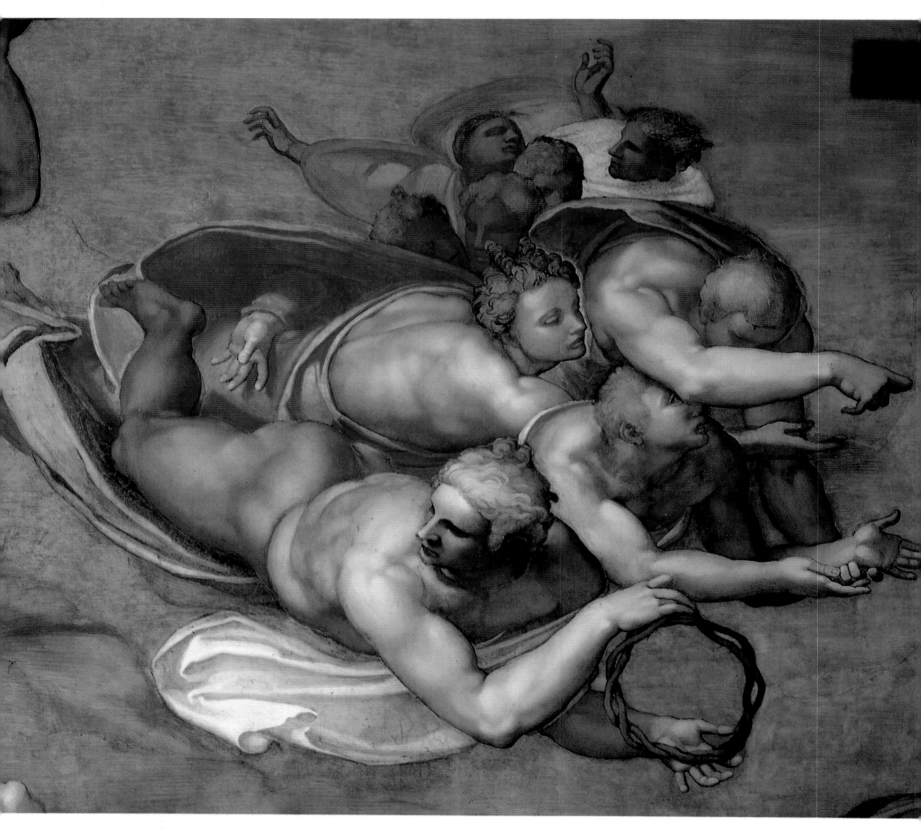

Alongside the figures raising the cross in the left lunette is a group of slightly foreshortened angel figures gliding toward the center of the wall, one of whom bears the crown of thorns. The restoration work has revealed the remarkable delicacy of the modeling of their naked forms and the attention to the way the light falls.

THE ANGELS WITH THE INSTRUMENTS OF THE PASSION

Although Michelangelo made profound changes to the traditional structure of superimposed "orders" in the composition of the *Last Judgment*, one sees clearly its division into three basic zones: above, in the lunettes, the angels bear aloft the instruments of the passion, symbols of Christ's sacrifice and the redemption of humanity; in the center, Christ the Judge and the Virgin Mary are surrounded by the Apostles and a host of blessed; and below, we see the risen who, once more in their mortal form, ascend heavenward as they weave through groups of angels with trumpets heralding the Apocalypse, and groups of damned souls are driven downward into the nether regions of hell.

"He depicted, for the greater punishment of those who have not lived good lives, all of Christ's Passion; he has various naked figures in the air carrying the cross, the column, the lance, the sponge, the nails, and the crown in different and varied poses with a grace that can be executed only with great difficulty." Interestingly, Vasari writes of naked figures rather than angels, noting the extraordinary complexity of the foreshortening and poses, marveling at the virtuosity and yet utter naturalness of their representation. The wingless angels billow headlong into the foreground from a radiant blue sky above the files of blessed ranged in the section below. In the left lunette the traditional subject of the raising of the cross in the presence of Christ the Judge is transformed into swaths of convulsed athletic forms seemingly caught in a sudden turbulence. In the right lunette other angels struggle to raise the column of the flagellation, gliding wingless through a clouded firmament in acrobatic poses. Marked foreshortening and counterpoised or opposing movements, rendered in contrasting use of light and shade, are all hallmarks of the syntax of bodies that Michelangelo had devised. They are epitomized here in the crowning lunettes of the *Judgment* wall, made

more prominent by the resplendent lapis lazuli blue backdrop. These formal contrivances won great admiration from Michelangelo's contemporaries, but also elicited aspersion for what was seen as the artist's ostentation of his vituoso knowledge of human anatomy, and criticism for the lack of wings on the angels and their unbecoming attitudes: "I cannot admire the efforts of the angels in Michelangelo's *Judgment*, those that bear up the cross, the column, and the other sacred mysteries, who are more like mountebanks and jugglers than angels" (G. A. Gilio, 1564).

In terms of idealized beauty and the canons of human proportions, the lunette angels are effectively close in form to many other of Michelangelo's previously sculpted or painted figures. Compared to the *ignudi* on the ceiling, these angels striving against the turbulent atmosphere about them seem to hark back to the Florentine soldiers of the *Battle of Cascina*, who ready themselves by the waters of the Arno, freshly apprised of the approach of the enemy.

The dramatic agitation of the angels with the instruments of the passion sums up the theme of the entire scene. The entanglement of figures is matched by the agonized intensity of their expressions: taut faces, their eyes half-closed in terrible concentration or wide with trepidation, as if in dread of the fearful vision before them. One of the most novel, and perhaps the most disturbing, motifs of Michelangelo's representation of the Apocalypse is the general sense of dread, which also pervades the blessed around the figure of Christ the Judge, which reinforces the emotion that is so unlike the exaltation and inner radiance traditionally associated with the idea of beatitude. Here the predominant feeling is anguished fear, deep distress, apprehension, inner suffering, or invincible oppression—a feeling characterized at the fresco's very summit in the wingless angels.

The angels are intent on erecting the column of the flagellation, its top inclined sharply toward the center of the wall in counterpoint to the cross in the opposite lunette. They appear to be struggling against some atmospheric turbulence, their bodily movements dynamically entwined.

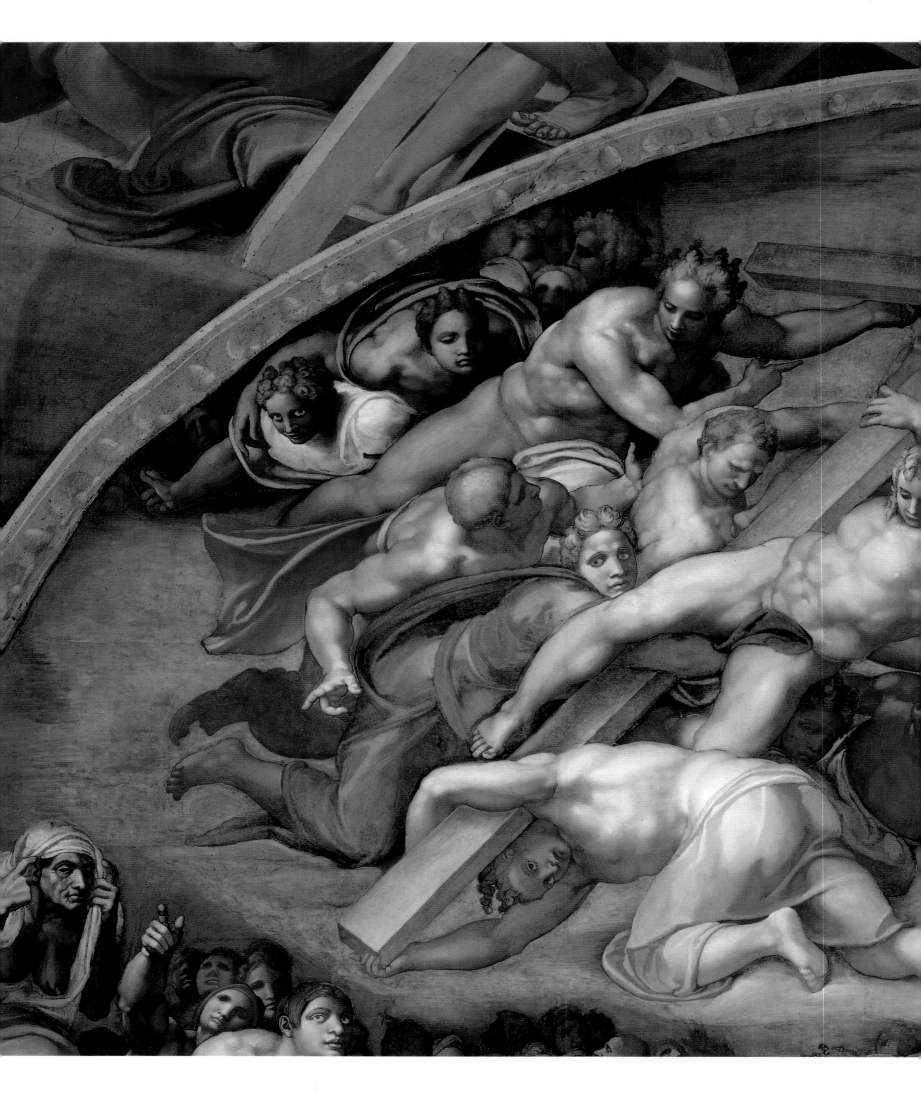

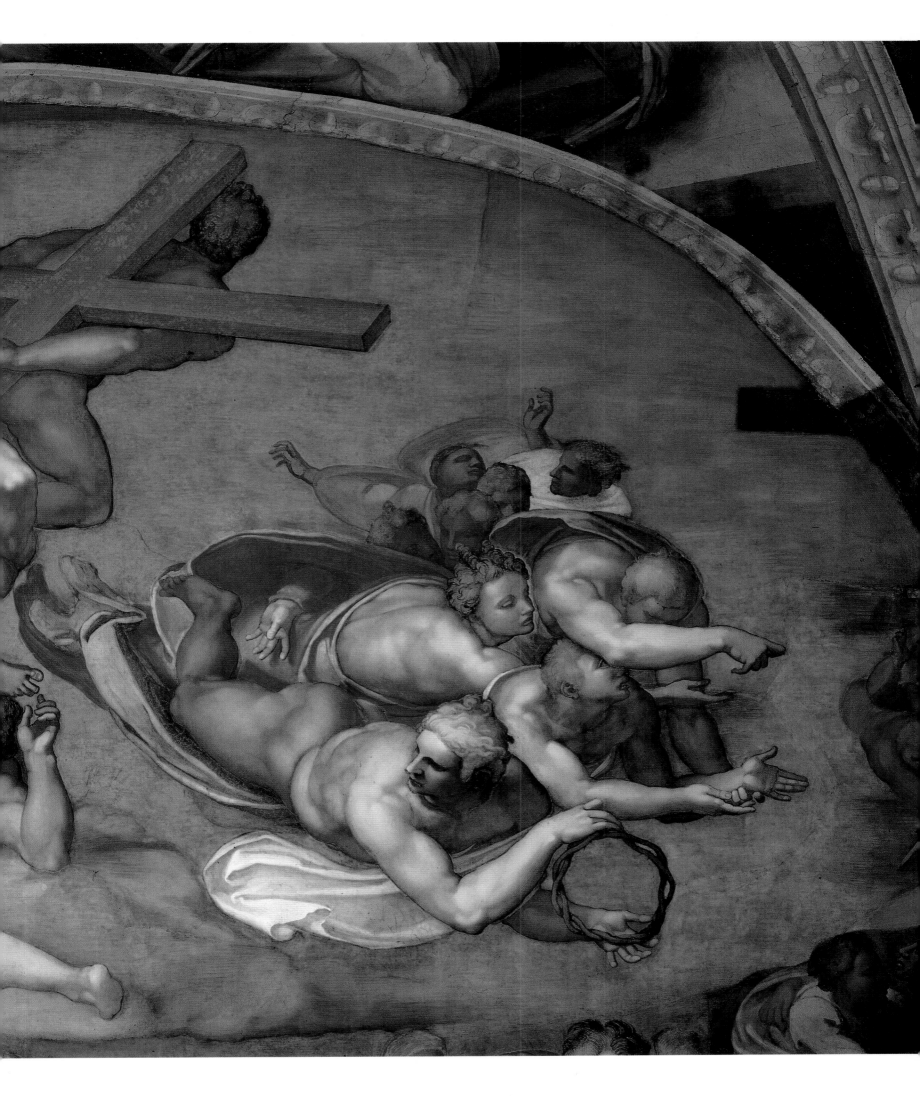

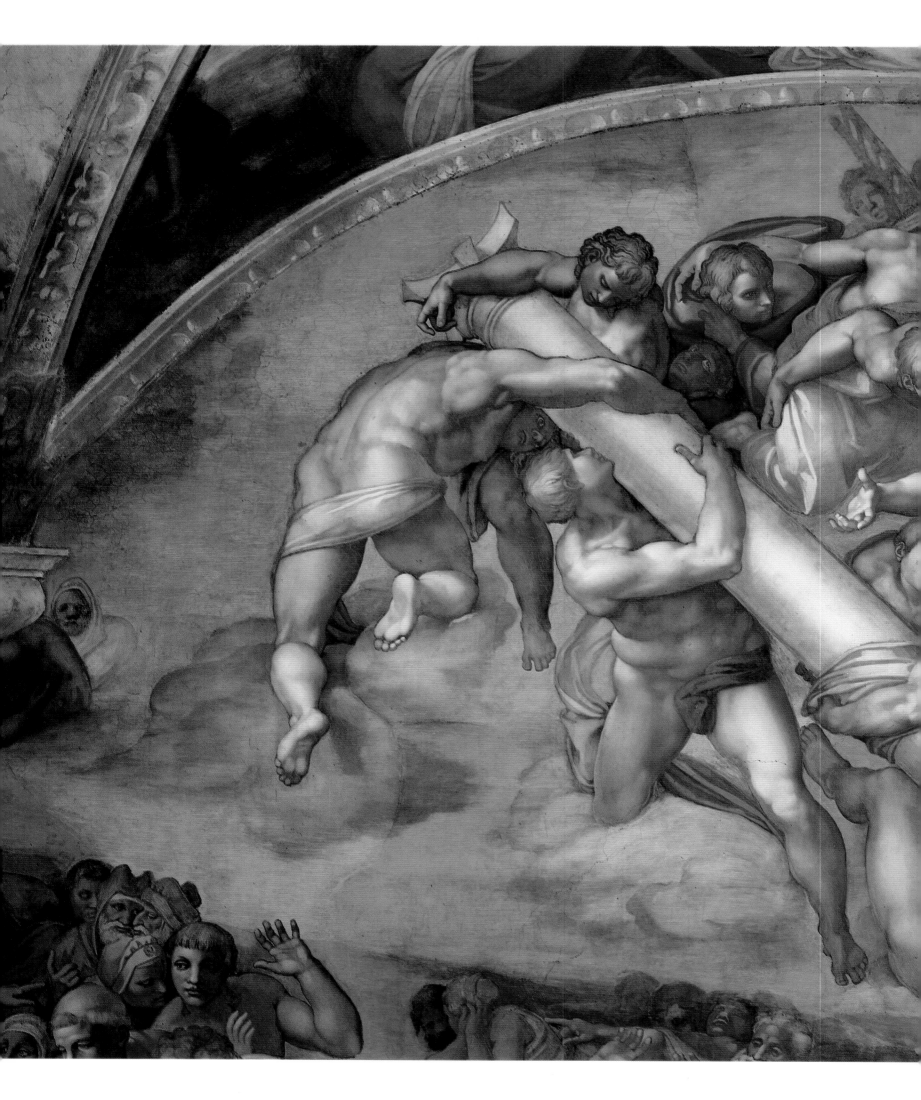

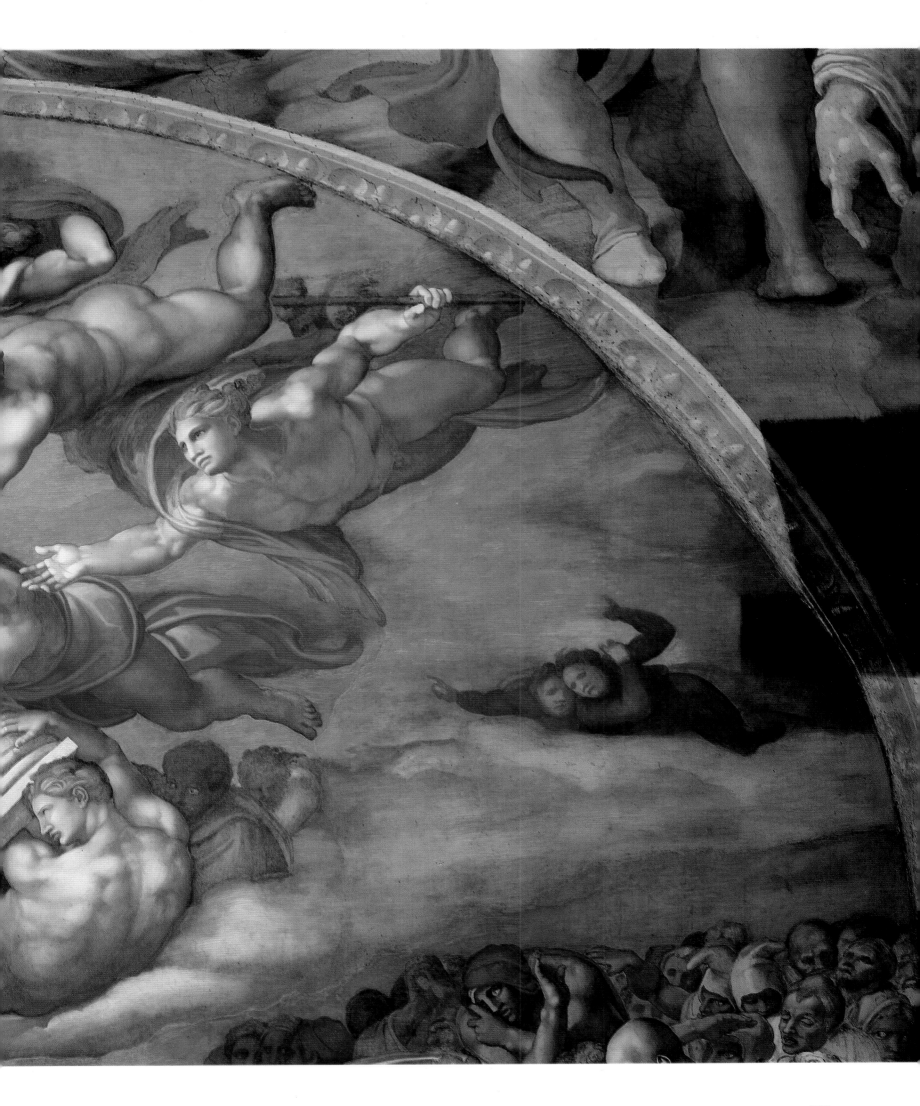

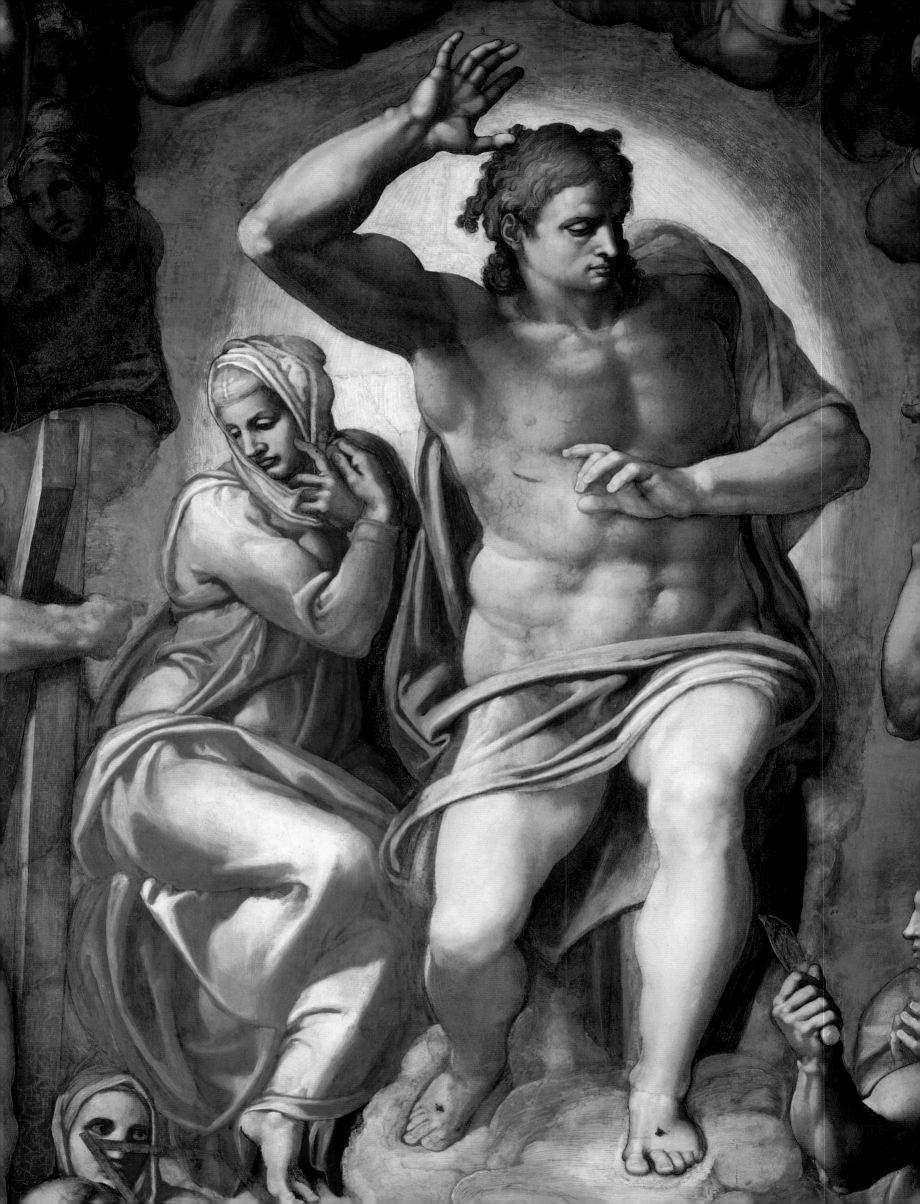

CHRIST THE JUDGE AND THE VIRGIN MARY
AMONG APOSTLES, PATRIARCHS, AND THE BLESSED

Attended by the Virgin Mary, the figure of Christ the Judge commands the center of the composition, encircled by apostles, prophets, patriarchs, sibyls, and heroines of the Old Testament, and by the martyrs, virgins, and saints, forming a double, swirling corona of bodies about him. In earlier representations of the Last Judgment Christ is featured according to the description in the Gospel of Saint Matthew, "seated upon the throne of glory" and flanked by the Apostles, who in turn sit "on the thrones of the twelve tribes of Israel." Christ is often pictured with his arms outstretched to show the signs of the crucifixion, or with his right palm facing upward and the other turned down, signifying the calling of the elect and the condemnation of the sinners. Instead, Michelangelo's *Judgment* shows Christ in movement rather than immobile, rising forth, like he "who comes from the clouds in the sky" at the end of time, with his right arm raised above his head and the left hand level with the lance wound at his heart. His pose and uplifted arm—reminiscent of the central figure of Michelangelo's youthful *Battle of Lapiths and Centaurs*, or of Zeus hurling his thunderbolt in the drawings for the *Fall of Phaethon*—suggests an act of awful and definitive condemnation. Vasari himself saw this, describing the fresco thus: "There is the figure of Christ who, seated with a stern and terrible face, turns to the damned to curse them." In truth Christ wears an impassive expression that betrays neither wrath nor reproof. The close link between his gesture and the sense of motion conveyed in the composition as a whole would seem rather to suggest an imperious signal for the Apocalypse, which both determines and pervades the dreadful turmoil of humanity's end. Moreover, despite its some hundred figures, the fresco's astonishing sense of unity largely stems from the subordination of the gestures and attitudes of the figures to the sense of clockwise rotation, whose formal and symbolic pivot is the dominating central figure of Christ.

In addition to doing away with the thrones of the Apostles, Michelangelo has replaced the formula of the deesis (Christ enthroned with the Virgin Mary and John the Baptist in the act of interceding) with the figure of the Virgin, presented close by her son's side, sharing the glowing aureole that envelops him. Around the corona of saints and Old Testament figures unfolds a heaving composition of interwoven figures that recede into the distance, portrayed in a close-knit sequence of postures and daring foreshortenings. As in other parts of the fresco, some of the background figures that were not envisioned at the outset nor drawn on cartoons were added by Michelangelo *a secco*, as a means of heightening the sense of field depth. Notwithstanding the foreshortening, compositional counterpoint, and entangled forms, the gestures and motion are consistently regulated by precise rhythmic relations, with inventions of free and dynamic symmetry. In addition to the superb eloquence of the faces and expressions, and the complex orchestration of the groups of figures, the sense of thrall and dramatic tension pervading the tiers of saints thronging around Christ the Judge—not passive witnesses but animated participants in the awesome destiny of humanity—is largely communicated by the positions of hands and arms, which loom into the foreground: arms outstretched in affirmation, interrogation, imploring, or which shield the body or face, as if in fear, anguish, or extreme distress.

The gripping emotional tenor of Michelangelo's representation denotes a further distance from the traditional Last Judgment iconography, and is masterfully sustained throughout the vast fresco, securing the observer's innermost participation in the unfolding catastrophe. As Vasari remarked: "To tell the truth, the multitude of figures and the magnificence and grandeur of the work are indescribable."

This intensity, together with the variety and wealth of human expression, is one of the principal features of the entire fresco, and owes much to the artist's sublime ability in representing the human body, of the "amazing diversity ... of the various and unusual gestures

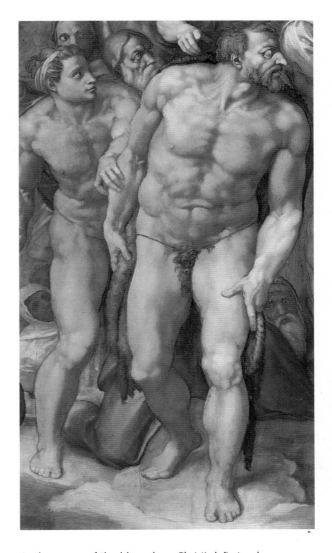

In the group of the blessed on Christ's left stands the imposing figure of Saint John the Baptist, his tense gaze turned upon the Redeemer. Generally, representations of the Judgment feature the deesis composition of Christ enthroned flanked by the Virgin Mary and Saint John the Baptist in the act of interceding. In the Sistine version, the Virgin is closely bound to her Son, as if portraying the direct relationship between judgment and divine mercy. Here, the Baptist holds a commanding position among the blessed, symmetrically opposite Saint Peter.

225

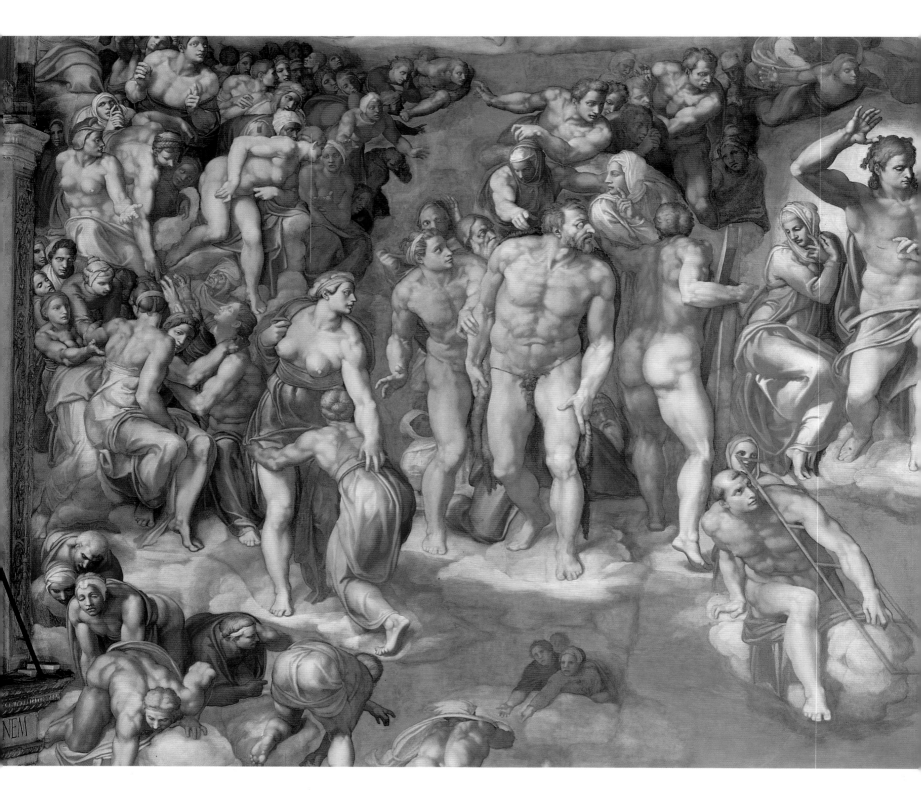

of the young and old, the men and women."

In the figures of Christ, Saint Sebastian, and numerous others, Michelangelo seems to want to rival the classical models of the heroic nude. Here, in this portrait of the resurrection, the beauty of the unclothed human body has become a symbol for the glory of the chosen ones. Be that as it may, it was the very nudity of many figures that provoked the bitter and scandalized reactions of many of the fresco's detractors. A few days after the fresco was exposed to view, Nino Sernini wrote to Cardinal Ercole Gonzaga that "the very reverend Theatines are the first to state that the nakedness is out of place, that [these figures] bare themselves" ("gli Rev.mi Chietini sono gli primi che dicono non istar bene gli ignudi in simil luogo, che mostrano le cose loro"). Among those making allegations of obscenity in the course of the ensuing decades were Pietro Aretino and the ecclesiastic G. A. Gilio, who wrote: "While the idolatrous Gentiles ab-

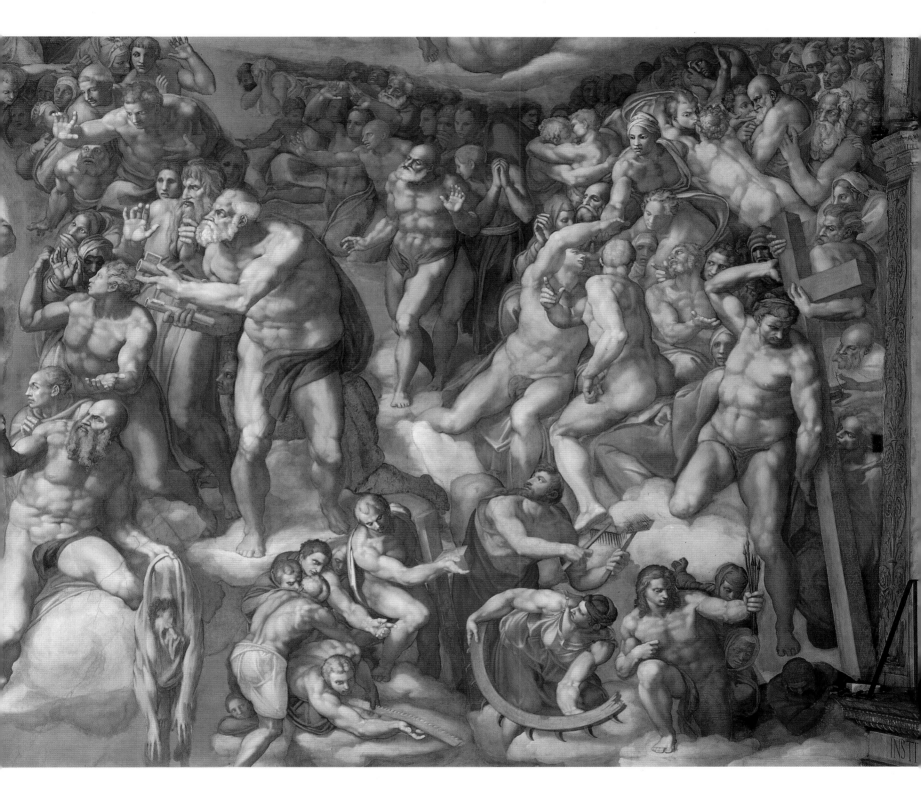

horred licentiousness, dishonesty of act, thought, and word, are we to gaze fondly at the sacred figures thus naked and shameless and disgraceful, when the divine services are performed and the Holy Sacrifice is being offered up?" ("Se dunque i Gentili idolatri hanno abborrito le sporcherie, le disonestà negli atti, ne' pensieri e ne le parole, vagheggeremo noi le figure sacre nude e disoneste e scandalose, quando se celebrano i divini uffizii e s'offerisce il santissimo Sacrifizio"). What aroused the indignation of many of the artist's contemporaries, and threatened the fresco's very survival, appears nevertheless in a new light, centuries later, in the observation of the present pontiff, John Paul II, who, when the restored *Last Judgment* was unveiled, declared the Sistine Chapel to be "the sanctuary of the theology of the human body."

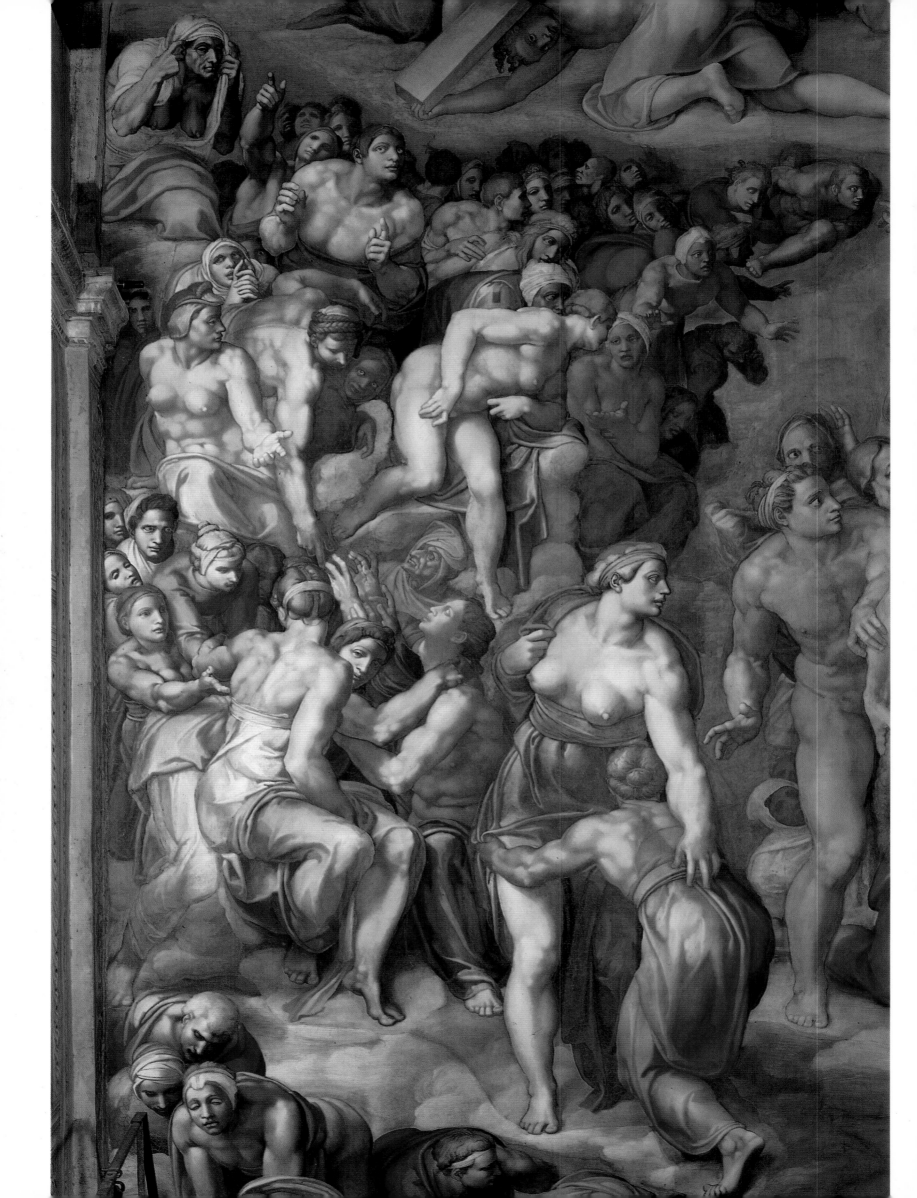

At the left border of the ranks of blessed stand the female martyr saints and virgins together with sibyls and Old Testament heroines, corresponding to the figures of the male saints, confessors, and prophets ranked on the right, opposite. The extraordinary variety of pose and complexity of foreshortening used for the gestures and attitudes of the former group often surpasses the agitation conveyed by the figures in the central corona. In many cases, the visual expressions are startlingly characterized and concentrated. Traditionally, the large figure protectively drawing a kneeling girl toward her is identified as Eve; the "designations" of the other figures in this group are still under discussion.

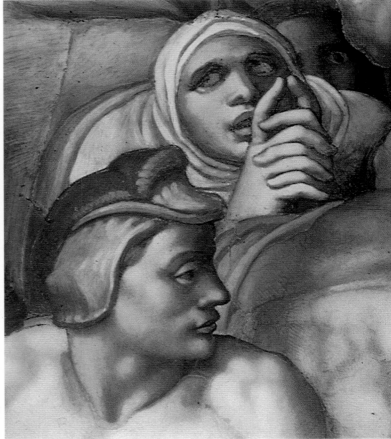

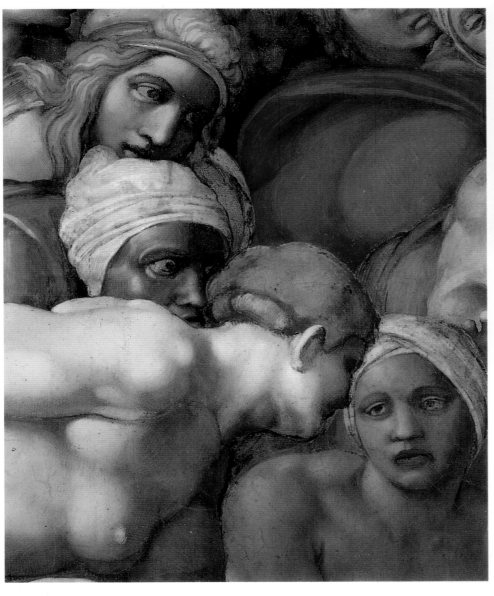

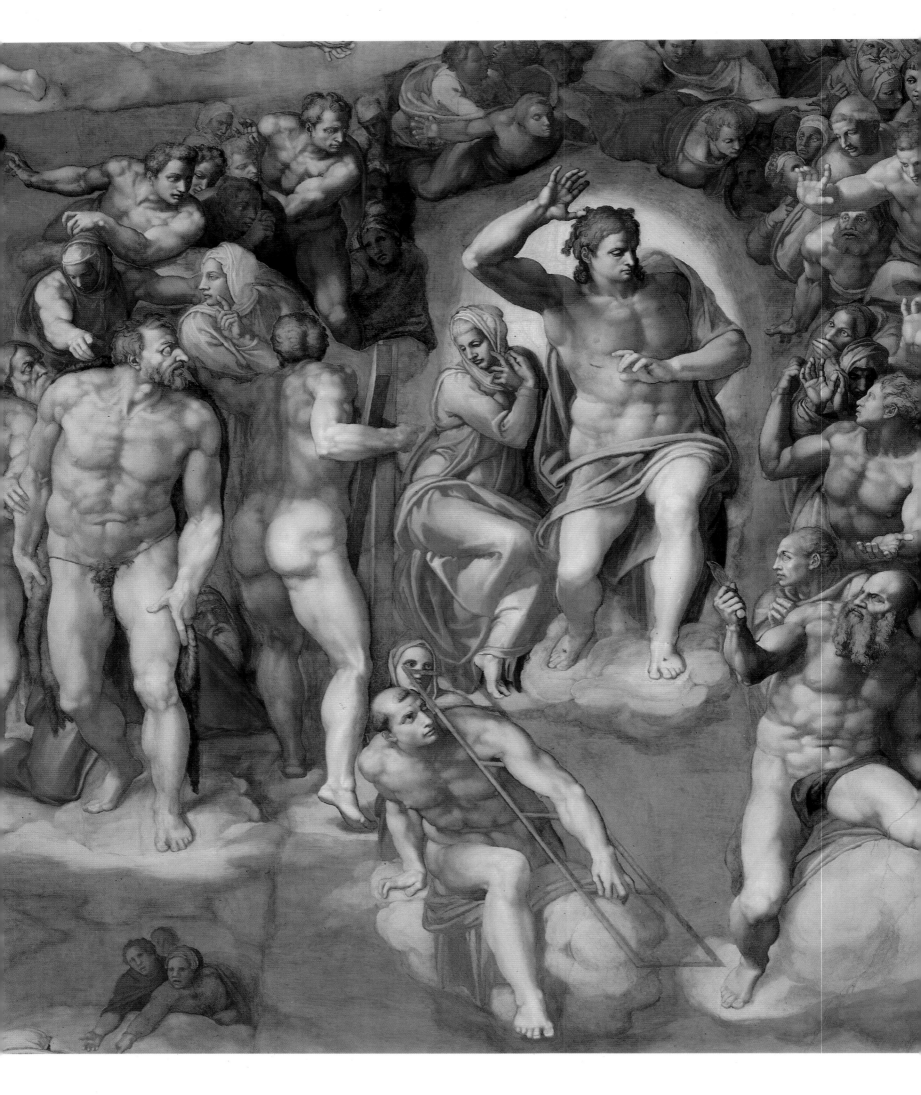

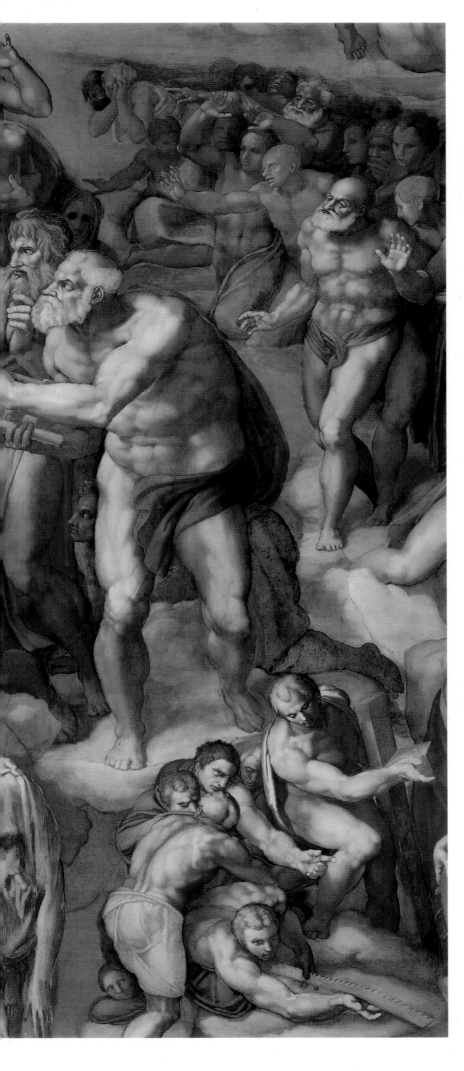

Standing out forcefully from the other saints ranged around the figure of the divine Judge is the figure of Saint Peter, forming a counterweight to the Baptist on the left; the saint holds out two huge keys, the emblems of the pontiff's power to release or bind, a role that has become superfluous with

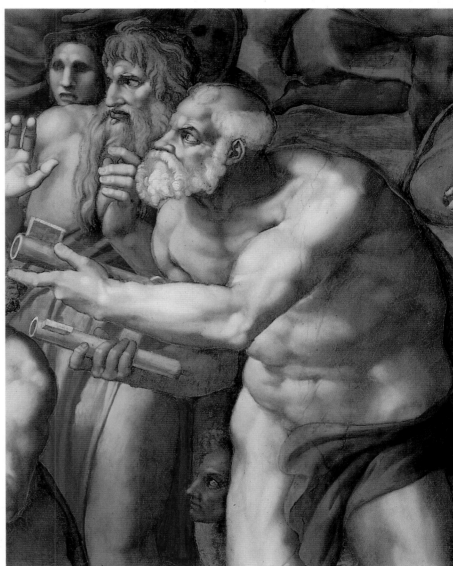

the advent of the Apocalypse. Below the figure of Christ are seated Saints Lawrence and Bartholomew, each bearing the emblem of his martyrdom, respectively the gridiron and the flayed skin. Their preeminent position amid the elect stems from the fact that their feast days coincide respectively with the chapel's foundation and with the coronation of its founding pontiff, Sixtus IV.

231

The face on the skin held by Saint Bartholomew is alleged to be an anguished portrait of the artist Michelangelo himself, who thus contrived to leave a somewhat contradictory personal token, testifying on the one hand to his fear of the "second death," of his profound dread of the "flesh" and

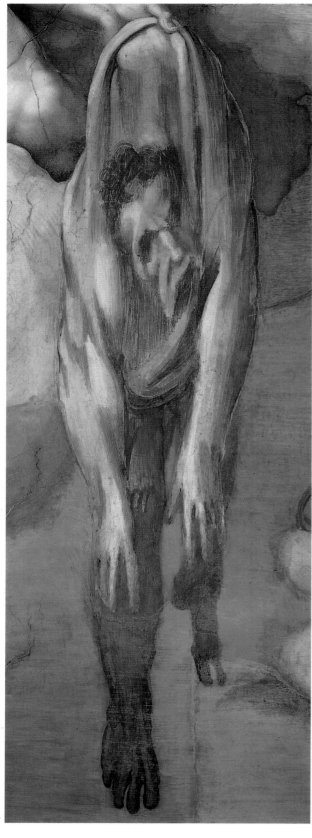

carnal weakness, and on the other to his intense yearning for spiritual renewal and salvation.

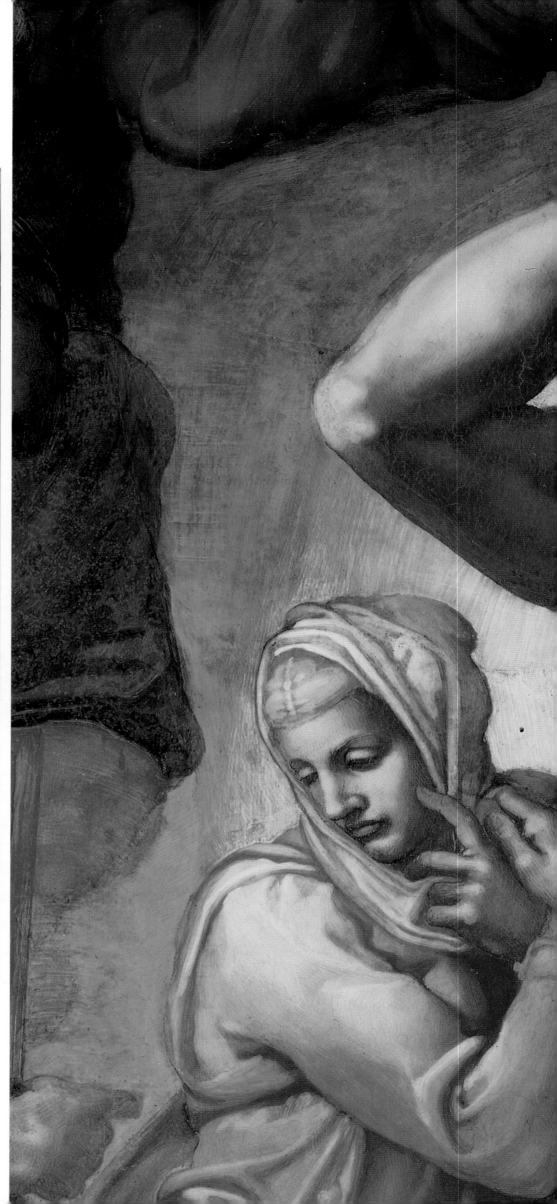

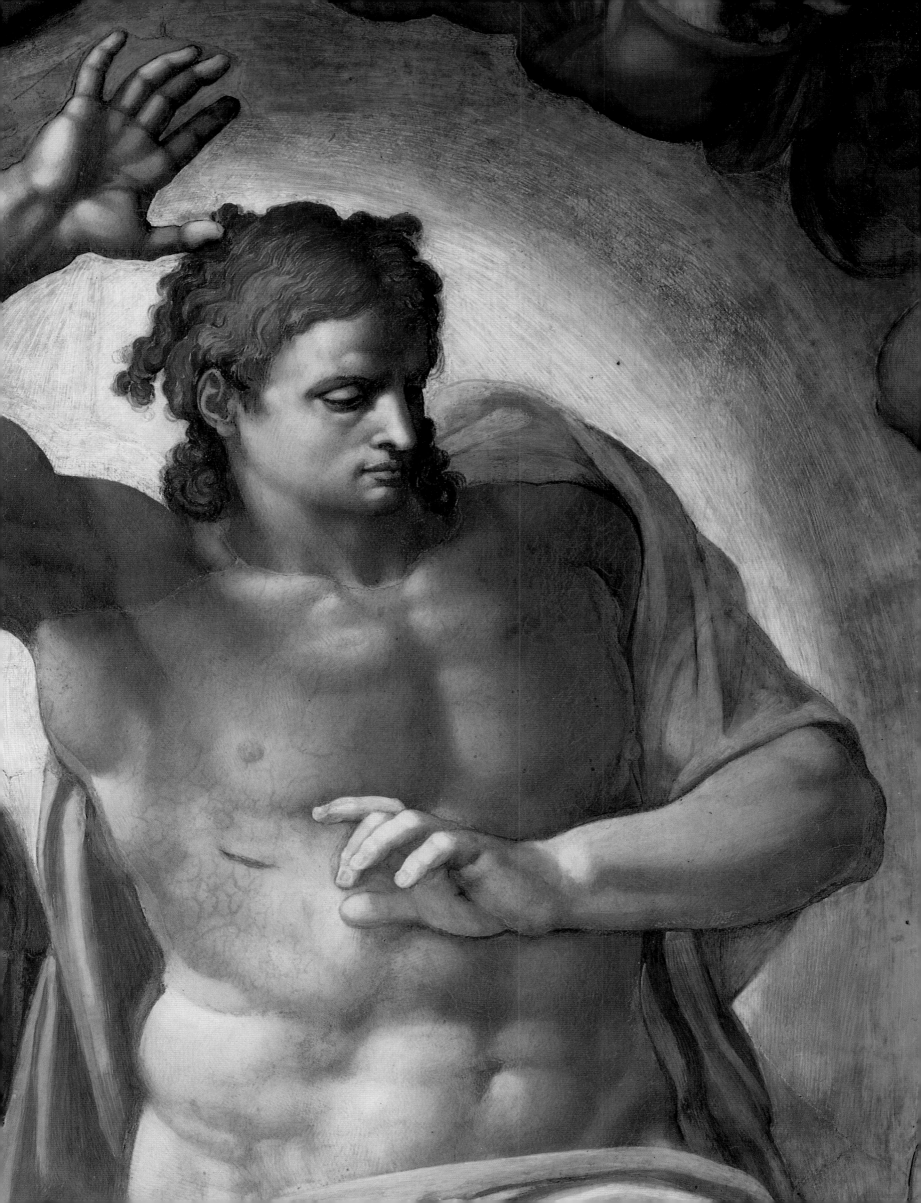

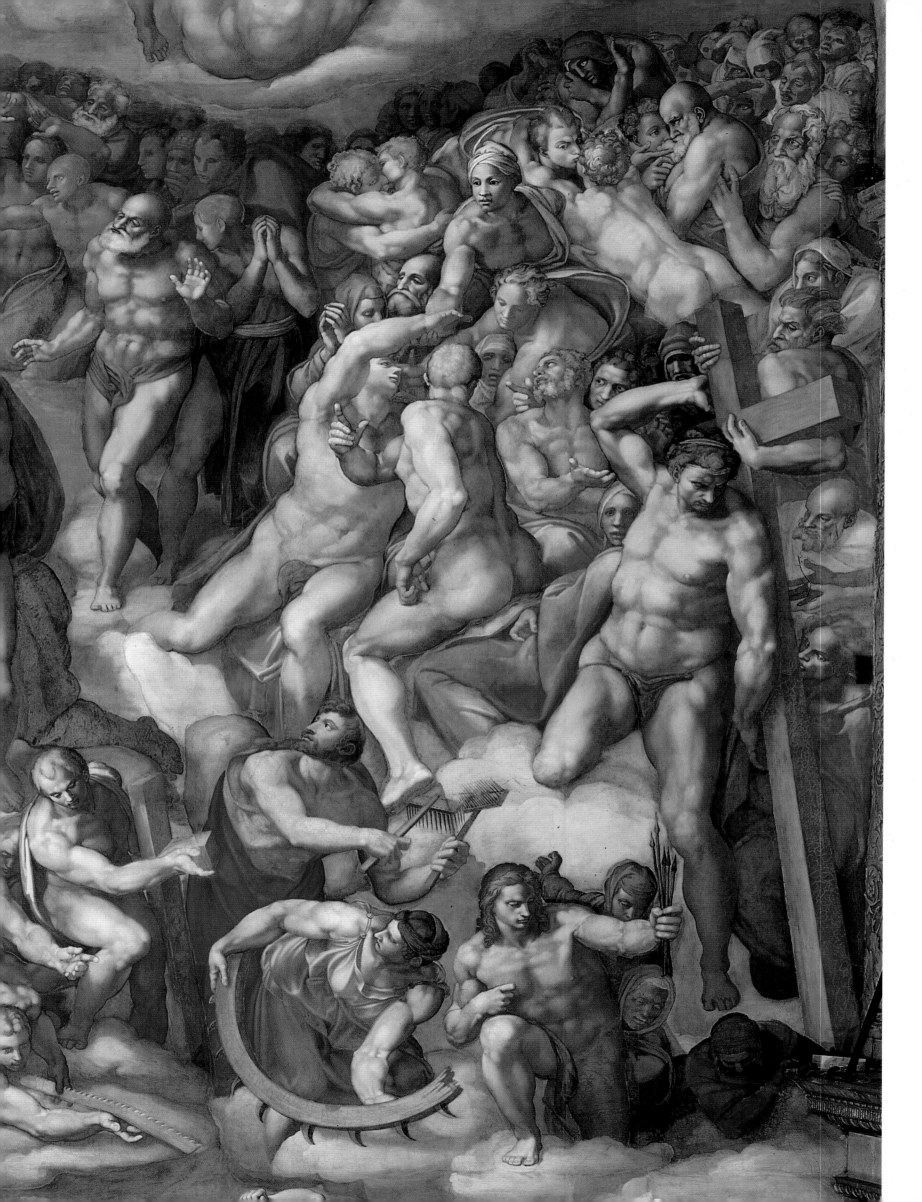

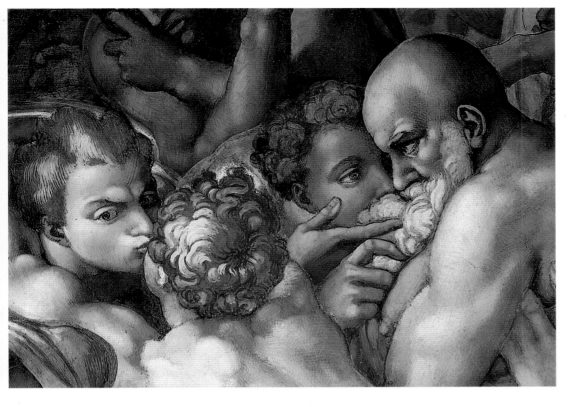

Various, often diverging identities have been put forward for numerous figures among the throngs of the elect in the *Judgment* fresco. The towering, ingeniously foreshortened figure propping up the cross on the right has been identified as Simon the Cyrenian, who helped Christ on the road to Calvary; alternatively, the figure could be Dismas, the good thief. Slightly further down, in a squatting position, is Saint Sebastian, portrayed as an *ignudo* of classical beauty clutching the emblems of his martyrdom. On his left we can see Saint Catherine of Alexandria and Saint Blaise, who were almost entirely repainted by Daniele da Volterra; Michelangelo's original representation of them had provoked accusations of obscenity. One of the most disparaging voices was Gilio's, who wrote of Saint Catherine that "to ensure our mockery he has depicted her kneeling indecorously before Saint Blaise, who stands above her with his combs, as if

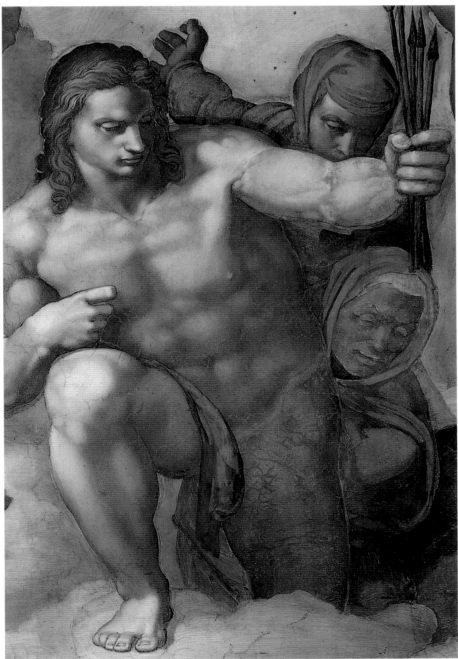

enjoin her to remain still, and she looking up at him as if to say 'What if I don't?' or the like" ("per meglio far le persone ridere, l'ha fatta chinare dinanzi a san Biagio con atto poco onesto, il quale, standole sopre coi pettini, par che gli minacci che stia fissa, et ella si rivolta a lui in guisa che dica 'che farai?' o simil cosa"). The poses of the two figures before Daniele da Volterra carried out the alteration can be appreciated in the painting of the fresco made by Marcello Venusti (Naples, Galleria Nazionale di Capodimonte).

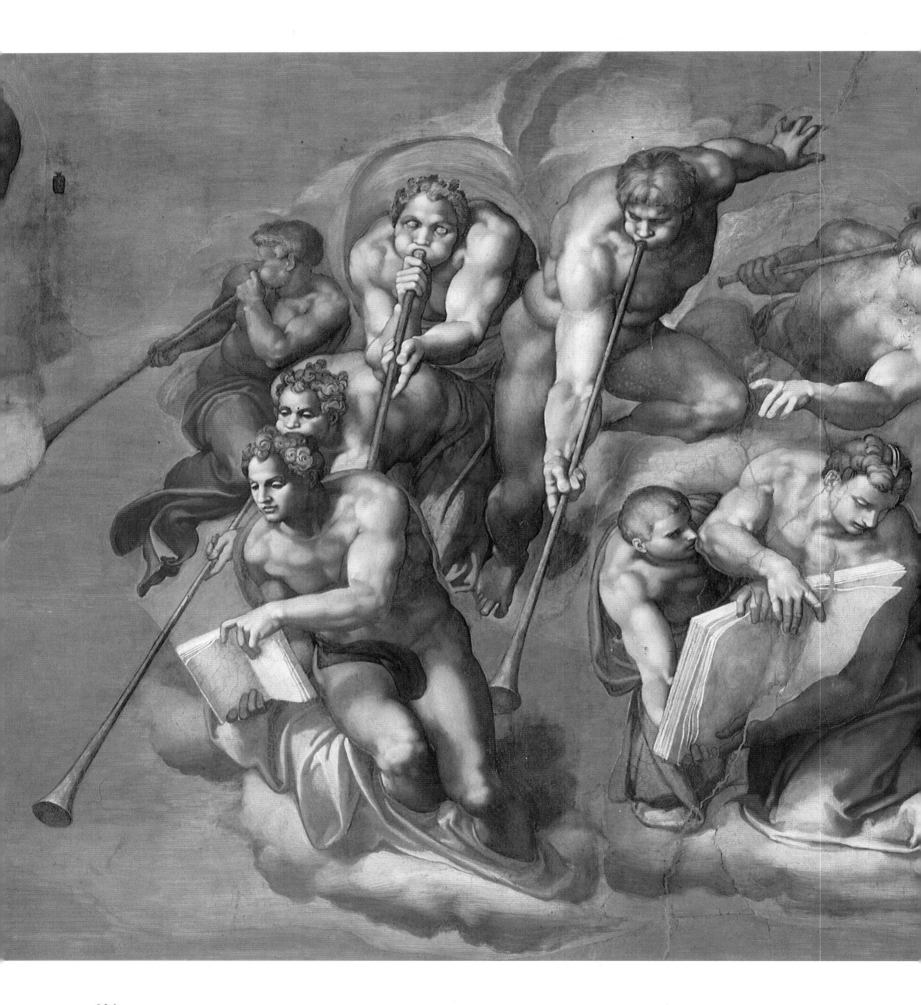

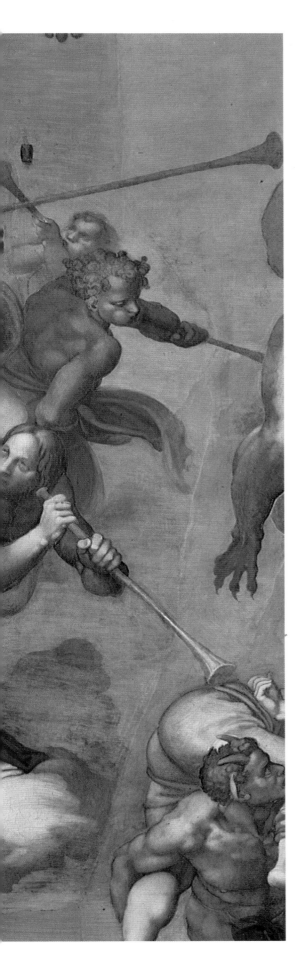

At the center of the lower section of the fresco, beneath the figure of Christ the Judge and the ranks of the blessed, a group of eleven wingless angels sound the trumpets of damnation and resurrection. On the left several members of the elect ascend toward the ranks of saints as if wafted or drawn upward by some supernal force, while others ascend with difficulty, supported or assisted by their companions. On the right the reprobates claw and wrestle each other, striving desperately to evade their grim sentence, and some are being dragged by demons downward to hell. The tier of bodies is rarer here, compared to the section immediately above, making the figures stand out dramatically against the azure sky as they are driven toward the abysmal space below. Further down still, through an opening we glimpse an infernal grotto populated by diabolic figures, beside which is represented the rising of humanity from the grave, resurrected in the flesh, a scene contrasted on the other side by the damned souls hurled earthward to a scene of brutal violence, in which the human attributes assume lurid and beastly forms.

This lower section of the fresco was painted after the scaffolding was lowered in December 1540, but work was suspended for the entire month of March owing to an accident, recounted thus by Vasari: "During this time it happened that Michelangleo fell no small distance from planks on the scaffolding of this work and hurt his leg, but because of the pain and his anger he did not wish to be treated by anyone."

The first effective description of Michelangelo's depiction of the "resurrection of the flesh" can be found in Condivi's biography of the artist:

At the sound of these trumpets the burial places on earth are seen to open up and humankind issues forth in all kinds of marvelous attitudes; some, following the prophecy of Ezekiel, have their skeletons just reassembled, other have them half-clothed in flesh, and others completely so. Some are naked, some attired in the shrouds and winding-sheets in which they were wrapped when borne to the grave and from which they are seeking to divest themselves. Among these are some who as yet still do not seem really fully awake, and looking up to Heaven they stand there as if in doubt as to where divine justice is calling them.

In the background of a desolate land Michelangelo depicted the restitution of the flesh to the newly risen dead, whose movements and expressions convey a sense of awkward awakening, a return to consciousness from the depths of a long and tormented slumber, in which their joy seems to be mixed with the memory of a terrible cataclysm. The impression received is of a slow and arduous unfurling of bodies from the burial mounds, an emergence from some invincible torpor, from constraints of a mental rather than a physical nature, that seem to hold them yet in bondage. The conception spurred the artist to unleash his finest compositional skills: some of the risen aid their fellows, sustaining or bracing the bodies of those who have not yet regained consciousness, with compassion, with attitudes that recall scenes of the Deposition, or the Lamentation.

In the bottom right corner, against a fiery red sky, between Charon's boat and the figure of Minos, the *Judgment* reaches a peak of intensity and violence in the tragic portrayal of the wrongdoers being urged forward by the brutish demons, The references to mythological and literary sources—particularly to Dante's *Inferno*, which is strongly hinted at in the portraits of the grim, scoffing, and grotesque demons—detracts nothing from the dramatic immediacy of the damned as they are hauled hell-ward in a horrendous melee of twisted bodies, of wretched gesticulation, of faces transformed into abominable, horrifying masks. Despite such imagery, by foregoing the traditional iconography Buonarroti avoided lingering over physical punishments, and instead portrayed damnation as a prevalently interior experience: a question of utter despondency, remorse, and the dread of mental rather than physical annihilation.

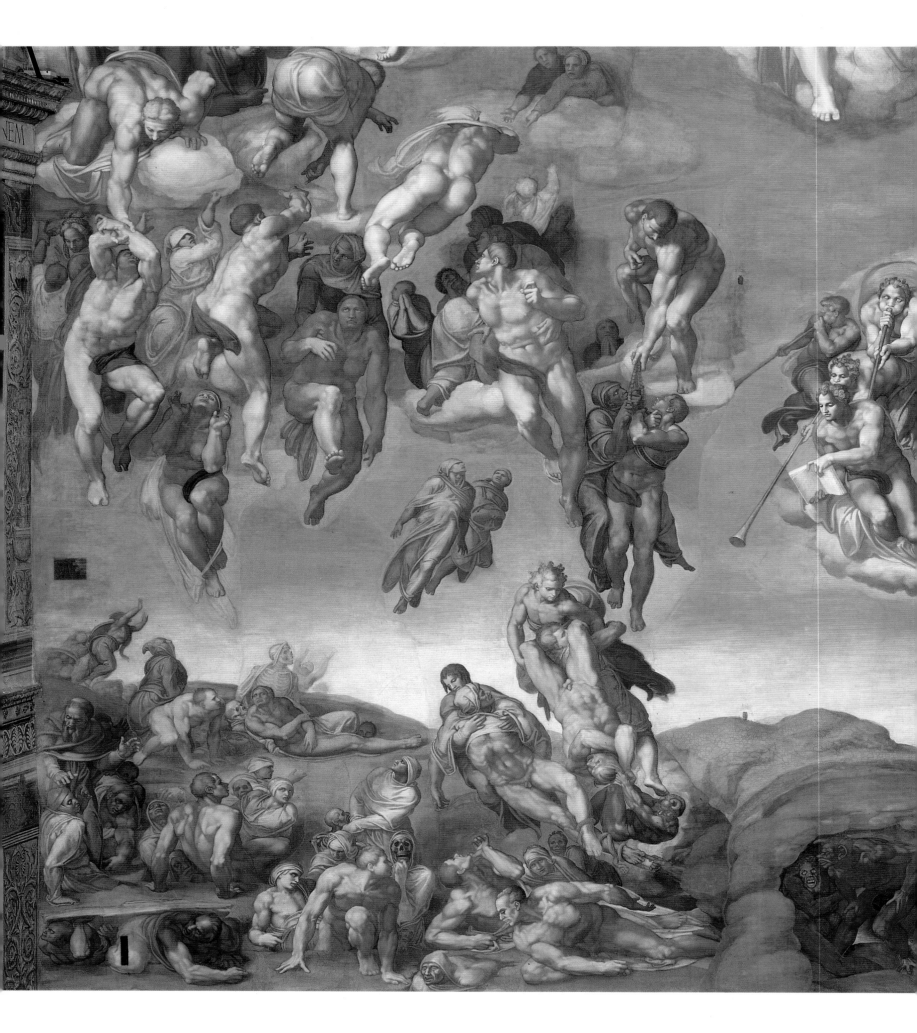

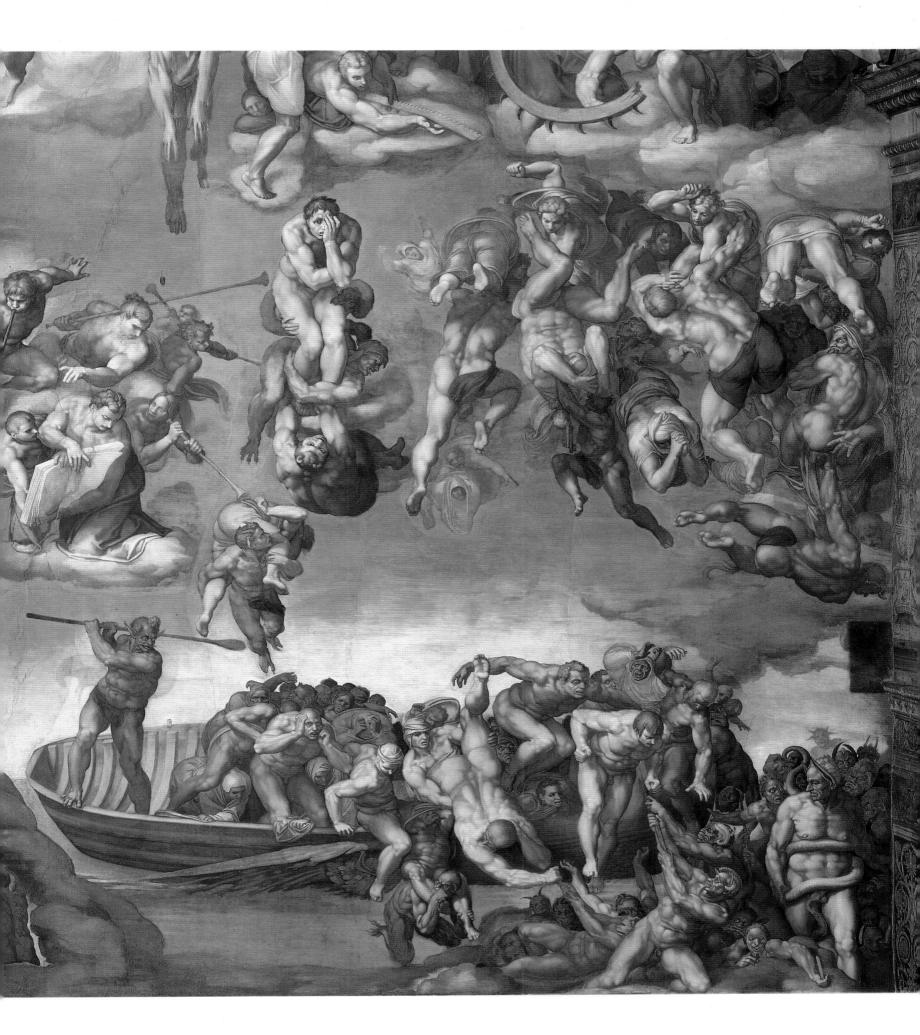

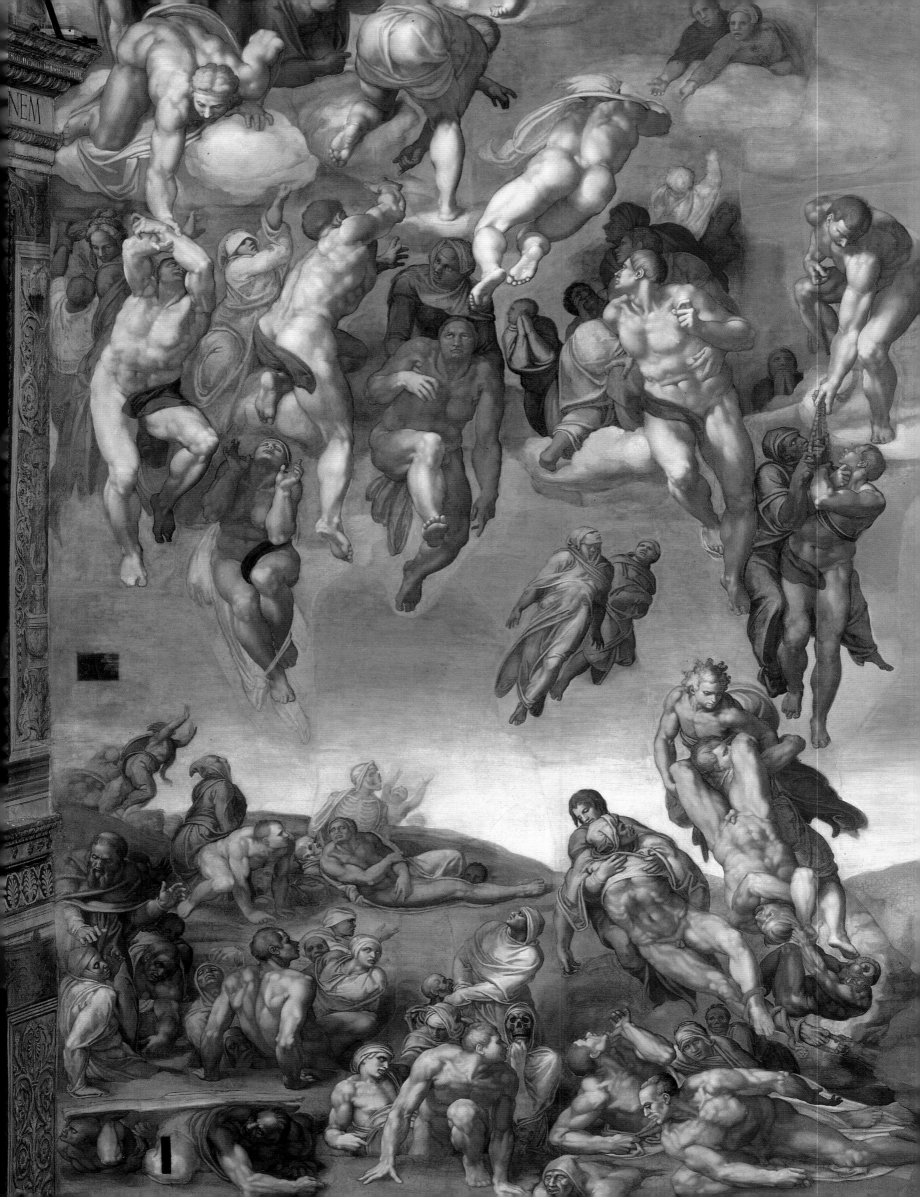

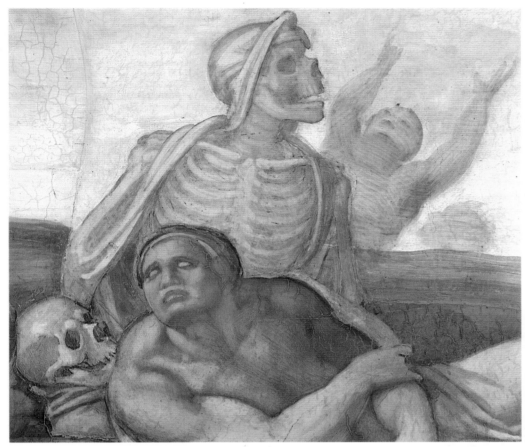

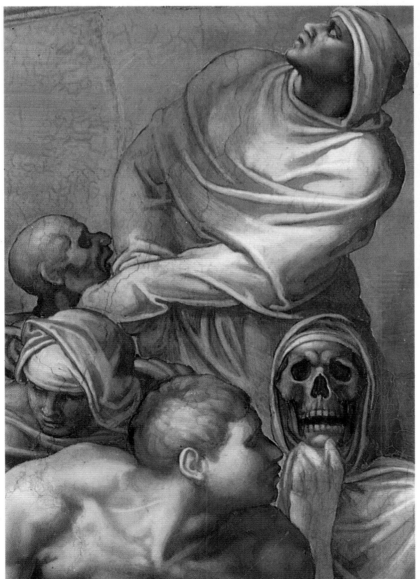

Michelangelo depicted some of the risen as if they were being drawn heavenward or caught in flight; others, however, still burdened with the weight of their mortal coils, have to be propped up or helped, their ascension slow and labored. At the core of this group a female figure lifts a suspended figure whose countenance betrays his sluggish coming of awareness. In his representation of bodies in movement, captured in dynamic and constantly varying poses, with foreshortenings devised to convey the *difficultà* (difficulties), Michelangelo seems to have given a free rein to his peerless talent, but was nonetheless unable to avert the shrewd faultfinding of his detractors. Among them was Ludovico Dolce, who praised his skills at representing the *ignudi*, but accused him of being limited to muscular and elaborate naked forms devised with foreshortening and proud mien; their being all much alike, he dryly

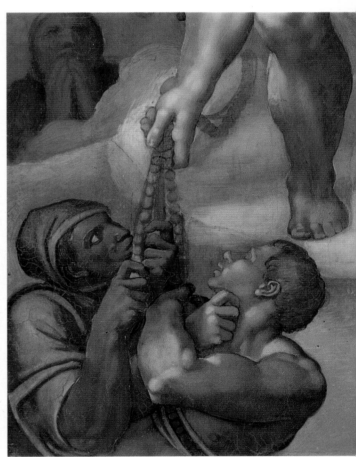

commented, "Once you have seen one of Michelangelo's figures, you have seen them all" ("Chi vede una sola figura di Michelagnolo, le vede tutte").

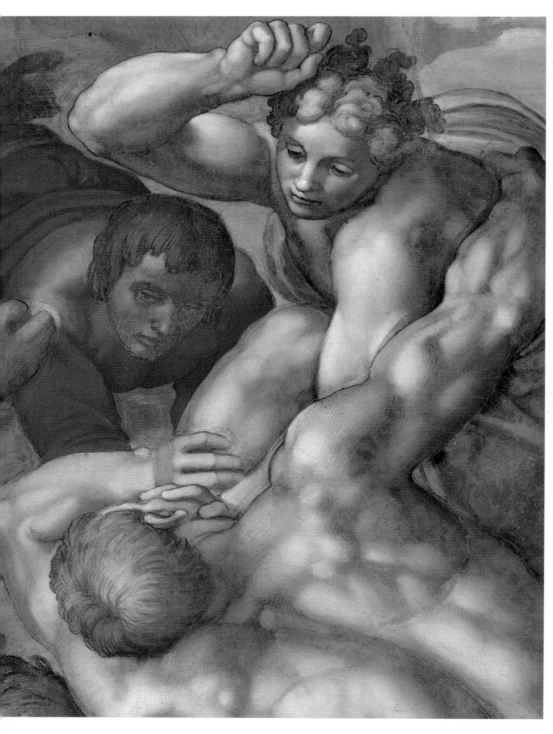

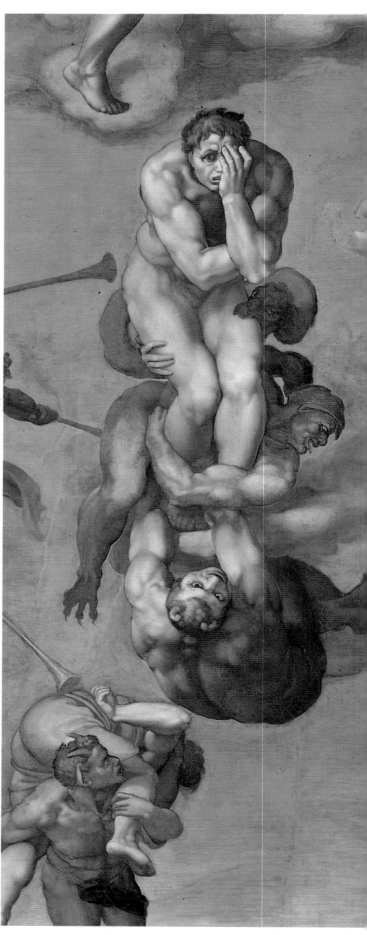

One of the most violent and dynamic formal focuses of the entire composition of the *Last Judgment* is achieved in the representation of the reprobates' despairing struggle to elude their fate. Knotted figures engaged in furious combat burst into the foreground or struggle to climb, while others plunge or are wrenched downward by demons to the frightful, flame-filled chasm below.

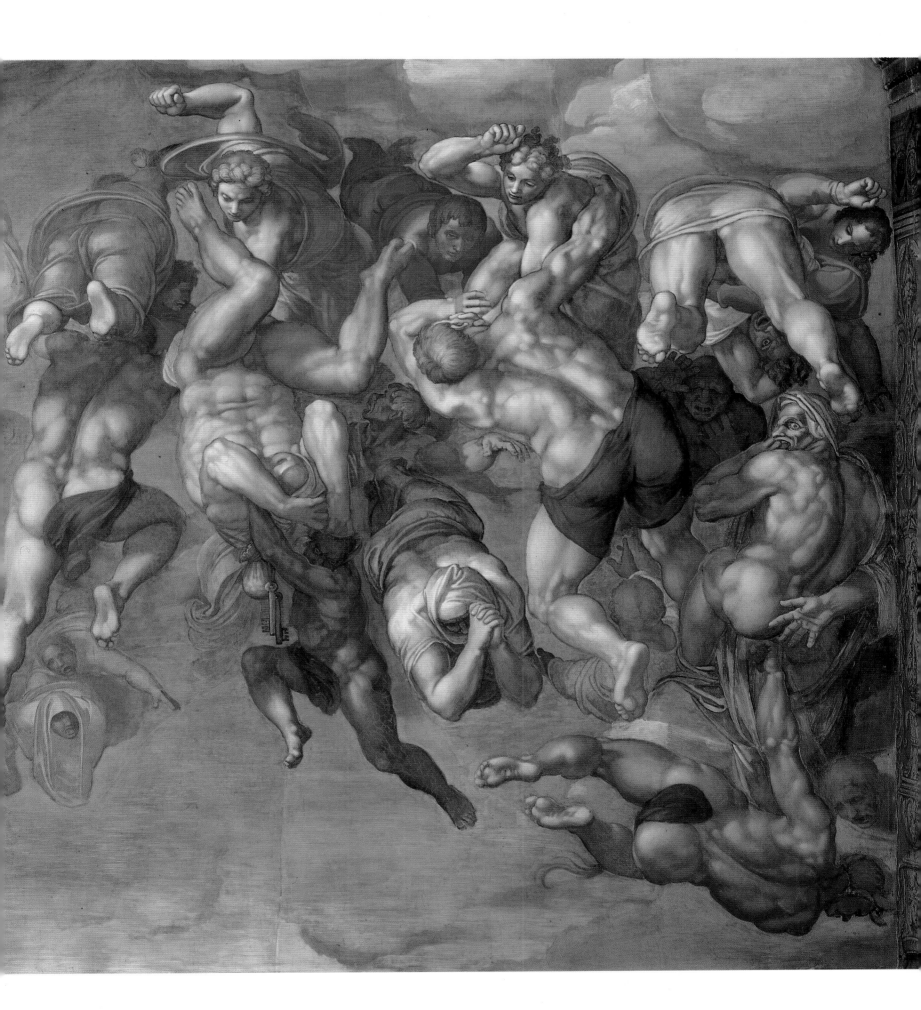

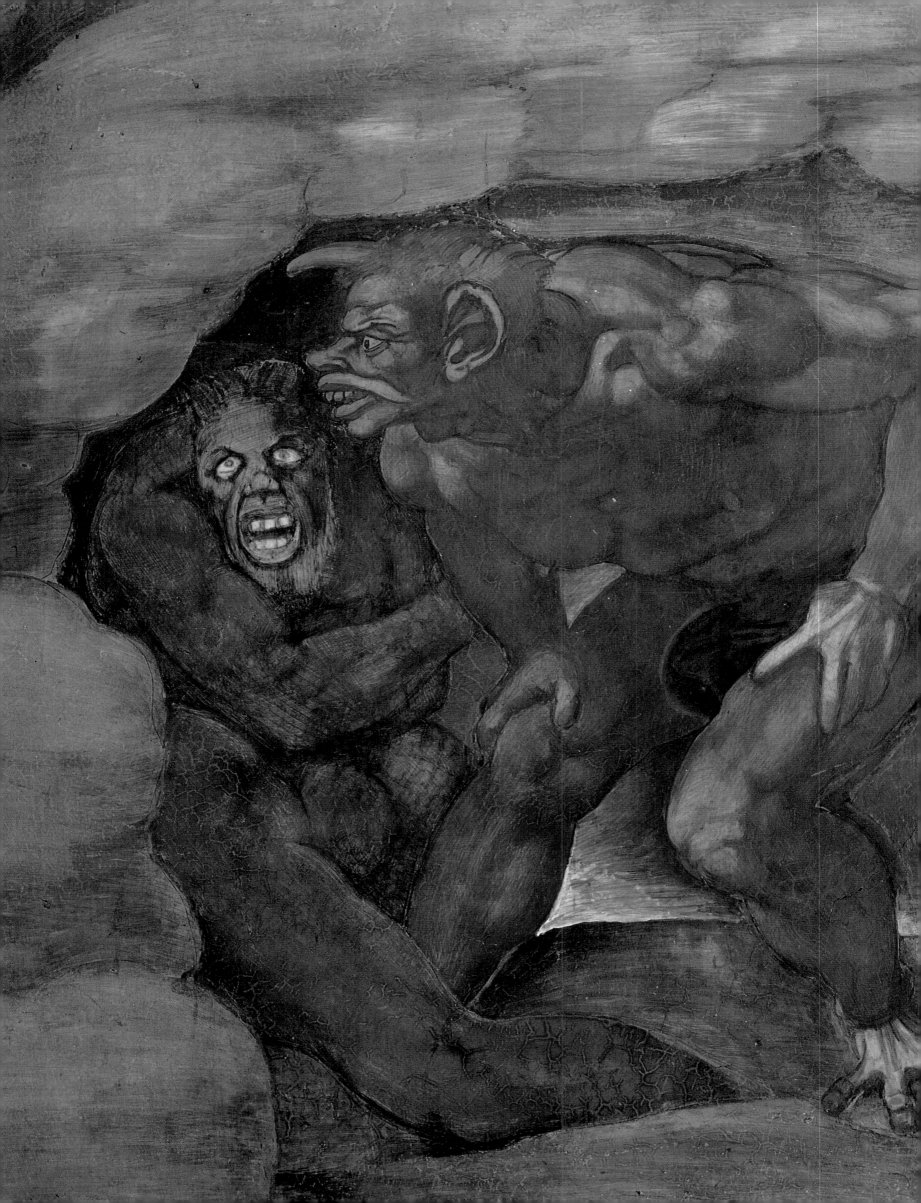

In the central section between the land of the resurrected and the infernal chasm lies a cavern inhabited by monstrous creatures and demonic figures. Its critical position above the centrally placed altar of the chapel has been attributed to an anti-clerical sentiment on Michelangelo's part; it is more likely to be a dire reminder of the manifestation of the devil prior to the Apocalypse. Among the various sources from which Michelangelo drew inspiration for images of the devil were German and Flemish prints, with which he was acquainted from his youth, and the *Divine Comedy* of Dante, whose work the artist passionately admired.

In the images of the demons cruelly thrusting or dragging the damned out of Charon's boat, or those pressing fearfully around Minos, one can gather the sulfurous and hideous atmosphere of the fiends Malebolge, Malacoda, Libiccocco, Graffiacane, mad Rubicante, and fanged Ciriatto, and the vile and decrepit company of Barbariccia: mocking masklike faces, savage figures of horned devils, tonal shifts from repugnant, monstrous, and coarse, with claws that scratch and laverate the reprobates. This imagery was much praised by Giovan Paolo Lomazzo, who cited them in his treatise *L'arte della Pittura* (1584) for their sheer variety and expressive vigor: "[He] made them accordingly with scornful and wild bodies and faces … coloring them ebony and with insect wings, and others with horns and teeth jutting from them mouths, and with claws and talons from their

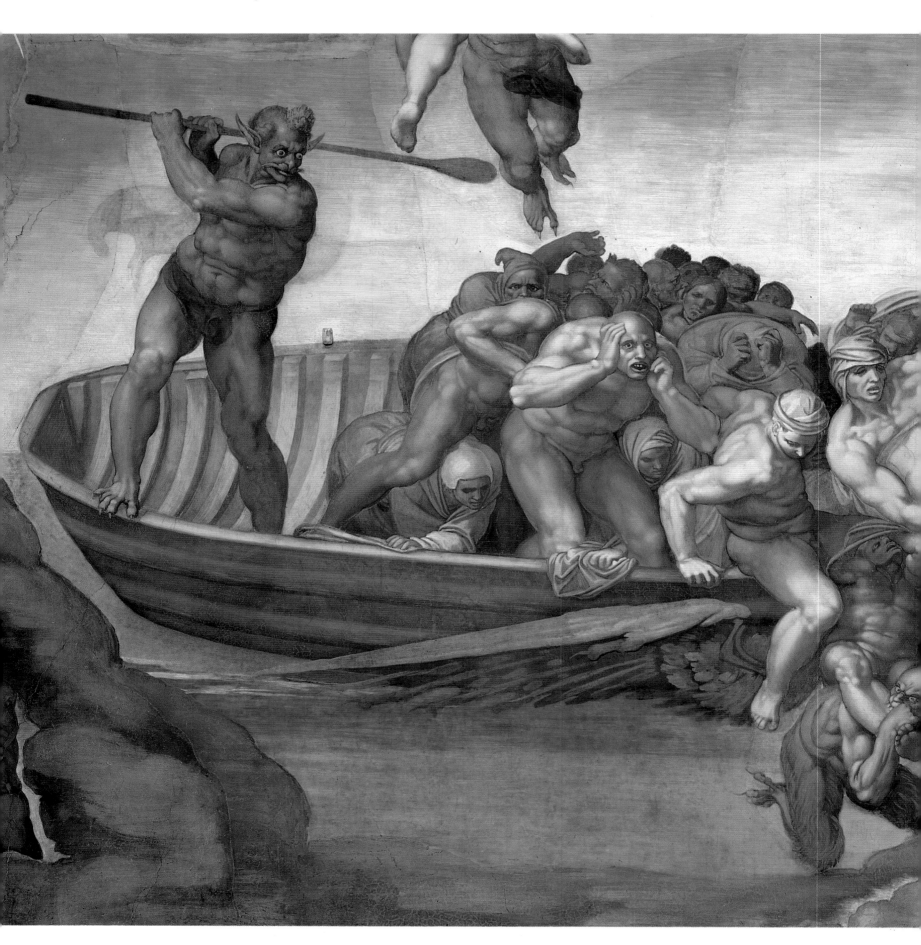

hands and feet, resembling diverse beasts"
("Facendo in loro secondo i suoi atti il corpo con
facce sdegnose e fiere … facendole di colore ebano
e con le ali di tignola, et altri con le corna e denti
fuora della bocca e con le ugne sporte in fuori a
piedi ed alle mani, fatti in diverse forme d'animali").

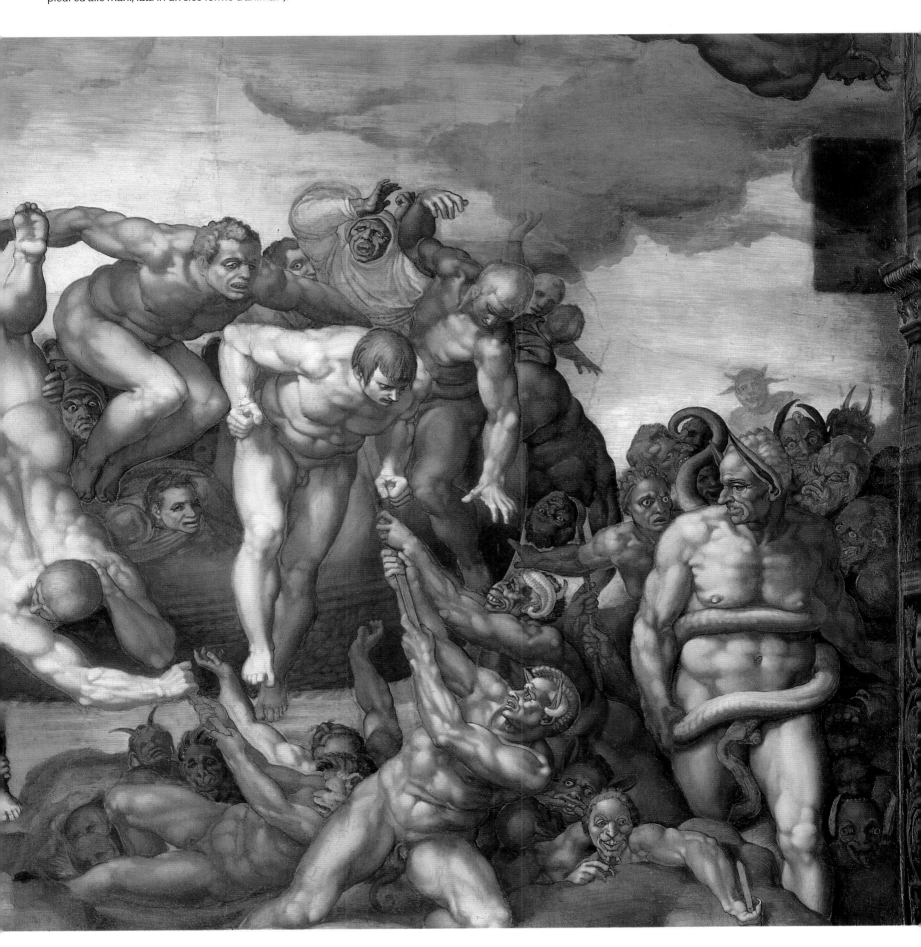

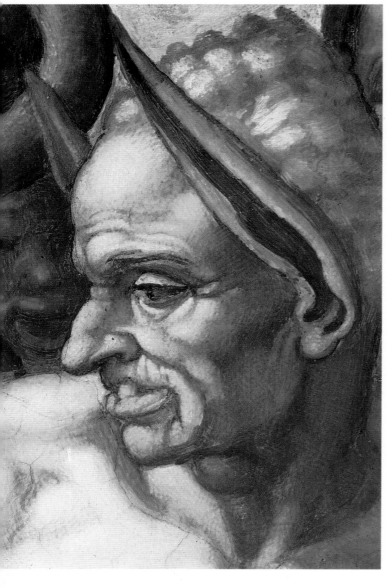

The figures of the Stygian boatman Charon and [the sentencer] Minos dominate the scene at the bottom right, with its welter of writhing demons and damned souls. Charon, standing menacingly in the prow of his boat, echoes Dante's vision of "The devil, Charon, with eyes of glowing coals, summons them all together with a signal, and with an oar strikes the laggard sinner"; whereas for Minos, according to Vasari this was a portrait of the master-of-ceremonies Biagio da Cesena, a "very high-minded person" who was among the first to be put off by the newly unveiled fresco owing to the presence of "so many nudes so indecently displaying their shame" and adjudged the fresco "not a work for a pope's chapel but rather one for baths or taverns."

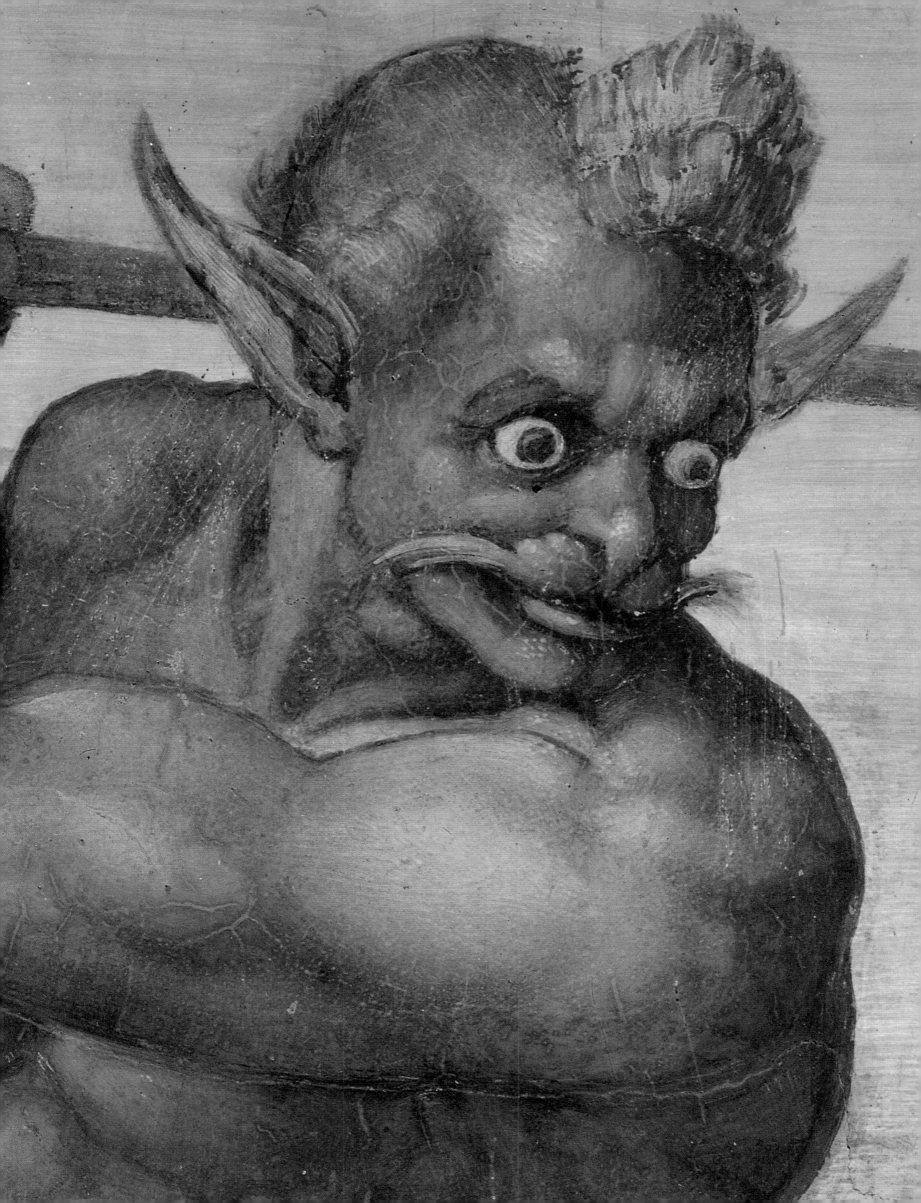

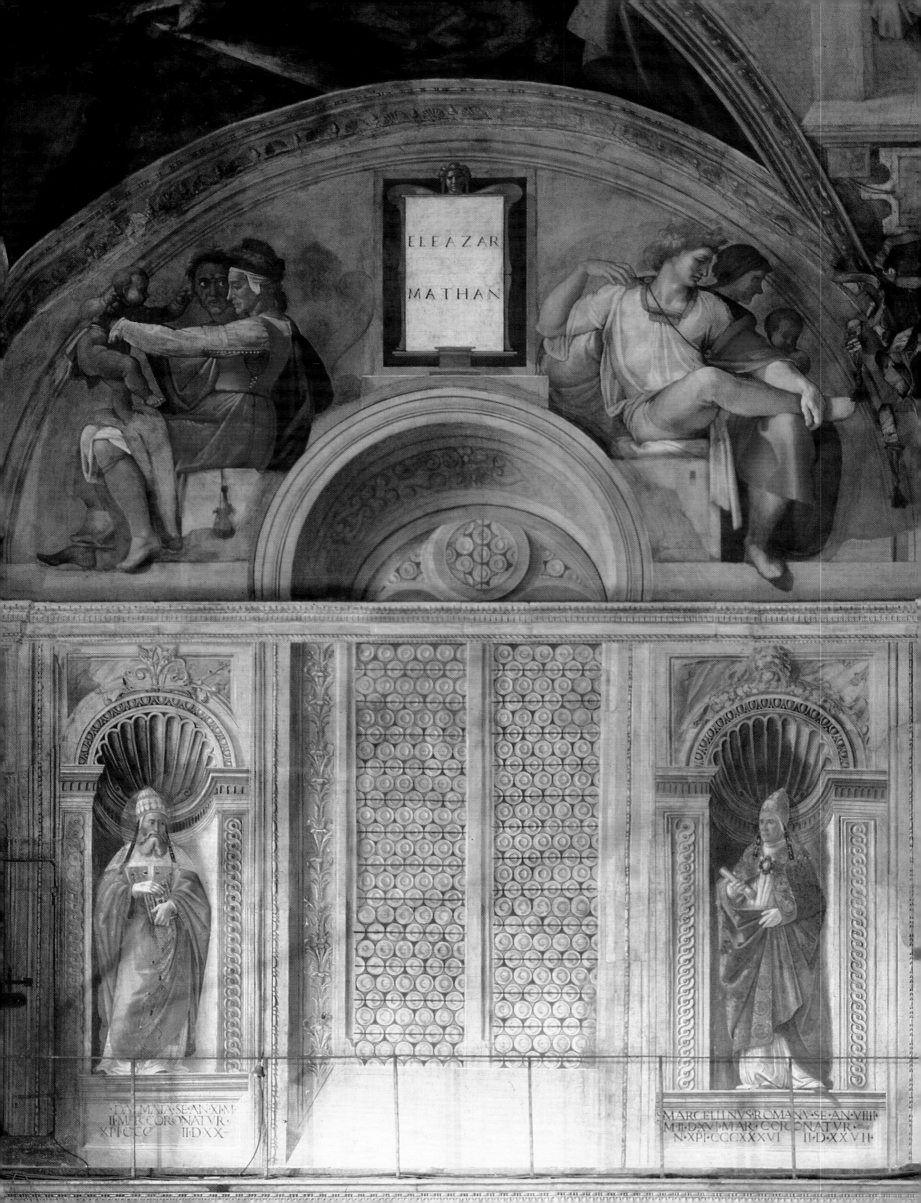

ELEAZAR

MATHAN

The Restoration

Gianluigi Colalucci

The restoration of Michelangelo's frescoes in the Sistine Chapel was a venture that shook the very foundations of the art world more than any other single art event has managed to do in the last quarter of a century.

Promoted and conducted with rigorously conservative objectives, over the course of its execution the restoration program assumed an ever-growing significance in historical and critical terms—an importance that was foretold when the very first patches were cleaned and was fully confirmed by the restoration of the Eleazar-Matthan lunette.

The task of cleaning Michelangelo's frescoes was the logical continuation of a broad restoration program involving all the chapel's the fifteenth-century frescoes, including those depicting the life of Christ and the life of Moses, a project that was begun in 1965 by Deoclecio Redig de Campos.

In 1980 De Campos's successor in the post of General Director of the Vatican Museums, Carlo Pietrangeli, in fact inaugurated the restoration program with the two sixteenth-century frescoes by Matteo da Lecce and Hendrik van den Broeck on the entrance section of the chapel.

Work proceeded with the Popes cycle in the upper register, painted by the same fifteenth-century artists who completed the frescoes below. The scaffolding constructed especially for the task enabled a close-up technical survey of Michelangelo's ceiling lunettes. This inspection proved invaluable as it revealed the extent of damage to the paint caused by the application of layers of very dark animal glue, a substance that left a snakeskin effect as it dried and contracted.

In the case of the *Last Judgment*, however, the fresco's state of conservation was already known, thanks to the inspections carried out yearly by the Laboratorio Restauro Pitture of the Vatican Museums. Once the need for the restoration of the vault frescoes had been taken into consideration, in June 1980 the first tiny trial patches of cleaning were performed on the Eleazar-Matthan lunette.

The startling results of the initial tests greatly furthered our knowledge of Michelangelo the painter and prompted us to proceed with cleaning the entire lunette.

The operation aimed to gather fundamental on-site data on Michelangelo's technique, the state of the frescoes, and the restoration techniques to be applied. It would enable a proper assessment of the results of cleaning in order to evaluate the feasibility of such a large-scale operation, and if all was well, begin to draw up a restoration schedule that would include the *Last Judgment*.

The task of cleaning the lunette, carried out by Gianluigi Colalucci, lasted through January 1981. The following month the results of his undertaking were revealed to scholars and members of the public, and only after receiving positive opinions and the encouragement of expert historians and eminent art critics was a proper restoration project formulated.

This was expected to span a period of twelve years and comprised three phases: the lunettes, the vault, and the *Last Judgment*. Each phase was to last four years. As will be seen, only the restoration of the vault exceeded its schedule (by one year), while the *Judgment* required a few additional months' preparatory analysis.

The operation, which was carried out under the supervision of Carlo Pietrangeli, was directed by Fabrizio Mancinelli, and performed by the team of restorers from the Laboratorio di Restauro Pitture of the Vatican Museums: Gianluigi Colalucci (chief restorer and technical director), Maurizio Rossi, and Piergiorgio, assisted by Bruno Baratti and Giovanni Grossi.

The preparatory phase of scientific analysis, a procedure of paramount importance in modern restoration technology, was performed by the Laboratorio Ricerche Scientifiche of the Vatican Museums, directed by Nazzareno Gabrielli, who was assisted by the Istituto Centrale per il Restauro, Rome; the ICCROM, and several departments within the universities of Rome and Turin.

Pasquale Rotondi, formerly the director of the Istituto Centrale per il Restauro, was the consultant for restoration work until 1991, the year of his death; his place was taken by Giorgio Torraca.

In the course of restoration, in 1987 a special international commission was set up composed of eleven specialists and technical experts presided from 1991 by André Chastel, and after his death by S. J. Freedberg. Previously, another committee established in the United States by the Samuel H. Kress Foundation in conjunction with the International Foundation for Art Research had made a thorough study of the operation under way and of the scientific documentation; the committee was composed of eminent restorers. The establishment of these two commissions coincided with a period during which a small though determined group of individuals exerted much

Page 250: The cleaning of the ceiling frescoes began with the Eleazar-Matthan lunette set into the entrance wall of the chapel, and forms part of the cycle of sixteen lunettes featuring the Ancestors of Christ, two of which were destroyed to make way for Michelangelo's *Last Judgment* fresco.

Above: Detail before restoration of a bronze clamp applied in 1904 to ensure the adhesion of the *intonaco*; the metal is not visible as it was covered in plaster and colored to disguise it.

Right: Gianluigi Colalucci cleaning the female figure in the Nahshon lunette looking at herself in the mirror. Under the cautious hand of the restorer, Michelangelo's well-conserved color returns to its original splendor, particularly in the parts where the layer of foreign matter was thickest.

pressure on the project, and resolved to stop the restoration.

The first results of the cleaning operation, presented in New York in 1984 once the lunettes had been restored, secured widespread acclaim from both art historians and conservators; but they also drew heavy criticism from a minority, largely composed of individuals anxious to preserve the image of a tormented Michelangelo, and who were keen that the paintings remained somber, veiled in lampblack, dust, and glue, refusing to give credence to the work underneath and the brilliant chromatism of the fifteenth-century originals that were gradually coming to light during the cleaning process.

The gradual but eventually conspicuous alteration of the appearance of Michelangelo's frescoes was a long process caused principally by two concomitant factors: the structural fractures in the chapel walls, and the seepage of rainwater from the roof and *chemins-de-ronde.* The building itself, constructed over an existing medieval chapel known as the Capella Magna, soon showed signs of structural weakness and was subsequently shored up to halt

the subsidence. In 1504 new signs of collapse prompted immediate further intervention.

After the application of twelve iron tie-bars under the chapel and another twelve on the extrados of the vault, and when this remedy seemed to have accomplished the task, Julius II commissioned Michelangelo to paint the chapel ceiling, a task that involved demolishing the damaged earlier star-spangled blue vault painted by Pier Matteo d'Amelia.

After a further spell of subsidence to the building, perhaps caused by excavation work on the foundations of New Saint Peter's nearby, fresh cracks began to appear in the vault and walls of the Sistine Chapel. In 1552 the stone lintel over the chapel entrance broke off, followed by other alarming signs of imminent danger. It was not until 1570, however, with the construction of three large buttresses, that the building was finally rendered safe again. The serious fractures running the length of the ceiling risked causing it to cave in. Thankfully, this never happened, as the shallow barrel vault was constructed using the proven building techniques devised by the Romans, and was built from blocks of tufa and a mortar of lime and *pozzolana* laid on a timber counter-frame. The only part of the ceiling that has shown any sign of instability and structural detachment is the central band, which is around eighty centimeters thick where the curve becomes virtually flat.

The main damage to Michelangelo's frescoes lies along this structural weakness, where fragments of the *intonaco* have broken away. As a consequence of earlier deterioration, in 1570 (or perhaps 1566), the Modenese painter Domenico Carnevale was summoned to retouch the damaged parts. Carnevale hence reconstructed *a fresco* two figures from the *Sacrifice of Noah*, the last fingers of Adam's hand in the *Creation of Man*; the left hand of God in the *Separation of Earth from the Waters*; part of the head of the Prophet Jeremiah and the figure of his attendant; together with parts of the figures of the king and queen in the *Punishment of*

Haman. The painter undoubtedly also effected some retouching on the *Last Judgment*, as the fractures run vertically through the work, and here we find the same wax filling and colophony that he used for the ceiling; further confirmation lies in the initials "D. C." and the date "1566" at the tip of the oar being pulled by Charon.

If the signature and date were indeed

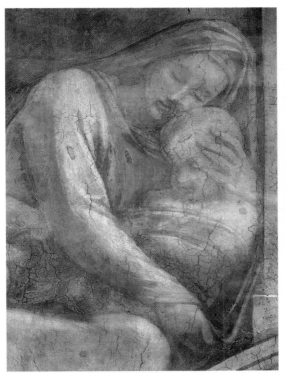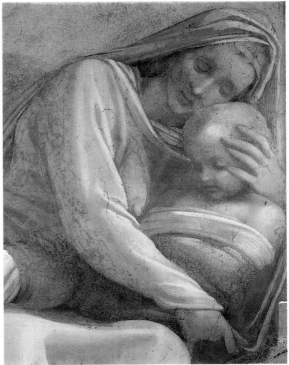

The Salmon-Boaz-Obed lunette. The figure of the mother and child before cleaning (left) and after (right). One can see that in fact the woman's breast was uncovered, as if she had just finished suckling the child; before cleaning the woman's breast was hidden by the veil applied during one of the bouts of censorship to the ceiling frescoes.

put there by Carnevale—as would seem likely—he must have been also responsible for the first attempt at cleaning the *Judgment*, and perhaps the ceiling, which had been badly darkened by soot deposited during a fire that destroyed the altar baldacchino in 1525.

This conviction stems from the fact that Carnevale left his mark on the part of the oar painted *a secco*, a non-autograph part that had been created to replace an original Michelangelesque detail.

The phenomenon of *a secco* parts that had disappeared and been repainted recurs frequently in the vault. Consequently, once Carnevale's initials were discovered it was logical to credit him both with the loss of the original details and with their replacement.

It comes as no surprise that original *a secco* fresco fragments came away during Carnevale's restoration work, and were duly replaced, as this problem concerns modern restoration methods as well. In the past, and even in more recent times, when restoration was the exclusive domain of painters, the problem of the loss of *a secco* parts was not a concern, as one can infer from the notes

The five close-ups of the fresco after cleaning show how certain parts of the fresco's surface damaged by the settling of the building's foundations were replaced by Domenico Carnevale in 1566.

On this page: the nape of the prophet Jeremiah and the figure of his assistant behind him; the left hand of God, in the Separation the Earth from the Waters; two figures from the Sacrifice of Noah.

Page 255:: Adam's hand in the Creation of Man, and the refrescoed part of the king Ahasuerus and Esther in a detail from the Punishment of Haman.

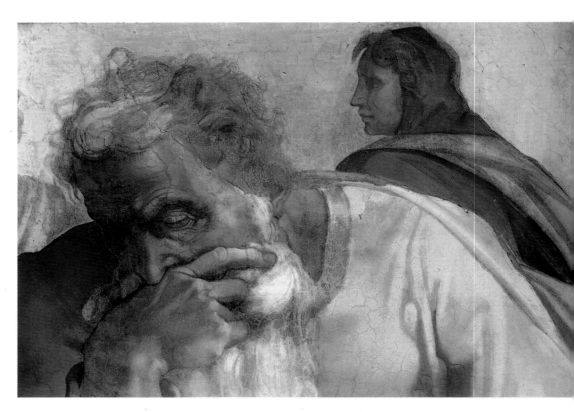

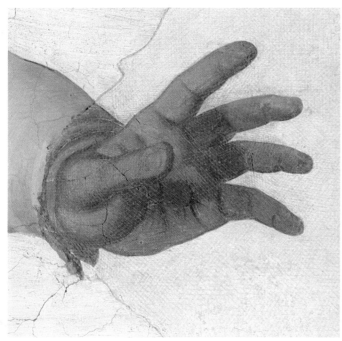

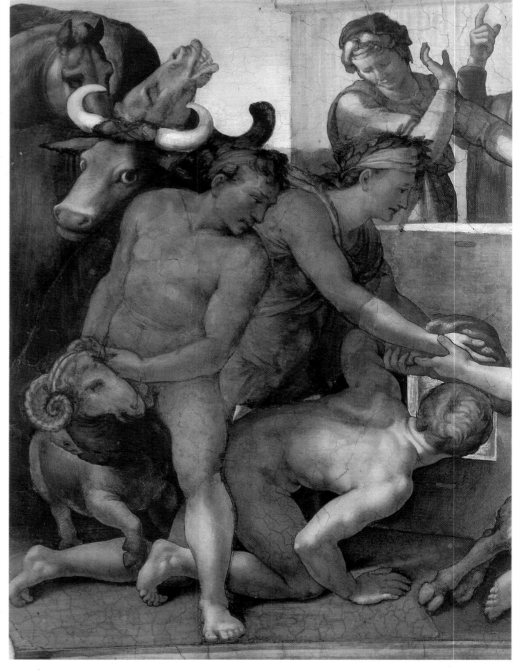

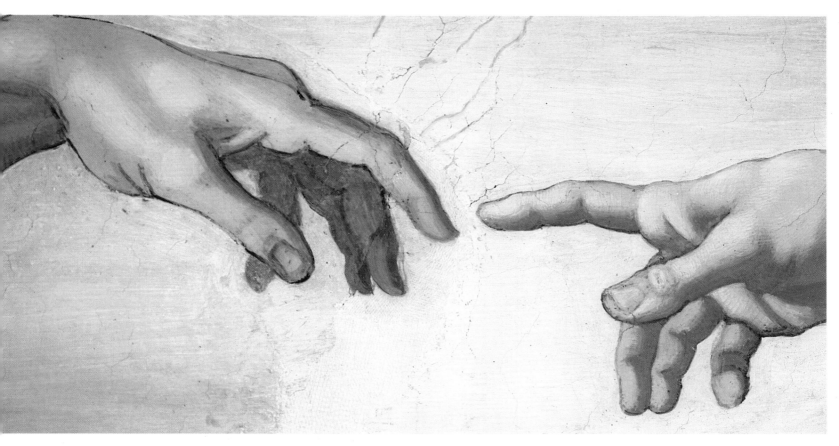

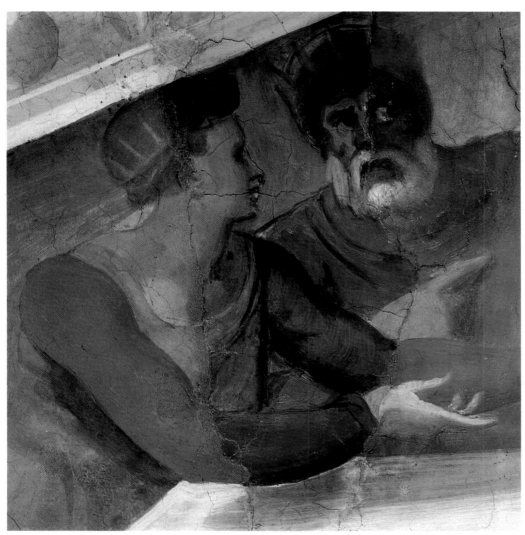

on fresco cleaning penned in 1866 by Giovanni Secco Suardo in his famous treatise on restoration; Saurdo's manual was closely studied and followed in Italy even until the mid-1950s.

Even though the threat to the frescoes's stability ended once the building itself was made sound, the damage wrought by the seepage of rainwater continued for some time, for centuries in fact, and if the frescoes of the vault have withstood over time it is only by virtue of Michelangelo's masterful fresco technique and the excellent quality of the *intonaco* of lime and *pozzolana*, which has shown the proven compactness and resistance of a formula known from antiquity.

The water seepage was aggravated by the fire that damaged the roof of the chapel, which remained open to the sky for a long time; the result was extensive salification, a process that manifests itself in the form of broad whitish patches in the case of sulfur carbonate and nitrate, or snakeskin patterns in the case of the silicates; both substances were found in high percentages in the *pozzolana* mortar and the blocks of tufa used for the construction of the vault.

These conspicuous flaws, largely coinciding with the lunettes, on the tablet-bearing putti and in line with the prophets and sibyls, seem to have obliterated the frescoes, so much so that in a letter of May 7, 1547, the scholar Paolo Giovio wrote to Giorgio Vasari, saying of Michelangelo's frescoes that "The entire vault ... is being consumed by saltpeter and cracks."

The sheer extent of the damage made virtually impossible the task of the "mundator," appointed conservator and custodian by Pope Paul III *motu proprio* in 1542, with the charge to keep the Sistine paintings clean and, in particular, free of lampblack.

At times a more thorough cleaning operation was necessary, requiring several pairs of hands, or an expert restorer with a team of assistants. This was the case with the painter Annibale Mazzuoli, who from 1710 to 1712 undertook the radical restoration of the frescoes gracing the ceiling. There is no evidence from the records that Maz-

zuoli worked on the *Judgment*. The painter carried out his cleaning with a sponge soaked in *vino greco* (perhaps one of the white Calabrian wines popular in Rome's *osterie*), a technique that helped remove the saline efflorescences, the dust, and the thick mantle of lampblack. In Goethe's day the air in the chapel was so thick with smoke that when the writer went to see the frescoes during his celebrated travels through Italy, he was soon forced to return to the open.

Mazzuoli was furthermore obliged to apply bronze clamps to reinforce the detached sections of *intonaco*, and spread a coat of keratin-based glue, albeit very diluted, obtained from boiling the hoofs of animals; his aim was to give new tonic to the colors and also hide the white salt stains. This was common practice with Roman restorers in the eighteenth and nineteenth centuries; and to judge from the accumulated layers, detected particularly in the damaged areas of the lunettes, it was probably effected several times in the course of the years. Annibale Mazzuoli concluded his task by repainting the shadows and retouching the colors that had suffered most, or had been lost entirely through water seepage.

In 1814 further manipulation, perhaps only retouching, took place, as documented by the date and two names of *doratori* (gilders) scratched on the knee of the Prophet Hezekiah. The restoration work undertaken in 1904 by Ludovico Seitz, and later in the 1930s by Biagio Biagetti, focused essentially on consolidating the *intonaco*. Seitz resorted to the application of brass clamps, whereas Biagetti used a more modern technique consisting of injections of a mixture of mortar and casein. Although Biagetti realized full well that the entire chromatic intonation was as if obscured by "smoked glass," neither restorer ventured to actually clean the frescoes, because the layers of glue that had been applied in the past were hard to remove. Consequently, in 1904, after a perfunctory cleaning, the painted areas were treated with a more "reversible" solution of gum arabic, and then gone over with a

tone of brown, especially in the shaded areas.

Owing perhaps to its frontal position and physical convenience, the damage and subsequent restoration to the *Last Judgment* were of a quite different order. Although the wall was also coated with lampblack, grease, and animal glue, the darkened surface was irregular and riddled with fungal growths, not to mention the inexpert retouchings and sundry forms of tampering; other damage includes scratches from ladders or from the poles for the baldachino over the altar. Four guy rings for the eighteenth-century baldachino were also fixed to the wall, causing holes in the fresco itself.

A crack, rising almost central from the foot of the wall, travels vertically up toward the ceiling, petering out at the lunetted part on the top right. The water seepages and resulting salification have affected only the central and upper part of the paintings.

Over the centuries, countless attempts at cleaning and restoration seem to have been made on the frescoes, but only four are actually accounted for: those of 1566, dated and signed by Domenico Carnevale; of Pietro Camuccini in 1824–25; and, more recently, of Seitz in 1904, and Biagetti in 1935–36.

Carnevale plugged the long vertical crack with wax and rosin, but not without first cleaning; as a consequence the *a secco* finish of the lapis lazuli blue of the sky was lost, together with other *a secco* painted details, such as Charon's oar, Saint Lawrence's gridiron, Saint Bartholomew's knife, and the sponge and pole of the Passion symbols. The sky was not repainted, except for the clouded area behind the trumpeting angels; other perished sections were repainted by Carnevale himself.

Pietro Camuccini, the brother of the more famous painter Vincenzo, actually tried to clean part of the fresco, namely in the right lunette and the group of blessed figures immediately below. He was stopped by order of the Accademia di San Luca, who feared that cleaning would reveal the old lesions beneath. Thereafter Camuccini was forced to effect a *risporcatura* over the cleaned parts

consisting of crosshatched brush-strokes of dull glaze.

Despite the lack of records and documents, there can be no doubt that other attempts at cleaning were undertaken in various periods, even recently. In each case, the operation was suspended, perhaps owing to poor results obtained, and each cleaned section was duly retreated to make it once again obscure.

The figure of Christ the Judge was certainly cleaned at some stage; this takes the form of a series of close-knit, irregular, light horizontal lines that slightly lighten the blue ground, which had become almost black. In his report Camuccini noted the corrosion caused by a strong solution [applied to the surface], presumably to destroy the work; for his part, Taja observed that "the face of the Judgment is reft here and there by ugly patches of white niter that has limed the pigment itself." Recent studies carried out by our team in conjunction with Turin University would seem to suggest that this cleaning operation was of the "pictorial" kind, namely, confined to the sections of sky alone, and followed a "pictorial" concept, by which an attempt was made to restore an overall luminosity to the composition, without interfering with the figures themselves.

The interventions on the *Judgment* were not limited to normal maintenance or attempts at restoration; there was also the notorious session of censorship ordered by the Council of Trent on January 21, 1564. This operation was carried out under Pius IV and Pius V immediately after the death of Michelangelo on February 18, 1564. The first painter commissioned to do the job was Daniele da Volterra, who worked in 1565, the year of his death; he was succeeded by Girolamo da Fano (though this is yet to be confirmed); and thereafter by Domenico Carnevale who, as observed above, also carried out more authentic restoration operations. A total of forty-four instances of censorship have been detected, mostly executed in tempera, without harming the painted surface below. Only in the case of the figures of Saint Catherine and Saint Blaise has the original *intonaco* been chiseled away and the paintwork redone *a fresco*. The latter was completely replaced, the former only partially (the original parts include the head, arms, and wheel). The original version of these two figures, as with the other censured personages, are known to us via the scrupulous copies on panels commissioned from Marcello Venusti by Cardinal Farnese in 1549 (Naples, Museo Nazionale di Capodimonte).

By tradition, the censorious additions to the *Judgment*, ironically referred to as "braghe" (trousers), are attributed to Daniele da Volterra, but this was not so, as his contributions were added to by Carnevale, and perhaps Girolamo da Fano in the sixteenth century. Other modifications were made by some highly inexpert painters, later, in the eighteenth century, as noted by J. Richard.

It is easy to infer from this outline of past events that the state of the *Judgment* was a very complex affair, and necessitated a protracted period of in-depth study in anticipation of the restoration.

The restoration of the vault, which started in June 1980 with the Eleazar-Matthan lunette, finished in 1989, and the ensuing restoration of the *Judgment* was terminated in March 1994.

The cleaning operations were carried out according to the standard practices of painting and fresco restoration, except in certain cases in which the state of repair of the frescoes called for more specific intervention. The procedure included fixing the detached *intonaco*; fixing the peeling paint layer; consolidating the disgregated pigments; cleaning and removing foreign matter, and deteriorated repainting, reducing the sixteenth-century in wax and rosin fillings, plugging gaps; and, lastly, painting in missing details in watercolor. Special C80 treatment was employed exclusively in specific areas compromised by marked saline efflorescence. Of all the previous conservation efforts, Carnevale's *a fresco* additions were conserved, together with most of the reinforcement clamps applied in the eighteenth-century, in 1904, and later in the 1920s and 1930s.

Generally speaking, the conservation operation was largely a question of patient cleaning. This is one of the most delicate operations that can be effected on a painting. Unlike nearly all the work involved in consolidating the painted surface or the stability of a paint layer or pigments, which involve specifically technical aspects, cleaning directly affects the image of the fresco or painting, and therefore has historical and critical implications.

The accumulation of foreign deposits on the paint layer, the nature of these deposits, and the way they age and alter over time all conspire decisively to modifying the work's appearance. The thicker this veil of foreign deposits, the darker and more intense will be the colors beneath it, and the more their thickness and distribution on the surface will be uneven. In the case of paintings on such supports as canvas, panel, or copper, the alterations to the tones of each color are generally caused by the aging of the varnish applied at the outset as a protective coating—a transparent layer that modifies the refractive index of the various pigments, enhancing their timbres. To varying degrees this form of coating tends to turn yellow and lose its transparency. In the course of their existence nearly all old paintings have received a further coat of varnish; in certain periods, especially the eighteenth and nineteenth centuries, the varnishes used had an accentuated amber hue, in tune with the tastes of the period.

The practice of cleaning off the layer of added, inauthentic varnish liberates the colors from a heavy filter that impedes a full appreciation of the delicate variations of color; cleaning also tends to resurrect the original tones and timbres. It is undeniable that the accumulation of varnishes in some cases confers an air of fullness and mystery to works of modest workmanship, thanks to the fact that this translucid veil interferes with our perception of the subject matter of the painting, glossing over the lapses in quality. In the case of the works of the great masters of the past,

 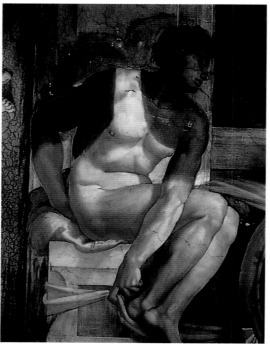 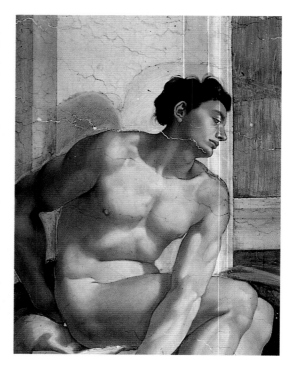

however, this filter is merely an unwanted obstruction to our full appraisal of the painting. The restorer's precise duty is, nonetheless, to preserve as much as possible of the original coat of varnish, which is nearly always very thin and slightly yellowed, as this layer is an integral part of the work, and sometimes the yellowing effect was desired by the artist. The same problems affect the more complex question of the original colored varnishes.

In the case of wall paintings, however, and of frescoes in particular, none of the substances that accumulate on the paint layer were envisioned by the artist as enhancing to his work, as fresco paintings were never treated to a final coat of varnish. The patina the colors have acquired over time derives from the steady process of carbonation of calcium hydrate, which is the active component of lime mortar and sand, or lime and *pozzolana*, or lime and ground marble. Frescoes were created with precise tones and timbres, therefore, the modification of which was not foreseen.

While the surface gathering of dust was an admissible factor, the accumulation of lampblack was quite unacceptable. In fact, from the times of Pope Paul III it was considered essential that the Sistine Chapel frescoes be kept free

of dust and lampblack and other deposits that might be considered detrimental to their conservation.

The practice of fresco restoration has, however, always implicated the restorer's use of substances which, spread over the entire field of the paint layer, have tended to have the same function as a varnish on canvas and panel paintings. The need for this stems from the fact that the cleaning process itself nearly always leaves the fresco arid, and with an undesirable layer of dust deriving from the dry residues of foreign matter that is not entirely removed.

Restorers of the past, whose approach was based on the integral resurrection of the work in hand—even by means of repainting, "bringing up to date," and reinterpreting—paid little or no attention to questions of reversibility regarding the materials they applied to the frescoed surface. Consequently, they used whatever was at hand: egg white, beeswax, casein, animal glue, cherry gum, gum arabic, ox bile, dextrin. Often these substances were mixed with a small amount of linseed oil. The preference and use of the various materials was determined by the customs of the period and region.

The substances listed above tended to decay very quickly; once they had

Three phases in the process of cleaning the ceiling frescoes. The first shows the shoulder of the *ignudo* above the prophet Ezekiel, used for the original trial patches of cleaning. The second shows the cleaning at a more developed stage, in which the part concealed beneath a heavy layer composed of deteriorated animal glue, soot, and grease, is still very dark and reveals nothing of the subtle modeling discovered beneath after cleaning. The third photograph shows the restored figure of the *ignudo*.

aged they were rarely an addition or enhancement to the restored frescoes, as they might in the case of works on canvas or panel. Hence the removal of such substances can only be of benefit to a fresco.

Particular advantages are gained from the point of view of conservation, as the compact, impermeable and vitreous layer that these materials produce covers and suffocates the tenuous paint layer. The impermeability of the paint layer also tends to prevent the wall and *intonaco* from transpiring; conse-

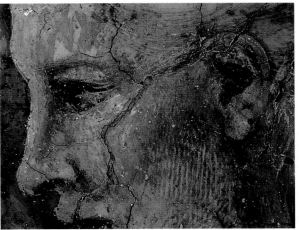

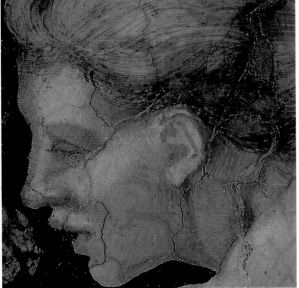

The main photograph shows a detail of the face of Eve in the Garden of Eden, from the *Fall of Adam and Eve* before restoration. One can see the small triangle of clearer paint that eluded the layer of animal glue applied by restorers in previous centuries. The small lighter patches are tiny blisters of paint caused by the contraction of the drying glue. These are more numerous on the upper part of the forehead, where Michelangelo made an *a secco* correction.

Before it was restored, the female face of the serpent was heavily masked by inexpert retouchings; the cleaning operation has rid the image of the clumsy reworking of the eye.

quently, with time the constant osmotic pressure of humidity passing from inside to out and vice versa provokes the detachment and ensuing disgregation of the paint layer itself, which entails the loss of the fresco—sometimes irrevocably. But besides its purely conservative purpose, the removal of this layer of foreign matter can have important aesthetic consequences, and hence implicate historical and critical assessment, as it heralds a new and correct reading of the work.

In the foregoing outline, which touches the core of the issue of cleaning the Sistine frescoes, I have attempted to stress the specific nature of wall-painting compared to the painting on movable media, in the hope of fending off the many prejudices that stem from a certain confusion of ideas and considerable lack of proper acquaintance with the facts.

The results of the cleaning project, remarkable as they may be, are the outcome of a simple procedure of removing the accumulated deposits from the surface of Michelangelo's frescoes—substances such as soot, saline efflorescence, and applied materials such as animal glues, gum arabic, and artificial *sporcature*. This operation has inevitably brought about the resurrection of the original paint layer and the complete retrieval of the fresco's true coloring, for both the ceiling and the *Last Judgment*, as was presaged by the cleaning and critical presentation of the Eleazar-Matthan lunette in 1981.

Given the thickness and color of the layer of surface deposits, their simple removal entailed a straightforward

A moment during the cleaning operation on the ceiling frescoes. Gianluigi Colalucci is working on the *Drunkenness of Noah*, while the NTV crew from Tokyo film each phase of cleaning in detail.

The agreement with NTV involved innumerable reels of color film documenting the entire cleaning operation over a period of fourteen years.

260

technical operation, rather than some historical and critical intervention. This problem was thoroughly examined before embarking on the task of cleaning, and scrupulous attention paid to the proposed depth of cleaning, to assure that the chromatic values lost in the course of four and a half centuries would faithfully be restored to Michelangelo's Sistine paintings.

To ensure that the cleaning did not trespass beyond the established depth, namely as far as the fine stratum of patina that formed in the first decades of the fresco's existence, we performed a small test on the Eleazar lunette in which we overstepped our limit; this was fully documented with photographs, to determine exactly what was considered an excessive depth of cleaning.

The outstanding quality of Michelangelo's fresco technique has meant that the paintings themselves have reached us in excellent repair, and therefore, once the few parts painted *a secco* were identified, it was possible to proceed with the removal of the eighteenth-century retouchings and the poor-quality interferences, which masked the original fabric of the painted surface, a surface found to be in good condition except for rare instances. Carnevale's various reintegrations were, however, preserved, because they plugged gaps in the original work that had been irrevocably lost.

Before cleaning it was indispensable to pinpoint the parts painted *a secco*, and hence establish if these were autograph or later reworkings. The next stage was to determine which of the non-authentic parts should be removed and which conserved. To carry out these investigations it was imperative to draw on the close-knit and sophisticated team of technicians behind the Sistine restoration project.

Modern restoration practice differs from the techniques of the past not so much for the difference in the actual manual operations or the tools with which the restorers work (which, plain and even rudimentary, basically remain the same), as for the elaborate, in-depth scientific background research that ac-

companies the task, and allows the restorers to tackle the material aspects of the art work with considerable foreknowledge and not merely with empirical methods; these insights are naturally backed up by a consolidated philosophy of restoration. Decisions regarding the preservation of original parts were made on the basis of several factors. As stated above, it was decided to keep all those parts (nearly all of which executed *a fresco*) that integrated parts that were otherwise irremediably lost, such as the group of figures in the *Sacrifice of Noah*, or those of the *pentimenti*, or elements painted that were painted *a secco* at the outset (such as Charon's oar), which for reasons of earlier restoration attempts, or because they had deteriorated and had been retouched in the distant past. By contrast, the decision was made to remove all those retouchings and repaintings which were justified at the time of their execution, such as the attempts to mask the effects of water seepage or to hide the white patches of salification, to redo areas completely destroyed by efflorescence, where, however, the original was still retrievable underneath (as in the case of the foreground of the pregnant woman in the Rehoboam-Abijah lunette). On this basis, removal of the imprecise, poor-quality retouching was performed, and of those parts that detracted from the general tone (present almost everywhere), together with the repaintings, however carefully executed, such as those of Mazzuoli; these were quite out of keeping with the overall hue of the fresco once cleaned, as they were made to match a different palette, or because they had altered over time, and above all covered original parts in reasonable condition that could be revived without defect.

The cases of censorship, which mainly affect the *Last Judgment*, posed a separate conservation problem, however, as their removal, which, far from being a technical issue or operational convenience, raised critical questions of historical authenticity.

The historically accepted "braghe" painted in the sixteenth century, imposed by a vote of the Council of Trent

to "correct" the frescoes, which were deemed scandalous for their "shameless nudity," offer a significant testimony to a moment of immense importance in the Church of Rome's history, namely, the Counter-Reformation.

Once a distinction had been made between the sixteenth-century and seventeenth-century instances of censorship, thanks to an exacting scientific study, it was decided to honor the former and eliminate the latter, which, dating from much later, had no pertinence whatsoever from the historical point of view.

As the Saint Blaise and Saint Catherine had been redone *a fresco*, they could not be removed in any case, since the original painting had been chiseled away to make room for the *intonaco* of the new fresco.

The vault contained two corrections only, both applied in the eighteenth century—those reported by J. Richard, who declared having seen unskilled painters in the eighteenth century busy repainting the drapery of figures in Michelangelo's ceiling and *Last Judgment*.

Another case of censorship, executed with dark brushstrokes imitating a shadow, regarded only the genitals of one of the Noah's three sons in the *Drunkenness of Noah* scene. The other case concerns the naked breast of the woman suckling her child in the Salmon-Boaz-Obed lunette; here the part was veiled by a succinct piece of drapery in a heavy color, encroaching on the original sleeve. The overpainting was removed during the restoration of the lunettes.

The varying states of conservation detected in the ceiling and the *Last Judgment* prompted the team to investigate slightly different cleaning methods appropriate to each specific problem. Extensive fieldwork was carried out before choosing the solvents and methods to be used, for both the vault and the *Last Judgment*. For the ceiling, moreover, these tests were repeated each time the scaffolding was moved, that is, for every three lunettes; the same was also done for the curve of the vault, for which a suspended mobile structure was employed, constructed by the

For the *Last Judgment*, the cleaning method adopted was slightly different, owing to the presence of the delicate lapis lazuli sky blue, which did not permit washing away the solvent of cellulose gum. Furthermore, the layer of gluey deposits and the many areas that had been cleaned and then subjected to artificial *resporcature*, demanded a method more in tune with the new situation in hand. For this reason the method chosen involved a pre-washing phase of deionized water, together with explorative cleaning treatment with ammonium carbonate. Subsequently, after twenty-four hours had elapsed, tampons were applied consisting of four sheets of Japan paper soaked in ammonium carbonate, and held in contact with the painted surface for twelve minutes, followed by a brief treatment of a mixture of organic solvents. The cleaning was performed with ammonium carbonate, and only after a period of a few days, it was followed by the repeated with deionized water.

Separate methods were employed for the cleaning of the parts painted *a secco* and for the lapis lazuli blue of the sky in the *Last Judgment*. Before cleaning, the *a secco* parts had to be protected and rendered impermeable with Paraloid B72, so as to avoid damage from the water that would be used for the border parts of the fresco. Similar treatment was applied to many tempera retouchings. Subsequently, proceeding with a very manual operation, the protective resin was gradually removed, exclusively from the paint's surface, wherever it was dirty, but not from the substance of the paint itself, thereby enabling the tiny portions of liberated surface to be cleaned with brushes soaked in the same solvent used for cleaning the frescoed areas. The resin absorbed by the pigment in the course of the operation impeded the water from penetrating and causing damage. Afterward, the resin was duly removed from the surface of the pigment through absorption.

A different method was adopted for the lapis lazuli blue of the *Judgment* sky. The paint was not given a coat of protection, as this highly disgregated pig-

Servizi Tecnici of the Vatican. In this case the tests were made on the seam between one bay and the next.

For the cleaning of the vault the solvent used was a gelatinous composition of water; ammonium bicarbonate; sodium bicarbonate; desogen; and carboxymethylcellulose [cellulose gum], created at the I.C.R. and having a ten-year history of application in fresco conservation; this substance made it possible to soften and distend the dark surface of the vitreous and tenacious glues without endangering the original paint layer and its fine patina.

The solvent was left for three minutes on the fresco's surface to soften the glue, which was then removed with a simple solution of deionized water. Over a certain period, the ceiling was cleaned sector by sector with abundant quantities of deionized water, to ensure that no microfine residues of solvent remained on the fresco's surface.

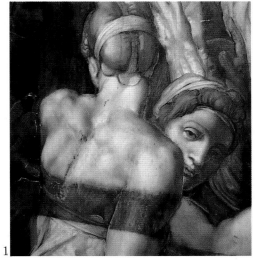

1

2

3

4

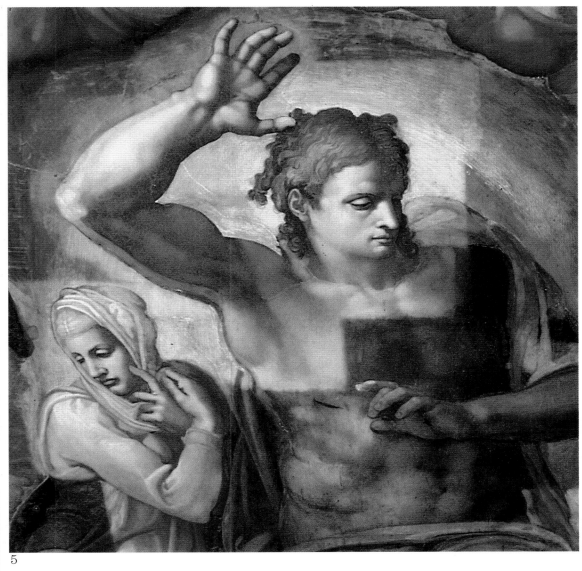

5

The cleaning of the *Last Judgment* involved first applying tampons of ammonium carbonate to soften and bloat the layer of glues, and a solvent to dissolve the grease. Though certainly darker than that of the ceiling, the layer of dirt, soot, and animal glue masking the *Judgment* fresco (fig. 1) was generally less tenacious and consistent. The reason for this is the greater amount of soot from the altar candles, and the many past attempts to clean the fresco, most of which were abandoned because of the poor results achieved each time.

The cleaning of the two central figures of Christ the Judge and the Virgin Mary (fig. 5) was fraught with difficulties owing to the many original *a secco* corrections, particularly for the figure of Christ and for the pale drapery across his lap (fig.2).

The ammonium carbonate tampons (fig. 3) were applied on the parts to be cleaned and carefully kept moist for no less than twelve minutes. This was the minimum time necessary for the layer of foreign matter to become sufficiently soft and hence be safely removed.

The group of wingless angels raising the column, and most of the blessed on the right (fig. 4) were cleaned by Pietro Camuccini in 1824, and then given a coat of glaze when the results of his work proved unsatisfactory.

ment, which was delicate at the outset and had been subjected to earlier bouts of cleaning and brushing, would not have withstood the aforementioned cleaning process used elsewhere.

In this case a painstaking, very "manual" method was preferred which involved dabbing the colored surface with a tiny natural sponge dipped in deionized water; the process was then repeated with ammonium carbonate. This slow and meticulous dabbing of the sponge and the movement of the liquid gradually lifted off the foreign substances and dust that had accumulated over time. At the same time, the pressure of the sponge itself helped increase the cohesion of the pigment to its support.

In the course of the restoration of the chapel ceiling a crack running through the breast of the left *ignudo* above the Persian Sibyl was found to contain a fragment of original fresco, once part of the chest of the figure; this piece had been used by Carnevale to plug the crack before filling it with lime and *pozzolana* mortar. The date of the filling can be inferred from the typical iron nails Carnevale planted in the surface to ensure the stability of the fresh filler. The fragment proves once and for all that no coat of animal glue was applied to the original fresco, and that the cleaning operation under way was indeed resuscitating the original tones of Michelangelo's colors.

No form of "protective" coat was applied to the frescoes, as the fairly rapid aging of such a substance would soon entail its removal. Only certain parts of the lunettes were treated with the specific C80 method, based on a separately applied combination of acrylic resin, Paraloid B72, and deionized water. The advantage of this method is that it reinforces the flaking pigments without promoting the formation of a harmful resinous surface coating.

A three-percent solution of Paraloid B72 was applied to the blue pigment of the *Judgment* sky as the extent of disgregation in certain parts was so advanced that treatment was essential.

In this case it was not possible to adopt the C80 method as this would have proved too hazardous given the critical state of the pigment in question.

The future conservation of the Sistine frescoes is currently entrusted to the special microclimate created by an array of instruments that continually replenish the ten thousand cubic meters of air in the chapel one point seven times per hour. The air fed in from outside is filtered and treated for pollution, and the relative humidity of the environment is kept at between fifty and sixty percent, with a temperature ranging from eighteen to twenty-five degrees. The conditioning plant was designed by the Vatican's Servizi Tecnici in conjunction with the Delchi-Carrier company, and based on parameters ascertained during research carried out by technicians from the Padua division of the CNR (National Research Center).

The restoration work itself is documented by some 15,000 photographs, in black and white, color slides, and Ektachromes, covering each of the three phases: before, during, and after cleaning. Each phase of the operation was filmed on-site by the NTV network, Tokyo, amounting to some 150,000 feet of film in 16 mm and 35 mm format.

The conservation of the frescoes, the technique of execution, and the restoration operation were all carefully mapped out on the basis of ECG photogrammetric surveys of the painted surfaces, and all the data stored in a CAD database on an Apollo DN 3000.

The scientific and technical studies included both ultraviolet and infrared surveys and photography, stratigraphic analysis, elemental analysis, atomic absorption spectrophotometry, observations with microscopes and videomicroscopes, infrared spectrophotometry, and liquid chromatography, mineralogical and petrographic analysis, microbiological analysis and chromatic sample readings, carried out both before and after cleaning.

The complex restoration operation, which culminated in a Mass officiated in the Sistine Chapel by Pope John Paul II, on April 8, 1994, had the dual purpose of ensuring the lasting future of the frescoes, and of restoring to view the full chromatic range of Michelangelo's paintings, which had remained hidden for so long.

A third though no less important outcome of the undertaking is our knew knowledge of Michelangelo's painterly technique, about which in the past there was much speculation, mostly influenced by the indecipherable pictorial surface masked by layers of glues and lampblack.

It had long been the general opinion that the surfaces in question were painted *a secco* on a fresco base. This misperception was the reason for contention over the choice of method for cleaning the frescoes. The restoration has made it overwhelmingly clear that Michelangelo painted in pure *a fresco* technique, creating a fresco of unparalleled excellence at technical level.

Michelangelo had experimented with this fresco technique much earlier, during his apprenticeship in Ghirlandaio's workshop, after which he seems to have not tried his hand again until he was called to paint the Sistine frescoes. For this reason the initial stage of work on the Sistine Chapel was not easy, nor were relations among the *garzoni* and painters called in to help him in his daunting task.

Given his demanding technique and his perfectionism, it is easy to understand why Michelangelo had trouble with those helping him; even some of those he himself had summoned from Florence were banished from the scaffolding. But Michelangelo's tribulations with his assistants were not the only source of trouble. He faced a major challenge when the mortar of lime and *pozzolana* on the vault failed to dry and began to sprout mold. To get around the problem, Michelangelo decided to eliminate the first layer of lime and travertine, a poorer type of mortar; he continued with the *pozzolana*, however, as this is a volcanic stone found in Lazio and affords a strong, resistant mortar, though somewhat difficult to use in frescoing. This decision was evidently well pondered, as his experience in Florence would otherwise have advised him to adopt the more customary component of river sand.

Instead, he performed trials with the *pozzolana* mortar, which had been used extensively in Roman times. Not being a truly inert medium like sand, it dries out rapidly, leaving the fresco artist scant time to work in. To get around the problem Michelangelo modified the ratio of lime to *pozzolana*, normally one to three respectively, reducing it to one to two, and hence concocting a type of mortar defined as *grassa* (heavy), which as it dried tended to leave a snakeskin pattern, such as those visible on the frescoes of the vault. In order, therefore, to obtain the extraordinary smooth surfaces that characterize most of the figures in the ceiling and *Judgment*, Michelangelo probably pressed the *intonaco*'s surface while it was still moist and already painted, with an iron and paper. In this way, besides creating a smooth, compact surface, the process of carbonation was encouraged, as the pressure brought the water to the surface of the material.

The *intonaco* of the *Last Judgment* is of the same quality and finish as that of the ceiling. However, in several instances Michelangelo supplemented the traditional mortar mix with carbonate of white lime, which may have helped lighten the ground tone of some of the figures, while conferring added compactness to the *intonaco*. It is documented that the wall of the *Judgment*—originally prepared for painting in oil—upon Sebastiano del Piombo's recommendation to the pope, was chiseled out by Michelangelo and clad with a *scarpa* or lining of well-fired brick that projected twenty-five centimeters at the crown. Vasari's explanation for this solution was that it was devised to prevent dust settling on the fresco. However, considering that the projection made the wall surface more prone to collecting candle smoke, it may have served to correct the perspective effect of the wall.

Independently of various personal vicissitudes, including Michelangelo's relations with the pope, work on the frescoes must have been influenced by the deadlines affecting both the ceiling and the *Last Judgment*. The artist in fact began each time by transferring preparatory drawings by means of the *spolvero* or pouncing, a technique that involves making tiny holes in the paper drawings, placing these on the surface of the fresh *intonaco*, and slapping a cloth bag of charcoal dust against it; the dust passes through the holes in the paper to leave a set of fine dotted outlines on the wall. The method requires lengthy preparation, as the drawings must be precise in every detail, and it takes time to make the perforations. But the technique enables the transfer of detailed, complex drawings without harming the flat surface of the *intonaco*; the subsequent painting must follow the *spolvero* lines, which the brush tends to avoid so as not to dirty the color. For this reason, like many painters of the trecento and quattrocento (witness Signorelli), Michelangelo outlined the contours of his faces, particularly those of the *ignudi*, with the tip of brush dipped in black. This method was used for the transfer of most of the preparatory drawings for the *Last Judgment*, but toward the end of the task, in both cases the *spolvero* method was replaced by the more rapid "indirect incision" technique. This method involves making a cartoon: a drawing of the figure was made on a sheet of fairly thick paper. It was placed against the fresh *intonaco* and traced with a rounded point of ivory or boxwood, thereby leaving a groove in the soft surface of the wall, which acts as a guide for the subsequent brushwork. It goes without saying that such a method is inadequate for transferring finer, detailed artwork.

The reason why Michelangelo switched methods as he approached the end of the job is unclear, but at a guess it greatly speeded the work process. At this point there was probably no interval between drawing and painting. As soon as the drawing was ready—perhaps even only summarily sketched out—it was rapidly transferred to the *intonaco*, after which the painting proper began, which did not always in fact faithfully follow the lines traced out beforehand. This method requires greater improvisation from the artist than that of the drawing and *spolvero* technique. Singularly Michelangio-lesque in nature are the ceiling lunettes, which were painted without the use of cartoons, and hence via impression, and without dividing the main figures into *giornate*, whereby we have the extraordinary case of *giornate* five and a half meters long. It has been suggested that, given the size of each *giornata*, the pictorial technique is not in *buon* (true) *fresco*, but involved *pittura a calce*, or lime painting. Though it may seem odd, it is indeed proper fresco work, albeit swiftly and confidently executed in a succinct painterly hand. It has also been proposed that the lunettes, and perhaps also the other parts of the ceiling, were painted *a secco* in a later phase.

There is no evidence to support these ideas. Instead, there are plenty of indications to the contrary, if we are to interpret correctly what Vasari stated on the question.

The lower part of the lunettes was left unfinished because the scaffold platform did not allow comfortable access; consequently, until the eighteenth century both the *arriccio* and the runs of paint were visible. There are no traces of *a secco* finishing touches; these would have been preserved at any event, despite the restoration attempts of 1710 during which the unfinished part was completed with a large plaster patch painted gray so as to create a continuous band between the fresco and the impost cornice. Michelangelo was very sparing in his use of *a secco* color, as can be observed in his choice of pigments, which were all strictly apt for *a fresco* work—with a minor exception, notably in the *Judgment*: on occasion the artist resorted to *a secco* painting for last-minute corrections. The frescoes give one the conviction that the pictorial execution is complete in every part and detail, and that there are no compartments in which there are preparatory sections not painted *a secco*. Therefore, to judge also from the scientific investigations made (and thanks to the recently completed restoration operation), we may confirm that Michelangelo's paintings in the Sistine Chapel are in *buon fresco*, perhaps the finest example of fresco work we will ever witness, finally accessible for all to see.

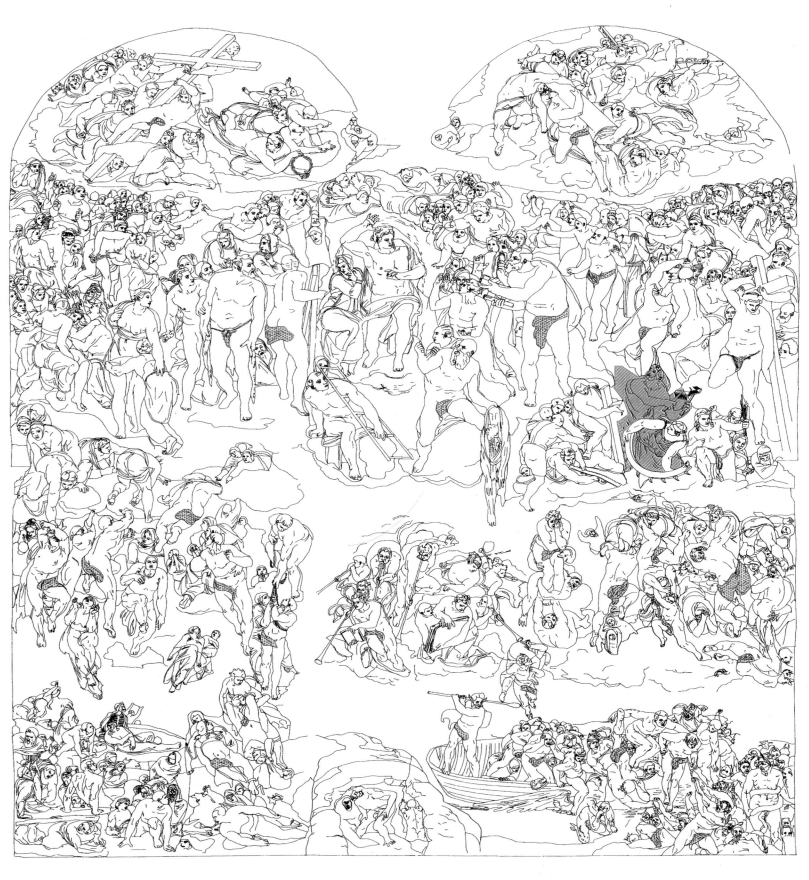

 Corrections *a secco*

 Corrections *a fresco*

By order of the Council of Trent, the *Last Judgment* was "corrected" immediately after Michelangelo's death, when a series of discreet drapes were added to hide the nakedness of certain figures. The first acts of censorship, namely the addition of the famous "braghe" (trousers), were carried out by Daniele da Volterra in tempera, except for the figure of Saint Blaise, and most of Saint Catherine (top right), which were refrescoed. Upon Volterra's death the task was continued by Girolamo da Fano (unconfirmed) and Domenico Carnevale. Further tampering with the fresco was perpetrated in the eighteenth and nineteenth centuries. The present restoration project entailed the removal of the later "corrections" but the conservation of those effected in the sixteenth century, as they constitute an important historical document related to the upheaval under way in the Roman Catholic Church, namely the Counter-Reformation.

The diagram shows all the cases of censorship, irrespective of the period in which they were carried out.

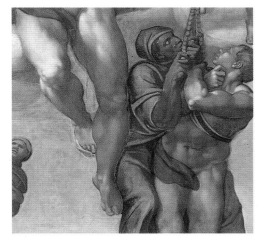

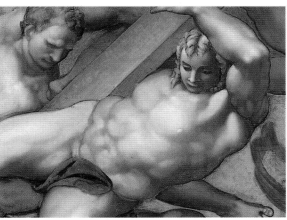

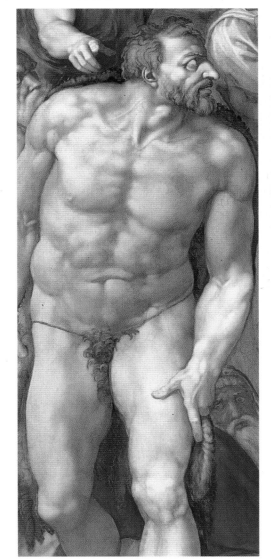

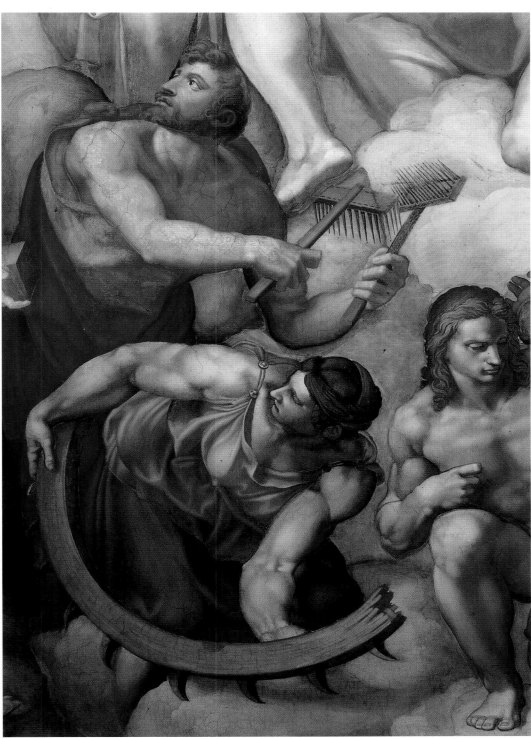

The three pictures on the left show several cases of censorship which color analysis revealed as dating from the sixteenth century. The clothing of Saint John the Baptist *(left)* was more carefully painted than the others, with a greater attempt to blend with the original fresco; this would seem to suggest that it was executed by Daniela da Volterra, in tempera.

Above: The Saint Blaise and Saint Catherine group was considered so indecent by the censors that at the time that Volterra evidently thought it best to refresco rather than paint over with tempera. The original composition is known to us via several coeval copies, particularly that of Venusti (Naples, Museo Nazionale di Capodimonte). The figure of Saint Blaise did not originally turn his gaze on Christ, but was leaning over Saint Catherine, who was completely naked. Volterra destroyed the original and redid the entire section of Saint Blaise in red, whereas for Saint Catherine the authentic parts include the head, arms, and wheel; the body was redone dressed in a green tunic.

BIBLIOGRAPHY

Bibliographical repertoire up until 1970:

Steinmann, E., and R. Wittkower. *Michelangelo-Bibliographie, 1510–1926*. Leipzig, 1927.

Dussler, S. L. *Michelangelo-Bibliographie, 1927–1970*. Wiesbaden, 1974.

Bibliography

Aretino, P. *Lettere sull'arte*, Hrsg. E. Camesasca (3 vols.), Milan, 1957–1960.

Bambach, C. C. A note on Michelangelo's cartoon for the Sistine Ceiling: Haman. *The Art Bulletin*, LX 1983: 661–665.

Bardeschi Ciulich, C., and P. Barocchi. *I Ricordi di Michelangelo*. Florence, 1970.

Barocchi, P. and R. Ristori, eds. (6 vols.) *Il Carteggio die Michelangelo*. Posthumous edition. Florence, 1965–1983.

Barocchi, P., ed. *Il Giardino di San Marco: Maestri e compagni del giovane Michelangelo*. Exhibition catalogue. Florence, 1992.

——. *Trattati d'arte del Cinquecento. Fra Manierismo e Controriforma* (3 vols.). Bari, 1960–62.

Biagetti, B. "La volta della Cappella Sistina. Primo saggio di indagine sulla cronologia e la tecnica delle pitture di Michelangelo", *Rendiconti della Pontificia Accademia Romana di Archeologia* XII (1936).

Brenk, B. *Tradition und Neuerung in der christlichen Kunst des ersten Jahrtausends*. Vienna, 1966.

Bull, M. "The iconography of the Sistine Chapel ceiling" *The Burlington Magazine* CXXX (1988): 597–605.

Buonarotti, M. *Rime*, ed. E. N. Girardi. Bari, 1960.

Calì, M. *Da Michelangelo all'Escorial, Momenti del dibattito religioso nell'arte del Cinquecento*. Turin, 1980.

Chastel, A. "Contemporanei di fronte alla rivoluzione della volta" Various, *La Cappella Sistina. I primi restauri*.... Novara, 1986: 149–174.

——. *Le sac du Rome, 1527*. Paris, 1984.

Cicerchia, A., and A. M. De Strobel. "Documenti inediti dell'Archivio Segreto Vaticano sui restauri delle Stanze e della Cappella Sistina nel Settecento." *Monumenti, Musei e Gallerie Pontificie Bollettino* VI (1986): 148–152.

Clements, R. J. *Michelangelo's Theory of Art*. Zurich, 1961.

Colalucci, G. "Gli afreschi della volta sistina. La tecnica di esecuzione," Various, *La Cappella Sistina. La volta restaurata*.... Novara, 1992: 26–35.

——. "Le lunette di Michelangelo nella Cappella Sistina", *Tecnica e stile: esempi di pittura murale del Rinascimento italiano*, ed. E. Borsook und F. Superbi Gioffredi. Florence, 1986: 76–81.

Condivi, A. *Vita di Michelangelo Buonarroti*. Rome, 1553.

Conti, A. *Michelangelo e la pittura a fresco*. Florence, 1986.

De Hollanda, F. *Da Pintura Antigua*, ed. J. De Vasconcellos. Porto, 1930.

De Maio, R. "Michelangelo e san Carlo.", *Atti del Convegno Internazionale su san Carlo Borromeo II*. Milan, 1986.

——. *Michelangelo e la Controriforma*, Bari, 1978.

De Vecchi, P. "Il 'Giudizio Universale': fonti iconografiche, reazioni, interpretazioni." Various, *La Cappella Sistina. I primi restauri*.... Novara, 1986: 176–207.

——. "Sintassi dei corpi e modi delle attitudini dalla volta al' 'Giudizio'." Various, *La Cappella Sistina. La volta restaurata*.... Novara, 1992: 224–235.

De Vecchi, P., and G. Colalucci. *Michelangelo. La Cappella Sistina, I: Il Giudizio Universale*. Milan, 1995.

De Vecchi, P., V. Guazzoni, and A. Nova. *Michelangelo*. 3 vols. Milan, 1984.

Delacroix, E. *Journal 1823–1850*. Paris, 1893.

Doetsch, I. E. "Der wahre Michelangelo. Die Restaurierung der Fresken Michelangelos in der Sixtinischen Kapelle in Rom." *Restauro* XCV (\): 87–100.

Eliot, A. "The Sistine Cleanup: Agony or Ecstasy?" *Harvard Magazine* LXXXIX (1987): 28–38.

Fahy, E. "Michelangelo and Domenico Ghirlandaio. *Studies in Late Medieval and Renaissance Painting in honor of Millard Meiss*. New York, 1977.

Feldhusen, R. *Ikonologische Studien zu Michelangelos Jüngstem Gericht*. Berlin, 1978.

Fillitz, H. "Zum Problem der Deckenfresken Michelangelos in der Sixtinischen Kapelle." *Römische Historische Mitteilungen* XXVII (1985): 401–412.

Finch, M. "The Sistine Chapel as a Temenos: An Interpretation Suggested by the Restored Visibility of the Lunettes." *Gazette des Beaux-Arts* CXV (1990): 53–70.

Freedberg, S. J. *Painting of the High Renaissance in Rome and Florence*. Cambridge (Mass.), 1961.

Frey, D. *Michelangelo Studien*. Vienna, 1920.

Frey, K. *Michelagniolo Buonarroti. Sein Leben und seine Werke*. Berlin, 1907.

Gilbert, C. "On the Absolute Dates of the Parts of the Sistine Ceiling." *Art History* III (1980): 158–181.

Goethe, J. W. von. *Italienische Reise*, Stuttgart, 1862.

Gordon Dotson, E. "An Augustinian Interpretation of Michelangelo's Sistine Ceiling." *Art Bulletin* LXI (1979): 223–255; 405–429.

Greenstein, M. J. "How Glorious the Second Coming of Christ: Michelangelo's Last Judgement and the Transfiguration" *Artibus et Historiae* X (1989): 33–57.

Gutman, H. B. "Jonah and Zachariah on the Sistine Ceiling." *Franciscan Studies* XIII (1953): 159–177.

Hall, M. "Michelangelo's Last Judgment: Resurrection of the Body and Predestination." *Art Bulletin* LVIII (...): 85–92.

Hartt, F. *Michelangelo Buonarroti. Paintings*. New York, 1964.

——. "'Lignum Vitae in Medio Paradisi': the Stanza di Eliodoro and the Sistine Ceiling." *Art Bulletin* XXXII (1950): 115–145; 181–218.

——. *The Evidence for the Scaffolding of the Sistine Ceiling*. Art History V (1982): 273–286.

Hartt, F. and G. Colalucci. *Michelangelo. La Cappella Sistina I: la Preistoria della Bibbia*. Milan, 1989.

——. *Michelangelo. La Cappella Sistina III: La Storia della Creazione*. Milan, 1990.

Hartt, F., G. Colalucci and F. Mancinelli. *Michelangelo. La Cappella Sistina II: gli Antenati di Cristo*. Milan, 1989.

Hatfield, R. *Trust in God: the Sources of Michelangelo's Frescoes on the Sistine Ceiling*. Exhibition catalogue, Syracuse University. Florence, 1991.

Hibbard, H. *Michelangelo*. Harmondsworth, 1975.

Hirst, M. "'Il modo delle attitudini'. Taccuino di Oxford per la volta della Sistina." Various, *La Cappella Sistina. I primi restauri*.... Novara, 1986: 208–217.

——. *I disegni preparatori*, Various, *La Cappella Sistina. La volta restaurata*.... Novara, 1992: 8–25.

——. *Michelangelo and his Drawings*. New Haven – London, 1988.

——. "Two unknown studies by Michelangelo for the Last Judgment." *Burlington Magazine* CXI (1969): 27–28.

Hope, C. "The Medallions on the Sistine Ceiling." *Journal of the Warburg and Courtauld Institutes* L (1987): 201–204.

Johannides, P. "On the Chronology of the Sistine Chapel Ceiling." *Art History* IV (1981): 250–253.

Kuhn, R. *Michelangelo, die Sixtinische Decke: Beiträge über ihre Quellen und zu ihrer Auslesung*. Berlin, 1975.

Lanckoronska, C. "Appunti sulla interpretazione del 'Giudizio Universale' di Michelangelo." *Annales Institutorum* V (1932–1933): 122–130.

Maeder, E. "I costumi degli Antenah di Cristo." Various, *La Cappella Sistina. La volta restaurata*.... Novara, 1992: 194–201.

Mancinelli, F. "Il ponteggio di Michelangelo nella Cappella Sistina." *Tecnica e stile: esempi di pittura murale del Rinascimento italiano*, ed. E. Borsook und F. Superbi Gioffredi. Florence, 1986: 73–75.

——. "La technique de Michel-Ange et les problèmes de la Chapelle Sixtine." *Revue de l'Art* XX (1988): 9–19.

——. "Michelangelo: il problema degli aiuti." Various, *La Cappella Sistina. La volta restaurata*.... Novara, 1992: 46–57

——. "The Technique of Michelangelo as a Painter: a note on the cleaning of the first lunettes in the Sistine Chapel." *Apollo* CXVII (1983): 362–367.

Mancinelli, F. and R. Bellini. *Michelangiolo*, Florence, 1992.

Mancinelli, F. and G. Colalucci. "Il vero colore di Michelangelo. Le lunette della Cappella Sistina." *Critica d'Arte* L (1985): 72–89.

Mancinelli, F., G. Colalucci and N. Gabrielli. "Il 'Giudizio finale' e il suo restauro. Note di storia, tecnica e conservazione." Various, *La Cappella Sistina. La volta restaurata*.... Novara, 1992: 236–255.

——. "Michelangelo. Il Giudizio Universale" *Art Dossier* 88 (1994).

——. "Rapporto sul Giudizio." *Monumenti, Musei e Gallerie Pontificie: Bollettino* XI (1991): 219–249.

Mancinelli, F. and A. M. De Strobel. A. M., *Michelangelo. Le lunette e le vele della Cappella Sistina*, Roma, 1992.

Michelangelo Buonarroti nel IV centenario del 'Giudizio Universale'. Florence, 1942.

Michelangelo e l'arte classica, Exhibition catalogue, eds. G. Agosti and V. Farinella, Florence, 1987.

O'Malley, J. W. *Giles of Viterbo on Church and Reform: A Study in Renaissance Thought*. Leyden 1968.

——. "Il mistero della volta: Gli affreschi di Michelangelo alla luce del pensiero teologico del Rinascimento" Various, *La Cappella Sistina. I primi restauri*.... Novara, 1986: 92–148.

Pagliara, P. "Nuovi documenti sulla costruzione della Cappella Sistina." Various, *La Cappella Sistina. La volta restaurata*.... Novara, 1992: 256–265.

Panofsky, E. *Die Sixtinische Decke*. Leipzig, 1921.

Perrig, A. *Michelangelo's Drawings: the Science of*

Attribution. New Haven – London, 1991.

Pirina, C. "Michelangelo and the Music and Mathematics of His Time." *Art Bulletin* LXVII (1985): 368–382.

Redig de Campos, D. *Il Giudizio Universale di Michelangelo.* Milan, 1964.

———. *La Cappella Sistina.* Novara, 1959.

Redig de Campos, D. and B. Biagetti. *Il Giudizio Universale di Michelangelo.* Rome, 1944.

Salmi, M. ed. *Michelangelo Artista Pensatore Scrittore* (2 vols.). Novara, 1965.

Salvini, R. *Michelangelo.* Milan, 1978.

Salvini, R. E. Camesasca, and C. L. Ragghianti, *La Cappella Sistina in Vaticano* (2 vols.). Milan, 1965.

Shearman, J. "La costruzione della Cappella e la prima decorazione al tempo di Sisto IV." Various, *La Cappella Sistina. I primi restauri...* Novara, 1986: 22–87.

———. "Le funzioni del colore" Various, *La Cappella Sistina. La volta restaurata....* Novara, 1992: 80–109.

Sinding Larsen, S. "A Re-reading of the Sixtine Ceiling." *Acta ad Archaeologiam et artium historiam pertinentiam* IV (1969): 143–157.

Steinberg, L. "Michelangelo's Last Judgement as Merciful Heresy." *Art in America* 63 (1975): 48–66.

———. *Michelangelo's Last Paintings.* Oxford, 1975.

Steinmann, E. *Die Sixtinische Kapelle* (2 vols.). Munich, 1901–1905.

———. *Michelangelo im Spiegel seiner Zeit.* Leipzig, 1930.

Summers, J. D. *Michelangelo and the language of Art.* Princeton, 1981.

Taja, A. *Descrizione del Palazzo Apostolico Vaticano.* Rome, 1750.

Tanaka, H. "The Three Scenes of Noah in the Sistine Paintings by Michelangelo." *Art History* IX (1987): 1–57.

Thode, H. *Michelangelo und das Ende der Renaissance* (6 vols.). Berlin, 1902–1913.

Tolnay, C. de. *Corpus dei disegni di Michelangelo* (4 vols.). Novara, 1967–1980.

———. "Le Jugement Dernier de Michel-Ange." *The Art Quarterly* III (1940): 125–146.

———. *Michelangelo* (5 vols.). Princeton, 1943–1960.

———. *Michelangelo: Sculptor, Painter, Architect.* Princeton – London, 1975.

Various, *La Capella Sistina. I pirmi srestauri: la scoperta del colore.* Novara, 1986.

———. *La Capella Sistina. La volta restaurata: il trionfo del colore.* Novara, 1992.

———. *Michelangelo e la Sistina. la technica, il restauro, il mito.* Exhibition catalogue.Rome, 1990.

Vasari, G. *La Vita di Michelangelo nelle redazioni del 1550 e del 1568,* ed. P. Barocchi (5 vols.). Milan – Naples, 1962.

von Einem, H. *Michelangelo.* Stuttgart, 1959.

von Pastor, L. *Geschichte der Päpste seit dem Ausgang des Mittelalters.* Freiburg i. B., 1886–1907.

Wallace, E. W. "Michelangelo's assistants in the Sistine Chapel" *Gazette des Beaux-Arts* CX (1987): 203–216.

Weil Garris Brandt, K. "Twenty-five questions about Michelangelo's Sistine Ceiling." *Apollo* CXXVI (1987): 392–400.

Wilde, J. *Michelangelo. Six lectures.* Oxford, 1978.

———. "The Decoration of the Sistine Chapel" *Proceedings of the British Academy* 94 (1958).

Wind, E. "The Ark of Noah: a Study in the Symbolism of Michelangelo." *Measure* I (1950): 411–421.

———. "Maccabean Histories in the Sistine Ceiling" *Italian Renaissance Studies.* London 1960: 312–327.

———. "Michelangelo's Prophets and Sibyls." *Proceedings of the British Academy* LI (1960): 47–84.

———. *Pagan Mysteries in the Renaissance.* London, 1958.

———. "Typology in the Sistine Ceiling. A Critical Statement." *Art Bulletin* XXXII 1951: 41–47.

Winner, M. "Giona: il linguaggio del corpo." Various, *La Cappella Sistina. La volta restaurata....* Novara, 1992: 110–119.

Wittkower, R. and M. Wittkower. *Born under Saturn.* London, 1963.

PICTURE CREDITS

INDEX

Page numbers in italics refer to illustrations.